Sex, Drag, and Male Roles

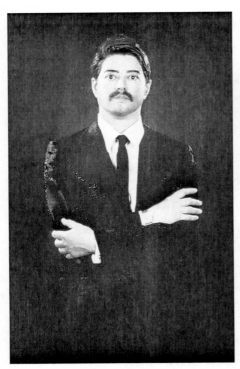
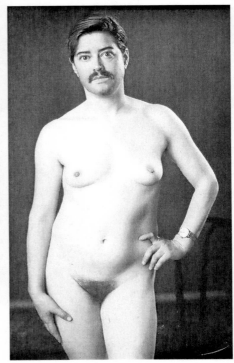

Diane Torr in and half-out of male drag.
Shoot for *Adam* magazine, April 1989.
Photographer: Annie M. Sprinkle, PhD.
Used with permission.

Sex, Drag, and Male Roles

Investigating Gender as Performance

Diane Torr and
Stephen Bottoms

THE UNIVERSITY OF MICHIGAN PRESS
ANN ARBOR

2013 2012 2011 2010 4 3 2 1

A CIP catalog record for this book is available from the British Library.

Library of Congress Cataloging-in-Publication Data

Torr, Diane.
 Sex, drag, and male roles : investigating gender as performance / Diane Torr and Stephen Bottoms.
 p. cm. — (Critical performances)
 Includes bibliographical references and index.
 ISBN 978-0-472-07102-9 (cloth : alk. paper) — ISBN 978-0-472-05102-1 (pbk. : alk. paper)
 1. Drama—History and criticism. 2. Sex role in the theater.
 3. Gender identity in the theater. I. Bottoms, Stephen J. (Stephen James), 1968– II. Title.
 PN1650.S48T67 2010
 792.02'8—dc22 2010007940

for Johnny and for Donald
in loving memory

To gain supreme victory, it is necessary, for one thing,
that . . . men and women unequivocally affirm their brotherhood.
 —SIMONE DE BEAUVOIR, *The Second Sex*

If I can't dance, I don't want to be a part of your revolution.
 —EMMA GOLDMAN

Contents

A Note to the Reader

This book, like others in the series Critical Performances, results from a collaboration between a performance artist, Diane Torr, and a critic, Stephen Bottoms. The usual format for such a project might be for Stephen to introduce a collection of Diane's performance texts and perhaps conduct an interview with her at the end, but we decided early on that a different approach was needed in this case. As a performer trained in dance and martial arts, Diane's performances are rooted in the physical as much as in the verbal, so the publication of "scripts" can render only a very partial impression of her work (though a selection is nevertheless included in part 3 of this book). Moreover, Diane's work has often been a reflection of, and is integrally related to, the shifting contexts in which it has appeared. Her work as a male impersonator or drag king has been staged in theaters, clubs, and galleries, but it has also been disseminated through participatory workshops, lecture demonstrations, and television appearances and has been witnessed as "invisible theater" by (mostly unwitting) passersby in city streets across the globe. The best way for us to present her work in print is thus to tell the *story* of that work rather than simply trying to document it using trace remains. The substance of our collaboration has involved Diane digging back into her past to provide a personal commentary while Stephen has attempted to contextualize that narrative in relation to other theatrical and historical developments. The result, we hope, is not simply a book about a single artist but one that helps elucidate a broader cultural history.

Since we wrote this book together, our voices alternate throughout. In order to avoid constantly re-marking ourselves as authors of differ-

ent sections, we have opted simply to indicate changes of voice through the use of different fonts.

So when the text looks like this, Diane is writing.

And when the text looks like this, Stephen is writing.

In the final chapter, we'll return to the first font, writing collectively. Font changes aside, we hope that the book's structure is clear and straightforward. In the introduction, Stephen offers a critical overview of the issues raised by Diane's work and considers them in relation to a longer historical perspective. Readers unconcerned with such "academic" matters may choose to leap straight to part 1, where Diane begins her personal narrative. Over the course of three chapters (interrupted only occasionally by Stephen's historicizing interjections), she traces the evolution of her work within the developing context of feminist performance through the 1970s and 1980s, up to and including the beginnings of the drag king scene in the early 1990s. Then, building on this foundation, part 2 presents four chapters that reflect on different aspects and applications of female-to-male drag performance through the 1990s and into the 2000s. Chapter 4 looks at the peculiarly sexy appeal of drag king performance in club contexts, whereas chapter 5 considers "passing" performances in everyday locations. Chapter 6 then looks at a number of Diane's stage performances, linked by the theme of cultural memory, while chapter 7 brings the story up to date by considering some links between female-to-male drag and the transgender movement. Part 3 concludes the book with a selection of Diane's performance texts, including her "Do-It-Yourself Guide" to becoming a man for a day.

Prologue

PISSING CONTEST #1 (HOMAGE TO NAM JUNE PAIK)

14 April 2007. The James Cohan Gallery, West 26th Street, New York City

"In the spirit of the late Nam June Paik and his longtime affiliation with Fluxus, James Cohan Gallery has invited renowned Fluxus artist Larry Miller to present a performance event at the gallery in conjunction with our exhibition of Paik sculpture."

The *Fluxus Champion Contest,* a Paik composition first presented at the "Festum Fluxorum Fluxus" in Düsseldorf in February, 1963, was among those selected for realization on this occasion. In Paik's outline for the event, five men assemble. Each unzips and pees into a white pail while singing his country's national anthem. The composition states that the flow of each man's pee has to be continuous. When he peters, falters, or stops, he is disqualified and his anthem ends. The last man singing is the winner.

A longtime resident of New York, I am now based in Scotland, where I grew up. I happened to be in town for this event, though, and so Larry Miller—an old friend and colleague—invited me to participate. He needed an international cast, and the fact that I am female—and would have to cross-dress as male—didn't worry him in the least. Indeed, it was very much in the Fluxus spirit. The movement's instigator, George Maciunas, enjoyed cross-dressing, and when in 1977 he married Billie Hutching (in a performance titled *Fluxwedding*) both partners wore brides' dresses—and Larry acted as bridesmaid.

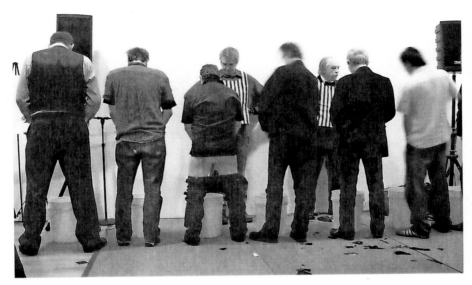

Diane Torr as Angus McTavish, among the contestants in Nam June Paik's *Fluxus Champion Contest,* as realized by Larry Miller (the referee to the right). James Cohan Gallery, New York, 14 April 2007. Photograph by Kathy Brew. Used with permission.

On the day of the performance, we were asked to gather at 5.30 p.m., ready to go. Seven contestants all arrived with bladders bursting: an American, an Englishman, a Frenchman, a Pole, a Lithuanian, a Korean, and a Scot. I came as Diane and changed into my male persona in the bathroom. At least some of my competitors were aware of this, although most of them just seemed to be focused on holding their pee in. In honor of the occasion, I had created a new character I dubbed Angus McTavish, the kind of rough, gruff, working-class Scotsman you might find at a Glasgow soccer match. No doubt some people wondered what this guy was doing in a Chelsea art gallery. The young female cellist, on hand to perform in another Paik piece (originally written for Charlotte Moorman), later confessed to me at a dinner that Angus had terrified her. She was very relieved to discover I was a woman.

So anyway, there we all were, waiting backstage, dying to pee. What we hadn't been told was that our performance wouldn't happen until about eight. At some point during the lengthy wait, I just decided the

hell with this and went to pee. I then immediately drank two liters of water. When we finally got to the contest itself, I was dying to pee again, but I wasn't gripping my thighs in agony. Some of the others looked to be in serious pain.

We all had to line up with our backs to the audience. I stood out in the line-up because I was the only one with my ass showing: I had to pull my pants down so I could pee, but I figured this just came across as Scottish exhibitionism, *Braveheart* style. Larry, who was acting in the Paik role of adjudicator on the pee streams, was not about to give away my secret, so I just got on with the task of singing "Scotland the Brave" while directing my pee through a "urinelle." This is a plastic-coated, cardboard funnel, designed for female use during camping trips, but it turned out to be less than ideal. I could direct the pee, but a lot of it leaked out and ran down my legs, soaking my jeans and underpants. Still, I kept on peeing, and at some point I realized there were only two of us still singing our national anthems.

I hadn't come with any expectation of winning; the whole thing just seemed like a hoot to me. But women can regulate the flow of their pee rather better than men (who just kind of have to let it go), and when I realized it was just me against the guy next to me, I became determined to win. It was a matter of national pride!

Afterward I carried on in character, keeping up Angus's Glaswegian banter as Larry awarded me the victory trophy, a decorated toilet-seat arrangement, which he had assembled and signed, together with a large cardboard cutout image of the *manneken pis* (the famous Brussels statue) gushing forth in a sprayed-on golden arc. The audience clapped and cheered (the pioneering feminist artist Carolee Schneemann among them). Then I went backstage and redressed as Diane, high on my victory and the general festive spirit of the occasion. Weirdly though, I found that a couple of the losing competitors were furious when they realized they had been beaten by a woman. Apparently they had taken it all rather more seriously than I had, suffering a degree of pain in the process, and felt they had been cheated.

I was astonished, although perhaps I should not have been. One of the few things that still distinguishes men from women is that they can pee standing up. Had I somehow encroached on this final bastion of male privilege? Or are some people just sore losers?

Sex, Drag, and Male Roles

Introduction: Why Act Like a Man?

When asked, "What's a drag king?" I reply: "Anyone, (regardless of gender) who consciously makes a performance out of masculinity."
—DEL LAGRACE VOLCANO

The first time I saw Diane Torr perform as a man the experience was a little unnerving. In the context of a lecture-demonstration, she had first appeared as "herself" and presented a slide show documenting the development of her work. She then disappeared offstage, leaving us to watch a video about her "Man for a Day" female-to-male transformation workshops. Eventually she reappeared as Danny King—her middle-aged, middle-class, middle-management character—complete with business suit, slicked-back hair, mustache, stubble, and shiny black shoes. What was disorientating, though, was not the cosmetic transformation but the change in physicality. Danny walked on slowly, planting his feet squarely onto the stage floor as if he owned it, and then stopped, folded his arms across his chest, and stared at us with a look of absolute indifference. He made as if to begin speaking, then thought better of it. He adjusted his posture, looked down at his shoes, back up at us, and stared some more. A moment more, and he began striding casually around the stage as if checking out its dimensions, utterly unconcerned by the presence of observers. By the time he finally deigned to speak to us, he was indisputably in command of the stage and his audience and yet he had *done* almost nothing. Despite his diminutive stature (Diane is five foot four), we had ceded authority to him as a commanding, masculine presence. Indeed, some subconscious part of my brain was telling me that this was, in fact, a man even though my conscious mind knew that Danny was also Diane. The uncanny effect was further underlined as Danny began to explain—in character—the means by which he was creating this impression of "innate" masculine entitlement.

My fascination with Diane's drag performances began there, with the simple fact of her ability to adopt and inhabit varying forms of masculine physicality that men tend to assume are inborn. Her apparent ease in exposing this strange artifice of naturalized masculinity is an unsettling reminder that the assumptions men have about their own identities are themselves based on performance, even pretense. Working with Diane Torr, and watching her perform, has been a way for me to keep what I hope is a healthy sense of perspective about my own daily performance of masculinity. But of course Diane did not get into male impersonation in order to niggle at the self-awareness of men. Her objectives, rather, are epitomized by the Man for a Day workshop—originally the Drag King workshop—which she first facilitated in 1990, in collaboration with Johnny Science, even before she had presented any full-drag performances of her own. The workshop's goal has always been to help facilitate women in "passing" as male in the world at large. In seeing the world, at least temporarily, from a man's perspective, and in being responded to as male, women are able to distance themselves critically from their socialized perspectives as females, sometimes with life-changing results. To take a male character created in the studio out onto city streets as a functioning identity is to cross over not only the line between "art" and "life" but the line between female and male experience, thereby challenging all kinds of constructions and assumptions.

Diane is one of the key pioneers of drag king performance as it emerged internationally during the 1990s, but her drag work grew logically out of other gender-related investigations she conducted during the 1980s as a part of New York's then thriving East Village performance scene. That work, in turn, grew out of the ideas and influences she absorbed in her formative years as an artist during the feminist awakenings of the 1970s. Her personal artistic evolution, in effect, shadows a cultural evolution in feminist, queer, and transgender activism.[1] It will be part of our aim to trace something of that history through this book. With this in mind, though, it is important to acknowledge that my involvement with this project will seem curious to some. Diane proposed the collaboration because of our ongoing dialogue on performance matters and also because of my previous work document-

1. In recent years, Diane has moved on to explorations that lie beyond our current, gender-crossing remit, and so our narrative will not engage in detail with developments in her work since the turn of this new century.

ing New York–based experimental theater.[2] At first I was hesitant to agree because I was acutely aware that drag king performance is a phenomenon strongly associated with (though not exclusive to) lesbian subculture. Obviously I can claim no "right" to write about that milieu. It gradually dawned on me, though, that Diane's interest in having a straight man in this particular double act was itself a statement of sorts. Opening up a dialogue *across* presumed sex and gender boundaries has always been one of her primary objectives as an artist, and female-to-male drag is, after all, as much concerned with men as it is with women—even though in this case men become the objects of performative scrutiny rather than its agents.

Moreover, to assume that the cross-dresser is a figure of concern only to a particular subculture is to participate in what Eve Sedgwick calls the "minoritizing view" of queer activity, which sees it as being of little or no significance to the majority culture. The alternative, "universalizing view" sees "the lives of people across the spectrum of sexualities" as being fundamentally intertwined and interdependent (Sedgwick 1990: 1). Important critical work has previously been done on drag king activity as a manifestation of lesbian community identity; see particularly Judith Halberstam's work in both *Female Masculinity* (1998) and *The Drag King Book* (her 1999 collaboration with the photographer Del LaGrace Volcano) and the diverse collection of essays in *The Drag King Anthology* (2002), edited by Donna Troka, Kathleen LeBesco and Jean Noble. Yet even as queer communities need to be nurtured and celebrated, it is equally important that their boundaries remain to some extent porous and that greater understanding of diversity is pursued on all sides. As transgendered performer Joey Hateley observes with typical English dryness, "It's not necessarily a challenge for me to perform to my peers—to dykes and drag kings and trans people. It's more political for me to perform in a straight bar and have some bloke say 'fuckin' hell mate, that was just top. Can I buy you a beer?'" (Hateley and Hateley 2008).

There is also an important distinction to make here. Whereas studies such as Halberstam's *Female Masculinity* set out to examine the cultural position of butches, tomboys, and other women whose everyday self-presentation appears more masculine than feminine, this book is specifically about females performing or adopting male roles, in such a way as to ques-

2. See especially my *Playing Underground: A Critical History of the 1960s Off-Off-Broadway Movement* (Bottoms 2004).

tion the assumption that biological markers of sex are also the grounds of gender identity. After all, what distinguishes "maleness"? In the eyes of most, it is probably still the penis—which females supposedly "lack"—and yet men do not go around flashing their members to legitimize their privileged status in the world. They rely on performative metonyms for their manhood, on markers, if you will, of male masculinity. As Diane's work demonstrates, all of these can be appropriated and performed equally well by women with a little rehearsal. Butch and boyish women challenge social norms and expectations in different, and arguably more profound, ways than do women performing male character roles. Nevertheless, since female forms of masculinity are still regarded, by all too many, as being merely "inferior copies" of an assumed original, there is also political value in demonstrating that this "original"—male masculinity—is itself "a copy, and an inevitably failed one" (Butler [1990] 1999: 189).

AN EXPERIMENT

What does it mean to perform masculinity? As the brief discussion so far should make clear, this is a question with no single answer, one that shifts radically according to context and definition. Gender distinctions always intersect with, and are shaded or even defined by, issues of (for example) class, ethnicity, sexuality, and nationality, and as this book progresses these other elements will variously come to the forefront. At the risk of reductiveness, however, one way to begin to come to grips with the issue is to point out that notions of masculinity always already exist in a constitutive, binary relationship with notions of femininity. Without the one the other has no meaning. As in all such binary pairings, moreover, one partner is privileged (implicitly or explicitly) over the other. In patriarchal cultures, as a general rule, masculinity is given precedence. To "act like a man" is thus to assume a certain authority and control, and to "be womanly" is to submit to a certain passivity. Of course this distinction has greater force in some cultures than others, and it is one that individuals constantly deviate from in a multitude of ways, but as long as the male-female binary itself remains in place as a guiding principle of cultural organization, assumptions about our "essential differences" tend to reinforce this basic opposition of "man leads, woman follows." To perform masculinity is to perform mastery, whether attempted or achieved, whether earnestly or playfully, whether over oneself, one's environment, or other people.

One chilling demonstration of this basic dynamic was provided by the Stanford prison experiment of 1971. This psychological research project was an exercise in simulated incarceration designed to monitor behavior in individuals subjected to arbitrary power differentials. A group of male volunteers were randomly assigned roles as guards and prisoners in a mock prison environment. Those roles were underlined by casting the subjects into polar extremes of gender disparity, between masculine militarism on the one hand and feminized vulnerability on the other. As the Stanford researchers explain:

> For the guards, the uniform consisted of: plain khaki shirts and trousers; a whistle; a police nightstick (wooden batons); and reflecting sunglasses which made eye contact impossible. The prisoners' uniform consisted of a loose fitting muslin smock with an identification number on the front and back, no underclothes . . . and a cap made from a nylon stocking. . . . Since these "dresses" were worn without undergarments, the uniforms forced them to assume unfamiliar postures, more like those of a woman than a man. . . . [They also] made them look silly and enabled the guards to refer to them as "sissies" or "girls." (Haney, Banks, and Zimbardo, 2004: 24–25, 32)

What is immediately striking here—in an experiment conducted just as the second-wave feminist movement was getting into its stride—is the researchers' seemingly unexamined assumption that the dichotomy of powerful-powerless should map directly onto, indeed *be represented by,* the binary distinction of masculine-feminine (quite irrespective of the biological sex of the participants). The differences in costuming and resultant physicality imposed on the participants, far more pronounced than those experienced in most "real" prisons, stemmed from the psychologists' wish for one group to experience—in an accelerated way—"the emasculating process of becoming a prisoner" (25). During the course of the experiment, however, the researchers observed that their awkwardly exposed captives signally failed to demonstrate "the assertive, independent, aggressive nature of male prisoners" in "real prisons" (32). Instead, after some initial resistance to their roles, they "adopted a generally passive response mode while guards assumed a very active initiative role in all interactions" (26).

In his recent book revisiting the prison experiment's implications, *The Lucifer Effect,* lead researcher Philip Zimbardo notes that "the initial script

for guard and prisoner role-playing came from the participants' own experiences with power and powerlessness" such as "their observation of interactions between parents (traditionally, Dad is the guard, Mom the prisoner)" (2007: 216). This statement remains undeveloped—a fact indicative of Zimbardo's general tendency to avoid the gender implications of his research. He may be alluding, though, to Betty Friedan's foundational feminist text *The Feminine Mystique,* which argued that American women of the postwar era had been conditioned into "dependent, passive, childlike" relationships with their husbands, and pictured the suburban home as a "comfortable concentration camp" ([1963] 1973: 296). The young men participating in the Stanford study were sons of the generation of women Friedan was writing about, and it does seem that—while there were certainly many other factors involved in shaping their responses—the experiment's imposition of an extreme gender dichotomy in costuming and role-playing prompted them to internalize and act out stereotypically binarized extremes of "masculine" aggression and "feminine" passivity. This was, moreover, no mere "act"; although physical violence was explicitly prohibited by the researchers, the guards became increasingly aggressive and abusive even as it became apparent that their cruelty was having a real psychological impact on the prisoners. The result was that an experiment initially intended to last two weeks had to be cut short at six days because five of the twelve prisoners had already reached the point of "extreme emotional depression, crying, rage and acute anxiety" and one had developed "a psychosomatic rash which covered portions of his body" (Haney, Banks, and Zimbardo 2004: 26). The researchers also noted that the prisoners had become so passively accepting of their incarceration that it did not even occur to them that they had the right, at any time, simply to quit the experiment. The line between role-playing and the real had vanished.

The Stanford experiment provides an intensified physical illustration of Judith Butler's argument in her landmark study *Gender Trouble* (1990)—and its clarifying sequel, *Bodies that Matter* (1993)—that gendered behavior is produced as a consequence of socially determined norms rather than as an outworking of any internal "essence" of gender. That is, the dominant system of assumptions about gender constantly reproduces itself through our reiterative enactments of its premises: if we are told that we are "male" or "female," we learn that we are supposed to behave in broadly masculine or feminine ways and may subsequently come to assume that those behaviors are "natural" to us. As Butler explains pithily in her preface to the book's

1999 reprint, "[T]he anticipation of a gendered essence produces that which it posits outside itself" ([1990] 1999: xv). Biological sex, as the Stanford incident illustrates, may have very little to do with "determining" gender behavior except insofar that in the everyday run of things our initial reading of genitalia—"it's a girl!"—acts as the first trigger for us to begin imposing "normalizing" expectations on the child.

Why, then, do we not all end up reenacting the extremes of behavior seen in the Stanford experiment? Because, Butler maintains, gender norms are not fixed in stone for all time, but are constituted by a collection of unwritten regulations that are constantly evolving through the performative repetition of their behavioral premises, and constantly vary according to the contextual specifics of class, race, and geographical location. Thus, while we cannot arbitrarily step outside of the binary gender framework and simply "choose" our own ways of being, a degree of individual agency may come into play through our modified repetition of the existing gender models available to us. For example, a woman who comes to feel oppressed (in whatever way and with whatever degree of consciousness) by social expectations of femininity may begin to challenge them by modifying or replacing them with some adapted version of "masculine" behavior or attitudes. As Butler concludes, "[T]he task is not whether to repeat, but how to repeat or, indeed, to repeat and, through a radical proliferation of gender, *to displace* the very gender norms that enable the repetition itself" ([1990] 1999: 202–3). Repetition may proliferate difference to the point where—in an ideal world to come—the binary separation of male and female eventually loses its authority.

Butler's argument is familiar to anyone who has engaged in gender-related studies over the past two decades. Indeed, *Gender Trouble* is now seen by many as the foundational text for contemporary gender-queer thinking. First appearing in 1990, moreover, its history is almost exactly coterminous with that of the "drag king" performance genre which it is one purpose of this book to investigate. (Butler, of course, took the drag act as an exemplary instance of the potentially subversive repetition of gender norms, although at the time she was writing the drag *queen* was her assumed referent.) Another development of the last two decades has been the growing interest in "masculinity studies" in the academy, which has turned unprecedented attention to the ways in which men are "constructed" both socially and culturally. It is notable, however, that, in spite of the influence of Butler and other key feminist and queer theorists, such studies of mas-

culinity *still* overwhelmingly tend to assume men as their given subject, un-reflexively conflating sex with gender. The silliness of this is clearly apparent if one considers the idea of women identifying themselves with something called "femininity studies." Yet men will lay claim to masculinity because, as the Stanford example makes painfully clear, it is equated with power. As Judith Halberstam notes in *Female Masculinity,* "[M]asculinity and maleness are profoundly difficult to pry apart" (1998: 2). Despite her astute reading of the blind spots in some key 1990s texts on masculinity, the problems she outlines have been repeated in many a publication since.

It is almost a commonplace nowadays to suggest that men, too, are male impersonators (see Simpson 1994), imitating the available models of masculinity and anxiously trying to live up to some idealized notion of what a "real man" looks like. It has also become something of a commonplace in contemporary theater and performance for male artists—gay and straight—to seek to question and ironize these dominant models of mas-culinity.[3] Yet all too often the status of such artists as biological men de-picting biological males still tends to naturalize the notion that men "pos-sess" masculinity (or, in Lacanian terms, that they "own" the phallus). Men are very good at masochistic self-criticism—indeed, David Savran has ar-gued in *Taking It Like a Man* that masochism is intrinsic to contemporary white heterosexual masculinity—but as long as their reflections lead auto-matically back to *themselves* we are stuck in a closed loop. The situation is rather as if the "guards" in Zimbardo's prison experiment had organized a therapy group to discuss how difficult it is being guards all the time, but without inviting or even referring to the "prisoners" whose existence de-fines them as guards.

One might, of course, have more sympathy with the prisoners at-tempting to organize themselves as a means of resisting their oppression, just as feminist groups have done for decades. Again, though, there is the danger that when those on *either* side of a binary divide define themselves according to the terms of that division they simply reinforce the very sepa-ration that is the root of the problem. As Butler asks, "[T]o what extent does the effort to locate a common identity as the foundation for a feminist pol-itics preclude a radical enquiry into the political construction and regula-tion of identity itself?" ([1990] 1999: xxxii). Or, to put it another way, what

3. My study of the playwright Sam Shepard, *The Theatre of Sam Shepard: States of Crisis* (Bot-toms 1998), took his interrogations of machismo as one of its main concerns.

if we could begin to see our insistent cultural separation of men and women as *no less arbitrary* than Zimbardo's initial separation of guards and prisoners? Such a proposition, which still feels radical, seeks not to erase difference but to acknowledge its multiplicity (why draw this line here when one could make other distinctions here or here or here?). Indeed, as the sociologist R. W. Connell pointedly observes, an entire century of "sex difference" research—investigating everything from mental abilities to "emotions, attitudes, personality traits, interests, indeed everything that psychologists thought they could measure"—has consistently concluded that "sex differences between men and women, on almost every psychological trait measured, are either non-existent or fairly small" (1995: 21). No consistent, significant distinctions between the male and female sections of the human population can be traced because individual personalities vary in so many, multitudinous ways that no neat, binary pattern emerges. This is not to deny the importance of gender identity to one's makeup but simply to acknowledge it as one factor among many. The absence of totalizing distinctions should probably not come as a surprise to any of us. Even biological differences do not work to neatly distinguish us, since there exists a whole spectrum of variations in physical attributes, including hundreds of recognized intersex conditions. Yet our societies continue to propagate the notion that men and women are somehow worlds apart, and use this manufactured gulf to explain and justify the still very pronounced differences in our cultural and economic fortunes.

A LITTLE HISTORY

In focusing on the performance of male characters by female-bodied performers, this book modestly proposes that such practices can function to challenge and critique the continuing, structural power divide between the sexes. "If subversion is possible," Butler notes, "it will be subversion from within the terms of the law, through the possibilities that emerge when the law turns against itself and spawns unexpected permutations of itself" ([1990] 1999: 127). It is important to acknowledge, though, that such permutations are by no means a new invention and that—as Diane has always stressed—contemporary drag king performance is only the most recent manifestation of a long-standing, though historically fragmented, tradition of female-to-male theatrical cross-dressing. This tradition, as I will seek briefly to demonstrate, has existed on the borderlines of cultural accept-

ability because of its tendency to trouble the established gender order. "Male impersonation, when seriously intended, was a risky encroachment on patriarchal prerogative," Laurence Senelick argues in his encyclopedic history of theatrical drag, *The Changing Room,* whereas the still older convention of men impersonating women has been "hallowed by tradition as a violation of taboo; hence it could be safely indulged in by college students, naval cadets and Rotarians alike" (2000: 340). This is not to belittle the struggles that many male-to-female performers have faced, particularly in the last century or so, as a result of homophobic prejudice. But for women to "upgrade" themselves to the status of men, *and to do so plausibly,* is to imply that the authority traditionally held by men is a matter of posture and theatricality (bluff) more than divine or biological right. Indeed, Marjorie Garber has speculated that the male fascination with performing absurd exaggerations of femininity—"balloon breasts, fluffy wigs, make-up"—may itself "mask another (I hesitate to say, a deeper) concern about the artifactuality and detachability of maleness." In English slang, she notes, the word *cod*—as in *codpiece*—"means both scrotum or testicles, and hoax, fool, pretence or mock. The anxiety of male artifactuality is summed up, as it were, in a nutshell" (1993: 125).

In England, during the Shakespearean era of codpieces (around the turn of the seventeenth century), puritanical proscriptions against women displaying themselves "lasciviously" meant that they were barred from appearing on public stages as performers, whether in female or male roles, although they began to do so in France, Spain, and Italy at around this time. Female characters in the theater of Shakespeare's day (including those disguising themselves as men in plays such as *Twelfth Night* and *As You Like It*) were played by apprentice male actors. However, after the restoration of the English monarchy in 1660, following an eighteen-year republican period during which theaters were banned, the tradition of boys playing women's roles was swiftly done away with, not least because King Charles II liked to see women perform, and indeed to select mistresses from among those on show (most famously, Nell Gwyn). Like the monarch, society at large seems to have regarded the new breed of actresses as frankly licentious, and since tight male breeches showed off a woman's legs far better than did full skirts it was logical enough that these first English actresses frequently appeared provocatively cross-dressed, just as was the case on the continent.

The right or ability of women to assume male roles onstage does not

seem, at first, to have been widely questioned. This may be because the early modern conception of sex roles was somewhat different from the diametric opposition of female versus male that is commonly assumed today. Women were regarded as different from men, but different in the sense of being incomplete or inferior versions of the same template (a worldview traceable all the way back to Aristotle). It follows that women could attempt to play males, albeit perhaps in a mode of comic inadequacy, once religious and legal objections to the theatrical display of female bodies were overcome. Indeed, "breeches roles" became so popular during the Restoration that between 1660 and 1700 almost one in four of the new plays produced in London included male roles written for performance by women. This sudden popularity clearly owed a great deal to the titillation factor involved, but breeches roles were not simply a matter of pandering to the male gaze. This was also a period when women were publicly staking a claim to sexual liberty of their own. As one female character in Aphra Behn's *The Rover* (ca. 1677) remarks, "For as 'tis true, 'all' men are stark mad for wenches, so 'tis true, however custom pretends otherwise, that we wenches be as inly stark as men" (1987: 24). This bold willingness to compete on equal terms also seems to have factored into women playing male roles. As the cross-dressed Anne Reeve would remark to the audience in John Dryden's 1672 epilogue to *Secret Love, or The Maiden Queen*:

> What think you, Sirs, was't not all well enough,
> Will you not grant that we can strut, and huff?
> Men may be proud: but faith, for ought I see,
> They neither walk, nor cock, as well as we.
> (qtd. Senelick 2000: 214)

It would be easy, perhaps, to assume that Dryden intended this joke to rebound on Reeve, that her imitation of masculine strutting did not measure up to "the real thing." And yet, thanks to the increasing number of theatrical reviews and memoirs published in the eighteenth century (as popular print culture expanded rapidly), it is possible to trace evidence that some breeches performers *did* succeed in creating entirely plausible performances of maleness. Peg Woffington, for example, became particularly celebrated for her rendition of the role of Sir Harry Wildair in George Farquhar's *The Constant Couple*. When she first assayed the role in 1740, one reviewer asserted that "in the well-bred rake of quality, who lightly tripped

across the stage, there was no trace of the woman. The audience beheld only a young man of faultless figure, distinguished by an ease of manner, polish of address, and nonchalance that at once surprised and fascinated them" (qtd. Wahrman 2004: 48). Likewise, memoirs published after Woffington's death in 1760 remarked on the fact that "Females were equally well pleased with her acting as the Men were, but could not persuade themselves that it was a Woman that acted the Character" (qtd. Straub 1992: 129). This fascination with Woffington's Wildair allegedly extended to the point where "The Men grew envious [of her], and the Women loved [her]," an inversion of the conventional expectation that made some observers distinctly uneasy, particularly in response to Wildair's love scene with his leading lady. An otherwise approving review in *The Actor* (1750), for instance, maintained that "no one of the audience ever saw without disgust" Woffington's attempt at this scene: "it is insipid, or it is worse; it conveys no ideas at all, or a very hateful one; and either the insensibility, or the disgust we conceive, quite break in upon the delusion" (qtd. Straub 1992: 134). Modern commentators generally agree that "no ideas at all" alludes to the known absence of this Wildair's penis, and "a very hateful one" to the specter of same-sex love. The eighteenth century, however, had no concept of lesbianism in the modern sense. Women seducing other women were often thought to be hermaphrodites of some sort, representatives of a "third sex."[4]

Toward the end of the eighteenth century, a more rigidly binarized system of gender classification began to dominate public discourse. One manifestation of this shift was the fact that breeches roles—despite having been popular for over a century—began rapidly to fall out of fashion. The role of Sir Harry Wildair, to take but one example, was performed in London by women on at least twenty-eight occasions between 1788 and 1790 but then received only three more cross-dressed performances over the next dozen years. Equally significant are the posthumous recastings of Woffington's achievements. She made "a great attempt for *a woman*, but still it was *not Sir Harry Wildair*," William Cooke asserted in 1804 (almost half a century after the actress's death); "dress it how you will, the spectator [always] sees it as a woman," James Boaden concurred. This despite the 1780 memoir of Thomas Davies, who stressed that "no male actor has since equalled her in

4. See particularly Randolph Trumbach's "London's Sapphists: From Three Sexes to Four Genders in the Making of Modern Culture" (1996).

that part" (see Wahrman 2004: 49–50, 55). Senelick argues that such comments indicate changing theatrical tastes and a growing preference for greater realism. The ability of women to convince in male roles during the eighteenth century, he contends, was thanks only to "highly conventionalized . . . ways of playing" that permitted "outward, behavioral signs" and "mere congeries of gesture and pose" to be read as indicative of masculinity (2000: 214, 216). But how, one might ask, is masculinity to be presented onstage—whether by men or women—*other* than by means of gesture, pose, "behavioral signs," and costuming? Senelick seems to assume that some fundamental essence of manhood lay beyond the ability of women to reproduce. Yet, as Dror Wahrman persuasively demonstrates in *The Making of the Modern Self*, that notion of essential gender difference is *itself* a historical construction that dates from around the end of the eighteenth century. Prior to that, women could be celebrated not only for passing convincingly onstage as men but for doing so in everyday life (a realm in which "realism" was of course essential).

Historical evidence for this last point is not hard to come by. Throughout the seventeenth and eighteenth centuries, passing women were an identifiable phenomenon. Indeed, it was not unknown for the pope to issue special dispensations for women whose cover had been blown to continue dressing as men (as was the case, for example, with Catalina de Erauso, an early-seventeenth-century Spanish adventurer). Among other surviving records, the annals of the Dutch East India Company covering the late seventeenth and eighteenth centuries report more than a hundred cases of seamen having been exposed as female. In all likelihood, many more went undetected. Similarly, in England, *The Annual Register* (founded in 1758) regularly recorded cases of women who had passed as men during the latter decades of the eighteenth century. Vern and Bonnie Bullough, who report these examples in *Cross-Dressing, Sex, and Gender* (1993), conclude that such accounts commonly involve women from lower-class backgrounds seeking a measure of mobility and economic betterment that their female status would not allow. (Conversely, accounts of male-to-female cross-dressers are less common in this period and usually involve cases in which upper-class men are permitted by privilege to indulge themselves in wearing women's clothing.) Some such women were punished for their transgressions; Mary Read and Anne Bonny, for example, were sentenced to death for piracy in 1720 (the latter, pregnant at the time of sentencing, was hanged after giving birth). Yet it was also common for the exploits of

cross-dressing women to be celebrated in the popular culture of the period. As Wahrman puts it:

> The female knight or warrior [and] her ability to put on male garb, successfully pass as a man, and excel in that most manly pursuit of all, war, was formulaically celebrated in hundreds of street ballads with titles like "The Female Warrior," "The Maiden Sailor," "The Soldier Maid," or "She Dressed Herself Like a Duke." . . . Her confidence in fulfilling these masculine roles as well as any man . . . was commonly reaffirmed. (2004: 21–22)

Such narratives also sold well in pamphlet form and regularly drew audiences in the theater, often by emphasizing romantic imperatives such as the need to cross-dress as male in order freely to pursue one's (male) lover. No doubt many women also cross-dressed for not so heterosexual reasons during this period, but there was no general conception at this time that masculine women were sexually "deviant." There was scandalmongering, of course. Henry Fielding's *The Female Husband* (1746), for example, was a sensationalized account of the trial of Mary Hamilton, who had been caught posing as a man in order to marry another woman; Fielding's salacious narrative went as far as to tantalize readers with a reference to "something of too vile, wicked and scandalous a nature, which was found in [Hamilton's] trunk." Randolph Trumbach concludes, from other surviving evidence, that this was, indeed, a dildo (1996: 129). And yet this case appears not to have "tainted" the perception of other cross-dressing women. Another successful pamphlet of 1746 was by the actress Charlotte Charke (an erstwhile theatrical colleague of Fielding's), whose *Narrative of the Life of Mrs. Charke* recounted her own adventures in passing as a man offstage. Although the *Narrative* includes various scenarios depicting Charke's cross-dressed flirtations with women, these accounts—never suggesting anything more sexual than wordplay—remained acceptable to readers of the day. (Modern critics have debated the question of her "true" orientation, although, of course, this is unknowable at this remove.)

Other cross-dressing women of the period also enjoyed a degree of fame and financial success when their stories became public. Hannah Gray, for example, who joined the army as James Gray in 1745, apparently as a survival tactic after being abandoned by her husband, allegedly endured five hundred lashes in routine punishments without being detected as female. When she was eventually exposed, she enjoyed a brief career onstage

playing male roles before retiring on her army pension to open a pub, whose shingle read, "The Widow in Masquerade or the Female Warrior." (Clearly she was happy to cash in on her renown!) By 1801, however, in another case of history being rewritten to reassert gender distinctions, a reprint of Gray's story amended the narrative to emphasize her "utmost disgust" at being forced to dress as a man and replaced a masculine-looking cover portrait with a softer, more feminine rendition. Similarly, the naval adventurer Mary Ann Talbot had to qualify her own turn-of-the-century memoirs with apologies, insisting that she had been forced into cross-dressing as male by a seducer and that it "was by no means congenial to [her] feelings" (qtd. Wahrman 2004: 23). This despite the fact that she continued to wear male garb long after the death of the man in question. Other popular narratives of this later period also tended to insist on the flaws in the gender act being apparent to anyone who looked for them. In short, whether cross-dressing occurred onstage or in everyday life, the "common sense" view was now that the disguise could easily be seen through—and any previous evidence to the contrary could be rewritten to refute its own implications. "There is no woman, nor ever was a woman, who can fully supply this character [of a man]," William Cooke's 1804 treatise insisted, for "There is such a *reverse* in all the habits and modes of the two sexes . . . that it is next to an impossibility for the one to resemble the other so as totally to escape detection" (qtd. Straub 1992: 133).

One factor in this shift of attitudes around the end of the eighteenth century may have been the various accounts of "sapphist" relationships that began circulating publicly from about 1770. "[T]he new sapphist's role probably did begin to affect women's consciousness to some degree," Trumbach notes, although "the stigmatization [of gay women] was never as great as that experienced by male sodomites" (1993: 135). Wahrman notes that "essentialized maternity as an innate precondition of femininity" began to be emphasized in popular culture around this time, whereas women adopting more masculine attributes were increasingly derided as unnatural (2004: 15). Wahrman emphasizes, however, that the changing attitude toward cross-dressed women was just one factor in a general shift in the perceptual world order: just as the revolution in France swept away the ancien régime in 1789, so an ancien régime of gender gave way around this time to emerging, Enlightenment era conceptions of the self. Prior to the late eighteenth century, an individual could try on roles and be seen, to some degree, to *become* the role assumed; indeed, women cross-dress-

ing as men may have seen themselves, on some level, as both female and male. The new consensus, however, was that outward behavior sprang from an internal core of essential identity. Thus, where the old order had maintained broad distinctions between masculine and feminine but had permitted individuals to vary from that broad pattern, the new view replaced "gender play" with "gender panic" (Wahrman's terms) and began to insist that divergence from established gender patterns was unnatural to the point of being inconceivable. "Assume no masculine airs," Isabella Howard, Countess of Carlisle, counseled women in 1789, since "real robustness, and superior force, is denied you by nature; its semblance, denied you by the laws of decency" (qtd. Wahrman 2004: 79). Meanwhile, in the newly independent United States, men were being encouraged to disavow effeminate European manners and embrace their natural, rugged masculinity, a situation slyly satirized in Royall Tyler's play *The Contrast* (1787), whose central character, Manly, is just a little too convinced of his own authenticity.

It is not surprising, in light of changing attitudes, that female-to-male cross-dressing was less widely recorded, and certainly less celebrated, in the nineteenth century than in the eighteenth. Although the phenomenon persisted, exposure of the "masquerade" was now more likely to be posthumous. On his death in 1865, for example, after forty years working all over the world as a doctor in the British Army, and having attained the rank of Inspector General of hospitals, James Barry was discovered to have a female body. As a woman he would not even have gained medical training. Many other female cross-dressers were discovered after their deaths during the American Civil War of 1861–65. Feelings on both sides of that conflict ran so high that it is not surprising many women sought to participate directly in the war effort. Mary Livermore, a nurse in the Union Army, estimated that there were as many as four hundred cross-dressers on her side alone (see Bullough and Bullough 1993: 158). In her book *Amazons and Military Maids* (1990), Julie Wheelwright excavates a rich international history of women posing as male soldiers extending well into the twentieth century.

Even as cross-dressing remained a life-and-death reality, though, the nineteenth-century stage reassigned the woman in male garb as a knowingly artificial novelty act. Although breeches roles persisted, those figure-hugging garments became increasingly distant from everyday masculine attire, as trousers extended off and down the leg. The woman in breeches

was thus a visibly theatrical convention rather than any reflection of off-stage reality, and she became associated—in particular—with androgynously youthful male roles rather than the performance of adult characters such as Harry Wildair. Senelick dates the first "principal boy" in British pantomime to 1815, noting that this tradition became increasingly entrenched "throughout the Victorian era owing to the fixation on the female legs and bosoms" (2000: 262). It persisted well into the twentieth century also, thanks in part to the popularity of J. M. Barrie's *Peter Pan.* The fact that "the boy who never grew up" was conventionally played by a woman speaks volumes about the way women had become infantilized onstage. Boys and women were linked by their fresh-faced innocence while adult males stood aside on another plane of maturity and authority altogether. These attitudes were apparent even when women did appear in adult male roles during the nineteenth century. When Madame Vestris played Macheath in Gay's *Beggar's Opera* in 1820, for example, one reviewer described her as "nothing more than a premature scapegrace, a sort of Little Pickle, mounted into the dignity of boots and cravat" (qtd. Senelick 266). This hardly sounds like "Mack the Knife," but the era demanded that criminality be neutered and sentimentalized by being rendered boyishly feminine. The notorious highwayman Jack Sheppard also came to be played by cross-dressed women.

Later in the nineteenth century, some outstanding individuals, such as the American actress Charlotte Cushman and French actress Sarah Bernhardt, succeeded in lending some dignity to the cross-dressed female by achieving success in major Shakespearean roles. Even there, though, gender stereotypes connecting femininity with immaturity and indecisiveness dictated which roles were permissible for cross-casting; characters such as Romeo and Hamlet were considered rash and youthful enough to be inappropriate models for adult manhood and thus fair game for female performers. Bernhardt, though fifty-four when she first assayed the role, insisted that her Hamlet was a youth of twenty, and that since no male actor so young could have a real understanding of the character's genius, the role was better suited to a mature woman who could convince as a youthful man (just as in the principal boy tradition). Decades later, in 1936, Eve Le Gallienne was using the same justification: "If one thinks of Hamlet as a man in his thirties, the idea of a woman's attempting to play the part is of course ridiculous. But Hamlet's whole psychology seemed to me that of a youth rather than a mature man" (qtd. Ferris 1993: 2).

Charlotte Cushman, performing in the mid-Victorian period, somewhat twisted this trend of women playing "flighty" young men because her stoutly unfeminine appearance in breeches did not lend itself to eroticization by the male gaze. "Singularly masculine in her energy and her decisive action," one London reviewer of Cushman's Romeo noted in 1846, "this lady might pass for a *youthful* actor with little chance of her sex being detected" (emphasis added). Another concurred that "what there was of the woman just served to indicate juvenility, and no more" (qtd. Merrill 1999: 116). By working within permissible conventions, Cushman became a star on both sides of the Atlantic, but, as Lisa Merrill has persuasively demonstrated in her study *When Romeo Was a Woman,* her ambiguous gender performances—both onstage and off—also made her the center of a circle of female admirers at a time when the possibility of lesbian attraction was barely even acknowledged culturally.

In subsequent decades, some similarly destabilizing manifestations of female-to-male cross-dressing began to appear in the "illegitimate" context of variety theater. Annie Hindle, for example, who relocated to the United States from her native Britain in 1867, developed a male impersonation act by adapting the approach of the male *lions comiques* performers then popular in England, acts that parodied certain types of middle- and upper-class masculinity for their largely working-class audience. The American Ella Wesner also began performing successfully as a male impersonator in 1870, probably after seeing Hindle's act, and others later followed suit. Like their male-to-female "drag" counterparts, who began to appear at almost the same moment (the term *drag* probably referred to the drag of a long evening gown), the new breed of male impersonators were frankly theatrical creatures, strutting the stage solo and singing popular ditties to their audiences. Within this format, though, performers such as Hindle and Wesner could appear strikingly convincing as men. Unlike principal boys, with their corseted waists and bestockinged legs, these male impersonators dressed in contemporary male fashions, wore their hair short, and were sufficiently well built that observers felt they could have passed as male offstage. In Hindle's act, according to a review in the *New York Clipper,* "her sex is so concealed that one is apt to imagine that it is a man who is singing." The same journal said of Wesner that "she might easily walk Broadway in male attire without her sex being suspected" (qtd. Rodger 2002: 110). Their acts consisted largely of songs bragging about their female conquests and their superiority over other men, and these parodies of

masculine swagger were very popular with audiences. There appears to have been little hostile reaction to their cross-dressing, even though Hindle's masculine appearance extended to an authentically stubbled chin (a natural consequence of having shaved off facial hair). Their acts would surely have been more controversial had it been known that both Hindle and Wesner were romantically involved with other women. Wesner eloped to France at one point with Josie Mansfield, the former mistress of an army colonel, and Hindle posed as a man to marry her dresser, Annie Ryan, in 1886. The marriage, when exposed, ended Hindle's career, but not because of any outcry over lesbianism. Rather, her explanation that she was in fact a man—who had posed as a woman playing men—was generally believed in those limited parts of the press that took an interest in the offstage lives of variety performers.

Laurence Senelick suggests that the first generation of male impersonators may have been popular in America precisely because of the historical moment in which they first appeared. In the immediate aftermath of the gender-blurring Civil War, he notes, "the gold rush and western expansion prompted so great an influx of cross-dressers that advertisements in the mining regions had to specify 'No young women in disguise need apply'" (Ferris 1993: 89). Against this backdrop, and playing largely to working-class audiences that cared little for bourgeois standards of decency, the early male impersonators could get away with playing raffish lads and rakish drunks. Their successors, however, had to make their acts more "refined" in order to flourish in the changing climate, as variety theater managers began to expand their business by seeking a more respectable, family-oriented clientele. A new, younger generation of male impersonators such as Bessie Bonehill, Hetty King, and Vesta Tilley (all British based, but equally popular in America) gained acclaim by "grafting onto the Hindle/Wesner fast man the freshness of the principal boy" (Senelick 2000: 332). Tilley, who became *the* iconic male impersonator of the late Victorian and Edwardian eras, made a point of never swearing, spitting, or even ad-libbing onstage. Her youthful male characters were more likely to aspire to romantic love than boast of sexual conquests, and the fact that she sang in a soprano voice removed any danger that she would conjure a genuine illusion of maleness, however winningly androgynous she could be.

The success and longevity of the Tilley model rested on its ability to survive the public opprobrium that began to be directed at cross-dressing of any sort in the last decade of the nineteenth century. The taxonomies of

sexual perversion that had begun to be outlined by the new "science" of psychiatry (Richard von Krafft-Ebbing's *Psychopathia Sexualis* was first published in 1886) quickly became public knowledge as a result of high-profile events such as the trial of Oscar Wilde in 1895 for "gross indecency." Wilde's flamboyantly stylish personality became associated in the public mind with the new concept of "homosexuality," and—more broadly—any kind of diversion from the imposed norms of masculine and feminine behavior began to be read in terms of "sexual inversion." Thus, as Gillian Rodger notes, "[C]omplaints about women in 'pants' roles [began] to appear in American newspapers in the mid-1890s, and these proliferated as the new century began" (2002: 121). To avoid charges of deviance, performers had to publicly advertise the unambivalent femininity (and thus heterosexuality) of their offstage identities. In 1904, for example, Vesta Tilley denounced "The 'Mannish' Woman" in an article of that title for the *Pittsburgh Gazette Home Journal,* which appeared just before she played that city. "[T]here is nothing so charming as the little home woman," she wrote, "whose soft voice and gentle manner have done so much to make the world a better place" (qtd. Rodger 2002: 122). Meanwhile, just as had occurred a century earlier, cultural commentators felt the need to revise previous opinion by insisting that male impersonators had *never* appeared convincingly masculine. As one 1898 commentary had it, "[T]he most versatile actress in the world could never really play a man convincingly, and the fact that she cannot do it and wouldn't if she could is the real reason why audiences like to see women in knee breeches and short jackets" (qtd. Rodger 2002: 121).

Although male impersonation remained a popular item on variety bills for the first couple of decades of the twentieth century, the decline of variety itself (particularly in the face of growing competition from cinema), coupled with ever-growing public awareness of the "scientific" connection between cross-dressing and homosexuality, meant that its days were numbered. A few established female stars, such as Marlene Dietrich and Josephine Baker, were able to dress in tuxedos and still appear glamorously feminine. These exceptions aside, though, female-to-male drag survived only in socially or racially marginalized contexts through the middle part of the twentieth century. Gladys Bentley, for example, was celebrated for her top hat and tails performances on the Chitlin' Circuit of black vaudeville in the United States during the 1930s. With her deep, growling voice and raunchy lyrics, she was widely admired by fellow artists and bohemians,

but Bentley's multiply othered status as large, black, and openly lesbian prevented any mainstream acceptance of her act. By the McCarthyite era of the 1950s, she had recanted her past and married a man, claiming to have been "cured" of her deviance by taking female hormones.

An intriguing counterpart to Bentley's case is that of Stormé DeLarverié, another African American performer, who appeared as emcee of a traveling drag show, the Jewel Box Revue, between 1955 and 1969. The Jewel Box (whose history runs from the late 1930s to the early 1970s) featured a cast of twenty-five flamboyant male-to-female drag artists and DeLarverié as the sole female-to-male "turn." Yet her baritone voice and masculine appearance were so convincing that many observers apparently did not realize she was female and would assume that the "one girl" advertised in the cast was simply hiding in plain sight amid all the queens. The Jewel Box, with its frank celebration of cross-dressing in a deeply homophobic era and its multiracial cast (almost unheard of during the segregated American midcentury), remained an exotic curiosity throughout its existence without ever troubling the mainstream. DeLarverié is nonetheless a significant figure. In *Mother Camp,* her anthropological analysis of pre-Stonewall drag performers, Esther Newton states that, although "male impersonators ('drag butches') . . . are a recognized part of the profession, there are very few of them" (1972: 5). That DeLarverié is the only one of those few who has so far been accorded retrospective recognition is surely a testament to that rarity. Moreover, whereas Gladys Bentley had eventually submitted to pressure to become acceptably feminine, DeLarverié boldly took the opposite course by adopting a cross-dressed identity offstage as well as on shortly after she began performing with the revue (see Ferris 1993: 128). Perhaps it was the act of performing as male, onstage, that opened up possibilities for an alternative mode of gender expression in life.

PERFORMING POSSIBILITIES

The end of DeLarverié's stage career at the close of the 1960s coincided with the beginnings of the "second-wave" feminist movement. An invisible baton, perhaps, was handed on. As artists and writers began to consider the implications of feminism for their work during the 1970s, the female-to-male cross-dresser was among those aspects of cultural "herstory" to be retrieved from the patriarchal scrapheap. "I had never seen male impersonators," playwright Eve Merriam commented about the conception for her

1976 musical revue *The Club,* "and I love role reversals. Why hadn't I seen any women do this? Because they are not in positions of power and they *can't* do it because they would offend the power structure" (Karr 1980: 27). Using a treasure trove of music hall songs from the period 1894–1905, and sequencing them with dialogue composed largely of Merriam's carefully curated archive of chauvinist jokes—"his wife just turned forty, and he'd sure like to exchange her for a couple of twenties" (Merriam 1977: 8)—she created an entertainment evoking the heyday of the male impersonator, but with feminist bite. *The Club* is set in an exclusive gentleman's club in 1903, with its piggishly self-satisfied clientele all played by women in tuxedos and pencil mustaches, a factor that of course colored the reception of the gag lines considerably. Despite being largely derided by New York's male press critics when it opened off-Broadway at the Circle-in-the-Square in February 1977, the production won an extraordinary ten *Village Voice* Obie awards and proved so popular with audiences that it ran for two years and spawned a touring company. For Diane Torr, who arrived in New York in 1976, seeing the performance came as

> an epiphany of sorts. I was inspired that these women had taken on these roles, and were performing with such toughness and bravado. The performance itself was experimental in its staging, taking place in different parts of the theatre, and it sparked real excitement in the audience. I left the theatre feeling elated. *The Club* added to my feeling of excitement at being in New York, where anything, including a play with a large cast of female cross-dressers, could happen.

Part of *The Club*'s appeal, particularly for the lesbian community, lay in this rare attraction of seeing handsomely masculine women dominate a professional stage, although the heterosexual Merriam confessed to the *Advocate* that she had "never really thought about" its potential erotic appeal (Karr 1980: 27). For her, the production was all about "sending up the male power structure," and she took particular satisfaction from the way her cast of seven "enjoyed the power trip" (Henkel 1980: 13). As the *New York Times* reported, the long period of rehearsals and tryout performances for the show throughout 1976 had

> amounted to extended consciousness-raising sessions because for most of the women, playing men required an emotional commitment beyond mere

acting. . . . There was the problem of learning to move like men, and the actresses worked long hours with the play's director and choreographer, Tommy Tune, on the accretion of almost subliminal gestures into a whole movement pattern. (*"The Club"* 1977: 48)

This training notwithstanding, the *Times* was also clear that "no attempt is made to disguise the fact that they are women. Seven androgynes have [been] assembled." *The Club* seems to have evoked the gentlemanly tradition of male impersonation embodied by Vesta Tilley rather than the more aggressively masculine approach of Annie Hindle or Ella Wesner. "Just as the jokes don't get vulgar or extreme, the male impersonations remain subtle and seductive," Alisa Solomon noted, adding that "there's no swaggering and flexing, no belching or bellowing" (Ferris 1993: 148). Yet, as the *Boston Phoenix* observed, "[H]earing paeans to male camaraderie crooned in lilting soprano tones is pretty jarring [to modern ears]. One is repeatedly lulled into near-acceptance of the cast as gents, then jolted back to reality by their sweet Adeline-ish singing" (Clay 1977: 13).

The reference to "reality" is telling. *The Club*'s creators seem to have worked on the assumption that women could not (or should not) present a plausible image of maleness, and instead relied for the play's impact on the kind of gender-bending effect (as distinct from gender-crossing) described by the *Phoenix*. The impression created was one of androgyny rather than full-on masculinity, and this approach placed it very much in line with the mainstream of 1970s feminist thought. As Tracy Hargreaves has demonstrated in her book *Androgyny in Modern Literature,* the concept of androgyny was ubiquitous in gender discussions at that time because the idea of women appropriating traditionally "masculine" characteristics, and balancing them with existing strengths, seemed like a way out of the limiting confines of socially constructed femininity. As Carolyn Heilbrun put it in *Toward a Recognition of Androgyny,* "[T]his ancient Greek word—from *andro* (male) and *gyn* (female)—defines a condition under which the characteristics of the sexes, and the human impulses expressed by men and women, are not rigidly assigned. Androgyny seeks to liberate individuals from the confines of the appropriate" (1973: x). This notion of fusing gender characteristics is apparent in the comments of some of *The Club*'s cast members—"I strongly believe that each of us encompasses all things," noted lead soprano Gloria Hodes, as "we are both male and female" (*"The Club"* 1977: 48)—and also within the comic dialogue itself.

ALGY: You know, there's something not quite masculine about that little Johnny.

FREDDIE: Well, maybe it's because half his ancestors were male and the other half female. (Merriam 1977: 16)

The potential problem with the androgynous ideal embodied by *The Club*, however, was that it did as much to reinforce gender binaries as to question them. As Kate Bornstein was to observe in *Gender Outlaw*.

Androgyny assumes that there's male stuff on one side of the spectrum, and female stuff on another side of that spectrum. And somewhere in the middle of this straight line, there's an ideal blend of "male" and "female." However, by saying there's a "middle," androgyny really keeps the opposites in place. . . . Androgyny could be seen as a trap of the bi-polar system. (1995: 115)

In the context of *The Club*, the problem could be rephrased as follows: these are women, not actually men, and there is no point in having them attempt to *convince* as men; it is fun to see them flirt with an androgynous middle ground, but there is no danger of them crossing over it. This approach reflected the accreted history of proscriptions that, as we have seen, date back to the late eighteenth century. Such assumptions also clearly underlie the female-to-male cross-dressing narratives that appeared in mainstream movies slightly later. In both *Victor/Victoria* (1982) and *Yentl* (1983), the leading women (Julie Andrews and Barbra Streisand, respectively) pass themselves off as men in order to survive and advance themselves, and their androgynous self-presentations become sufficiently familiar during the course of the films that there seems something slightly jarring about their (inevitable) resumption of feminine attire at the conclusion of the narratives. This gentle questioning of standardized femininity, however, poses no real threat to male masculinity because neither Andrews nor Streisand ever really looks male. The films invite a conventionalized suspension of disbelief on the part of spectators, and the fact that both narratives are set in past periods aids in the pretense that the people meeting these women cannot see through their disguises; modern people tend to assume that historical people were less perceptive than we are. In all this, the actuality of women's historically proven ability to pass as male is never seriously entertained.

The flip side of this argument, of course, is that for the feminist movement emerging during the 1970s the "serious" adoption of male roles was

not even on the agenda. The need to articulate and protest the specific cultural injustices faced by women required that a politicized commonality of interest be found *among* women *as* women, and in certain contexts this meant actively criticizing those who appeared too "male identified." Butch lesbians were distrusted by many feminists for appearing to betray their sex by "mimicking" male behavior, a distrust that prompted, in turn, a defense of butch women on the grounds that, far from trying merely to pass themselves off as men, they were extending the role options available to women. "None of the butch women I was with, and this included a passing woman, ever presented themselves to me as men," Joan Nestle emphasized of her experience of butch-femme relationships in the pre-Stonewall era (1987: 100). The 1980s saw the emergence of a theatricalized celebration of this butch-femme heritage, in the performances of Split Britches and other regulars at New York's WOW Café (see chapter 2), but here too the assumption was that, as critic Alisa Solomon put it, "a lesbian in male clothing, after all, is not dressed as a man, but as a butch" (Ferris 1993: 151). It was not until the mid-1990s that this orthodoxy began seriously to be challenged by a constituency of women who "insist[ed] that their butchness is or was only a route to a desired status as a man" (Butler [1990] 1999: xii).

This "coming out" of the transgender movement, both within and beyond the lesbian community, coincided (not all that coincidentally) with the embrace of the drag king as part of queer subculture. Prior to the 1990s, however, lesbian-oriented male impersonation had existed only in fairly isolated instances. "The drag show scene I had written about in the 1960s," notes Esther Newton, "was a world of gay men, in which the ten or so lesbian 'drag kings' competing against each other in a Chicago drag ball seemed almost an oddity among hundreds of drag queen contestants" (1996: 162). Even as late as 1994, Sarah Murray could plausibly assert that

> drag has not developed into an autonomous theatrical genre within the lesbian community. Lesbians don't dress up like Fred Astaire and dance around the stage to entertain each other. . . . We don't dress up in suit and tie and talk like Gregory Peck. We don't tie on chaps and swagger around saying "howdy pilgrim" invoking the aura of John Wayne in front of the appreciative gaze of a group of lesbians. . . . Why don't women do drag like men do? (1994: 343–44)

Murray goes on to outline a series of very plausible answers to this self-posed question, including the obvious political one: "Why embrace that which oppresses you?" (353). If gay men's embrace of female drag can be read as an explicit rejection of masculine power status, and a kind of celebratory affirmation of their "feminized" marginalization, it makes less obvious sense—conversely—for women to mimic the sex *responsible* for their relative disempowerment.

What, then, prompted the subsequent embrace of theatrical artifice? Within only a couple of years of the publication of Murray's article, the image of the mustached or bearded drag king poking mischievous fun at male attitudes and privileges had become familiar in both the lesbian club context and the mainstream media. A new mood of relative confidence and empowerment led to an abandonment of what Murray calls the "lesbian-feminist asceticism" of the previous generation (355), in favor of a new spirit of fun and role-playing. Yet the rise of the drag king in the 1990s resulted not from some organic revival of hidden subcultural traditions—as some have assumed—but from the activities of an identifiable group of New York–and San Francisco–based performance artists, whose example caught on very quickly both nationally and internationally.

In New York, the primary instigators were Diane Torr and Johnny Science, who began running female-to-male transformation workshops in 1990 (although the individual journeys that led them to this point stretched back many years). Science, a makeup artist and musician—and female-to-male (FTM) transsexual—always maintained that he had coined the term *drag king* himself. Two years later, just as Diane was beginning to present full-length theatrical performances in drag, Science organized the city's first Drag King Ball (May 1992), which incorporated the first formally judged drag king contest (perhaps inspired by the African-American/Latino drag queen contests showcased in Jennie Livingston's 1990 documentary film *Paris Is Burning*). Subsequently, the organization of drag king contests in New York was taken up by Tracy Blackmer (a.k.a. Buster Hymen), who was mentored directly by Diane and went on to mentor other leading drag kings, including Mildred "Dred" Gerestant. Maureen Fischer (a.k.a. Mo B. Dick), who began her influential Club Casanova drag king night in 1996, also acknowledges Buster Hymen as an early inspiration.

Foundational as the Torr and Science drag king workshops were in New York, it would be misleading to posit them as a singular point of origin for the movement. Related developments were taking place almost simultane-

ously in San Francisco. Shelly Mars's drag performances at the Baybrick Inn in the mid-1980s acted as a kind of harbinger of the Bay Area scene, which began to take off in the 1990s as a result of Leigh Crow's popularity in the role of "Elvis Herselvis." Crow began performing lip-synch versions of Elvis songs in lesbian and alternative music clubs from about 1989, and by 1991 she was singing live in role. (In the same year, she was parodically married off to drag queen Glamouretta Rampage—Justin Bond—in an event at the Klubstitute Bar.)[5] Because she was doing both "the King" and an inversion of the classic drag queen routine, Crow began calling herself a drag king, more or less simultaneously with Johnny Science's introduction of the term in New York. (There is no reason to suppose that either borrowed the term from the other.) Crow went on to promote the drag king concept internationally—Elvis Herselvis toured to Australia in 1993, for example—and in San Francisco was aided and abetted by other influential FTM artists in the Bay Area's emergent trans scene such as Stafford, Jordy Jones, and Annie (now Anderson) Toone. There is a whole other book to be written about these West Coast developments.

Still, it was not until May 1994, two years after New York's first Drag King Ball, that the first official San Francisco Drag King Contest took place at the Eagle bar hosted by Crow. And when, the following year, a major cover story for *SF Weekly* brought the emerging drag king scene to public attention, journalist Amy Linn made a point of noting that "many observers trace the modern, American usage of drag king to . . . Diane Torr and Johnny Grant [another Science alias], who together planted the garden of a blossoming cult happening" (1995: 12). The pair had yet to host a workshop or perform in the Bay Area, but between them they had already made several appearances on nationally televised talk shows. Journalists in England were also citing Diane as a catalytic figure in 1995. In a feature on London's new drag king night, Club Naive, for the *Independent,* Frances Williams noted that her workshop at the Institute of Contemporary Art (ICA) in November 1994 "was followed up by Britain's first drag king contest in March at the National Film Theatre [for the London Lesbian and Gay Film Festival]" (1995: 4). By 1996 drag king fraternities were springing up all over North America and Europe, sometimes as a direct result of Diane's having visited cities— from Boston to Berlin—to perform and/or teach workshops.

5. I am indebted to Anderson Toone's online "Drag King Timeline" for this and other information on the San Francisco scene (Toone 2002a).

These historical details will be fleshed out further in chapter 4. Suffice it to say here that, while Diane was not the only figure responsible for the emergence of drag king culture in the 1990s, she was undoubtedly one of the most influential. Certainly, she was the individual who insisted most adamantly on performing—and teaching others to perform—realistically plausible male characters who could pass on the street rather than simply remaining within the confines of club performance. This was an important intervention, but, as was the case with some of her historical precursors, Diane's ability to blur the line between the theatrical and the everyday, the natural and the artificial, has proved to be a source of unease for some observers. Indeed, it appears to explain why, despite her key role in the emergence of drag king performance, her contribution has tended to be minimized in the major literature on the subject to date.

Annabelle Willox, for example, in her essay for *The Drag King Anthology*, has questioned whether the label should be applied to Diane's work at all because she "performs a non-theatrical form of drag that is more akin to male impersonation than drag" (Troka, LeBesco, and Noble 2002: 278). The awkwardness of her phrasing, however, reveals the awkwardness of her distinction. Just how "theatrical" does drag need to be before it qualifies as drag? Willox seems to assume here that drag kings must necessarily present an overtly theatricalized masquerade of masculinity—a swaggering cowboy in chaps, perhaps, or a preening rock star—a direct counterpart to the drag queen's masquerade of femininity. Yet, while drag queens are often wildly extravagant in their self-presentation, this is an appropriate reflection of the fact that the femininity they celebrate and parody is inherently ostentatious. As Joan Riviere put it back in 1929, "womanliness and 'the masquerade' . . . are the same thing" (qtd. Butler [1990] 1999: 72). Femininity is *defined* by a response to the viewer's gaze in most cultural constructions. Since masculinity, by contrast, is usually constructed as that which is more seemingly "natural," more understated, one might conclude that naturalistic understatement is the most "natural" mode for the drag king to adopt. (It should be noted that Diane herself is not greatly concerned with labels and indeed eventually renamed the drag king workshop the Man for a Day workshop specifically to minimize the danger of misinterpretation by those who might be seeking a training in more exaggerated role-playing.)

Judith Halberstam rightly foregrounds this issue of restraint and under-

statement in drag king performance in her chapter on the topic in *Female Masculinity.* Her concern, however, is the opposite of Willox's: rather than wanting more theatricality, she wants less. Elucidating female masculinity as an outward expression of inwardly felt gender identities, she attempts to read drag king performance as an extension of offstage butchness. Thus, in laying out a taxonomy of drag king "types," Halberstam clearly privileges what she calls "butch realness"—which is "relian[t] on notions of authenticity and the real"—over the mere "femme pretenders" whose "performances are far more performative [theatrical?] than the butch realness ones, but possibly less interesting" (1998: 250). Indeed, Halberstam seems uneasy with the very idea of "pretending" and describes as a "methodological problem" the fact that most of the New York drag kings she encountered "would not identify as butch" (244).

Halberstam partially rethinks her position in *The Drag King Book,* in which she confesses to "giv[ing] up on this quest . . . to find a butch brotherhood behind the Drag King world" (Volcano and Halberstam 1999: 1). Even so, she again displays a clear preference for those performers who are not so much "acting" as doing "what comes naturally" (36). Given her overriding concern to champion and critically legitimize a constituency of butch women that has often been marginalized even by feminists, Halberstam's bias is understandable. She falls, however, into precisely the trap outlined by Butler, of attempting to locate a politics in common identity, thus implicitly *de*legitimizing those she does not perceive as being "in" that group. As Donna Troka has pointedly noted, Halberstam disregards the very "fluidity of identity that many of her subjects [have] worked hard to achieve" (Troka, LeBesco, and Noble 2002: 4), and this is particularly the case with respect to Diane Torr. In both *Female Masculinity* and *The Drag King Book,* Halberstam devotes considerable effort to refuting any suggestion that a theater artist (a trader in pretense) might have been a catalytic figure in the development of the new subculture. "[Torr's] workshop, obviously, has little to do with drag kings or kinging," she writes,

> and certainly we would not want to attribute the origins of modern drag king culture to a workshop that is primarily designed for heterosexual women and unproblematically associates masculinity with maleness. For masculine women who walk around being mistaken for men every day, the workshop has no allure. (1998: 252–53)

This passage, relying on assumption rather than research, is misleading in a number of respects. For one thing, while the workshop has always catered to women of all orientations, it was certainly not "primarily designed for heterosexual women" (indeed, its very earliest incarnations included Johnny Science giving talks on phalloplasty surgery, presumably with an eye to any potential transsexuals present). Halberstam is also wrong to claim so categorically that masculine women, in general, could have no interest in a workshop that she herself had never experienced. (Indeed, chapter 7 offers evidence that many butch women have found it useful for a variety of reasons.) Her comments serve to underline the extent to which she "would not want" drag king performance to be associated with affected artifice as opposed to authenticity. And yet drag king performance *is* theatrical, by definition, however understated the role-playing may be. "When you put on a costume you're doing a character, no matter how you look at it," observes pioneering drag king Shelly Mars (who wryly identifies herself as "butch couture"), "so who *are* you? What would your guy wear? How would he think? How would he move?" (2007).

A telling counterpoint to Halberstam's position is provided by Tina Papoulias in her account—for the lesbian magazine *Diva*—of Diane's first London drag king workshop in November 1994. On this occasion, the workshop's location at the ICA, rather than in a queer-specific context, resulted in a wide range of participants that initially surprised Papoulias.

> Being one of only 12 lucky girls to experience a transformation into the "man of our dreams" in Torr's London workshop, I was expecting to land in a room filled with lesbians, with whom I could flirt. . . . I was stunned to discover that the majority of the women were straight-identified and had not come to the workshop to explore lesbian masculinities. My initial surprise and suspicion would soon be challenged, as I witnessed the ease with which most women proceeded to build their characters and settle into their suits, an ease which was made all the more extraordinary by the fact that they had never performed like this before. Within the space of an hour, we had all become absorbed by the spectacle of our own transformation, gleefully tightening each other's breast bandages, pinning dick stuffing in our Y-fronts, and generally strutting around. With the application of make-up, things started becoming more unsettling for some. . . . Facial hair is the line that most of us, even those of us that pass, do not normally cross. With the

gradual trendification of the dildo, it is stubble that has now taken its place as the final frontier beyond which few women dare to tread. . . . As the transformation continued, further unsettlement was produced as straight-identified women found themselves turned on by each other's alter egos, out lesbians became closeted gay men, and a mother started teasing her be-stubbled daughter into whipping out her new penis for the camera. (1995: 40)

This passage is worth quoting at length because of the extent to which it emphasizes *both* the "ease" with which the participants found themselves slipping into male roles *and* the uneasy challenges that this transformation presented to their everyday assumptions about their own identities as they "got into character." Far from being easily distinguishable, the theatrical/artificial and the everyday/real exist in a fluid, mutually informative relationship with each other. We return here to Judith Butler's key point: everyday gender identities may themselves be the result of habituated role-playing rather than reflections of some unchanging internal essence. "Gender is the repeated stylization of the body," she writes, "a set of repeated acts within a highly rigid regulatory frame that congeal over time to produce the appearance of substance" ([1990] 1999: 45). Alternative stylizations of the body may therefore open up alternative possibilities for lived experience.

TRANS ACTIONS

Indeed, if the act of sticking on facial hair represented the crossing of a line for lesbian culture in the mid-1990s—as Papoulias suggests—this is not only because it epitomized an embrace of artifice of which some were wary ("Sincerity and authenticity were needed, in art as in politics," Sarah Murray notes of the 1970s feminist movement [1994: 355]). In signifying maleness, rather than (or as well as) female masculinity, drag king role-playing helped lead some toward a frank embrace of "male identification" in their everyday lives, a choice that would once have been taboo in the women's community. As Del LaGrace Volcano writes in *The Drag King Book,* "[F]or some of us, what started out as a performance or an experiment became the reality of choice. [When] I donned a Drag King persona it didn't feel like much of an act. I was astounded by how natural it felt to be a guy and be

free of the anxieties I had lived with for years around not passing as a 'real' woman" (Volcano and Halberstam 1999: 21, 27).[6] The fact that drag king theatricality began to be embraced by the queer community in the mid-1990s is thus indicative of a significant cultural shift, one that relates, as has been noted, to the growing visibility of the transgender movement around this time. Indeed, the relevance of the Torr and Science workshop to emerging trans discourses was recognized through its inclusion in the major Minneapolis conference "Genders That Be" in 1996,where Diane appeared alongside trans artists and activists, including Kate Bornstein, Jordy Jones, Loren Cameron, and Steven Grandell.

Trans identities necessarily challenge notions of essence and authenticity and involve the adoption of new "roles" in ways that radically destabilize attempts to maintain borderlines between different identity groups. This much was apparent in the events surrounding what is sometimes described as the transgender movement's "Stonewall moment." In 1991, the organizers of the Michigan Womyn's Music Festival chose to enforce a strict reading of their separatist-feminist ethos by expelling from the festival Nancy Jean Burkholder, a postoperative male-to-female transsexual, on the grounds that she was "actually" a man (even though she did not identify as one). Only "womyn born womyn" were to be admitted, the festival organizers insisted, a criterion that effectively excluded not only male-to-females but also, had they sought entry, their female-to-male brothers. Burkholder's expulsion did not prompt an immediate reaction, but by 1994 the new transgender movement had coalesced sufficiently to organize a protest camp—Camp Trans—which was set up adjacent to the festival ("For Humyn born Humyns"). Thereafter, a consciously inclusive approach to the definition of transgender was pursued by many leading voices in the movement so as to avoid the divisive and damaging effects of exclusionary policies such as this one. "The identity can cover a variety of experiences," writes Stephen Whittle in his preface to *The Transgender Studies Reader*, and "it can take up as little of your life as five minutes a week or as much as a life-long commitment to reconfiguring the body to match the inner self" (Stryker and Whittle 2006: xi). Whittle's objective is not to erase or ignore the differences between experiences as radically distinct as those he describes, but to build as broad a church as possible.

6. It should be stressed that Volcano, another key figure in the development and dissemination of drag king culture internationally, does not owe any particular debt to the Torr workshop but came to drag performance by his own route.

The "five minutes a week" reference could be taken to imply a staged drag act, lip-synching to a song in a cabaret environment perhaps. But is that, one might reasonably ask, enough to qualify as "really" transgendered? In her book *Gender Outlaw,* the transsexual performance artist Kate Bornstein implies that it is not and, indeed, that stage drag is just "a gimmick, a *shtick* . . . an appropriation" unless it is informed by the reality of a transgendered lifestyle offstage (1995: 92). Again, where is one to draw the line between authenticity and mere artifice? When is gender-crossing "just an act" and when is it in earnest? These questions are thrown into sharp relief by Whittle, who as the first man to work as editor of the British *Journal of Gender Studies* was compelled to ask in a 1998 editorial exactly *why* he had been invited to take up this role. The possibilities, he decided, included the following.

> I am a woman really but deluded in thinking I am a man, therefore as a woman I can edit the journal . . . or I am a woman really and an acceptable performance of masculinity by a woman, because I acknowledge it as performance, by being out about my trans status . . . or I am a woman really and my oppression as a woman lies in my childhood experiences as a girl and my experience as a woman who lives as a transsexual man . . . or I am a woman really and it is just that my body morphology simply is no longer 100% female . . . or I am a man really but the acceptable face of manhood because of my childhood experiences—wherein others thought I was female and therefore oppressed me as such . . . or I am a man really but my position as male is undoubtedly contested . . . or I am a man really but my feminist credentials are pretty good. (Stryker and Whittle 2006: 200–201)

Whittle concludes by noting that, while he does not care which of these is the "real" reason for his appointment, "they all have some potential validity to me" (201). Since several of these possibilities seem mutually exclusive, however, Whittle is clearly placing the repeated word *really* in question. Why, indeed, do we insist on knowing what "the real" of someone's gender identity is when such a thing may well be unknowable? Drag acts, similarly, can throw the status of gender reality into doubt insofar that they bring into focus the ways in which performance and theatricality are themselves constitutive of reality, as well as being representations of it.

Authenticity, perhaps, lies not so much in substance or essence as in *intention,* in the desire to explore experiential possibilities. Might we, indeed,

think in terms of theatrical artifice *becoming* authentic? Can we, to reverse Whittle's terms, reconfigure the inner self to match the body? We all know, for example, that wearing a different set of clothes can affect the way one holds and carries one's body, or can change one's mood or attitude. Sometimes when this happens we decide to wear those clothes more often to accomplish the same effect. Alternatively, we might try to find ways to maintain that altered sense of self even when wearing more familiar clothing. In broad terms, that is precisely what Diane hopes to achieve by helping women to experience, physically, the process of presenting themselves as men, and (ideally) being read by the world as men. Some participants have, indeed, gone on to seek permanent gender reassignment partly as a result of that experience (the "act" becoming "actuality"). But equally we might ask in what ways such an experience might alter a person's subsequent outlook, or physical demeanor, even when presenting as female.

The physical reality of gender, as R. W. Connell has argued, stems not so much from the possession of particular body parts as from the ways in which a body experiences its relationship with the world, the processes by which that body becomes acculturated to certain expectations and possibilities of expression. Thus, "Bodily difference becomes social reality through body-reflexive practices, in which the social relations of gender are experienced in the body . . . and are themselves constituted in bodily action (in sexuality, in sport, in labour, etc.). . . . Through body-reflexive practices, bodies are addressed by social process and drawn into history, without ceasing to be bodies" (1995: 64, 231). Although Connell is referring to lifelong experiences, his points apply equally well to relatively brief periods of time—as the Stanford prison experiment made chillingly clear. The performance research and drag king workshops conducted by Diane Torr aim at a more constructive form of temporary transgendering. The goal is for participants and spectators to experience, through performance, the *reality* of physical possibilities other than those we take to be "natural." How else might I move in the world? How else might the world respond to me? What unexpected pleasures might this experience give rise to? And how might power relations, in the process, be reconfigured?

Part One | FOUNDATIONS

One | Becoming Feminine

We are told that femininity is in danger; we are exhorted to be women, remain women, become women. It would appear, then, that every female human being is not necessarily a woman; to be so considered she must share in that mysterious and threatened reality known as femininity.

—SIMONE DE BEAUVOIR

PISSING CONTEST #2 (INTO THE WOODS)

The first time I remember being challenged by gender difference was when I was four years old. I lived on the outskirts of Aberdeen, Scotland, on a new housing estate called Mastrick, which pushed into surrounding farmlands. My two elder brothers and I would explore the countryside that abutted the estate, and that was our playground. I chose to play with my brothers and their friends because they were more fun than the local girls. Playing dolly dress-up in backyards seemed so dull, whereas the boys would go exploring on their bikes. I'd follow them on my tricycle, pedaling hard, determined not to be left behind. One day as we were cycling through the woods, we found a path that led to a circle of trees defining a clear patch of grass. Choosing a tree each, the boys all suddenly jumped from their bikes, unzipped their "spavers," and peed against the trees. I stood next to my tricycle in the middle of the circle, fascinated by their synchronicity and their ability to pee standing up. Of course I'd seen my brothers do this before, but always into a toilet and never with the purposefulness and importance that this gang action seemed to have. When they finished and nonchalantly turned round, zipping themselves up as they did so, their eyes caught my gaze. One of them demanded mockingly, "Oh, ye cannae dae that, can ye?" and I instinctively knew that this was the entrance or exit test, like a club membership challenge but

37

also more than that. It was a statement of quintessential difference and of my assumed inferiority. Taking up the challenge, I lifted my skirt and—pulling down my underpants—pointed out, "No but ah've got five holes to pee oot ae an' ye've only got the ane."

The boys came nearer. "Oh aye, well show us then." I bent down and started to pee, and they all squatted in a circle around my skirt, their heads upside down looking underneath. As the pee started to slowly dribble out, I pointed out the five separate holes as they appeared—the pee trickling arbitrarily from around and between the folds of my labia. If my cunt had been a compass, with the northern end at my clitoris, the five "holes" would have been located at north, northeast, south, west and dead center, with some "holes" overlapping as the flow increased and most of the piss coming from the central one at the end. As I stood up and pulled up my pants, the boys righted themselves, their faces flushed with blood and thrill. But my elder brother was the first to speak: "I'm tellin' Da' you showed yer privates in public." Disapproval was not the reaction I was expecting: I felt triumphantly proud of my secret, special skill as a girl, and the least I expected was respect, maybe even envy. Undaunted, I taunted him back: "Well I dinnae care, y'are only jealous cos ye've jest got the ane hole tae pee oot of." I don't remember if my brother ever told my father or even if it mattered. Maybe what I do remember has been embroidered on in memory. But I am sure of one thing: I claimed some significant territory for myself that day, squatting bare-assed in the middle of a circle of trees, demanding that a group of boys witness the mysteries of my cunt. That was my first public performance.

Growing up in Scotland in the 1950s, boys and girls alike learned that it was supposed to be men who had power and autonomy and women who lacked it. This was taught to us mainly by osmosis through the life performances of older men, who conveyed a strong sense that they owned the world. As a little girl I was in awe of my father, my uncles, and their friends. They wore big, double-breasted suits, and they would cultivate these little gestures of power, like jangling coins in their trouser pockets. I'd see someone doing that and think, "Oh, he must be rich, with all that money, he's very important." His pockets could, of

course, have been filled with pennies for all I knew. But these men acted like they owned whatever room they came into, and as children we just had to get out of their way. One of them might sit taking up almost the entire sofa, for instance, while I was wedged into a corner of it or exiled to sit on the floor.

Our father was very authoritarian, and he reinforced his power in our home with violence, particularly when he'd been drinking, which was frequently. When he was drunk he became really nasty, and each one of us, including my mother, felt his hand and his cow-buckle belt on numerous occasions. I learned to read these signs, too, to detect his shifts in mood. I knew what a certain flick of the wrist meant, what a certain tweak of his earlobe meant, and I knew that when I saw those indicators I had to make myself scarce before he lashed out at someone. "Patriarchy" was something I learned about as a lived reality, not an abstract concept, because when somebody rules a family the way my father did he has the power to determine everything. If my father was miserable, everybody else was miserable, too. He would have us running around the house cleaning or ironing his shirts or peeling potatoes. Whatever it was, we'd have to jump to it because he had been a petty officer in the Royal Navy and he knew how to enforce orders. On one occasion, when my brother wasn't peeling potatoes fast enough because he was watching television, Dad got rid of the TV. There was no questioning this, no argument to be had; it was his house, and while we were living in it we would follow his rules.

I think my elder brother David accepted all this because he was learning that he, too, in time, would be initiated into the secret brotherhood of adult men. As the eldest, he was expected to "toe the line" and follow in our father's footsteps. I would be in the kitchen, wiping dishes, and I'd be able to see David through the little hatch that opened into the dining room practicing his Air Training Corps salutes in front of the mirror. There was so much rigmarole, signals and gestures that he had to get right. I felt firmly excluded from a whole, forbidden world. Thankfully, though, I had an ally in my other brother, Donald. Even at the very youngest age, the established gender order simply did not seem to apply to Donald. Every Halloween, from the age of about six, he would be dressed in my mother's clothes as we went from door to door, singing songs and telling stories for apples, candy, or money. I

would be dressed as something ordinary such as an elf and my elder brother as a soldier, but nobody thought there was anything "queer" about Donald's drag.

I must have been seven, and Donald—fifteen months older than me—eight or nine when he began his modeling routines in my mother's fur coat and earrings. Beginning at the back wall of our parents' bedroom, he would swish and pose, swish and pose his way to their wardrobe mirror. I would be standing next to the mirror, watching and judging the parade, awarding marks for "style" and "show." He never looked at me, only at himself in the mirror, yet he took my opinions seriously and would argue with me about the points I gave him. I became bored with the game after a while and would run out of reasons why he should get fewer points for the way he pointed his toes on the eighth walk to the mirror than on the second. It just didn't seem that important to me, but since it was to him we would invariably end up fighting, me fueled by frustration and boredom, him by his need to be seen and admired. With great indignation, Donald would hurl the coat and earrings to the floor and threaten to jump on them if I didn't admit that, yes, he was the queen of style for having (1) entered our parents' bedroom without permission, (2) gone into their wardrobe and searched through my mother's things, and (3) paraded round the room using her personal belongings as props. We both knew that these crimes, and especially that final desecration, were punishable with hidings from the cow-buckle belt, so no matter how furious I was I always had to relent: my brother was the queen of style not only in our neighborhood but in all of Aberdeen, no, in the whole of Scotland. There had not been a queen like him since Mary Queen of Scots, who was beheaded at the Tower of London for the crime of high treason against Elizabeth I. Comparing Donald's queenliness to Mary's usually titillated his fancy to something approaching euphoria, and he would strut around the bed like a peacock.

Donald and I shared a kind of conspiracy, and it was through this secret, mutual understanding that we were able to question and challenge the roles, and maybe even the destinies, that had been laid out for us. I used to resent the fact that I had to do the dusting, for example, and that my brothers got to do the fun stuff like digging the garden, so Donald and I would exchange tasks on the sly whenever we could. Our parents never seemed to object as long as the jobs got done,

so Donald would prance about the living room with the feather duster, singing along with the gramophone—usually to show tunes or a song like "Some Day My Prince Will Come"—while I did the weeding outside. We would also trade gifts. One birthday a parcel came for me from my grandma, which turned out to be a doll in matching green hat, coat, dress, socks and knickers, all hand knitted. I was just appalled, and I tossed it away, but Donald retrieved it. He invented all kinds of games with "my" dolls, such as the one in which he would put them all in the doll pram and then run like a maniac right around the block. Donald's notion of feminine play and dress-up was always a little "off," and that helped me, too, to look askance at the behavior that was expected of me.

When I was fifteen, we moved to the south of England, to West Wickham in Kent, where Dad was originally from. There were a lot of layoffs in Aberdeen at that time, and he took that as a prompt to "go home." I was forcibly uprooted and deposited in a rather posh girls' grammar school in Kent where I stuck out like a sore thumb, not just because of my Aberdonian accent but because my father refused to buy the full uniform (including a boater) that I needed. My tights were laddered, my clothes were wrong, and the school treated me as if I were a rebel. Meanwhile, both my brothers had left home and my mother was sick in hospital much of the time, so it was usually just me and my alcoholic father in the house (although he had the occasional girlfriend who visited him). He would beat me up, and he wouldn't give me any money to live on; the whole situation was untenable. I eventually ran away from home and wound up sleeping rough in London around Piccadilly Circus, where a lot of runaways congregated. I was there for about six weeks altogether, living by my wits, before I was eventually caught. My mother died in hospital while I was being held in a remand home, and I was only permitted to attend her funeral accompanied by a police escort. Yet my father's main concern seemed to be that, as the remaining female in the family, I couldn't stay to serve sherry to the guests! This whole sequence of events left me with a maelstrom of unresolved emotions that I suppressed for years.

After that I was sentenced to reform school for three years as a juvenile delinquent. At seventeen I should have been free to live on my own, but the laws for runaways were so punitive at that time that I was essentially "jailed" until I was nearly twenty. As my peers were gaining

employment or going to college, I was being detained at Her Majesty's pleasure. At the Crescent Training School for Girls in Bristol, bad girls were supposed to be improved, so they offered us a selection of five careers to which we could aspire: shop assistant, domestic helper, factory worker, typist, or gardener. Those were the options for unskilled young women at that time, but I had attended grammar school and I wanted to continue my education, so I insisted on studying for my "O" Levels.[1] They told me that was ridiculous, that no girl had ever done that while in approved school. But I was very willful and determined (that was what had got me through living with my father), and eventually they relented. In the end I was able to study for four exams and passed three of them (I didn't get the math), which was quite something given the circumstances. I had really worked for it because I knew that I was creating a precedent. It wasn't just about me but about the other girls who might also be able to take this route if I came through. I don't know how I developed this sense of having some power in the world. Maybe I learned it from Donald and his ability to transcend living on that council estate in Aberdeen.

They let me out of the approved school after nineteen months, but I had to complete my sentence by going to live with foster parents, who wrote reports on me. By the time I moved back to London in 1969, legally free to live my own life, I knew that I wanted to challenge the entire system. And the countercultural mood of the period encouraged me in this conviction: revolution was not just a possibility, it was *positively going to happen*. Realizing I needed tools for analysis, I began studying sociology at a further education college in Fulham. Both of my lecturers were Marxists, and this is how I "got religion." Flower power was on its way out, and Marxism was the new black; it had a lot more potential for worthiness, indignance, and endless circular arguments. The Socialist Party meetings I attended taught me so much. I could discuss the political situation in practically every country in the world, and I made a list of the ones that needed "doing." I also learned from fellow socialists how to access dole money by not admitting I was a student, and how to turn back my electricity meter to keep my bills down. Such actions always came, of course, with accompanying politi-

1. "O" (Ordinary) Level qualifications (General Certificate of Education) were normally taken by English schoolchildren at age sixteen, after which they either left school or continued to the "A" (Advanced) Levels for the next two years.

cal analyses outlining their ethical imperatives. This is the real shit, I thought. I had always felt like a rebel, but now I had a theory to go along with it.

In 1971, at the Socialist Scholars' Conference at the Roundhouse in Camden, I was in attendance with the other sociology students and our lecturers. The first speaker was giving a very dull reading of his paper, "Trotsky's Liberation from Stalinism," when suddenly a group of women jumped onto the stage and took hold of the microphones. I realized with horror that the ringleader was a new member of our class, an Italian named Vittoria Borelli who had been much given to arguing with our lecturers. She didn't hold them in the same esteem that the rest of us did; perhaps, we had whispered, she was a counterrevolutionary. And now here she was at the conference, bellowing into a pirated microphone. "SHE who controls the means of communication," she declared, emphasizing the pronoun, "has the POWER!" This last bit was so loud that our ears hurt with the amplified distortion. One of our lecturers yelled at her to get back in her seat, but Vittoria just laughed at him. (I found out later that he had recently made a pass at her, which she had rejected.) "Damn women's libbers," a red-haired student muttered next to me, "bloody lesbians!"

"Why are there only men on this panel?" Vittoria continued, loudly. She had a point there, I thought, but didn't men usually know more? Couldn't they speak better than women? Certainly they always seemed to dominate the discussions we had in class. I had accepted the position of listener, assuming my time would come, but as I watched Vittoria commandeering this audience, I couldn't help but notice the men's response to her. Indignant, furious, clambering out of their seats, they ordered and then pleaded with Vittoria to let the conference continue, while she taunted them loudly about their attitudes of self-importance and condescension toward the female members of the socialist movement. She didn't give a fig for their authority and leadership. "You call yourselves radicals?!" she jeered. At that, the whole conference erupted. Several men moved forward to grab the microphone— "She's a fucking anarchist!" yelled the red-haired student beside me— and Vittoria began singing a happy-sounding Italian song, which jarred wonderfully with the anger of the crowd as it sailed out of the public address system. I was thrilled by her performance and looked on in delight as her girlfriends stood in an outward-facing circle to protect her.

By now, thanks to them, she was holding all the microphones and singing loudly. The men couldn't reach her, and they were too politically correct to be seen to hit women. The conference was abandoned. The battle lines were drawn. Yes, revolution is possible, I thought, but not without equality, and it was up to us, as women, to outline the terms and make our own voices heard.

That incident also stimulated an interest in the power of performance. By 1974 I had enrolled in a dance and theater course at Dartington College of Arts in rural Devon, about as far from the urban class struggle as one could be. Though renowned for its artistic radicalism, the college was located in Dartington Hall, a former home of aristocrats, and despite the radical spirit of the college's founders, Leonard and Beatrice Elmhirst, there was still a distinct atmosphere of class privilege about the place. As a fervent Marxist-feminist, I quickly set about challenging the status quo: helping to organize support for the cleaners' attempts to form a union, cofounding a Women's Group (which demanded that the college administration refer to all female students as "Ms."), and demanding that contemporary feminist texts be purchased for the college library. I also confronted the male-dominated Student Union over its lack of female leadership. Even as I was challenging others, though, some of the college's teaching was challenging me.

The head of the dance program was Mary Fulkerson, who was teaching a new dance form called Release Technique. I had previously studied the Martha Graham technique in intensive courses at the London School of Contemporary Dance and had taken improvisation classes (in "how to be a flower") with Lindsay Kemp at the Dance Centre in Covent Garden, but none of my dance training experiences equipped me for Mary's work. She saw dancers not as technicians who follow directions but as artists who create dance works, whose palette is the body. In this she owed much to her own training with Barbara Clark at Illinois State University, and to the writings of Mabel Ellsworth Todd (author of the seminal 1937 text *The Thinking Body*), with whom Clark had studied. There was a whole alternative dance lineage to be discovered here, but coming from Martha Graham classes, where students stood in rows as in a battalion and followed the directions of the dance teacher as if he or she were a sergeant major, I found Mary's teaching methods both radical and unsettling. There was nothing remotely similar in the British dance world at that time.

I began to see Mary's nonhierarchical approach to dance as complementary to my own anti-authoritarian political convictions. She encouraged us to find our own particular movement vocabularies through the discovery of our bodies. We studied anatomy, kinesiology, and postural alignment techniques. Mary's method of teaching was to create interior images of the body, which she fed to the students as they were lying in stillness in a position called "constructive rest" (in which the weight of the body is taken through a balancing of the bones, allowing the muscles to relax). These images were accompanied by a description of the bones of that area and the places where they were located. So, for example, in picturing the pelvis as a "basin" Mary would explain that the sacrum is a large, triangular bone at the base of the spine, and the keystone of the pelvic arch. It lies between the two ilia, or hip bones, which are like two semicircles that form the side curves of the basin and extend in the front to the symphysis, or pubic bone. Having outlined this structure, Mary would then suggest movement possibilities such as rolling or turning on the pelvis, or using the pelvis to explore its relationship with the rest of the body. In this process, our attention was directed inward so that we developed a three-dimensional awareness of the body rather than simply thinking in terms of the two-dimensional reflection that the dancer is accustomed to seeing in the studio mirror. It also allowed for the development of improvised movement that was not self-conscious. Bad habits of posture and movement were also corrected as we learned about the neural-muscular-skeletal system, not just theoretically but through applied movement imagery and physical experience. Ultimately, the body becomes trained from the inside through developing a consciousness of how it works in harmony with gravitational forces.

I became completely hooked on learning as much as I could about the body, its mechanics, and what I was able to do with it. In class, during this process of developing our own movement vocabularies, we became conscious not only *of* our bodies and their capabilities but of *ourselves as bodies*, as physical masses moving through space, each one with its own height, weight, and density. As an avid feminist, I found that this new physical awareness of my body's capabilities empowered me in a way that no amount of theoretical reading had done so far. In a culture in which women are still taught to think of themselves in two dimensions rather than three—as desirable objects that are there to be

looked at—it's easy to feel that body confidence is something we don't own but must buy. In wearing a certain lipstick or the right pair of designer jeans we try to imitate the images presented to us, images most of us can never live up to. The best possible antidote to this ingrained inadequacy is to learn to experience ourselves as three-dimensional beings. In Mary Fulkerson's classes, "self-possession" became a reality rather than a suggestion.

Mary's influence on me was also felt indirectly through the teachings of other groundbreaking American dance artists whom she had been instrumental in bringing to Dartington. Visiting tutors included Steve Paxton, Valda Setterfield, Albert Reid and Marjorie Gamso, all of whom had worked with the legendary Merce Cunningham. Steve Paxton was the originator of the dance form known as Contact Improvisation, which I learned firsthand from him on his first visits to Dartington. He and Valda had also both been key participants in the postmodern dance experiments at New York's Judson Memorial Church during the early 1960s. Through them I was introduced to the work of a fellow Judson choreographer, Yvonne Rainer, and to other new ideas in dance. Also at Dartington I learned about recent American developments in music, theater, the visual arts, and criticism. I read Susan Sontag's "Against Interpretation" and "Styles of Radical Will," John Cage's "M," and the poetry of Allen Ginsberg. By the time I graduated in 1976, there was only one possible answer to the question "What next?" I knew I had to go to New York, to get closer to the source of the work that had inspired me.

I worked as a gardener at Dartington Hall through the hot English summer of 1976, and by September I had enough money for the airfare. I had acquired a J1 student visa to study at the Cunningham Studios. Once in New York, I took classes there for two years. I also sought out experimental dance classes with major teachers, including Anna Halprin and Simone Forti; took Contact Improvisation workshops with Nancy Stark-Smith, Lisa Nelson, Paul Langland, and Danny Lepkoff; and furthered my study of Release Technique with two of its major exponents, Nancy Topf and Andre Bernard. Yet my commitment to feminism also made me question the dance scene I found in New York. Much of it was still dominated by the Martha Graham tradition, which I had little time for, finding the aesthetic outmoded and unappealing. Moreover, too many of the dancers I met seemed unbelievably *passive;*

they would just sit around waiting to be chosen by choreographers and then told what to do. One guy I met at the Cunningham Studios had been waiting around for eight years trying to get into Merce's company. I knew I was never going to be that kind of dancer: I didn't have the patience, I didn't have enough technical ability, and I didn't just want to be doing other people's bidding. I wanted autonomy, and I took inspiration from documentation of Yvonne Rainer's 1968 work, *The Mind Is a Muscle* (see Wood 2007), whose central lesson seemed to be that it was the responsibility of any dancer to determine her own course, to define the terms of her own practice and investigation.

I was galvanized by the idea that I could treat any material I wanted in terms of dance, and I drew inspiration from all around me. New York was such a playground at that time. It was a dangerous place, but there was so much to see and do. I might spend a whole day just hanging around in the Metropolitan Museum, for example, looking at Egyptian hieroglyphs and their inscriptions. I became fascinated with the two-dimensional movement that was described there, so I combined that with some Indian Kathak dance movements I had studied at Dartington to make a short piece that I performed at a friend's loft, *Egyptian Stock*. On the same bill, I performed another solo called *Found Dance*, which was inspired by watching an elderly bag lady in Central Park. She had made a sort of semicircle around herself with her bags and danced within it, making oddly erotic movements as if this were some ritual to permit fertilization by the wind. I made that piece as a sort of homage to all the misfits and weirdos you could find wandering around New York in those days.

I was also inspired by punk rock, which burgeoned on the downtown scene in the late 1970s thanks to CBGBs (where I saw Blondie and the Ramones) and other band venues such as the Mudd Club, Danceteria, and TR3, where I was inspired by girl bands such as Bush Tetras, the Slits, and the Raincoats. The idea at the heart of punk was that anybody could play any instrument—you didn't have to be trained, you could just pick something up and try it out—and that thought influenced a lot of crossover artistic activity at the time. In 1978, for instance, my friend Martha Wilson—founder of the Franklin Furnace arts space—put together an all-girl band called DISBAND. This included Martha, myself, performance artist Donna Henes, and writer Ingrid Sischy (then the editor of *Artforum*). I invited another friend to join, visual and perfor-

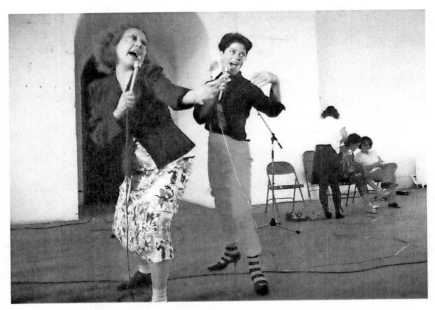

DISBAND performing at P.S. 1, New York, 1979. Left to right: Martha Wilson, Diane Torr, Ilona Granet, Donna Henes, Ingrid Sischy. Photographer: Sarah Jenkins. Used with permission.

mance artist Ilona Granet, and there were other occasional members such as Barbara Kruger, who contributed songs to our repertoire. The thing about DISBAND was that none of us actually played any instruments. Instead, our songs were like small, theatrical skits. We sang and danced about and hit things for percussion, and we used lots of odd props: a bedsheet, a hammer, a radio, a flag, a candelabra, Colonel Sanders' chicken buckets. In one very popular song called "Big Dick, Little Dick," Ilona and I used a rubber hose that ran down the inside of my pants and up the inside of her pants, and then poked out of our flies. The song would start with Ilona singing "I've got a big dick" and pointing at her end of the hose, and then I'd sing "I've got a bigger dick!" and pull mine out so that hers got smaller. We'd each be yanking on the hose, chanting "I've got a big dick, you've got a little dick, I've got a bigger dick, look at my dick!" And it just went on like that until we had either broken the hose by yanking it too much, or until one of us pulled it so hard and fast that the other one fell over.

I guess we thought there was some kind of feminist statement in all this. I performed with DISBAND from 1978 to 1980, and we got gigs in clubs and galleries such as TR3, the Kitchen, and Chicago's Museum of Contemporary Art. We even toured Italy on a bill with Laurie Anderson, Chris Burden, and others. The problem for all of us, though, was that this kind of activity really didn't pay any bills. We all had to grapple with the question of how to survive in New York as artists.

When I first arrived in the city, I had been thrilled to secure paying work as a general assistant for a satirical feminist newspaper called *Majority Report,* edited by Nancy Borman. The paper's offices on Sheridan Square were a meeting place for all kinds of women: wives on the run from their husbands, political activists, lesbian separatists, feminist scholars, and the occasional hellfire such as Valerie Solanas, author of the notorious *S.C.U.M. Manifesto* (Society for Cutting Up Men) and the woman who, in 1968, had shot Andy Warhol. I was suddenly meeting women whose books had helped form my consciousness, writers such as Susan Brownmiller and Kate Millett, and I even got to conduct an interview with Shere Hite, whose *Hite Report on Female Sexuality* (1976) had caused quite a stir. As with so many feminist papers of the 1970s, though, *Majority Report*'s finances were in poor shape, and only eighteen months after I began working there it folded.

With my J1 visa having expired, I was illegal. I had to get work "under the counter" with no questions asked and a fake Social Security number. This led, invariably, to low-skilled jobs determined by my sex, work as an artist's model or a temporary secretary, for example. Eventually an artist friend suggested that I try working as a go-go dancer since it was easy money and cash in hand (ten dollars an hour plus tips). With my dancing ability, my friend suggested, I would have no problem. It turned out that most go-go venues were actually workingmen's bars outside of Manhattan in New Jersey towns such as Perth Amboy, Paterson, Harrison, and Secaucus. It seemed feasible, I thought, to have a separate identity as a go-go dancer.

By watching other dancers, I quickly discovered that the go-go formula basically consists of ten moves—fingers down the inside of the leg, circling the nipples, bending over and looking between your legs, and so on—which had to be repeated at various intervals during the thirty minutes you spent onstage. These were the "money shots" in that—if done right—they virtually guaranteed a dollar tip from the

grateful male to whom a particular move was addressed. I quickly found that I could make quite a bit of money this way and that I even enjoyed it: flaunting my body, pouting my lips, and being sexually outrageous. I'd never before had the opportunity to be so licentious in public. I called myself "Tornado," which suggested a fast and wild persona that I felt I had to live up to.

At the same time, though, I was having a crisis of conscience. I was, of course, well aware of the feminist arguments about women being treated as sex objects, and the sex worker's role in the perpetuation of that stereotype. At first I tried to deny to myself that I was one of "those" women, and at one of my early gigs I even attempted a kind of punk parody of the moves that other dancers were making, as if this was a critical exercise. Of course I didn't make any tips except from a couple of newly arrived Mexican immigrants who had never been to a go-go bar before. I realized that I either had to play the game or get out of the business, and I knew I needed the cash. In an effort to understand my situation, though, I began reading Andrea Dworkin's *Pornography: Men Possessing Women* (1981). This was the most prominent book on the topic at the time, and I would read it during my breaks: I'd dance for half an hour, then go into the toilet and read some more of Dworkin's book for half an hour, then go back out and dance. I guess I was trying to test the theory against the practice, but I quickly decided that Dworkin, though a good analytical critic, had little understanding of the life situations of the women involved in sex work. For her pornography was a form of sexual violation comparable to rape, but that viewpoint seemed to render people like me as helpless victims—or even as brainless bodies—so wasn't *she* violating us, too?

Somehow through a friend (Robin Epstein) of a friend (Sarah Schulman), Dworkin heard that I was reading her book and that I was a go-go dancer. One day I received an unsolicited phone call from her. At first she treated me as if I were a potential convert—another Linda Lovelace,[2] perhaps—but I quickly rearranged her thinking about where I was coming from, and we got into an argument about covert as opposed to overt sexual expression in women's occupations. I suggested that the ready smile of the secretary or the sly, flirting gesture of the

2. Lovelace, star of the hard-core porn movie *Deep Throat* (1972), had famously renounced her involvement in the sex industry.

waitress were expected behaviors—involving a covert sexuality—whereas with go-go dancing at least it was on the level. There's a certain integrity about this work, I said, and it pays better. She didn't agree with me, of course, and said that waitressing was a respectable position, but I said I'm not talking about respectability, I'm talking about how we survive. A lot of women who aren't skilled or are single mothers can make more money working three nights a week as a go-go dancer than they can working 24/7 at McDonalds. Speaking for myself, I said that I felt I was definitely following a feminist credo, in that I wanted to have autonomy, to be economically self-sufficient. I had tried working as a typist, but that left me no time to create artwork. Besides, whether in the role of buttoned-up secretary or go-go dancer, I was performing different kinds of feminine drag in exchange for money.

Dworkin responded by talking about the abusive nature of sex work and asked angrily how I could condone it. I drew what seemed an important distinction between those who choose to work this way and those who are forced into it, and I talked about the directness and financial rewards of working in a job where the exchange was clear. It might not be the safest job on the planet, I acknowledged, as there's no job protection and the working conditions are highly questionable. You have to deal with some really unpleasant managers in some pretty squalid places (you try changing and putting on makeup, with two other women doing the same, in a room the size of a toilet in the heat of a New York summer). But, I said, I was trying to persuade other dancers to form a union to improve things. For Dworkin this idea was beyond the pale; unionizing would be construed as a legitimization of this exploitation of women's bodies. It was at this point, about forty-five minutes into the conversation, that we mutually decided on an impasse and hung up.

Fortunately there was one feminist writer who did help me to get a clearer perspective on my situation. Reading Angela Carter's book *The Sadeian Woman* (1979), I developed an analysis that I could have relayed to Dworkin had I spoken to her again. This was, in short, "Morality Demands a Budget." Without a financial safety net of some kind, any of us might find ourselves destitute and forced to work the streets in order to survive. Dworkin, as a lecturer in women's studies, might decry sex work and want it outlawed, but to me that meant she was also basically against the women who were doing it. She thought they needed to be

rehabilitated, but as what, factory workers? It seemed a very elitist position to me. Dworkin was condemning an occupation that will always be a way for disempowered women to earn an income and build up capital. It might not be a desirable situation, but it is a reality, and Angela Carter seemed to me to be in touch with it. "The rich can afford to be virtuous," explained her polemical preface, "The poor must shift as best they can." But not just that: "Flesh comes to us out of history; so does the repression and taboo that governs our experience of the flesh." I contemplated this statement while standing with my legs apart, my ass in the punters' faces as I bent over looking at them from between my legs. I watched them watching me, and I knew there was an expectation on their part that I would turn to face them and undertake some other formulaic move. If I did not, they would get bored and look away. There was a jaded pattern to "sexy dance." I am paid to do what you expect. Flesh comes to us out of history.

In her essay "Uses of the Erotic—the Erotic as Power" (first published in 1978), which I also read around this time, Audre Lorde makes a similar point about how energy is repressed through society's control of each individual's sexual expression. She proposes the revolutionary power of unleashing erotic energy and channeling it into social change.

> As women, we have come to distrust that power which rises from our deepest and nonrational knowledge. We have been warned against it all our lives by the male world, which values this depth of feeling enough to keep women around in order to exercise it in the service of men, but which fears this same depth too much to examine the possibilities of it within themselves. (Lorde 1984: 53–54).

I decided that if I was to stay on as a go-go dancer I needed to use the form for my own purposes and explore my own notions of eroticism, my own seductive capacities. I decided to treat the various bars where I worked as sites for personal research. So, while turning out the formulaic moves frequently enough to keep the punters happy, I also started playing with fetish objects that appealed to me, like feather fans and rubber snakes, and trying out my own musical choices. At that time there was a lot of really hot music I could actually get excited about dancing to—"Tainted Love" was a particular favorite—and since I was seeing myself reflected in mirrors all the time I could imagine that I was

in a rehearsal studio, trying things out. On one occasion, in a bar called Vinnie's in Secaucus, I found myself dancing in a kind of sunken pit surrounded by mirrors, and I lost myself completely in watching myself move. It was a lunchtime gig, and there was hardly anybody in the bar when I started my shift. It was maybe fifteen minutes before I looked up to find a whole array of men leaning over the handrails, eating their hamburgers, watching me. That was revealing—to suddenly find myself caught and realize I had been lost in my own erotic reverie.

The irony is that with my new approach I stood out from the crowd, and so it was at this point that I started making real money. Instead of getting dollar tips I was getting five or ten dollars. I had never fit the conventional "sexy" image—my body was too muscular from doing aikido and yoga and I didn't have an "hourglass" figure—but now I seemed to touch something in certain men who were drawn to androgynous looks or the fetish imagery I was playing with, and as a result I gathered a small cult following of New Jersey men who wanted to know where "Tornado" was performing next. For me, though, this "research" was more about exploring what might be sexually interesting for me, as a woman. My idea was that we could play with our sexuality, explore, own our own erotic sensibilities. Today, of course, there's a new fondness for burlesque even among feminists, but at that time most feminists were—like Dworkin—utterly opposed to sex work. My question to groups like Women Against Pornography was: "You say *no* to pornography, but what are you going to say *yes* to? What erotic aesthetic would you *like* to see?" Or were they suggesting that we should have no sexual culture at all?

Of course what a lot of women did at that time was simply turn themselves into *undesirable* objects by not putting on any makeup and wearing overalls that made them look lumpy and shapeless. For some there was a certain protection in that, which is understandable, but it reached a point where some feminists would look askance at you simply for wearing lipstick. I felt that it was our responsibility, as women, to create a new culture, to create an eroticism that did not debase or humiliate, one that would critique the old forms and suggest and stimulate new ones. I wanted to raise the standards.

The moral pornographer would be an artist who uses pornographic material as part of the acceptance of the logic of a world of absolute sexual

license for all the genders, and projects a model of the way such a world would work. . . . Such a pornographer would not be the enemy of women, perhaps because he might begin to penetrate to the heart of the contempt for women that distorts our culture. . . . [He] will very soon find himself in deep political water for he will begin to find himself describing the real conditions of our world in terms of sexual encounters. (Carter 1979: 19–20)

In June 1980, I made my first, tentative attempt to reflect on the sex industry through performance. Colab, the interdisciplinary artists' collective of which I was a member, mounted a major exhibition in an empty massage parlor near Times Square. The *Times Square Show* featured the work of over a hundred downtown artists and was a landmark event that helped propel several of the visual artists involved—such as Tom Otterness, Kiki Smith, and Jenny Holzer—toward major critical and commercial recognition. The show also included a rather haphazardly programmed series of performances and film screenings. My own contribution, in collaboration with filmmaker Ruth Peyser, was a nod toward the seedy sex shops and porn cinemas that at that time still dominated the stretch of 42nd Street just off Times Square. Ruth and I took it upon ourselves to conduct "research" in some of the sex shops, spaces that women would normally never enter. I also experimented for the first time with dressing in male drag so as to access "undercover" the porn screenings at the Variety Cinema on Second Avenue and 14th Street. (I attended with a couple of male friends to bolster my disguise.) I wanted access to these zones normally forbidden to women. I wanted to see what it was that men were looking at.

In our *Times Square Show* performance, Ruth loudly read extracts from porn magazines while the audience looked at various artefacts we had bought from the sex shops (such as a model of then President Jimmy Carter with a spring-loaded peanut for a penis). Meanwhile I wandered around—again dressed in a version of male drag—prodding people in the back with a large dildo that I had strapped on under my jacket. We also performed various simulated sex acts on a rather surprised-looking blow-up doll. I think we felt we were "confronting" people with pornography, and certainly several people felt sufficiently provoked to leave. The art critic Lucy Lippard told me later that she felt the piece had been "very much on the edge," and when I asked what

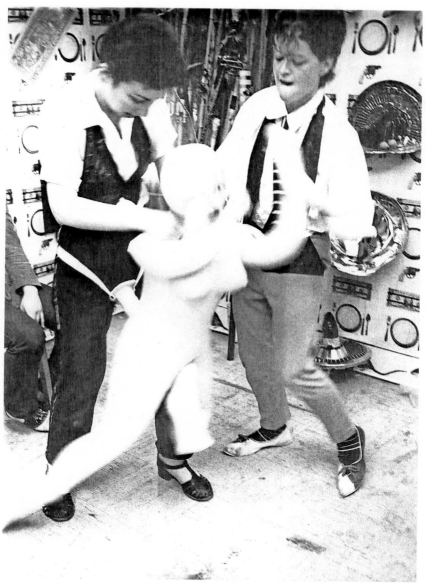

Ruth Peyser and Diane Torr performing at the *Times Square Show,* New York City, 1980. Photographer: Caterina Borelli. Used with permission.

she meant by that she said she had been left unsure as to whether the piece was for or against pornography. Personally I was less interested in telling people what to think than in prompting them to respond for themselves.

In 1981, I was invited by Peggy Shaw to perform at the WOW (Women's One World) Theatre Festival in the East Village. This was the second international arts festival to be organized by WOW's founding foursome of Peggy, her then partner Lois Weaver, Pamela Camhe, and Jordy Mark. Somewhat controversially, WOW insisted on a female-only audience, and I saw the invitation as an exciting opportunity to air some of the questions I had been asking myself as a go-go dancer in front of other feminists, with men taken out of the equation. What would it be like if women were to perform seductively for other women? What would change, or not change, in a go-go routine or its reception as a result of this altered context? But I also knew that there was, again, an element of provocation involved. Since many in the feminist community had a rather reflexive, unthinking disrespect for sex workers, I wanted to educate people a little as to what go-go dancing actually entailed, to have my fellow dancers be heard as people rather than dismissed as mere objects.

I found it harder than expected to recruit collaborators for this venture: most go-go dancers were rather shy about becoming visible outside of the job, often because they were controlled by a sense of shame about being considered "immoral" women. They did not appreciate their own value. (For this same reason, my attempt at forming a union went nowhere.) After much badgering, I finally found two dancers willing to perform at the festival: "Rebecca Furious," a Chilean immigrant who wanted to be a journalist; and "Daisy Mae," a trained dancer from a Mennonite family in Pennsylvania (the family had no idea she was working in go-go bars). Together we created *WOW-a-Go-Go* for the festival by combining go-go routines with personal monologues delivered by each of the dancers. Each of us had something she wanted to tell an audience. Rebecca's concern was with male violence. She had married a man to get away from her family, but he had turned out to be a criminal and a thug and she now worked double shifts as a go-go dancer—twelve hours a day—in order to stay out of the house and avoid him. She had become a very skilled dancer because she was working all the

time, which meant she was constantly rehearsing her act, and she had directed her fear into creating routines with powerful characters such as a pistol-twirling cowgirl and a femme fatale figure who never gave anything away (she could slip off her panties under a peignoir without anyone catching a glimpse of anything, while completely ignoring all the men clamoring at her). In our WOW show, Rebecca looked particularly fierce. I think she rather frightened some of the women who had never seen anything like this before.

Daisy Mae was quite a contrast. She used the opportunity to confess to her Mennonite mother (who was not in the audience) why she had stolen her negligee and panties from the laundry cupboard the last time she had been home to visit. Her performance was really about the loss of innocence, about how her fantasy had been to work in musical theater in New York, how she'd ended up in go-go bars, and how she had quickly learned that her mother's white lacy lingerie wouldn't cut it. Guys wanted to see black and gold, sparkling and sharp, not Daisy Mae's arabesques. My own performance also addressed this question of which "looks" sell. I started out in a very glamorous piece of vintage clothing, a full 1950s skirt with long evening gloves, dancing to swing music, and then stripped down to G-string and bra, doing a feather fan dance bump-and-grind style. I wanted to get behind that "feminine glamour" look, the sexy, sleek style that you see in women's magazines, because glamour seemed to me to be just another form of covert sexuality. Behind it is this sexual rapture, the fantasy that you can have not just these clothes but the sexual adulation that comes with looking like that. It's pure hypocrisy when one considers the way more overt sexual display is still treated with disdain. But it was also important for me to demonstrate that behind this glamour image there is not just some submissive and mollified female. As Jessica Abbe's review in the *Villager* explained:

> Ms. Torr performed two dances: first a tawdry number to Sinatra's "New York, New York," then the kind of dance she always wanted to do for the grinning hordes—a fighting dance in memory of the eighteenth-century Scottish rebellions. There was something moving, at once funny and sad, about this performance of warrior intensity—these strong muscles and strong moves by a woman in a gold G-string. She

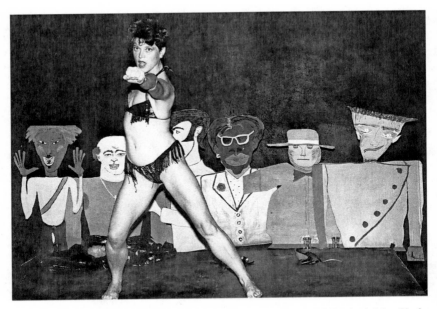

Diane Torr as Scottish go-go warrior in *WOW-a-GoGo,* WOW Festival, New York, 1981. Photographer: Mariette Pathy Allen. Used with permission.

seemed to be playing to two audiences; those who were passive witnesses to an artist's exorcism, and those (women) whistling and cat-calling in the traditional spirit of a New Jersey night. (Abbe 1981)

This review also described me as "an avant-garde Studs Terkel" for enabling Rebecca and Daisy's voices to be heard. Later, in an overview of the festival's forty-plus performances published in the feminist journal *Sojourner, WOW-a-Go-Go* was singled out as one of the three best—"and in many ways the most risky" (Blitzen 1981: 19)—alongside the first, eponymous piece by the Split Britches company and a project by former Open Theatre director Roberta Sklar. Such recognition was particularly valuable in helping to legitimize what we had done because the performance created quite a ruckus. Many people were openly critical of me for bringing erotic dancers into the context of a women's festival.

If the WOW performance was "risky," the reactions it prompted were nothing compared to what I experienced in the summer of 1982 in Amsterdam. I had been invited by curator Suzanne Dechert to pre-

sent a go-go piece at the International Women's Festival at the Melkweg (Milky Way), the festival on which WOW had initially been modeled. I had imagined that a European audience might be more receptive to this material, but one glance at the graffiti on the streets around the Leidseplein—such as "PORNOGRAPHY = DEATH"—made me fear for what the audience reaction might be. By this point I had lost contact with Rebecca and Daisy (their phones had been disconnected), so I had worked with two other dancers to create a new piece, simply called *Show*. We had dropped the personal narrative element in order to look more directly at the question of what erotic dancing might look like if women were to perform only for other women. Would we be obliged to conform to the same clichés of sexual expression that had been developed in response to male desires, or would women be interested in a reinvention of the erotic?

My feeling was that, in order to get beyond the stereotype, you have to confront what that is, if you're not to run the risk of simply recycling it. So the plan was for each of us first to present one of our "typical" go-go routines before going on, in the second part of the show, to present our own, personalized takes on the erotic. I would start out in leather fetish gear, cracking a whip for my dance to Joan Jett's "I Love Rock 'n' Roll," before offering a sharp contrast, a sexy, swaying, hula dance to a Chuck Berry song, "Havana Moon." I wore gold scallop shells on my breasts and a pink and gold, shimmering tight skirt with a trailing fringe. My collaborators came up with other responses for the second part of the show. Patti Head was five months pregnant and chose a "natural" style of dancing barefoot in a flimsy, billowing silk costume inspired by Isadora Duncan. The other dancer, visual artist Judith Jeger, created a sculptural mound covered with a tactile leopard print, a kind of fetish object around which she choreographed her movements, brushing her whole body over it and stroking it with her fingertips. We showcased *Show* in a performance at an East Village after-hours club, Laight Again, before we left for Holland, but in Amsterdam the audience was so incensed by the go-go routines in the first half that the alternative creations were not even seen.

Our performance topped the bill at the festival's "Decadent Night," where we found ourselves performing in front of about thirteen hundred women. Very few of them seemed to have dressed in the spirit implied by the evening's title. There were maybe three women in fetish

gear, but the vast majority were in dungarees and coveralls. Almost as soon as the performance began, the crowd began shouting and booing, yelling what I understood as "You're performing for men!" (the only males present were technicians) and "This is POR-NOG-RA-FEEEEEEEEEE!" When the show didn't stop, there was an audible rallying call of "FASCISTS!" Then the missiles started, first a beer mat, then many more beer mats, and then two or three bottles. We wanted to quit, but Suzanne Dechert, as director of the festival, insisted that we continue. Perhaps she thought we could win the crowd over with our individual erotic compositions. I duly went out to do my Chuck Berry number with the music turned right up to compete with the jeering from the audience, but I was only a minute into the dance when all hell broke loose. Audience members began pushing each other and spilling onto the stage, and then someone pulled the electricity.

Suddenly there was darkness, and as the music cut out we could hear the intense anger and confusion of the crowd. People were stumbling over each other, howling with a fury that, I realized later, stemmed from their sense that a "safe," feminized space had been violated. As the objects of this fury, my colleagues and I tried to make a hasty exit only to find that a group of angry women had arm-linked themselves to create a chain across the front door of the Melkweg, preventing our departure. In the melee, a hand grabbed mine and a voice said, "I know the back way out of here." It was the journalist Bernadette de Wit, editor of the Dutch lesbian newspaper *Diva*. We all linked hands in an unwieldy chain and managed to pull ourselves through the crowd, following Bernadette. Then we ran.

That experience brought home to me, forcibly, just what a volatile issue female sexual expression is. I realized that I would need to have the zeal and determination of a missionary if I were to continue in this direction, and to be willing to withstand all kinds of abusive treatment. There were also rewards to be had, certainly. In the midst of the chaos at the Melkweg, we were loudly congratulated by a group of women from Surinam, who thanked us for our performance with the words "We have never seen white women dance like this before." Despite such moments of vindication, though, I realized in Amsterdam that I had neither the support nor the inclination to go it alone as a "sex revolutionary." By then I had also had quite enough of performing in seedy New Jersey bars, so I made a conscious decision to step away from

sexually explicit performances. Within a few years, Annie Sprinkle and others would pick up that baton and begin to run with it much farther than I had.[3]

I created one more "go-go" performance, but this was a kind of exorcism in which I adopted a more analytical and comedic approach. My solo piece *GoGo World* was first performed in 1983 at New York's P.S. 1 (on a double bill with Eric Bogosian) before being toured extensively. In it I wore a costume designed by Mary Bright, which covered my body almost entirely but displayed exaggerated, cartoon versions of the body parts revealed by stripping: bright pink cushions for breasts, a bright pink, padded labia, and a long green clitoris peeping between. *GoGo World* was a kind of playful analysis of the aesthetics and politics of sleaze. I would start with a parodic rundown of the basic, formulaic go-go moves—commenting on their varying potential for securing tips—and then move on to geopolitics. It had occurred to me that analogies could be drawn between the styles of certain go-go dancers I knew and the hypocritical stances of certain governments. For example, you might see one dancer who was rather unsure of herself, just starting out, and then you would see her three weeks later and she had stolen your act. This reminded me of Belgium, a country adept, at that time, at dressing up other governments' ideas as its own. Germany, on the other hand, was like the very efficient go-go dancer who could accumulate piles of dollar bills without apparently doing anything very special to earn them. Meanwhile, the "English" go-go dancer would never admit publicly what she did for money, just as England didn't (and doesn't) like to admit to its dependence on the European community for trade.

The performance would move from this analysis of governments to an analysis of the people in the audience. What do *you* want? What are *you* looking at? I repeated a lot of the things that I'd heard in go-go bars from customers as they talked about the dancers, but I turned them around and directed them at the audience. The houselights would

3. Annie Sprinkle's first appearance on New York's downtown performance scene came in February 1984 when she appeared alongside Veronica Vera, Candida Royalle, and others in a show titled *Deep Inside Porn Stars*. Like *WOW-a-Go-Go*, this sought to provide audiences with firsthand accounts of sex workers' experiences (see Banes 1998: 231). This was the last in a series of "Carnival Knowledge" events on the theme of feminist pornography curated by Diane's friend and colleague Martha Wilson. [SB]

come up, and I'd point at different men out there, who would be shrinking into their chairs, and I'd say, "Oh, I'll give him a tip, he looks like a student," or "Oh, not that one, he's got an ass like a sack of potatoes," or "I'll give him a tip because he looks like he might come home with me." My coup de grâce was to put a five-dollar bill on the stage and yell, "Hey you guys, if you can pick this up with your testicles it's yours."

> In *GoGo World*, Torr has stripped the romanticism from the female stereotype of the woman who lives by her sexuality—the starlet, the whore with the heart of gold. Her performances dissect the power politics of sex for money, of manipulation, of giving only as much as you get. At first glance, she seems to assert the feminism and independence of such women, yet Torr is not so naive. As she reminds us at the end, gogo dancers live off their tips, and it is the men who tip. (Virshup 1983)

Amy Virshup's review in the *East Village Eye* suggests that *GoGo World* was more palatable to feminists than my other go-go performances had been. But that didn't mean I was advocating good behavior. As Angela Carter points out, the virtuous but powerless Justine in the Marquis de Sade's *One Hundred and Twenty Days of Sodom* "is a good woman according to the rules for women laid down by men and her reward is rape, humiliation and incessant beatings." She "learns not self-preservation but self-pity" (1979: 51). Justine's sister, Juliette, is her antithesis, the personification of rationality and self-mastery, calculating every step in the procurement of two ends: financial profit and sexual gratification. "If Justine is a pawn because she is a woman," Carter writes, "Juliette transforms herself from pawn to queen, and goes wherever she pleases on the chess board." Of the two sisters, Juliette is surely the wiser. And yet "there remains the presence of the king, who remains lord of the game" (79–80). When I read this I wondered, how do you get to be king?

Two | Becoming Androgynous

Women are laughing again. Women are smiling and singing and telling jokes. They're composing music with joyful melodies, producing witty plays, writing poems about love and hope. [And] nowhere has the blossoming of this women's culture been more startlingly evident than in the Women's One World Festival. . . . For the past ten years, the women's movement has been accused (and often justly) of having no sense of humor, no pizzazz, of being just a narrow-minded bunch of furrow-browed dykes contemplating social injustices. . . . We were oppressed, we are oppressed and the reality and fact of our oppression was so depressing that we became creatively immobilized. [But now] the Women's One World Festival heralds a new culture, steeped in lesbian/feminist consciousness. Born out of a decade of pain, it is blossoming remarkably strong and vivid.

—JANE CHAMBERS

Jane Chambers's *Advocate* review of the first WOW Festival, in 1980, vividly expresses its landmark significance in the history of feminist performance, as the anxious agitprop of the 1970s began to give way to a more confident and expansive creativity in the new decade. (In December of the same year, Chambers's play *Last Summer at Bluefish Cove* was to make history of its own as the first "out" lesbian drama to appear off-Broadway, at the Actors' Playhouse.) After the second, 1981 festival proved an even greater success, WOW was reinvented as a permanent venue rather than an annual, itinerant festival. A storefront space was located on East 11th Street in New York, and an international collective of women (Diane included) raised the funds and provided the free labor needed to strip out and redecorate it in time for its opening in March 1982 as the WOW Café. The rest, of course, is history. As its ubiquitous presence in accounts of feminist theater in the 1980s attests, WOW was on the cutting edge throughout that decade and into the 1990s thanks to work of artists such as Holly Hughes, Carmelita Tropicana, Lisa Kron and the Five Lesbian Brothers, and, of course, the Split Britches company of Lois Weaver, Peggy Shaw, and Deb Margolin. Critic Jill Dolan recalls the joy of discovering the WOW Café after seeing so much lesbian-

feminist theater in the 1970s that seemed "political and ideological more than aesthetic or even theatrically interesting. [WOW artists] encouraged work that was much more daring formally and much less reverent politically" (2001: 106).

Still, it would be misleading to assume that WOW's work was sui generis. It represented, rather, a productive fusion of impulses from different creative communities. Visual artist Cathy Quinlan, for example, recalls there being "two different audiences" at the initial WOW festivals: "[O]ne was the lesbian theatre people, and the other was the art-world crowd, and there was a big split between those groups." For Quinlan, Diane's *WOW-a-GoGo* performance in 1981 was one of the shows that exposed that audience division: "[T]he art-world audience was pretty 'cool' about it all, or at least they pretended to be—they wouldn't be turned off, they could handle it—whereas for the lesbian-feminists it was challenging because this was one of the things that it had been decided was not OK for a woman to do" (2007). Of course, *WOW-a-GoGo* was itself the product of an "art world" approach to performance in that it treated erotic dancing conceptually as a found object to be recontextualized in a radically incongruous context (just as, for example, Warhol had brought commercial imagery into the fine art world). Given the array of interdisciplinary artists Diane had been associating with in groups such as Colab and DISBAND, her fusion of theatrical and conceptual approaches was logical, as well as arresting.

Performance art had been evolving throughout the 1970s from its origins in conceptually based gallery work. Indeed, it is worth noting in the context of this book that several notable female artists, including Eleanor Antin, Ana Mendieta, Martha Wilson, and Adrian Piper, had documented themselves experimenting with male alter egos in the early 1970s, applying facial hair and costuming to beg questions of their assigned "feminine" identities. (Thus Diane's first venture in the direction of approximated maleness, at the *Times Square Show*, had notable precedents.) Around the turn of the 1980s, though, performance art was becoming more consciously theatrical and populist in orientation, particularly in New York. This was thanks in no small part to the emergence of a number of East Village club venues where solo performance artists began to appear as late-night cabaret acts. Club 57, founded by artist Ann Magnuson in 1979 in the basement of a Polish church at 57 St. Mark's Place, was the first venue of this new wave. Another key space, the Pyramid Club on Avenue A, was established in 1980. "There weren't any rules," recalls Martha Wilson, because "nobody knew

what performance art was, and nobody cared particularly to define it. It was happening in these bars, late at night, so nobody was particularly looking and you could just do whatever you wanted" (2007). Wilson, who had founded the cross-disciplinary Franklin Furnace arts space in a storefront on Franklin Street in 1976, recalls the evolution of this "illegitimate" art form as being intrinsically related to a pragmatic, understated feminism. Since white male artists still tended to be taken more seriously by the major, established institutions, it was logical enough that others began to explore spaces and methods on the margins of mainstream acceptability.

> The Fluxus artists of the sixties had this concept of intermedia, where the barriers between all the different media would be broken down, and that really started to happen in this period toward the end of the seventies, beginning of the eighties. . . . At Franklin Furnace we showed artists whose work was perhaps more marginalized because they were female or black or gay or short. The minimalists had generally been white boys, but the generation after that wanted more emotion, wanted more mess, didn't care about craft. Everybody was collaborating with everybody else, helping each other out and seeing what they could get away with. (Wilson 2007)

The palpable excitement generated by the WOW festivals was, in effect, a result of the cross-fertilization of explicit feminist politics with this promiscuous but previously unfocused wave of creative energy. As Holly Hughes recalls of the earliest events she attended at the WOW Café, there was

> a whole different kind of approach to feminist performance that I had never seen before. . . . We had women like Diane Torr trouncing around in negligees and kissing booths and lingerie shows. It was *for* women. People would come in there and strip off their clothes and put on lingerie. It had a lot of the drag theatre flavor and permission. And everybody became a performer. It was so *avant*. (1989: 174)

Hughes's reference to "drag theatre" is telling here given the extent to which Diane's go-go performances did indeed represent a self-consciously exaggerated performance of "feminine" eroticism. But male-to-female drag also fed directly into the emerging WOW aesthetic. Hughes herself cites as key inspirations "the gay male drag performances of Charles Ludlam, Jack Smith and Ethyl Eichelberger," all of whom could be seen per-

forming in downtown theaters and clubs in the early 1980s (qtd. Newton 1996: 191). Similarly, Peggy Shaw acknowledges that "we took a lot of the aesthetic for WOW from Hot Peaches," the gay theater troupe with which she toured and performed internationally between 1972 and 1978: "the garbage aesthetic. The idea that you should just hurry and get something up. Because what are you waiting for? And everybody's a star" (qtd. Carr 1998: 66).

Given this heritage, it is not surprising that cross-dressing was a key element of the WOW aesthetic from the very outset. Among the leading attractions at the festivals of both 1980 and 1981 was a cross-dressed rock cabaret revue coordinated by WOW cofounder Jordy Mark, *Sex and Drag and Rock 'n' Roles*. For Anderson Toone, who was Mark's main collaborator at the first festival, this event marked the beginning of the (pre)history of drag king performance (see Toone 2002). Toone and Mark sang songs as both men and women, switching roles onstage, and Peggy Shaw put in a guest appearance as James Dean. The following year Toone appeared at the festival with the Bloods (an all-butch, cross-dressed rock band), while Mark put together a new revue, encouraging performers and audience members to attend dressed as their favorite "drag fantasy." This instruction prompted visions of fantastical femininity, as well as masculinity. Pamela Camhe, for example, "appeared . . . as 'the lady in red,' surrounded by an aura of black balloons which she petulantly popped with a lit cigarette while singing a la Dietrich the altered lyrics 'Failing in Love Again'" (Baracks 1981: 103).

The playful manipulation of gender apparent here became a defining feature of WOW as it developed during the 1980s, most famously in the many-layered masculine/feminine double act of Peggy Shaw and Lois Weaver in a string of Split Britches productions. Critics such as Sue-Ellen Case celebrated their performances as a revival of the butch-femme role-playing tradition apparent in lesbian bar culture in the 1950s and 1960s but with a newly theatricalized self-referentiality. Where butch-femme couples had been frowned on by many feminists during the 1970s for presenting an uncritical echo of the heterosexual "norm," Shaw and Weaver were recognized as playing freely with a wide range of gender role options. Case noted that "the butch-femme couple [is] playfully inhabiting the camp space of irony and wit, free from biological determinism, elitist essentialism, and the heterosexist cleavage of sexual difference" (1989: 297–98).

Significantly, though, WOW performers did not prioritize the idea of

women performing in male drag per se—in the sense of playing male characters in the way that gay actors such as Charles Ludlam played female ones. Instead, the WOW aesthetic came to be marked by a playful use of a spectrum of masculine and feminine attitudes that were available for women to manipulate as they chose, while remaining proudly and essentially female. In Holly Hughes's film noir parody *The Lady Dick* (1985), for example, Peggy Shaw's male-sounding character Mickey Paramus is nonetheless clearly identified as a butch lesbian and is referred to in the stage directions (as are all the characters) using female pronouns (see Hughes 1991). "The iconography of butch-femme culture present in performances at WOW is not about cross-dressing," Kate Davy noted. "Wearing the 'gender' of the other sex is not the point" (1994: 144). Indeed, Shaw herself notes that (occasional cabaret turns notwithstanding) it was not until 1991, when Split Britches collaborated with the London-based drag queen troupe Bloolips on *Belle Reprieve*—a parodic adaptation of Tennessee Williams's *A Streetcar Named Desire*—that she finally played a male character role. As Stanley Kowalski, "flexing her muscles in a torn T-shirt, Shaw actually managed to surpass Brando in animal magnetism," Laurence Senelick recalls (2000: 490). Yet Shaw herself felt very ambivalent about the production at the time, stating, "I used to be rough and tough, and very male-identified when I met Lois, and playing that role was very regressive for me" (Raymond 1992: 24).

Throughout the 1980s, "male identification" tended to be frowned on in the lesbian feminist community, for understandable reasons. The potential for what would become the female-to-male drag and trans movements of the 1990s was certainly present, but largely latent. Anderson Toone, for example, credits Shaw as his "drag father," and thus as a key inspiration in his own transgender journey: the Mark/Toone *Sex and Drag and Rock 'n' Roles* revues seem to have been formative experiences for some of those involved. To others, however, the revues fit comfortably within an early 1980s model of female gender play. In her account of the 1981 WOW Festival, *Village Voice* critic Barbara Baracks described the revue as Jordy Mark's "annual androgyny act" and, while praising her polished performance, also noted that "after so many days of WOW, even drag can weary" (1981: 103). In the context of this women's festival, it seems that women dressed in masculine clothing were viewed as androgynous rather than cross-gendered as such, and were, indeed, a familiar sight. Much less familiar—and thus perhaps more subversive—was

Diane's decision to bring go-go dancers into this female-only context, to use a form of über–feminine drag to beg questions about the women's community's self-imposed limits on sexual expression. Indeed, *WOW-a-GoGo* caused such a stir that Peggy Shaw made a point of underlining its impact at the festival's closing revue. In her guise as Gussie Umberger, the lesbian shopping-bag lady, she quipped that "I've been to 37 women's festivals, and this is the only one that had go-go girls" (Baracks 1981: 103). Shaw later commented, more seriously, that "many women were upset by the show because they didn't know how to act, how to react, or how to be with these women" (qtd. Solomon 1985: 95).

As Holly Hughes's previously cited comments indicate, though, the sexual expressiveness of Diane's go-go work was also perceived as liberating by many in the WOW sorority, and it fed directly into the emerging aesthetic. Indeed, in December 1981, Diane and Cathy Quinlan initiated WOW's "XXX-rated Xmas Party" at Club 57, a women-only benefit event organized to raise the rental down payment for the new East 11th Street WOW Café space. Another provocative display by Diane's New Jersey go-go colleagues was complemented on this occasion by the participation of Lois Weaver, Peggy Shaw, and others, whose cabaret number climaxed with a chorus line of exposed bottoms across which a cute message for the audience had been inscribed cheek by cheek. The event as a whole represented an overt celebration of women's sexuality. It also caused something of a stir in the neighborhood, with attendees confronted by picketers at the door. Local anarchist Lee Penn, a friend of Diane's, led male colleagues waving placards with slogans such as "Women get back in the kitchen!" a Yippie-style expression of mock outrage that men were excluded from the event.

Another small sideshow that night involved Bradley Wester, with whom Diane was then collaborating on a new performance. In the playful spirit of the evening, Wester decided to gate-crash the party in very specific female drag.

> Diane and I looked similar in those days; we had similar facial structure, similar body types, short dark hair—quite fetching I would say! And we lived next door to one another on East 10th Street, so that night I went round to her apartment and her boyfriend David Paskin let me in and helped me dress up in Diane's clothes. It was one of the most erotic things I ever did, partly because I secretly thought David was really hot. We went through her things, and I chose some fabulous vintage clothes, put on her makeup, ear-

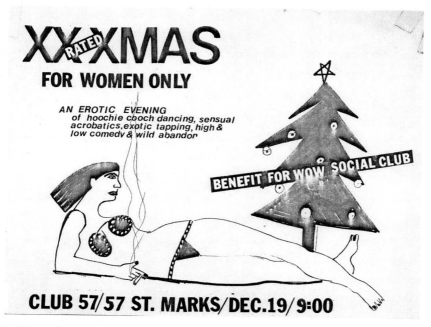

Publicity flyer for WOW's XXX-rated Xmas Party, December 1981. Artwork by Cathy Quinlan. Used with permission.

rings, a hat—I totally "did" Diane—and then I was escorted to Club 57, where I was let in with no problem at all. I must have been convincing! I started mingling and scoping out where Diane was, and when I found her she looked me right in the eye and said, "I know you!" But it took her a moment to figure out who I was. When word got around that I was a guy, they got a little cadre together to kick me out, but Diane was outraged. She said "Are you kidding? This guy went to all this trouble, he's a completely convincing woman, and he got in without anyone knowing. No way are you kicking him out!" And I got to stay for the whole thing. (Wester 2007)

Wester's anecdote highlights the limits of drag and gender play at WOW during this period. Its women-only policy was intended as a means of creating a safe, communitarian environment free from the kind of domineering and potentially predatory male presence encountered in so many mixed contexts. And yet this separatism was necessarily based on an es-

sentializing, biological distinction between the sexes, making no allowance for gay or cross-dressing men or other gender variance. The WOW position was thus controversial even among feminists. Indeed, the influential *Village Voice* theater critic Erika Munk had publicly distanced herself from the first WOW Festival, writing that "a liberation movement that calls itself mine has the basic lack of decency and self-confidence to think it can and should discriminate" (Munk 1980: 114; see also Shalson 2005). Although Diane remained involved with WOW for some time after the opening of its café space, her next performance explorations sought increasingly to challenge—rather than reinforce—the culturally imposed division between the sexes.

Looking back, I must admit that I sometimes felt rather awkward at WOW, as if I wasn't a fully subscribed member. Although I did have sexual relationships with women, I was also involved with men, and it seemed to me that WOW was more accepting of lesbians than bisexual women. Perhaps I was also held at arm's length because of my go-go performances. But I was already something of an anomaly within the lesbian-feminist community in the early 1980s because of my insistence on continuing to dress up and wear makeup. For me, though, experimenting with style had nothing to do with dressing "for men." I enjoyed searching out vintage clothes, which you could still get cheaply at that time, because they felt so good to wear. They were beautifully made from luscious fabrics like satin and crepe de chine. The feel of silk on your skin is just the most sensual thing. Why deny myself that in order to fit in with the lumberjacketed aesthetic that predominated at that time?

At the same time, though, I was becoming interested in exploring notions of androgyny that went much farther than the question of how you present your clothing and hair. My dance training had made me feel strongly that the "biological" distinctions between male and female bodies are culturally overstated. My study of Release Technique, for example, taught me to think of the body as a physical mass, moving through space, subjected to universal forces of gravity and motion. Sex is largely immaterial to such considerations even in the pelvic region! My release tutor in New York was Nancy Topf, and her classes

placed particular emphasis on the pelvis, the main weight-bearing area of the body. She had made the deep psoas her unique focus of investigation. The psoas is a major muscle in the body, responsible for stabilizing the base of the spine, allowing the spine to flex, and rotating the hips for a free range of movement. The psoas is engaged particularly in the actions of crawling, squatting, and moving from all fours to standing and the reverse. In Nancy's classes we explored these movements in depth, repeatedly, and I often felt as if I were reenacting, in fast forward or fast reverse, the process of evolution itself, from the primordial slime all the way up onto two legs. This training gave me a strong sense of bodies *as bodies*, irrespective of gender.

As a complement to these physical explorations, I took courses in anatomy and kinesiology with Irene Dowd at New York University and became fascinated with the question of humanity's biological heritage. For example, I was intrigued to discover that the coccyx—the four tiny bones at the very bottom of the spine—are all that now remains of a primordial tail. How much of who we are now, I wondered, behaviorally as well as anatomically, is biologically inherited from the three and a half billion years that it took us to evolve from amoeba to biped as opposed to socially constructed during our few thousand years of conscious history? As a feminist thinking in these terms, one quickly realizes that men and women are bound together as one species—*Homo sapiens*—and not separated as two (as in the *Men Are from Mars, Women Are from Venus* analogy of self-help guru John Gray). Our similarities vastly outweigh our comparatively insignificant differences. Why then, I wondered, did so many people—from male chauvinists to separatist lesbians—insist so adamantly on maintaining the imagined gulf dividing male and female?

In 1978, I had begun making solo dances of my own, exploring these questions in a mode of playful enquiry. On a visit to the Natural History Museum, for example, I decided to make a dance for my newfound relatives, the dinosaur skeletons, which at that time were contained in large glass cabinets. Humans are not, of course, directly descended from dinosaurs, but we do share a biological heritage, which is rarely considered. (There's a brilliant analysis of our evolutionary family tree in paleontologist Neil Shubin's 2008 book *Your Inner Fish*.) By imagining each one of the skeletons—palaeosaurus, platasaurus, and so

on—as one of my predecessors, I created a series of duets and pretend ancestral dialogues. I went from cabinet to cabinet, emulating the shapes and imagining the movements of each one and dancing on the benches in front of them. The dinosaur rooms were largely ignored by visitors in those days, and I had the place to myself, accompanied by an audience of one, my friend and dance colleague Julie Harrison, who took photographs.

Another influence on my thinking at this time was Contact Improvisation, which I had studied at Dartington with its creator, Steve Paxton. As its name implies, this dance approach is based on a spontaneous improvisation between partners in almost constant contact with each other. In contact improvisation there is a continuous giving and receiving of weight between two bodies working as if they are one; the emphasis is on trusting and working together with your partner, being available to the possibility of being both a leader and a follower but never holding on to one position. This way of working was challenging for both male and female students. In most forms of dance duet, men are accustomed to lifting and leading their female partners while women are accustomed to being led and held. To find oneself suddenly expected not only to take the lead but also to take a man's weight was revolutionary. Needless to say, many of the men had difficulty surrendering the initiative to their female partners: I've had my share of partners who really didn't like my taking a leadership role—my being "the top," if you like—and who were constantly trying to get me into a position where they could lift or carry me or throw me around, or who even tried to prevent me from lifting or carrying them, thereby impeding any sense of smooth flow in energy or movement. On the other hand, there are men who get really irritated with women who always want to be in the passive role, who won't experiment with lifting or carrying. The roles we assume as men and women in our lives obviously affect the roles we assume as dancing partners, and I saw the need to get beyond those boundaries of self-definition in order to go farther in our physical explorations. Steve had created a nonhierarchical "art-sport," and as one of the first students in the United Kingdom to learn this form I was thrilled by contact's potential to challenge conventional male-female dynamics, at least in terms of movement.

A key inspiration for Steve Paxton in his development of Contact Improvisation was the Japanese martial art form aikido. I wanted to

know more about "the source," and so in September 1977 I began study-ing aikido at New York Aikikai with Sensei Yamada. I also wanted to in-vestigate this form because I had a practical interest in learning self-de-fense. New York in the late 1970s was a wonderful playground for young artists, but it was also an extremely dangerous place to live. There was very little police presence in those pre-Giuliani days, espe-cially downtown in the East Village and on the Lower East Side, where I hung out. There were many artists and different ethnic communities living there, but also a great many homeless people, and burned and abandoned buildings. The areas around Clinton Street and Avenues C and D, in particular, were almost completely lawless, a zone inhabited by outlaws, junkies, drug dealers, and muggers, as well as by ordinary families. In the United Kingdom I had never really felt threatened on the streets, but in New York I was attacked three times within the first year of my arrival. I tried various strategies to make myself less "visible" as a potentially vulnerable female: except for dress-up occasions, I stopped wearing makeup, and I started wearing gender-neutral cloth-ing. I also learned to play the blues harmonica, and whenever I felt threatened I would play it as I walked along, as if to warn people off. That worked for a while, but I knew I needed a more effective form of self-defense.

Little did I know, when I began my aikido practice, that it would be-come my main physical study, a form I still practise three decades later. Created by Morihei Ueshiba in the early twentieth century, aikido (lit-eral translation: "the way of harmony with universal energy") teaches students to develop their physical, mental, and spiritual potential si-multaneously. Aikido's approach to dealing with aggression and vio-lence is to neutralize attacks by blending with the motion of the at-tacker and redirecting the force of the attack rather than opposing it head-on. The techniques are completed with various throws or joint locks. No distinction is made between male and female practitioners because as a self-defense discipline aikido trains both sexes alike to deal with bodies that may be bigger and heavier than one's own and, in-deed, to deal with many opponents simultaneously, not just one. It teaches the practitioner to be flexible, fluid, and centered, able to react quickly and spontaneously.

I learned to center myself by imagining my *ki* or *chi* center, also called the *tanden* (which is about two inches below the navel and two

inches in), and using that as a focus point for my breath and energy. In extending *ki,* you feel your energy as a strong, flowing current that moves from the center through the whole body. Flowing through the pelvis and legs, it grounds you. The "unbendable arm" in aikido is achieved by imagining a current of energy flowing from this *ki* center and out through your arm for a distance of a thousand miles. Your arm is like a conduit for a limitless, far-reaching energy flowing effortlessly through it. Having learned visualization through my study of Release Technique, I was open to the possibility of using the imagination to extend the will. When you throw opponents, imagine tossing them through the opposite wall. It's not a bad way to dispense with potential aggressors. Another useful technique, for women in particular, is *ki-ai,* which involves using *ki* energy to extend the voice, making it extremely loud and powerful. This catches potential attackers off guard, as I quickly discovered in practice on New York's streets. Once, at eleven o'clock at night on Chrystie Street, off Houston, I was approached by three men, one of whom made a grab for my breast as they passed me. I extended my arm to block his attack, at the same time letting out a strong *ki-ai* shout. They were so shocked that they simply shrank away from me, as if I were the aggressor.

Female aikidoists, being generally smaller than men and less inclined to carry our strength in our upper bodies, have a lower center of gravity. This, I discovered, can be a positive advantage in aikido because you have a solid base from which to work. A physical mass comes toward you with momentum and—in attacking you—connects with you as another physical mass. You need to blend momentarily with your attacker in order to take over his center of balance and then redirect his energy, thus using his own weight and momentum against him. Being confronted with men who were often twice my size and dealing with their attacks over and over again on the aikido mat is a tough way to learn, but the lesson is simple. When you're dealing with an attack, physical size matters much less than energy: how it is being received and how it is being directed.

I conjured up many fantasy utopias during my aikido training. I imagined a world in which all women would have this opportunity to learn to defend themselves, where all women were free from the tyranny of male aggression. I also had epiphanies, particularly about gender. On the aikido mat, we all wear the same white *gi,* a white

jacket, white pants, and white belt. The only distinction is the black belts and black *hakamas* (or divided pants) that black-belt aikidoists wear. There are no other colored belts to denote rank, as in judo and other martial arts, so during class what you see is a blur of white-clothed bodies on a white mat in a white room. In some dojos, white-belt women are also allowed to wear *hakamas* to further conceal their "modesty," but in New York Aikikai none of us took that option. In this environment, with men and women all wearing the same clothes and practicing variations on the same movements, you realize that gender really can be immaterial. The distinctions that are made about gender outside of the aikido dojo are often based on suppositions about the physical superiority of the male and the frailty and dependence of the female: men demand, women acquiesce. These basic tenets of gender remain in place in our culture, even after decades of feminism, and yet the suppositions on which they are based are utterly flawed.

I learned to adopt a certain physical neutrality, on top of which I was able to assume different gestures, different behaviors, by choice. I can sway my hips from side to side, for example, because I know what that "sexy," "feminine" vocabulary is. In fact, I couldn't have survived in go-go dancing without it because my body did not, in itself, match the curvaceous stereotype that men in bars want to see. I was muscular, and I didn't have much of a waist. I used to see men out of the corner of my eye, as I danced, making gestures with their hands in parallel lines—straight up and straight down—and then pointing at another dancer and making hourglass gestures. On some occasions I even over-heard men taking bets about whether or not I was a transvestite with a penis taped up between my legs inside my G-string. To succeed in that context, I really had to perform.

It was this awareness of my physical ambiguity that led me to ask Bradley Wester to collaborate with me when I was commissioned to present a performance for Danspace, at St. Mark's Church, in January 1982. As friends we had always joked about our physical similarities, so I proposed creating a piece that explored a kind of androgynous move-ment vocabulary, capitalizing on the way that our bodies, placed to-gether, seemed to blur conventional gender distinctions. It wasn't an easy collaboration, though, because our backgrounds, rather than our appearances, were very different. Bradley is primarily a visual artist, and his performance work at that time was composed of very con-

trolled, refined tableau images, beautifully lit. He was very much in the Robert Wilson mold, and indeed right out of college he had been hired to perform with Wilson in a piece at Lincoln Center called *DIA LOG / Curious George* (1980), which had also toured Europe. That experience had really cemented his emphasis on precision. Everything had to be just so, completely fixed, whereas I was used to performing in bars and clubs like Club 57, the Mudd Club, and the Pyramid, where raw, improvised interactions with the audience were de rigueur. Still, I think we learned a lot from each other: Bradley made me more appreciative of a certain standard or quality of execution, and he became perhaps more appreciative of the audience's presence.

> When I first saw Diane's work it was riveting because the discomfort level was so very high.[1] She had these go-go dancers, and all the guys in the audience were like these cool, aware, downtown artists, but there was a raw, scary power to her performance that seemed very "punk." She would just get up in front of a crowd in a bar and take over! Karen Finley struck me as having that same kind of energy. (Wester 2007)

Nowadays, anyone researching gender blurring has a huge library of books to draw on for inspiration, but back then Bradley and I scoured the shelves of St. Mark's Bookstore only to find that very little was available. The most useful book we found was *Polysexuality*, edited by Francois Peraldi for the Semiotext(e) series (1981), which is a collage of writings mostly by French thinkers who were almost unknown in the United States at that time. We were particularly struck by the contributions of Félix Guattari, who argued that "in principle, a conjunction between the actions of feminists and homosexuals" could stand in opposition to dominant, heterosexual masculinity, but that in the process, binary oppositions like feminine/masculine "would be repudiated."

> The pair feminine/passive, masculine/active [is] a point of reference made obligatory by power in order to permit it to situate, localize, territorialize, to control intensities of desire. . . . I think it's important to destroy notions which are far too inclusive. Notions like woman, homo-

1. *WOW-a-Go-Go*, retitled *Go-Go Girls Seize Control*, played in 1981 in New York at the Inroads performance space on Mercer Street, in Soho, where Bradley was the programmer.

sexual. Things are never that simple. . . . The question is no longer to
know whether one will play feminine against masculine or the reverse,
but to make bodies, all bodies, break away from the representations and
restraints of the "social body," and from stereotyped situations, atti-
tudes and behaviors. (Guattari in Peraldi 1981: 80, 86–87)

Arousing Reconstructions, as we called our performance, was struc-
tured in three main sections. In the first part, Bradley entered in a
woman's black coat, high heels, earrings, and makeup and moved care-
fully around the beautifully laid dining table that he had prepared as
the stage centrepiece. He wasn't exactly in drag, though; there was no
pretense that he was a woman rather than a man, and his body lan-
guage wasn't particularly effeminate. When he spoke his voice was rec-
ognizably male, though soft. He began a monologue with the words
"When I dream, I often change sex" and went on to describe a recur-
ring dream in which he is bitten by a snake and transformed into a
pregnant Japanese woman. ("Men aren't much where bodies are con-
cerned if they do not achieve such a becoming-woman. From whence
comes their dependence on the woman's body or the woman image
which haunts their dreams?" [ibid.: 81].) After that he struck a series of
silent poses for the audience, leaning seductively across a chair, expos-
ing a shoulder, and so on. He gradually removed his coat and shoes to
reveal a naked body but for a skimpy leather flap across his genitals and
then stood and looked at the audience. He seemed very feminine in
that moment, and yet he exuded a very masculine sense of precision
and control, so he was very difficult to "read."

In the second part, I entered in men's clothes—heavy black boots,
black trousers, shirt and tie, leather jacket—and proceeded to occupy
the space in a much more aggressively masculine way. This was "Philip,"
a male character loosely based on the actor Jean-Paul Belmondo in the
Godard film *Breathless,* although again there was no real attempt to hide
the fact that I was female. I strode about, shoved my hands in my pock-
ets, stared at the audience, and struck poses like lifting one foot onto a
chair and then leaning casually on my knee. I also barked out a mono-
logue, partly in French (some extracts from *Polysexuality* in their original
language). I, too, then transformed myself, removing my male clothing
to reveal a kind of diaphanous all-in-one bodysuit in which I climbed
onto the table and danced a sinuous, belly-dance routine to Eastern

Diane Torr and Bradley Wester as archers in *Arousing Reconstructions*. Danspace at St. Mark's Church in the Bowery, New York, 1982. Photographer: Mariette Pathy Allen. Used with permission.

music while kicking Bradley's beautiful place settings all over the floor. This demolition was intended as the kind of iconoclastic gesture that might seem daring and powerful coming from a man but far less palatable from a woman. Again, then, there was a collision in this moment of seemingly feminine, masculine, and androgynous registers.

In the third part of the performance, we both appeared naked but for "Amazonian" leather flaps over our genitals and one breast (these costumes, like my bodysuit, were made by the New-York-based British designer Mary Bright). We proceeded to mirror each other by executing the same physical movement routine. We moved between a series of different tableau poses. There was one with our backs to the audience, for instance, in which we jutted out our arms and legs, tensing them like bodybuilders to pronounce the outline of the muscles. In another tableau we resembled Rodin's *Thinker,* the earnest intellectual, and in another we held our hands to our mouths in the way Marilyn Monroe used to, taking that cute, sexy little intake of breath. Another image was cheering at a baseball match, and yet another involved standing with hands on hips and pouting seductively at the audience. It was a series of archetypes—stereotypical ideas of masculine and feminine behavior—but the idea was that by executing them together, as two such similar-looking, nearly naked bodies, we could make these images seem less stable and familiar, detached from their usual contexts. We had realized that in order to challenge gender we had to present the conventions so that people could recognize the question; the real challenge was not to avoid these conventions but to dislodge them from their usual contexts.

Our choreography sequence ended with a two-step zydeco dance. Bradley, who is from New Orleans, is a big fan of Cajun music, so in rehearsal we would often warm up by dancing to tapes he brought in. It occurred to us that finishing the performance like this would be a playful, celebratory way to trample on all those archetypes of male and female that we had just executed so seriously. Then we disappeared offstage, as a short film played—showing two pairs of feet going up an elegant flight of steps (at the 34th Street Post Office) in cowboy boots. Bradley had shot it from a low, very dramatic angle—looking up at those boots ascending—and there was the implicit question of whose feet were whose, male and female, and whether or not it mattered. Finally, after the film had played, we reappeared "live" but on the outside of the building, going

down the fire escape. The audience could see us cutting diagonally across the big window at the back of the stage, as we went down.[2] We were dressed very glamorously in black, with diamanté earrings and high heels, and Bradley had arranged a light to catch us as we descended, so we really glittered. It was a gorgeous image for the audience to leave with, as if we were going out for the night: "Good-bye audience, we're going!" Maybe it was our escape from the constraints of gender.

Sally Banes wrote the piece up for *Dance* magazine, giving a brief outline of what we'd done and concluding that "though they earnestly raised fundamental questions," the piece "seemed unintentionally inconclusive" (1982: 20). For Bradley and me, though, there had been nothing "unintentional" about refusing to draw conclusions. *Arousing Reconstructions* was all about ambiguity, so if the piece itself was somewhat ambiguous then, in our minds, it had worked. We were seeking something similar to what Guattari describes in his account of a French transvestite theater troupe.

> [T]he Mirabelles are experimenting with . . . a theatre separate from an explanatory language, and long tirades of good intentions, for example, on gay liberation! They have recourse to transvestism, song, mime, dance, etc., not as different ways of illustrating a theme, to "change the ideas" of the spectator, but in order to trouble him, to stir up uncertain desire zones that he always more or less refuses to explore. (Guattari, in Peraldi 1981: 80)

The thing is, people *were* "troubled" by gender ambiguity in 1982 (as many still are today). Bradley makes the point that in a review of a piece he did at the Kitchen later that year, *Re: Gender*, Sally Banes first enthused about its Robert Wilson qualities, "so technically smooth and visually striking," but then accused him of using "the same set of uninteresting clichés you can see at any sleazy barroom drag act" (Banes 1998: 144–45). She seemed to feel that drag work was sleazy by definition, however technically accomplished. As Bradley says, "Charles Ludlam could get away with it because his work was meant to be ridicu-

2. The room that the Danspace project used at that time was not the main church hall of St. Mark's but a room at the back that was later used by the St. Mark's Poetry Project.

lous: it was all about camp. But this work wasn't at all" (Wester 2007). We weren't looking to use drag to make people laugh but to challenge them with something, just as I had been using go-go dancing to ask questions of spectators about their sexual assumptions.

My next performance, a solo titled *Amoebic Evolution,* was perhaps even more "troubling." In this piece, I wanted to link up the exploration of gender that Bradley and I had initiated with the ideas around evolution and biological heritage that had preoccupied me for some time. The opening section of the piece represented my attempt to distill billions of years of evolution into a few minutes of stage time. I had recently seen a film made by Tehching Hsieh, documenting his *One Year Performance* of 1980–81. Every hour, on the hour, throughout the year, he punched a time clock in his loft and then photographed himself standing beside it. The frames run together as a kind of jerky, animated film in which a year of Hsieh's life is compressed into seven minutes' running time. That gave me the idea of condensing even more time onstage. I started off as an amoeba, then moved into being a sea creature swishing through water—horizontal to the floor—then I gradually developed limbs and adapted the body to walk along the sea floor, and then I emerged on dry land, becoming amphibious, reptilian. I then went very quickly from reptile to ape (I had to skip a few evolutionary stages to condense it!) and then from ape into Neanderthal into biped. That was the sequence: I'm in water, I'm on land; now I'm a reptile, now I'm a quadruped, now I'm semibiped, and now I'm a biped. Throughout all of this, though, I was dressed in a man's business suit, and so I finally washed up as a modern man, asleep across an office desk.

The guy in the suit was a travel agent for "Global Jet Travel." I was interested in the irony that we can now travel so quickly around the world, anywhere we want, but we're still kind of stuck, static as personalities, trapped by social constraints. So after that very rapid picture of evolutionary change, the performance slowed right down to show this one man passing time in his office, a little bored and restless, flicking through magazines, talking to himself. I decided that a very big part of this character's essence was the urge to cross-dress, but he has to present himself in a suit and tie to do his job and survive. He's in a straight job, having to perform in a very straitjacketed way, but his in-

ner desire is represented in a film of myself dressed as a wind goddess in the gardens of Dartington Hall, which was projected onto the character's white-shirted back.[3]

Then, rather than leave him stuck, I decided to evolve this character further. First, he learns to *express* his inner proclivity to cross-dress; stripping down to a woman's dress, I danced on the desktop (an echo of *Arousing Reconstructions*). From there, though, because the gender binary is still somewhat limiting, he transcends that by going back into the wild and assimilating the animal again alongside his modern, urban self. So for that section my costume evolved again, to a strange, scale-backed reptilian outfit, as I danced wildly to loud, electronic music composed by Howie Solo. Then I ended the piece by crawling back into the wild, on all fours, to the sound of the ocean. *Amoebic Evolution* follows an entire cycle, from amoeba to amphibious polymorph, in which modern man is only one, rather stilted stage.

> A route of flight appears. To the inhumanity of "diabolical powers" answers the sub-humanity of becoming animal: becoming-beetle, becoming-dog, becoming-ape, to run off, "head over heels," rather than to bow the head and remain a bureaucrat, inspector, judge and judged. (Gilles Deleuze and Félix Guattari, in Peraldi 1981: 98)

In each one of us, it seemed to me, there's a polymorph, somebody who is neither male nor female but could be morphed into any possibility of being. Certainly I was seeing people on the streets or in parks in New York at that time whose behavior wasn't distinctly male or female but another morphology altogether. A lot of the people living on the street in the East Village had gone beyond the niceties of being cultured human beings—if they ever had those niceties. They were just living day to day. The junkies along Houston Street, for instance, seemed to me to move more like insects than socialized humans. I'm not saying that the way these people were living was desirable, but there was a *possibility* there; because they weren't conforming to social norms, they could operate in a different kind of way.

3. This film was my thesis project at Dartington, *Au Claire de la Lune*, in which I wore a silk parachute costume with arm extensions, in homage to the pioneering dancer Loie Fuller (1862–1928).

I shall repeat something Michel Foucault told me one day: it's really the feeling of animality, of this animality which drives us crazy, which makes us happy, which makes us sad. The spirit of celebration is so complete. You run after one another. You fall, you fall again. Wild goats coming down from the mountain tops by the hundreds, jump, turn and fight. They have become so crazy, so magical, that they leap 20 or 30 metres. Some die in the fall. The flock doesn't stop, it keeps going, dragged along by a strong wind. (Frederic Rossif, in Peraldi 1981: 90)

My friend and colleague Cathy Quinlan told Stephen Bottoms in an interview that she recalled *Amoebic Evolution* being "really kind of shocking" because "you just didn't know what she was going to do next" (Quinlan 2007). I think another thing that added to the disturbance value was that by the time I came to perform the piece in New York, in the spring of 1983, I was four or five months pregnant, visibly "heavy with child" as I crawled along the floor of the Limbo Lounge on East 7th Street. I had made the piece, and become pregnant, during the six months or so that I spent in Amsterdam after the Melkweg debacle, and becoming pregnant was of course a forcible reminder of the fact that my body is both female sexed and capable of morphing. As a monologue in my performance *Girl in Trouble* puts it:

I want you to imagine that your belly is filling with water. It becomes so deformed that you feel the pressure tight against your skin. When you sit down, the bag protrudes into your groin and chest, and you seem to have constant heartburn. Your stomach is bloated out of your control. There is a very large amphibious being living in the water. It's pushed all your organs to the side, so it has room to dance, and it likes to dance. It floats around and you get fatter and fatter as it changes shape. You seem to be aware of it all the time, and you wonder, *is this what I want?*

I made *Girl in Trouble* in 1985 as a necessary way back into performance after a year or so of prioritizing my daughter Martina, who was born on 24 October 1983. I had a couple of afternoons a week of studio time while she was in day care, and I knew I had to create a piece that was about becoming a parent. Part of that involved confronting my own parents, but I remember going to the studio for six weeks and never getting to a point where I could confront memories of my father. When

finally I did, it was through recalling an incident in which he had tried
to beat me with a crowbar. I had locked myself in a room and instinc-
tively taken all my clothes off. Maybe I thought that if he saw me naked
he would have mercy. Telling that story became the starting point for
making the whole piece: "I want you to imagine that you're in a room,
and there's someone on the other side of the door that wants to kill
you." I juxtaposed that with an image of my mother, who failed to pro-
tect me: wearing a long, black, velvet dress, I sang Mendelssohn's "O for
the Wings of a Dove" to express her creativity and delicacy. If you come
from parents like that, then how do you be a parent yourself? My con-
clusion was that you have to reinvent the traditional roles without
those gender divisions—that you have to be both mother and father to
your child—another kind of androgyny. (This is not to say that Mar-
tina's father, Marcel, didn't take his share of the responsibilities. He was,
and is, a very good dad!) At the end of the performance, there were
slides of baby Martina in a bath, and I came out wearing a man's jacket
and smoking a cigar. Becoming a mother means adopting all kinds of
roles; it's another kind of morphology again. At one point I became a
dog for a year. I'd pick Martina up from school, and she'd tie her long
scarf onto me as a leash, tickle me under the chin, and make me run up
the hill behind her.

Girl in Trouble, which premiered at the Movement Research space
on Varick Street, was a kind of breakthrough piece that allowed me to
go on and make other work. I created a number of pieces in the latter
half of the 1980s, not all of which are relevant here. Maldoror's Gray
Lark, presented at P.S. 122 in 1987, was based on Comte de Lautrea-
mont's protosurrealist novel Les Chants de Maldoror (1869). The perfor-
mance juxtaposed text, film, and choreography to explore questions of
social and political hypocrisy. A solo show, Catastrophe and Beguilement,
toured to venues around the United States in 1988 (along with Girl in
Trouble, GoGo World, and Amoebic Evolution) and addressed my memo-
ries of the women I'd met in Afghanistan when working there for the
Release Agency in 1973.[4] More specific to this book's concerns, how-

4. Release was a London-based legal advice agency for young people, established in 1967
by the artist and journalist Caroline Coon. On behalf of the agency, I had visited people
jailed for drug possession offenses in Afghanistan, Iran, Turkey, and Pakistan and had writ-
ten reports on their situations as part of the effort to secure their release. These were even-
tually submitted to the UK's government Home Office.

ever, was *Girls Will Be Boys Will Be Queens,* which was performed at a number of downtown spaces in 1986 and 1987, including the Pyramid Club, WOW Café, Darinka, and BACA Downtown in Brooklyn. I made this piece in collaboration with my friends and fellow performers, Lizzie Olesker and Chris Koenig. Each one of us was a feminist, but each one of us was also questioning, in different ways, what it meant to "be a woman." *Girl in Trouble* had explored the challenge to my own sense of identity that motherhood had created, and in a broader sense *Girls Will Be Boys* was about our identities as females. If the world insists on seeing us as one sex or the other, what does that actually involve? Does anybody really know in themselves that they *are* a woman or that they *are* a man?

My collaboration with Bradley had been primarily about bodies and how they're viewed, so in a sense this was a complementary exploration into our *consciousness* of gender as something with which we live. We became fascinated, during our work on the piece, with the story of Herculine Barbin, whose memoirs had recently been published by Michel Foucault (English translation, 1980). Herculine was a girl raised in a convent in nineteenth-century France who doctors eventually decided was in fact a man. Actually, the records show that s/he was a hermaphrodite, with both male and female physical features, but at that time the medical establishment insisted on establishing a "true sex," and the emissions on Herculine's bedsheets, together with her/his amorous interest in the other girls at the convent, led the doctors to rule that s/he was a man. This forced change of legal sexual identity eventually drove Herculine to suicide. Lizzie, Chris, and I were fascinated and disturbed by this story. What would it be like to be raised as a woman and then suddenly be told that you're "actually" a man? How would that change of designation change your life experience? And what if, with that new awareness of being male, you could go back to being a woman again?

The Herculine story became the jumping-off point in the creation of a collaged sequence of scenes and images exploring the imposition of gender polarities on bodies and minds. So, for example, we began the performance as men, dressed in bulky, oversized suits (similar to the one worn by David Byrne in the Talking Heads film *Stop Making Sense*) and performing a dance routine to minimalist, electronic music. This involved very staccato, "masculine" movement up and down the

Chris Koenig, Diane Torr and Lizzie Olesker. Publicity still for *Girls Will Be Boys Will Be Queens*, New York City, 1986. Photographer: Paco Morales. Used with permission.

space, swinging our broad, padded shoulders. The scene was bold and funny, a parody of adult male movement, but then we followed it with something much more hesitant, exploring how an identity like that might develop. A young man doesn't just become a man. He starts out as a boy, trying on different gestures and mannerisms until they become "natural." So the three of us would stand on the spot and "try out" gestures like squaring our shoulders, pointing assertively, and jerking our heads back. This sequence was accompanied by taped voices suggesting hidden male anxieties: "I didn't shave," "I won't be hugged," "I don't want to be alone anymore."

Later in the performance there was a complementary sequence involving "female" stereotyping. Accompanied by a quiet, classical nocturne, we performed a sequence of soft, fluid, feminine movements— more circular than angular—but then toward the end of the sequence we began banging our feet on the ground sharply, breaking the mood, as if in mutual frustration at its constraints. Similarly, in another image, I stood still looking passively obedient while Lizzie, standing hidden behind me, beat on my chest with her fists. To designate "female" we wore long tunics with big, graffiti-style boobs painted on their chests— a contrast to the graffiti-style cocks painted on the men's suits. Set and costume design were by Loredana Rizzardi, and she also painted the backdrop with both cocks and cunts, again emphasizing polarities: "In the stylisation of graffiti," Angela Carter writes, "the prick is always presented erect, in an alert attitude of enquiry or curiosity or affirmation," whereas "the hole is open, an inert space, like a mouth waiting to be filled . . . a dumb mouth from which the teeth have been pulled" (1979: 4–5).

The images of masculine and feminine extremes were mediated by other sequences exploring states in between. So, for example, I performed a meditative routine using aikido moves and a *bokken*—the Japanese wooden sword. The practice of aikido is for me, as I've explained, a genderless or androgynous practice, and that's how I appeared physically. The sword wielding was intended to evoke the slicing up of XX chromosomes to create XY chromosomes, or XYY, or XXY. There are even cases of XXX, XXXX, XXXXX, XXXY, XXXXY, and an XY/XXY mosaic. The options are dizzying, especially when you realize that some people with the ostensibly female XX chromosomes have been

designated male due to physical variations. During this sword se-
quence, a voice-over presented extracts from the medical examination
of Herculine Barbin.

> Her voice is ordinarily that of a woman, but sometimes in conversation
> or when she coughs, heavy, masculine tones mingle with it. . . . Her
> chest is that of a man; it is flat and without a trace of breasts. Menstru-
> ation has never occurred, to the great despair of her mother. . . . If her
> thighs are drawn apart, one perceives a longitudinal groove that reaches
> from the suprapubic eminence to the vicinity of the anus. On the upper
> part is to be found a penial body, four to five centimeters long . . . This
> little member . . . is as far removed from the clitoris as it is from the pe-
> nis in its normal state. (Foucault 1980: 125–26)

As Judith Butler later wrote, "Herculine is not an 'identity,' but the
sexual impossibility of an identity. . . . Herculine is not categorizable
within the gender binary as it stands" ([1990] 1999: 32). But the real
question is, are any of us? In a later sequence, directly connecting to
the show's title, Lizzie sat dressed as a wan, business-suited man at a
desk. This character opened a briefcase, took out an orange, and
cupped it to his chest furtively, fingering the pronounced "nipple" (we
chose our oranges carefully). Then he tore into this "fetish object," bit-
ing and licking at it, while declaring, "I like the kind of woman who
takes control, shows what she wants. I like the kind of woman who
knows who's boss and isn't afraid to say so." This speech continued as
a list while Lizzie took a wig out of the briefcase and pulled it onto her
head, now looking very feminine in her suit. From there she took off
her suit pants to reveal pink knickerbockers underneath, put on glasses,
and sat on the desk like a schoolmarm. "Wake up, young people, from
your illusory pleasures," she told the audience, "Strip off your disguises
and remember that every one of you has a sex, a true sex." This was an
ironic invocation of Foucault's first line in his introduction to Hercu-
line's memoir: "Do we *truly* need a *true* sex?" (1980: vii). Lizzie contin-
ued like a scientist dismissing gender variation.

> The childish manifestations that must be remarked are not necessarily
> unwholesome; they probably perform a valuable function and develop
> budding sexual emotions, just as the petals of flowers develop in pale

and contorted shapes beneath their, er, enveloping sheaths. But in our human life the transmutation is often not so easy as in flowers.

We had stumbled, as three feminists questioning notions of gendered identity, into an abstract, poetic exploration of ideas around intersexed and transsexual bodies, around the possibility of *changing* identity and even sexual designation. This all evolved through fits and starts, and we just had to trust each other and hold on because nobody else, as far as we knew, was addressing this material at the time. Certainly there were very few "out" trans people, even in New York, and the feminist community at large didn't even want to touch these issues. After working with Lizzie and Chris, though, I knew that I had to take these questions further. I had performed a series of ostensibly male roles in *Arousing Reconstructions, Amoebic Evolution,* and *Girls Will Be Boys Will Be Queens,* but I also knew that these characters were never very convincing as men. I had wanted to play a symbol of "man" in those pieces, as part of my enquiry into gender constructions, but that's a long way from conveying the performance of a real one. I had wanted to appear androgynous, but I looked like a woman in men's clothing. It wasn't until I met Johnny Science that I got the push I needed to take the next step, to suspend my female identity altogether and experiment with transforming myself into a male persona who could "pass" in public.

Three | Becoming Masculine

I've been doing theatrical make-up since I was a kid. When I was nine years old I had a game called Spies, where I would take my friends, and I would use make-up to make them look older, and we would dress up and pretend to be spies. I did this on boys and girls, and when I was doing make-up on the girls, I was making them look like guys. So over the years this developed into quite a thing.

—JOHNNY SCIENCE (1998)

We've come a long way. Who would've thought that the transgender thing would be so huge now. When I go to colleges to do lectures now, there are so many trans-men it's unbelievable. But when Johnny first started the FTM support group, it was like finding a rare bird, or discovering a new species. Back then people were just trying to find their way, thrashing around in the dark.

—ANNIE SPRINKLE (2008)

When Diane first presented *Girls Will Be Boys Will Be Queens* in 1986, there were—as she notes—precious few "out" trans people from whom she and her collaborators could have learned, even in bohemian New York. The medical diagnosis of a transsexual identity, on which gender reassignment treatment depended, demanded that the individual be able to demonstrate a full-time, permanent commitment to living as the sex to which s/he felt s/he belonged; in short, would-be transsexuals had to be committed to "passing" as invisibly as possible. While this was often harder for male-to-females to accomplish than female-to-males (thanks to physical features often difficult to hide such as larger hands or broader shoulders), the attempt was nonetheless made, even to the point of constructing "plausible histories" that extended one's new gender identity back into the past to cover one's traces. Transsexuals were thus, partly thanks to the demands of the medical establishment, intrinsically closeted and for the most part committed to confirming and embracing the polarized concept of binary gender options (one must *be* or *become* either masculine male or feminine female). That situation only began to change in the late 1980s. One significant mo-

ment was the premier in November 1989—at San Francisco's Theatre Rhinoceros—of Kate Bornstein's performance piece *Hidden: A Gender,* which questioned the notion of neatly binarized gender identity by drawing—as had *Girls Will Be Boys Will Be Queens*—on Foucault's documentation of the Herculine Barbin case, as well as on Bornstein's own experiences as a male-to-female transsexual who now doubted whether she really was either "female" or "male" according to conventional definitions.[1]

In 1994, Bornstein published a successful book on the same topic, *Gender Outlaw* (which included the script of *Hidden: A Gender*), but by then other key texts in the new transgender movement had also appeared. In 1991, Sandy Stone published her landmark essay "The Empire Strikes Back: A Posttranssexual Manifesto," which defined the notion of "posttranssexuality" according to the need for transsexuals to come out, making themselves visible as a gender-crossers. This was necessary, Stone argued, to combat prejudice and ignorance, not least among members of the feminist community. As a male-to-female transsexual, Stone had been named and "shamed" as an imposter, an infiltrator of the feminist movement, in Janice Raymond's 1979 book *The Transsexual Empire,* which insisted on biological birthright as the essence of womanhood. "All transsexuals," Raymond wrote (apparently oblivious even to the existence of FTM transition), "rape women's bodies by reducing the female form to an artefact, appropriating this body for themselves" (qtd. Stone 1991: 283). "Though *Empire* represented a specific moment in feminist analysis," Stone wrote, "here in 1991, on the twelfth anniversary of its publication, it is still the definitive statement on transsexualism by a genetic female academic" (283).

The following year Leslie Feinberg's pamphlet *Transgender Liberation: An Idea Whose Time Has Come* provided the new movement with a more appealing and inclusive title than the one proposed by Stone. In Feinberg's usage, *transgender* functioned both as an umbrella term encompassing cross-dressers, transvestites, and transsexuals and, more specifically, as a descriptor of hir own in-betweenness as someone who had stopped short of completing a transsexual transition from female to male and whose decision to identify as neither was—for hir—very much in line with the feminist goal of liberation from gender constraints.[2] In 1993, the publication of

1. Yet another theatrical treatment of Herculine Barbin appeared in Caryl Churchill and David Lan's play *A Mouthful of Birds,* which premiered at London's Royal Court Theatre in 1986, the same year Diane and her colleagues made *Girls Will Be Boys Will Be Queens.*
2. *Hir* is Feinberg's preferred, gender-ambiguous use of the possessive pronoun.

Feinberg's novel *Stone Butch Blues* (in effect a fictionalized autobiography) opened a whole new chapter in lesbian and feminist understandings of trans identity.

In New York City, the unsung hero of female-to-male consciousness-raising during this pivotal period was Johnny Science. The name, of course, is a pseudonym, one of several that he used more or less interchangeably (others included John Grant, Johnny Armstrong, and John Austen). His given name remained a closely guarded secret, but in a former life he had also been Suzie Science, the lead singer in the rock band Science, one of the house bands at the legendary downtown club Max's Kansas City during the late 1970s and early 1980s. During that period, Suzie was also the club's art director and an advocate of lesbian sadomasochism (S&M) who made occasional solo appearances wielding leather implements at East Village performance clubs such as Danceteria. By the mid-1980s, however, he was appearing as—and being read as—a man in performances consumed primarily by male audiences. As his longtime friend, therapist Kit Rachlin, explains:

> When I met Johnny in 1985 he was doing an S&M live sex show at Belle de Jour, which was a professional dungeon.[3] He and his then girlfriend would act out various scenarios involving bondage or sex acts. They would write the scripts together and he would arrange the music. He would usually play a policeman, or a pirate, or a biker. The audience thought he was a genetic man, and his prosthetic phallus looked real enough from a few feet away that no-one would doubt it. (2008)

It was in 1986 that Science began inquiring seriously into gender reassignment. Swiftly deciding that this was the right decision for him, he adopted the name Johnny and began taking male hormones to facilitate the change. In a 1989 interview with Annie Sprinkle, Science explained that he had "lived totally as a man" even before 1986 and indeed had been dressing as a boy "from the time I was two. . . . From a very early age I made it clear that I should have been a boy, that 'God made a mistake.'. . . I have a male type of hairline. I never menstruated, hardly ever. I was always masculine in appearance. The hormones just gave me the extra push" (Sprinkle 1989: 29).

3. Belle de Jour was based in "a fashionable Chelsea loft and cater[ed] to a predominantly up-per-middle-class audience," according to the *Drama Review*'s 1981 article "Sex Theatre" (Burgheart and Blazer 1981: 72) about the sex theater scene in New York.

It was soon after he began transitioning (though no one is now sure of the exact date), when Science founded his "F2M Fraternity," a consciously inclusive support group for female-to-male transsexuals and cross-dressers and anybody interested in exploring the subject (including curious doctors, artists, and writers). This was, Rachlin recalls, part of Science's attempt to acclimatize to his new identity, but it was also a revolutionary step as no such support group existed anywhere else in New York at the time. In 1989, the Gender Identity Project was founded at the city's Gay, Lesbian, and Bisexual Community Center by Dr. Barbara Warren, but at the outset even this body worked primarily with male-to-female clients. It was Science's group, which met initially at Kit Rachlin's apartment, that provided the first real point of contact in New York for a female-to-male demographic that had been previously all but invisible, even to itself. He worked extremely hard to publicize its existence, sending out posters and flyers at his own expense (he had to appeal regularly to fraternity members for help with postage costs) and even appearing on Howard Stern's radio show. "Before the Internet there was no way to get a big voice out there to cross-dressers, and Johnny was a Howard Stern fan," Rachlin explains. Science was well aware of Stern's tendency to treat his guests as freaks, but "he knew that if you went on there and sounded sane, then the listening audience would get the message" (Rachlin 2007).

Annie Sprinkle, who had also first encountered Science at an S&M show (at Plato's Retreat), was one of the curious artists who attended one of the early support group meetings at Rachlin's apartment. As a veteran porn star who—during the 1980s—had begun looking for ways to make sexually explicit films and performances that focused more on female pleasure than on the conventional arousal of heterosexual men, Sprinkle's initial interest in the group was primarily erotic. "I loved them as people, but I was also really turned on by the whole FTM thing," she notes. "I was pretty hetero at the time, but transitioning into bi and queer. . . . I looked upon myself as the first FTM tranny fetishist" (2008). After meeting Les Nichols (formerly Linda Nichols) at her first F2M meeting, Sprinkle began a relationship with him, and in 1989 made *Linda/Les & Annie*. Part documentary and part sex video, this film was later subtitled (and is now on a DVD release as) *The First F2M Love Story*. Johnny Science shot and co-directed it with Sprinkle and Albert Jaccomma, and also wrote the music.

When Kit Rachlin asked Sprinkle if she would be willing to share the burden of hosting the fraternity meetings, she willingly assented. The Sprinkle

Salon, as it was known—her apartment at Lexington Avenue and 26th Street—was becoming established as a venue for various workshops and gatherings, ranging from her Sluts and Goddesses transformation workshops (for women wishing to explore their sexual goddess within) to support group meetings for sex workers. It was thus a logical step for members of the F2M Fraternity to find sanctuary there also, and they benefited directly from Sprinkle's warmth as a hostess and her sex-positive outlook. As she explained in an interview with Diane and myself:

> The hardcore FTMs were really struggling with what they called "issues." To me they were assets, but most of them thought of themselves as just horrible because they didn't have penises yet or they weren't passing as well as they'd like. They were so closeted and self-loathing, and had such low self-esteem, and I just kept trying to build them up and say, hey, you're so hot, you're sexy! I'd flirt with them, encourage them. I'd tell them to come out to their girlfriends if they didn't know. And then, of course, there were the legal issues—around driver's licenses and birth certificates—and because of the hormone treatment some of them were going through menopause. They were just going through horrible things, but I tried to be their cheerleader. (Sprinkle 2008)

Annie has such a big heart, and she was so open to all kinds of gender and sex variation that it was a natural thing for people to gravitate to her salon. I met both Annie and Johnny pretty much by accident, in April 1989, after she interviewed him for *Adam*, the men's erotic magazine, about his experiences as a transsexual. Johnny didn't want to be photographed, so Annie was looking for somebody who could illustrate the article by posing for "before" and "after" images of transformation from female to male. A mutual friend, the Dutch sculptor Sonja Oudendijk, recommended me to Annie because she knew of my previous male roles (her lover, the artist Peter Giele, had conceived and created a set for a touring version of *Amoebic Evolution* in 1988). Johnny made me up for the shoot, and it was in that process that I discovered how much more determinate you can be in a male role if you have the facial hair and five o'clock shadow. I was excited to actually become someone else. Johnny knew how to facilitate that; he was a master of

disguise, and he had something of a fetish for turning women into men.

The shoot at Annie's salon lasted all day, and I took on several different personae, suggesting different degrees of femininity, masculinity, and androgyny. At one point a dog showed up, so we had photos of me as a man with the dog sniffing my fake penis. Annie was snapping away the whole time, and Sonja was hanging around, too, contributing sly comments, but by the evening she was impatient for me to finish so that we could go to the opening of the Whitney Museum's Biennial Exhibition, which was happening that night. Finally she just said "Let's go! I'm not waiting any longer." She really meant it, so with no time to change I had to go with her in drag. I remember sitting in the back of the cab worrying what our friends would say when I showed up like that. But when we got to the Whitney it was very crowded and I lost Sonja almost immediately. Seeing some people I knew, I waved at them across the sea of bodies. They all gave me blank stares and ignored me. I walked over to talk to some other friends I'd spotted, but they didn't recognize me either and responded as if I were an intruder in their conversation. I suddenly felt very alone, a newly born man that nobody knew, a nameless, never before seen on the planet man. But I also noticed that people were creating space for me as I moved; even in that wall of bodies, I was accommodated. As a woman I had never experienced such treatment.

I decided to just get myself a beer and a wall to lean against because that's what guys do, right? I stood there observing the crowd for a while until I suddenly caught the eye of a woman I didn't know. I stared at her, expecting her to drop her gaze and look away, but instead the gaze was returned. She seemed to interpret my looking at her as interest in her, although I was just playing at being a man, trying on the pose of "interested observer." When she started walking toward me, I tried averting my eyes to show her that my interest was only superficial, but she had determined her course and there was no escape. "Hi, how ya doin'? D'you know any of the artists?" She smiled at me with an open, friendly face. I grinned weakly and grunted "Hi," afraid to speak for fear she would hear my female voice and go nuts. I felt trapped in a place of no identity. On the inside I still felt like Diane, and since there were no mirrors around to remind me how I looked as a man I felt as though I

just didn't know how to *be*. I shrugged and grunted, hoping she would go away, but she was hellbent on impressing me with her knowledge of the contemporary art scene. "Well you know," she said, "the Whitney has never shown so many *black* or *gay* artists before . . . this is the first biennial like this. Did you see the work of Tom Woodruff? The paintings—each one has an individual code."

I was sweating under my jacket and could feel my heart beating fast. I gulped down my Miller Lite, still staring at her in disbelief. How could I escape? How could she not see I was a woman? I tried looking around the crowd, as if searching for someone. "It's a kind of rebus effect," she continued, "each painting has an image in it that's a hidden letter. It could be contained in the floral decor of the frame. You have to look closely to find it." I turned my back on her, a supreme act of rudeness on my part and something I would never do as a woman. Nonplussed, she walked around to face me again and kept talking. She was chatting me up, in the way that women chat up men, and I was embarrassed to realize that she was using the same techniques I'd used myself. Why did she continue trying to engage me when I was obviously not interested? Here was proof of the old adage "Treat 'em mean, keep 'em keen." Where was her self-respect?

I walked away in disgust, taking the stairs to the second floor, where it was even more crowded. Pushing through a bunch of people, I found myself standing in front of a painting. Whose is it? Tom Woodruff's (inevitably), and, yes, on careful examination, there's the hidden letter in the painting. I was just getting interested when someone tapped me on the shoulder. "Do you see what I mean about the rebus effect?" she asked, as if picking up the conversation. I looked at her, then looked at the painting, and then, not knowing what else to do, looked pointlessly at the label next to it: TOM WOODRUFF it said. "He's been doing these paintings since he left Pratt. I knew him then." "Oh," I said, the only thing I'd said apart from "Hi." By this time my shirt was wet with perspiration, my face felt flushed, and part of my mustache seemed to be missing. I stared at her, thinking she must have noticed, but by now she was talking to me as if we were a couple on a date. I couldn't believe the way she had almost laid herself out on the Whitney's floor for me without even knowing who I was, without me even speaking to her. If only she could see herself, I found myself thinking as I beat a retreat to the men's restroom. (I used the cubicle, of course, and nearly lost my

penis when it fell out as I pulled down my pants. Fortunately it landed on the floor and not in the toilet.)

I found myself thinking a lot about the implications of that encounter. If women could actually go out and pass as men, I thought, they might learn a lot about themselves as women in the process. Perhaps we could begin to intercept our so-called normal behavior and learn other responses. And what kinds of adventures, what kinds of shared experiences, could women have together as men? I had already had some experience teaching participatory workshops called Performing the Self at art schools such as CalArts and the Museum School in Boston. These had been open to both women and men and had come out of my work on *Girls Will Be Boys Will Be Queens* and my desire to continue investigating questions of gender and identity. The workshops had been exploratory because I had a lot of unanswered questions. What do we mean by masculine and feminine behavior, and how easy or difficult is it to adopt a set of gender behaviors different from those in which you usually engage? How would such a process affect your own ideas of yourself, the person you think yourself to be? I had found that, when you engage with people on a deep level about questions of identity and how they see themselves, some fascinating material arises. I had also discovered, though, that the male participants tended to take the whole thing far less seriously than the women. For the most part, they just wanted a license to put on lipstick and high heels and wigs and for there to be a structure in which they could do that without seeming "queer." They were less interested in exploring what a female identity consists of than in simply getting up as drag queens. The female participants, by contrast, had been much less flippant and more engaged with the deeper questions because they saw how this exploration could be potentially empowering for them. For example, there were two women in the CalArts group who wanted to travel through Mexico, but they didn't want to travel as women because they felt they would be sexual targets. Their reason for taking the workshop was that they wanted to figure out how to "become" men for this specific purpose.

My problem at that time was that I didn't really have the facility to help these women "pass" convincingly; the "Performing the Self" workshop was geared more toward creating a stage performance than it was toward public subterfuge. So meeting Johnny, seeing what he

could do with makeup, and passing at the Whitney were signal experiences for me. It took a while to develop these ideas further because I was busy for much of that year, doing a Canadian tour of my solo shows among other commitments. I did make another drag appearance at Annie's behest the following month, though—May 1989—when I acted as the "man" who inserted a speculum into her vagina for audience members to view her cervix in the first-ever performance of her "Public Cervix Announcement" at the Harmony Burlesque Theater (see Carr 1989: 97). This was later to become the most notorious sequence in her one-woman show *Post-Porn Modernist,* although by then she was inserting the speculum for herself.

Then, at some point in 1990, Annie told me that Johnny had begun teaching something called a Drag King Workshop at her salon and asked me if I'd like to participate. I went along out of curiosity to see what he was up to, but it turned out to be not so much a workshop as a "makeover" session. Women would come wearing men's clothes, and Johnny would put makeup on them. Then he'd teach them a couple of gestures, but they were very stereotypical, how to grab your balls, for instance, or how to pose in a domineering manner. Johnny was mainly interested in the makeup, in the cosmetic transformation from female to male, and for a lot of people that actually seems to be enough. Some women are so excited at the surface change, once they get on facial hair and see themselves in the mirror, that they feel complete in that instant, and that's really as far as they want to take it. But of course that's just the outside, and to me it seemed like a superficial, underexplored idea, a one-dimensional construction of a male character. Johnny was always very approachable, so I suggested to him that he could include further training in the workshop, to take the experience beyond surface appearance. I proposed collaborating with him on this. Given my dance and performance background, my role would be to focus on physical presentation, to help people think about how to walk, stand up, or sit down convincingly as a man; about ways to take up space and interact; and about what gestures and attitudes might be appropriate to the appearance of their male characters. Johnny instantly liked the idea, and that's how we started doing the drag king workshops together.

Johnny always insisted that it was he who coined the term *drag king,* and certainly when the workshops started the term was so unfamiliar that people sometimes misheard us, thinking we'd said we were con-

ducting "dry cleaning workshops." We ran three or four in a year, usually at Annie's salon. The basic format was that participants would arrive and first get into the costumes and makeup of the male characters they fantasized about becoming. That always took a while, with Johnny working on each person's makeup individually, so I would invent exercises and tasks for people to carry out while this was being done. If you were waiting for your makeup job, you might be sent out somewhere to sit and observe men, unobtrusively, and to look for details of behavior and movement that might be useful in realizing your character. If your makeup was finished and you were waiting for others, you would be assigned some character development work, for example, thinking of a name, a job, sexual orientation, ambition, etc. Finally, when everybody was ready, I would continue this character work in a more structured way and offer some physical training.

Annie used to love participating in the workshops, sometimes joining us in drag but other times dressing up in very sexy, feminine outfits. When the participants were all made up, she would come in and serve us beer and sit on our laps. She loved flirting with these "new men," as she called them, and it was a real challenge for them to figure out how to respond to these come-ons in their new guises. How do you behave, as men, when this very curvaceous, sexy woman is flirting with you? That all became part of the learning process (one that many biological men would probably benefit from also!). Eventually, at the end of the day, we would take our newly developed male characters out and about on the streets to see if they could "pass." Part of the fun of this was always the challenge of entering male-only spaces, so I would often take people to Billy's Topless, on Sixth Avenue at 24th Street, a go-go bar where I had performed myself and where I still knew some of the dancers. In this environment, the participants were again encouraged to flirt and be sexually bold in their roles as men. There were three stages at Billy's, so we could spread out around the place and not be too conspicuous as a group. Because the dancers usually knew who we were, though, we shared a kind of conspiracy with them; the drag kings would tip the dancers constantly, and this would bring on a flurry of wallet openings from the other punters, who were not to be outdone. The dancers referred to us as "the Bearded Ladies Club," and we eventually became known to the bouncers, too, who would survey us mischievously before we entered the bar.

Apart from visiting Billy's, though, we usually tried to avoid going out and about in groups because the very fact of having suited executive types hanging out with long-haired rockers and football jocks would tend to draw questioning attention from passersby. Even so, we discovered that it can be a lot easier to pass as male than you might think. One sociological study of that time cited research suggesting that maleness is so privileged, socially, as the "universal norm" (with the female as "other") that "people see maleness almost whenever there is *any* indication of it. A single strong visual indicator of maleness [tends] to take precedence over almost any number of indications of femaleness" (Devor 1989: 48). We saw plenty of evidence of this point. On one occasion when Annie joined us, she had on a baseball hat and a mustache as "male" signifiers but also wore a very short skirt, high heels, and a tight top showing off her tits. A police car cruised past with the window down, and those of us walking behind Annie could hear them talking about her as they eyed her up. Then they accelerated a little and looked back, and we distinctly heard them say, "Oh my God, it's a man!" I thought that was fascinating, because Annie is probably the most feminine-looking female you could think of. Presumably they thought she was some kind of transvestite, but still the default assumption was, "it's a man." As Annie told Stephen during a three-way interview between us:

> We went to a lesbian bar that same night, [the Clit Club at the Pyramid], and even *they* thought I was a man dressed as a woman. At the lesbian bar! They didn't want to let me in. People just didn't have a clue about gender back then; even though I had enormous breasts and the body of a woman, I was a man because of a mustache and a little five o'-clock shadow. Diane was really a pioneer in that she helped people understand gender play and what it was and how to do it; for me it was really a performance art piece seeing her teach the workshop. (Sprinkle 2008)

Interest in the workshop spread quickly, and we began attracting all kinds of participants, from the trans-curious people already attending Johnny's support group to straight women looking to experience the world from the other side of the fence. We attracted many lesbians who were looking to explore masculinity in a playful way, but

there was also some tension at first with the lesbian community, as be-
came clear at the tenth-anniversary benefit party that the WOW Café
held at P.S. 122 in October 1990. Being part of WOW's history, I was
asked to contribute something to the program, and since I was work-
ing closely with Johnny, he came up with the idea of our performing
a song about the difference between transsexuals and cross-dressers.
Johnny wanted these things to be understood because a lot of people
at that time really didn't comprehend the distinction between people
who are seeking sex reassignment and people who enjoy passing as
another gender but are not necessarily interested in actually changing
their sex. He wrote a song for us in which I performed "Tornado's rap"
as a cross-dresser (Tornado, my former go-go name, was what Johnny
often called me).

> *Don't wanna have a double mastectomy, don't wanna have a hysterectomy*
> *Don't need no testosterone, got libido and muscles of my own!*
> *I don't need no man-made penis, in my pants is a mound of Venus*
> *Maybe my voice is a little high, but the mustache proves that I'm a guy.*
> *As a girl, posing as a boy, the patriarchy I will destroy*
> *I'm sick of being perceived as meek, a position of power is what I seek*
> *Paint five o'clock shadow on my cheek, and kick their butts clean into*
> * next week.*
> *Lesbians can pose as men, bring the matriarchy back again!*
> *Hit the bastards where it hurts the worst,*
> *In the boardroom, the bedroom, the press, and the purse.*
> *I just love the idea of infiltrating the secret world of men's creating*
> *To witness firsthand their woman hating*
> *I'll teach 'em all about emancipating!*

It wasn't great poetry, but it made its point. Johnny and I then rapped
out another verse together, this time from his point of view as a trans-
sexual, summing up his own sense of innate male identity.

> *Gender is immutable, it cannot change,*
> *We can't choose our gender, though it may seem strange*
> *Gender identity is in the brain*
> *If the body doesn't match it you can go insane!*
> *You can choose how you want your body to look*

But you can't change the brain, see, that's the hook.
Biology as destiny just ain't true
Body and brain don't always "do the do"
You could be a hermaphrodite, that is true
You could even have a penis and a pussy, too!

I must admit, I've never been sure about Johnny's conviction that "gender is immutable" because there are plenty of instances that would throw that idea into doubt. Les Nichols, for example, to whom Johnny may have been referring in that last line (he had retained his vagina after the phalloplasty operation), eventually switched back to a female identity. But Johnny was searching around for absolutes, and to me that seemed perfectly understandable because his life was so precarious. So I was happy to support him in making this statement. The problem was that—as Johnny's lyrics recognized—we were performing for a predominantly lesbian audience, and the lesbian community at that time was not very accepting of trans identities of any sort. For many, the desire to become (or appear to become) a man seemed like a basic betrayal of female solidarity, sort of like joining the enemy. People were scowling at me in the changing room before the performance because what was I doing bringing a man in there? After the performance there was more understanding, perhaps, but I wouldn't say there was acceptance. In 1990 FTMs were not visible, and they were not generally included within the lesbian and gay culture.

It wasn't until Brandon Teena was murdered in Nebraska on the last day of December 1993 that the whole issue of lesbian versus trans really came out into the open, at least in New York. There was a long article about the case in the *Village Voice* by a lesbian writer, Donna Minkowitz (1994), which used female pronouns to refer to Brandon and basically implied that "she" was a self-hating lesbian who could only have sexual relationships with women by pretending to be male. That prompted a storm of protest from people insisting that Brandon identified as male because he was either transgendered or a pre-op transsexual but certainly not a butch lesbian in denial. A lot of hashing out of positions had to be done as a result of that controversy, and an activist pressure group, Transexual Menace, was formed (I proudly wore its T-shirt and attended several demonstrations). Even so, it wasn't until 1999 that the director of Human Rights Campaign—the gay and les-

bian advocacy group—finally suggested that transgendered people should be included in their mission statement.

Looking back, though, the lack of acceptance of FTMs in the lesbian community in the early 1990s was perhaps forgivable given that trans people were themselves often very confused and conflicted about their motives for transitioning. Les Nichols, for example, told everyone that he'd done it "for male privilege." Obviously not everyone was as nutty as Les, but at one of Johnny's FTM support group events I met a newly minted man who had transitioned so that he and his girlfriend could be read as heterosexuals not lesbians. They were living out in New Jersey, miles away from anywhere, and he told me shyly that they had decided they were going to be constantly harassed out there as lesbians. I said wait a minute, you're saying you had a sex change because you didn't want to be discriminated against? And his response was, well, what other reason would you do this for? I must have looked a little incredulous, so he added that, really, he didn't mind being a man, and anyway his girlfriend—as the woman—was still in charge. (When I was introduced to her, she seemed so butch that I couldn't help wondering why it wasn't she who had had the operation!) Their story wasn't unique; the medical establishment at that time tended to see one of the justifications for sex change operations as "straightening people out."[1]

Johnny's support group gatherings were for people who were androgynous, people who were in transition, who thought they might go into transition, and people who didn't know where they fit on the spectrum at all. There was a lot of talk at the time about the sex change operation, because most of the FTMs committed to transitioning seemed intent on having both "top surgery" (mastectomy) and "bottom surgery" (phalloplasty). On one unforgettable occasion, when I dropped by Annie's dressed as my English mod character Jack Sprat, I walked in to find two guys standing there with their penises out and a room full of people looking at them and touching them. At first sight, it was a hilarious image. It turned out that both men had recently been through surgery: one had had it done privately, and the other through Medicare, and they were comparing the results. This was a big deal for everyone present, because it was very, very hard to make the decision to have a phalloplasty at that time, and the outcomes were uncertain.

1. Judith Butler provides a useful discussion of this issue in *Undoing Gender* (2004: 78). [SB]

It was important to Johnny and Annie that these guys should be honored for their bravery, and also that people should understand what was involved. The penises were scarred and bandaged from the surgery, and one still had a tube attached, but it seemed really important that we were able to admire and affirm these new bodies. As it turned out, both of them went on to experience severe side-effects to the surgery, and unfortunately—nearly twenty years later—phalloplasties remain notoriously unreliable. Partly for that reason, today's transitioning FTMs are often less eager to pursue bottom surgery than were their pioneering predecessors.

Johnny himself had been through some very difficult experiences to get to where he was. He'd felt male from quite a young age, and so growing up as a woman had put him completely at odds with himself. He knew he was a man but had really struggled to get the medical assistance he needed. Because of the gendered nature of so many types of work, it's often very difficult for people who are in those places of extreme confusion to figure out how they're going to survive from day to day let alone save up for surgery. Even when he had taken T-hormones and visibly become a man, Johnny was still in a desperate place economically, so he would find various ruses to try to survive, one of which was the drag king workshop itself (for which there was always a participation fee, initially of fifty dollars). And yet I was once challenged by a lesbian over whether Johnny had become a man in order to be heterosexual. I had to explain that, while he had been a butch dyke before transitioning he was now basically a gay man. As is now widely understood, gender identity and sexual orientation don't necessarily correlate at all. In Johnny's case, he moved from the lesbian S&M scene into a kind of netherworld of male sub/dom relationships, with himself as the "sub." He would come to do makeup at a workshop looking wiped out and regale me with tales of being a slave, like the occasion when someone he'd met in a bar and gone home with had tied him to a bed for days on end with a gun pointed at his head. This guy finally ejaculated at the moment when Johnny, completely exhausted with terror, gave "Sir" permission to shoot him. Johnny was lucky to survive, and he was pretty shaken up by this encounter, but he was undaunted.

If Johnny had a "fixed" orientation, perhaps it was just his determination to put himself out there, to take risks and experiment. That was what had prompted him to start the F2M Fraternity in the first place, and we had all benefited from that. At the same time, though, Johnny

lived in such a demimonde that he became rather unreliable as a collaborator. On one occasion, we had a workshop scheduled that he didn't turn up for at all, and I was forced to do the makeup myself by trial and error. I had watched Johnny often enough as he applied facial hair with beard-crepe and spirit gum, and five o'clock shadow with a stippling brush and beard stipple cream. But this was a real baptism by fire. One of the attendees, the literature professor Bell Gale Chevigny, who was in her late sixties at the time, wanted a big, bushy mustache like Stephen Crane's (the nineteenth-century American poet). It took me forty-five minutes, but I made the damn mustache; it looked really good, and it even stayed on. With her natural elegance and carrying a cane, Bell was transformed into a man of poise and stature who commanded people's respect when we went out and about in New York.

After that I began arranging the workshop dates myself and hiring Johnny as my assistant. When he showed up, it made life much easier, but if he didn't I would just do the makeup myself. The other problem between Johnny and me was that he was much less interested than I was in having our workshop participants pass as men outside the studio. He wasn't concerned with the subtleties so much as the broad signifiers, and it was his idea of fun sometimes to stick an extra bushy mustache or pork chop sideburns on a slim face that really needed something less obtrusive to be plausible. He had a thing for older men, too, and increasingly I would discover that he was turning women in the workshops into fantasy Daddy figures. My attitude was that, sure, we were there to facilitate people's fantasies, but that didn't mean we could impose our own. I had a particular concern with people feeling comfortable in their roles, not awkward or out of place, so you could say we "grew apart" in terms of our priorities. Still, that tension between the broadly comic and the plausibly realistic is one that has haunted drag king culture ever since in one way or another, and I have participated in a number of events that were less about "passing" than about sticking out like sore thumbs. Early on during the period that Johnny and I ran workshops at Annie's, for example, we were invited by two drag queens, Brenda and Glennda, to join in with something they called Trans Visibility Day. This involved a whole posse of queens and kings boarding the Circle Line—the tourist boat that takes passengers around Manhattan Island—and proceeding to flaunt ourselves outrageously. We dashed around all over the boat, addressing each other in character and generally mucking about, freaking out the

tourists. The brilliance of this was that they couldn't get away from us if they tried. The Circle Line takes two hours or so to complete its voyage, and for that period of time the passengers were subjected to a lesson in gender variation. We almost provoked fights by going into the "wrong" toilets. For those two hours the rules of "urinary segregation" (as Marjorie Garber calls them), which have caused so much awkwardness and embarrassment for trans people of all varieties, were subjected to a kind of gleeful mockery.

That day was a lot of fun, but my main concern was always with how you might exploit a certain *invisibility* as a man. From the very start of my collaboration with Johnny, I realized that to fulfill my side of the deal I would have to make a real study of men, looking much more closely at characteristics and behavior than I ever had before. I was keen not to rely on teaching simplistic assumptions about how men behave because that would result only in a two-dimensional cutout image of masculinity, so I began to spend hours observing them. I would stand around Grand Central Station, for instance, watching men buying tickets, going to the information booth, or running for trains. Developing a particular interest in men who hold hierarchical positions, I attended public meetings at City Hall to observe city councillors in action and sat in lobbies on Wall Street and Madison Avenue scrutinizing managers and executives. I was also a regular customer at a very friendly Ukrainian cafe, Veselka's, on Second Avenue and East 9th Street. The owners didn't mind how long I stayed, so I would sit at their long diner counter for hours, just watching men. I used to sit at the corner so that I could see these guys in close-up along both stretches of the counter, watching how they ate and chewed and scrunched up their napkins. Similarly, at a sports bar on Second Avenue, I'd watch how the men at the bar relaxed, how they lifted beer bottles and put them back down on the bar or how they filled a glass with beer from a bottle. Where's the fulcrum, where's the leverage? How is the forearm being used, as two separate bones or as if there's just the one? Is the whole arm moving or just the part below the elbow? Is there a swallow at the front of the mouth or a gulp at the back? And how are these movements interrupted when a guy responds to something happening in the baseball game he's watching on the television in the corner of the bar?

Due to my training in Release Technique, I had learned how to scru-

Diane Torr as Danny King, stroking ear (homage to Tony Torr), circa 1992. Photographer: Yvon Bauman. Used with permission.

tinize behavior carefully, to find out where a movement begins and ends. In observing men, I examined where the impetus for their movements came from. I noticed, for example, that a lot of men don't use their hips very much, that they move from their shoulders a lot of the time, and that they tend to move the head and neck as one unit so you don't see much torque action. These details are very important in terms of authenticity, and observing them became a serious study. As a result I gradually developed a character for myself whose physical vocabulary distilled some of the things I had noticed men doing repeatedly. This was the guy I used when I facilitated the drag king workshops with Johnny, and I named him, accordingly, Danny King.

As I've said, one of my key ideas in developing the workshop was to encourage women to experiment with passing as male in real life situations, just as I had at the Whitney, so Danny had to be a character who would allow me passage into places where I would never be allowed as a woman. I needed a means of operating that would make me untouchable, and, since I'm only five feet four inches tall, I had to compensate for that lack of height by making Danny into someone who carried a lot of *authority*, an innate sense of his own superiority. His range of movement is deliberately minimal and withheld, but every gesture is imbued with an energy that is condensed and focused into significance. He's always cool and collected. Danny doesn't respond, for example, if someone is rude or aggressive toward him when he's out at night. Even if someone tries something, I've learned to glare at them in a way that forces them to back off. Occasionally, when out on the streets, someone has queried my male persona, but my method of looking through them—as if to say, "Who the hell are you?"—and then walking on has never failed. The trick is to have the confidence never to come out of character.

As Danny gradually evolved, through the experience of teaching workshops and going out and about, I began fleshing him out with personal touches. His sense of inherent authority reminded me of the way my father and uncles had behaved when I was a child—their sense of supreme self-importance—so I adopted certain aspects of the way they had looked (the fancy suits, the slicked-back hair, the polished shoes) and certain mannerisms I remembered such as their habit of jingling coins in their pants pockets. Danny also began to pull pensively on his earlobe from time to time with his elbow cupped in his other hand. My

father had been in the habit of doing this, and the gesture usually signaled that a row was brewing and the cow-buckle belt would soon be wielded. You could say I took a certain amount of vengeful glee in appropriating that particular piece of body language.

Danny King is, of course, an extreme. He represents a stereotype of male authoritarianism, and since a lot of his gestures come from male behavior of the 1950s or 1960s he's also somewhat anachronistic. As a result of feminist challenges, many men have become more self-aware about male privilege and have begun to question this kind of behavior. That's not to say, however, that it has gone away. I still frequently see younger men who are executives, or are getting ready to be in top positions, who adopt behaviors of the Danny King type. You even see them in young boys growing up. They're trying to be men, so they'll try on attitudes of restraint and control that they think are manly, but they'll often look really awkward doing so because these gestures don't fit their bodies yet. Gradually, through repetition, the gestures become more real; they appear "natural." But anyone can do it with a little practice. What I think is important for people to realize is that much of this behavior is just bluff—but also that there are practical lessons in learning how to adopt and adapt it. In experimenting with these gestures, which so many men assume as their right but women often think are unavailable to them, you can learn to function as a physical body that owns itself, that has a sense of its own containment, of its physical boundaries.

I realized that I could highlight some of these points by turning Danny into a theatrical character, as well as a workshop facilitator. I attempted various informal, club-style appearances as a way to develop him for the stage, at the Pyramid Club, for instance, and at a gallery next to CBGBs on the Bowery called 303. The challenge now was to figure out how Danny would speak and hold a crowd, and I drew much inspiration from watching various gray-haired political spokespeople on television who would talk . . . very . . . slowly . . . as they considered each word and weighed it up. They'd waffle along without actually saying anything of substance, but they seemed to conjure a kind of respect anyway because of the *manner* in which they spoke. I was particularly struck by watching President George Bush giving his State of the Union address in 1991, following the first American-led invasion of Iraq. Despite the enormity of what had been occurring, his whole manner was

one of total emotional opacity. He smiled just twice in the whole speech, and physically he was so stiff and restrained that he never once touched his body except to take his glasses from his jacket pocket. That gave me the ammunition I needed to nail Danny as a stage character, and I made a short piece for P.S. 122's annual benefit event that year in which I sought to simply exude privilege and authority while saying very little. I wanted to blow that male cover by proving that a woman can inhabit and perform "naturalistic" masculine power just as well as men can. I wasn't interested in entertaining people (the usual priority for benefit "turns") as much as trying to unnerve them, and many people were quite taken aback. I'd performed as Diane many times at P.S. 122, usually presenting dance work, so for that audience seeing me as this controlled, controlling male was quite a jolt. As a *Boston Globe* journalist later described the contrast, "Danny [is] the kind of guy who tries to compensate for his lack of stature by being hyper-masculine. As Diane, Torr is thoughtful, articulate, open. But Danny is a poker-faced jerk who bristles with barely suppressed hostility. He gave me the creeps" (White 1993: 58).

Confrontation is still the basic strategy I use when giving lecture-demonstrations on female-to-male drag. I'll walk onto the stage as Danny King and, with houselights up, make a deliberate exercise of looking individually at each person in the room. I don't say anything, but I want people to feel themselves being watched; the audience as voyeurs experiencing the discomfort of being the ones looked at. As a result, when I do speak as this character, I have people's attention. In a lecture situation, the contrast will now be very clear between this role, Danny, and the role I'll have first appeared in, "Diane." As Diane, I usually "femme" myself up more than I would in everyday life: more makeup, more feminine clothing. That accentuates the transition to Danny, but the contrast also highlights my own performance of femininity, which is really no more "natural" for me than Danny is. As I perform "Diane" I'm very communicative and fluent. I try to bring people in and make them feel at ease; they can ask me questions, and I'll answer. But you can't get past Danny King. He's in that unfortunate Donald Rumsfeld tradition of opacity, which doesn't allow people to feel that "you could be my friend." People like to settle in when they're presented with a speaker; we like to see little nuances or aspects of a speaker's personality that endear them to us. But Danny simply pro-

jects reserve and resistance, forbidding you to enter into his space. The audience is lucky to have him there. He doesn't have to *give* them anything. Given how unsettling Danny is, I don't usually "maintain" him for too long in a lecture situation because otherwise nobody would ask any questions, and of course I'm there to facilitate dialogue. I'll perform in role for a while and then drop him, and sometimes there's an audible sigh of relief from the audience when that happens. There's a breathing out—a shuffling about and a moving around—whereas for Danny there's been total silence and attention. The uneasy respect he is accorded, as I hope I've demonstrated, is not a biological privilege but a cultural habit.

The other thing to stress about Danny is that in order to be convincing he had to have some depth as a character. He's not just an abstract archetype of masculinity but is specifically located culturally. He hails from Pittsburgh, Pennsylvania, a city that was built on the steel industry and is still very working class at its heart. It was always clear to me that Danny's class background—like that of my father and uncles—is definitely more working-class conservative than middle class. He had to be the kind of guy who would naturally be more comfortable eating in a diner, for example (where I had done so much of my fieldwork), than in a fancy restaurant. Also I was thinking about how Pennsylvania—although it's the birthplace of the United States, historically speaking—has been overshadowed for a long time by New York and Washington to the north and south. Rather like the state itself, Danny is someone who privately feels overshadowed by bigger men and compensates for that by asserting himself just a bit too forcefully. That insecurity is also part of his class background because working-class identity is really something that has been shifted around, particularly since Ronald Reagan was president. What does it mean to be working class? The old-style working-class identity was built around trade unions, but the new conservative working class is entrepreneurial. Under Reagan the notion was put about that anybody could invest in the stock market and own a part of the economy. So Danny King is very big on owning his own turf, on staking his claim as an individual.

Although Danny King remains my "signature" drag persona, and appears as such in my performance *Drag Kings and Subjects* (1995), I've created many other male characters, most of whom are considerably less unpleasant than Danny. At more or less the same time I was creat-

"Before" and "after" shots of participants in the Drag King Workshop, New York City, 1993. As featured in Paula Span's *Washington Post* article. Make-up by Johnny Science. Photographer: Cori Wells Braun. Used with permission.

ing Danny, for example, I developed the figure of Hamish McAllister—a Scottish shipping clerk and self-taught Robert Burns aficionado—as the central figure in *Ready Aye Ready* (1992), which was the first full-length performance I did in male drag. Shortly after that I created a gay male character called Charles Beresford. These roles are discussed in detail later in the book, but it's worth noting here how different they are from Danny. Becoming Charles Beresford, for example, entailed a whole different kind of physical challenge because he was based on a gay friend who was aware of his sexuality and wasn't afraid to flaunt it: I had to focus on loosening my body up rather than holding it in the way Danny does. Whereas Danny's body feels tightly contained and has a density to it, Charles Beresford's feels a lot lighter and his gestures are more fluid. There's a continuity, a flow-through in his movement that you don't often find in straight men, who tend to have quite staccato body movements. Hamish McAllister, by contrast, shares much of Danny's physical vocabulary as an authoritative, implicitly heterosexual male. He plants his feet deliberately on the stage and commands audience attention. Unlike Danny, though, Hamish is a very warm character, very amenable, because his task in *Ready Aye Ready* is to try to enthuse the audience about Burns, his poetry and history. So, whereas Danny will try to retain opacity by speaking and smiling as little as possible, Hamish is a raconteur. He speaks with an Ayrshire accent, which is quite soft and lyrical (as distinct from, say, the harsher, more guttural Glasgow accent), and during performances he banters amiably with members of the audience. In creating him, I was thinking about Scottish men that facilitate. Growing up in Aberdeen, I'd seen a lot of these characters on television, men who were particularly knowledgeable about Burns or ceilidh music or folk history and whose enthusiasm for their subjects had real integrity. Scots have a particular way of expressing passion that has an honesty to it, but at the same time it's not overdone; there's a dry humor and a certain disarming, self-deprecating quality as well. I wanted Hamish to communicate all that so his audience would feel immediately comfortable with him, which is important because some of the material he introduces is pretty explicit.

As I was working to develop my repertoire and experiment with different roles, Johnny was pushing the drag king concept in another direction, one that was more social than aesthetic. He was very keen on creating clubs and societies, and he had begun organizing Drag King

Club social events as early as 1990 in an attempt to build a sense of community among workshop alumni. These were usually just informal get-togethers in bars that were also open to the general public, but in May 1992—just a couple of months after *Ready Aye Ready* appeared at P.S. 122—Johnny extended the concept by organizing the first Drag King Ball at the Crow Bar (a small, mostly gay club in the East Village). This event featured the first drag king contest to be held in New York, and because, as a "ball," the emphasis was on dressing up and having fun, Johnny's mailed-out call for participants placed a rather different emphasis on the drag king idea than I had been doing in the workshops. "*EVERY* type of 'drag' is welcomed at this event (for the audience, as well)," it read, and "contestants/performers *(women)* are welcomed to present *any* form of drag, whether they are trying to 'pass' as male, OR NOT. We want to present *every* aspect of the varied continuum of cross-dressing / gender-blending women" (circular letter dated 5 May).

Johnny and I had our differences of emphasis, but I think we both believed that we were propagating a new culture. The Drag King Ball was widely reported in the New York press, and the workshop started to get written up also. In April 1993 we were invited to give our first drag king workshops outside of New York at Boston's Institute for Contemporary Art, which resulted in feature articles in both the *Boston Phoenix* and the *Boston Globe*. By the fall, no doubt partly because of this exposure in Boston, we found our New York workshops attracting leading journalists as participants. Holly Brubach, fashion editor for the *New Yorker*, attended as part of her research for the book *Girlfriend: Men, Women, and Drag* (eventually published in 1999). Paula Span, of the *Washington Post*, wrote a rather more immediate response, an article that was printed as a huge spread across the front page of the *Post*'s "Style" section. After that all hell broke loose. My phone didn't stop ringing, and suddenly I was fending off requests to appear on *Good Morning America* and all those talk shows I never watched. We had gone national.

Part Two | APPLICATIONS

Four | Drag and Sex

Drag kings are reimagining and reconfiguring masculinity for a queer female audience that is increasingly unafraid to claim it as part of our sexuality. . . . Yet the desire that resides in drag kings extends far beyond the capacity to admit the polyvalence of queergirl eroticism. Drag king desire is desire for the other, or more accurately put, the center's illicit desire for the margin, and the margin's desire for the power wielded by the center.

—KATHRYN ROSENFELD (2002)

The rapid popularization of drag king performance during the mid-1990s seems indicative of a number of shifting historical factors. As Rosenfeld notes, the fact that lesbians presenting not just as butch but as *male* could now be seen as sexily entertaining by other lesbians points to a new embrace and celebration of the "polyvalence" of queer desire and particularly to the growing acceptance of FTM trans-men within the community. Yet the rise of the drag king also suggests a complex exchange of desires between the queer margin and the cultural mainstream. On the one hand, the cool strut of (nominally) heterosexual male pop-culture icons began to be appropriated and queered as a site for same-sex female desire. On the other hand, the very notion of the drag king was being popularized nationally and internationally in part thanks to the coverage provided by the mainstream media: newspapers, magazines, and television talk shows. These organs found all sorts of pretexts for their (usually rather superficial) coverage and were sometimes quite hostile in their treatment of the subject. Yet their interest seems indicative of that "illicit desire for the margin" identified by Rosenfeld, a fascination with material considered kinky or taboo. Drag king performance, in short, developed not as a neatly sequestered phenomenon of lesbian subculture but as a queer conjunction of overlapping—and sometimes contradictory—interests. In this chapter, I will seek to trace something of that history through reference to some key events and performers in the United States. Diane then resumes the narrative on the other side of the Atlantic.

The curiously tangled nature of drag king eroticism is particularly ap-
parent in the case of Shelly Mars. Arguably the first modern drag king, who
was strutting her stuff in San Francisco several years before Diane and
Johnny Science began to popularize the idea in New York, Mars's idiosyn-
cratic cross-dressing performances nonetheless demonstrate intriguing
parallels with Diane's 1980s experiments. Having moved to the Bay Area
from her native Ohio in 1980 to study at the American Conservatory The-
ater, Mars regarded herself as an actor first and foremost and viewed her
drag performances as character roles. Like Diane, though, she paid her bills
at that time by working in the sex industry, as a dancer in one of San Fran-
cisco's bisexual bathhouses.[1]

> That's really where I started out. You had everything there—gay, bi, trans—
> it was pre-AIDS, of course. And I played with sexuality and gender because
> it was around at the time, basically, in this crazy cool place. My routines
> were like crazy little character skits. The characters would striptease into
> other characters. Most of the time I'd have more clothes on than the people
> watching me. (Mars 2007)

As a result of her bathhouse appearances, Mars was asked to perform at the
Baybrick Inn, where Nan Kinney and Debi Sundahl—the founders (in 1980)
of lesbian erotic magazine *On Our Backs*—were running erotic performance
evenings. Sundahl was a professional stripper who, like Diane, had won-
dered how erotic dance formulas developed for straight men might trans-
late into an all-female context. One of the differences, she claimed in her
1987 essay "Stripper," was that the dancers found "they had more freedom
of expression. They were not limited to ultrafeminine acts only; they could
be butch and dress in masculine attire" (178). That statement helped in-

1. The "sex industry" connection linking several of the drag king pioneers—Mars, Torr, Science,
and Sprinkle—is less surprising than it might at first seem when considered historically. Long
before female-to-male cross-dressing began to be associated in the public mind with "inver-
sion" or lesbianism, it was recognized as a sign of resistance to the norms of patriarchal econ-
omy. In Shakespeare's London, for example, at a time when a wife was effectively owned by,
and dependent on, her husband, "prostitution and cross-dressing were *alternative* social strate-
gies for social and economic survival" for women unable or unwilling to marry (Garber 1993:
30). In some contexts, moreover, they were not even "alternative" strategies; breeches were
worn by prostitutes in Venice during the same period as a means of appealing to clients of vary-
ing persuasions since they suggested boyish androgyny and provided access from both front
and rear.

form critic Jill Dolan's ideas about the polyvalent potential of lesbian erotic performance (see Dolan 1989: 63–64; and Dolan 1991: 78–80), yet it is also somewhat misleading in implying that there were multiple cross-dressing performers at the Baybrick. "I was the only one," Mars stresses, "and it was so *not* what people were doing. Either people loved it, and thought it was crazy, or they were like, 'What the fuck is she doing? This is totally not cool!'" (2007). This reaction was perhaps understandable given that Mars preferred to perform not as a butch female adonis but as a rather creepy, predatory male called Martin. This character, according to Mars, was developed less as a celebration of masculinity than as a way to exorcise her own fears of sexual abuse at the hands of her father. "I don't have any heavy-duty memories," she says, but "you just always felt like you were gonna get eaten alive." As a child, deflecting this perceived threat by playing masculine was a survival strategy for Mars, who observed, "I could be a tomboy as my defense" (qtd. Hasten 1999: 34). As an adult, she also found that mimicking predatory males could function cathartically as a means of appropriating and queering the ostensible "sexiness" with which aggressive masculinity is often invested by the mainstream. "He's a total pig," she says of Martin, "but he's so much *fun* . . . it's like he's a release of the male inside me" (qtd. Koroly 1995).

A version of one of Mars's Baybrick Inn performances as Martin is preserved in the film *Virgin Machine* (1988)—by the German director Monika Treut—in which a Candide-like female innocent leaves behind both her boyfriend and Europe and embarks on a voyage of discovery to San Francisco. She eventually finds herself in the Baybrick Inn and falls for the "corrupting" figure of a lesbian courtesan, Ramona, played by Mars. Yet this character's first appearance in the film is onstage as Martin; dressed in a suit and tie, hat, and Groucho-style moustache, she languidly struts about the stage, grooving to bass-heavy music and interacting lewdly with female audience members. Martin demands a kiss with tongues from one, fellatio on a half-peeled banana from another, then drags a third onstage and mimes finger-fucking her from behind. He then strips off his jacket and trousers (comically shaking them off his hips) to reveal big, baggy white shorts in which he proceeds to masturbate a beer bottle held casually at his crotch until a moment of "climax" when beer foams out. Mars's routine is arguably the most compelling sequence in the film and fully explains why Del LaGrace Volcano was so struck by a comparable live performance.

> I don't remember the first time I heard the term Drag King but I can vividly recall the night I witnessed my first Drag King act. It was San Francisco, 1985. The *On Our Backs* / BurLEZK gang were putting on strip shows for lesbians at the Baybrick Inn. In the mid-eighties this was an entirely new concept in lesbian nightlife. . . . The strippers were all thin women with big hair and long lacquered nails, a look that did absolutely nothing for me but seemed to drive the lesbian audience wild. So when "Martin" took centre-stage I was flabbergasted, excited and genuinely confused. . . . Not a muscle Mary or a hairy Larry, Martin was the Action Man of oxymorons. Even though in my head I knew he was female, the way [Shelly] performed Martin's masculinity was lewdly compelling and to me, incredibly seductive. Something clicked and from that moment a fetish was born. (Volcano and Halberstam 1999: 10)

The performance Volcano witnessed would have been one of Mars's last at the Baybrick. Later in 1985 she relocated to New York, where she quickly became a familiar figure on the downtown performance art scene as an "after hours Lily Tomlin" (in the words of one *Village Voice* critic), performing both male and female character roles in unhinged comic monologues at venues such as the Pyramid Club and P.S. 122. (She returned to San Francisco specifically to shoot *Virgin Machine* in 1987.) She also became a maverick presence at various New York drag king events organized during the 1990s.

But what of the "fetish" value that Volcano identifies in Mars's cross-dressing? The choice of word is significant because psychoanalytic orthodoxy has long assumed that fetishistic transvestism is a specifically male perversion, a manifestation of castration anxiety in which the fetishized object is thought to substitute for the phallus that the boy fears he lacks. Since women cannot fear castration, their interest in the phallus has conventionally been thought of not as "perverse" but as confirming the heterosexual norm. As Marjorie Garber sardonically remarks: "To deny female fetishism is to establish a female desire for the phallus on the male body as *natural.* Heterosexuality here—as so often—equals nature. Female fetishism is the *norm* of human sexuality" (1992: 125). As Volcano's comment suggests, though, to fetishize masculinity performed by a female body is to refute that "norm" and claim phallic power as transferable. Clare Taylor, in a careful study of modernist women's literature, argues that "for some women writers cross-gendering is a performance of fetishism which *enhances* the

(female) body/self as a *sexual* body/self for the subject, and a desirable body/self for the object of her desire" (2003: 9). According to this reading, cross-dressing may be experienced both as a form of sexual empowerment for the performer *and* as a site of fetishistic desire for the spectator.

Participants during the early development of the Torr and Science drag king workshops seem to have been acutely aware of both of these possibilities, not least because of the sexually charged context of Annie Sprinkle's salon. As Diane notes, there was inevitably an erotic charge around the appropriation of "forbidden" accoutrements such as men's underwear, prosthetic penises, and even facial hair. Two of the earliest write-ups of the workshop emphasize the potential for sexual play in the taking on of male garb. "I posed as a '70s gay s/m clone and gave a blow job to the other clone who looked just like me," wrote Christine Martin (drag name Chris Teen) in a fanzine piece, "Adventures of a Drag-King Queen."

> We checked each other out at the beginning of the workshop, and with one little glance we knew we'd fuck each other before the night was through. We helped each other choose clothes, moustaches and hair-dos. We assisted each other dressing and breastbinding (a highlight every time). In no time we both had faggy goatees and two matching hard bulges in our jock straps. (Teen 1990)

Shannon Bell, too, wrote up her own adoption of the S&M leather clone look at the workshop, explaining that "the only sort of man I'd want to be is a gay man" (Bell 1993: 92). There was a self-consciously political side to these choices. If male masculinity was to be appropriated and even celebrated, then it was important that the masculinity in question be politically marginal and "perverse," not the dominant heterosexual version. As lesbian activist (and later FTM trans-man) Pat Califia noted in a piece for Fiona Giles's 1997 prose collection *Dick for a Day* (a book inspired in part by the drag king workshop), "[M]y private dirty movies of let's pretend are all heterosexual, simply because male-female sex is so exotic and strange to me, [but] you can bet that if I have to be a man, even for one day, I am not about to become a heterosexual one. How could I stand it? I don't know how *they* stand it" (95). Califia's piece moves on to fantasize about indulging in anonymous, male-on-male bathhouse sex.

Sexual play, Chris Teen observed, is a political act, for "society has denied that girls could have an erotic attachment to anything including other

girls or other girls dressed as boys, [so] we better start playing (with full intentionality) all the parts that are available to us, and there are many" (1990). Yet, even as she and others emphasized the transgressive potential of male drag, the mainstream media were starting to take an interest. Daytime television talk shows enjoyed a boom in popularity during the early 1990s, partly thanks to a seemingly insatiable public curiosity about gender variation. As Garber noted in *Vested Interests* (first published in 1992), "in the last two years, Phil Donahue has broadcast at least sixteen programs on cross-dressing and transsexualism and Geraldo Rivera more than seven, and the question has also been discussed at length by Sally Jessy Raphael and Oprah Winfrey" (1992: 5). Nevertheless, the first such nationally televised show featuring female-to-male cross-dressers (as opposed to male-to-female) did not air until 9 November 1991, when *Donahue* featured—among others—Diane, Chris Teen, and a third workshop alumnus, Paco Moreno.[2] A telling distinction emerged between the drag kings and another guest, Sandy Bernstein, who explained to the audience that she dressed in male clothing as a daily norm, stating, "I have a female gender identity and a male gender role. . . . I feel emotionally uncomfortable in women's clothing; it's almost like a violation of my personality." Donahue's audience was both confused and fascinated by Bernstein, but it was clearly more perturbed by the presence of Diane and her colleagues. It was one thing for a woman to cut her hair short and dress up in a tailored business suit in order to be "emotionally comfortable," but quite another to apply fake facial hair and five o'clock shadow and affect a deeper voice range. The clear artifice of the drag kings, and the fact that they were apparently crossdressing for *pleasure,* not because they "had to," prompted audible hostility from members of the studio audience whose early 1990s outfits and hairstyles appear—from this historical distance—as peculiar as those of anyone onstage.

In 1992, Johnny Science and several drag king colleagues were featured on a comparable edition of the *Joan Rivers* show, although there was less controversy since the unflappable Rivers did not invite comments from her audience. Also that year, capitalizing on the media interest in women dressing as men, Science coordinated the first Drag King Ball in part as a press opportunity. As he explained to potential participants in a letter mailed on

2. As a news flash interrupting the broadcast indicates, this was also the day on which it was announced that the heterosexual basketball star Magic Johnson had AIDS.

16 May, he would assist with makeup backstage at the Crow Bar, prior to the 8:00 p.m. call time he had scheduled for journalists and photographers. "When the press arrive," he wrote, "we'll give them an amazing little show, and a stunning parade of crossdressed women. Then we'll let them have a question-and-answer period." On the night of the ball, reporters duly appeared from the city's major tabloids, the *New York Post* and *Daily News,* as well as from the *Village Voice, Screw, HX,* and others. Indeed, when Annie Sprinkle's colleague Veronica Vera turned up at eight to cover the event for the men's magazine *Adam* (and to act as one of three judges), "the scene at Crowbar . . . was pretty quiet, with press outnumbering drag kings two to one" (Vera 1992: 11). As the evening wore on, however, a full-scale party took off.

According to *Newsday,* Science "patiently transformed more than a dozen women of all ages during the course of the night." As he told the (male) reporter: "I just love making these women look like hot guys. When women look like men, they look like cute men, pretty men. They're really hot and I'm an aficionado" (Garbarino 1992). Reporting of the event generally emphasized what a "turn-on" cross-dressing is for performers and audience alike, and the contest was won by Alyse Milliken, whose "Palladium Man" character (parodying a particular brand of leering, nightclubbing, heterosexual male) climaxed his act by ripping open his shirt to reveal a lacy black bra and ample bosom. Unsurprisingly, it was this photographic opportunity that featured most prominently in the press coverage. Second place in the contest was won by "The King of Kings" (Jesus) as performed by Gloria Boehm, who had performed in Diane's *Ready Aye Ready* earlier in the year. "Her garb included a crown made of sticks," *Newsday* noted, and "a simple white robe (with only a G-string underneath, she confessed)" (Garbarino 1992). Coverage of this event thus established what was to become a familiar pattern, of mainstream media emphasizing the desirable female body to be discovered beneath the drag king's masculine attire.

Kit Rachlin, who attended the ball in drag along with her sister, remembers it as a wonderful party and also as "a really important, a historical moment. It was the first time I'd ever seen that term [*drag king*] in print, and if Johnny had stayed in the scene, I think that it would have become a legendary event. Instead it kind of just got erased" (2007). Although Science organized a second Drag King Ball that November, at the Enterprise Theater, it did not generate a comparable level of media interest. Science did not pursue such events any further, partly, Diane believes, because of

his increasing desire simply to pass as a gay man rather than putting himself in public situations that invited discussion of his transsexual status. In 1998, at the height of the drag king's cultural "moment," Science briefly revived his engagement with the subject (he had not assisted with workshops for two or three years by then) by hosting a low-budget cable TV show on the community access channel Manhattan Neighborhood Network. *That Show . . . with Johnny Science* typically featured shaky, handheld recordings of drag kings performing in clubs and makeover sessions conducted by Science himself. He would always preface the broadcast by explaining (as he had to Joan Rivers), "I am not a drag king. I'm just a regular guy who does special effects makeup on women to make them look like men."

After 1992, the organization of drag king contests in New York was taken up by Tracy Blackmer, the first performer in that city to fully exploit the entertainment potential of drag kings for queer female audiences. If Alyse Milliken had won the first New York contest by offering an overt parody of masculinity that was then peeled away to reveal the female body beneath, Blackmer was more interested in appropriating the kind of heterosexual masculine *cool* demonstrated by iconic pop-culture heroes such as Jim Morrison, John Travolta, and even Axl Rose, each of whom she successfully impersonated. *Cool* is, of course, intrinsically associated with masculinity, whereas the "feminine" equivalent is probably *allure,* an inviting toward rather than a standing back. As Blackmer noted:

> Men are heartthrobs in a way that women aren't—teenage girls just go nuts over [certain guys]—and I want to get a lot closer to that experience than I'm able to as a woman. Because even women who know they have sex appeal, they don't feel like they own it the way men do. Whereas with guys, it belongs to them—it's theirs. I want to be able to take things like that for granted. (Brubach 1999: 153)

These comments were made to the journalist Holly Brubach when both attended a drag king workshop in the fall of 1993. Blackmer had just moved to New York from Boston, where she had recently appeared as John Travolta in a drag show organized subsequent to Diane's ICA appearance that year. She had immediately been smitten by the possibilities: "It was the way people were looking at me after the performance. They weren't looking at me anymore, they were looking at John Travolta, with stars in their eyes. I got such a rush out of that" (2007). She credits Diane with mentoring her

in New York and helping to book her first couple of drag king shows at the Pyramid Club, but Diane sees Blackmer as an original in her own right, and certainly as the only drag king she has seen master Jim Morrison's swagger and attitude. At five foot ten, she had the height and looks to play such icons, and she also brought her musical talents to bear, figuring out how to sing live as Morrison rather than just lip-synching. Blackmer also developed an iconic drag persona of her own, Buster Hymen, a character based on a Guess jeans model she had found in *Vogue.* With aviator sunglasses, goatee beard, a huge, feathered cowboy hat, and a blonde, Claudia Schiffer–type model hanging off his arm, he seemed to her the epitome of male sex appeal: "He also had my haircut—layered hair that hung almost to the shoulders—so I could really perfect his look. After I found Buster, I became extremely popular" (2007).

Blackmer organized and hosted drag king contests throughout 1994 and 1995. At first she had difficulty recruiting just three volunteers to compete at each event, "but I took it upon myself to mentor people because I had been mentored" (2007). She would go to people's homes to show them how to construct facial hair and a penis, bind breasts, and so on, so that they could take part in the shows. One such mentee was Mildred "Dred" Gerestant, who first saw Blackmer perform at the Pyramid Club and went on to become a leading drag king in her own right. "Buster Hymen was the one who really inspired me to do drag," she notes. "Seeing her doing John Travolta's *Saturday Night Fever,* I thought, wow! She was so smooth, so sexy and powerful, and just knowing she was a woman up there doing a man, but as a woman, I knew I had to try that" (Gerestant 2007). Dred's first drag appearance came in December 1995 as one of the contestants in "Buster Hymen's Drag King Dating Game," which Blackmer was running on a monthly basis at the Bra Bar on St. Mark's Place (so-called because of the bras hanging from the ceiling as decor). In this parody of the television dating-show format, six "bachelors" would typically compete to go out on a date with the single "female" contestant, who might be a feminine woman, an effeminate man, or a drag queen. On the occasion when Diane competed, she recalls,

the drag queen was Sherry Vine. She was behind a cloth cubicle, so she couldn't see us, and we couldn't see her. Sherry auditioned us for a date by asking each of us different questions—things like: "If I were a dessert, what would I be and how would you eat me?" and "If you had unlimited re-

sources, where would you take me and what would we do?" I must have given good answers, because I won the date. The prize was a movie gift voucher for two.

The success of Blackmer's shows led to other people mounting drag king contests at lesbian venues such as the HerShe Bar, where Judith Halberstam saw her first such event in 1995. In the drag king chapter in *Female Masculinity*, she documents a HerShe Bar contest in detail alongside subsequent performances at Club Casanova, the regular drag king night that Maureen Fischer began promoting in March 1996 at a bar called Cake (at Avenue B and East 7th Street: it later moved to Velvet at Avenue A and 10th). Fischer, too, had been inspired to try drag after seeing Tracy Blackmer perform—with the band Space Pussy—in Provincetown, Massachusetts, during the summer of 1995. Fischer created a drag identity for herself, Mo B. Dick, based on a man she saw on the subway one day. "He had a beer gut, polyester shorts, cheesy shoes and maroon socks," she recalls. "I took one look at him and said: 'That's hot!'" A more affable version of the sleaze king pioneered by Shelly Mars, Mo B. Dick was, Fischer explains, "a schmuck from Brooklyn preoccupied with tits, ass and pussy. The kind of person you'd look at and say, 'What a dick!'" (Bailey 1997). He was also strikingly handsome, making full use of Fischer's chiseled jawline and natural charisma to command the attention of onlookers. Merciless with hecklers, Mo proved to be a superb compere (a talent Blackmer says Buster Hymen never really possessed). Fischer staged Club Casanova until December 1997, when it was forced to close as a result of Mayor Giuliani's puritanically strict enforcement of New York's arcane cabaret licensing laws. The Kings of Club Casanova, not to be thwarted, embarked on a bus tour of sympathetic U.S. club venues in spring 1998. In that same year, Fischer made a cameo appearance in John Waters's film comedy *Pecker* as a lesbian stripper who also disguises herself in biker-dude drag. She also features as one of the photographic stars of Volcano and Halberstam's *The Drag King Book* (1999).

Having helped pioneer the coolly sexy drag king type that Dred and Mo B. Dick further popularized, Tracy Blackmer had stopped performing drag by 1997 because, she recalls, "I had realized that I was mostly heterosexual, and that if I wanted to start attracting men, this was not going to be my most efficient manner of doing that." It's worth noting, however, that others might disagree. Leslie Lowe, for example, had found that performing as Elvis Presley made her irresistible to heterosexual men. Lowe, another

member of the Annie Sprinkle circle (she did makeup for *Linda/Les & Annie*), had first dragged up as Elvis in the late 1980s for a photography project by the East Village artist Plauto. She subsequently developed a lip-synch impersonation, which she performed at downtown clubs such as the Pyramid and the Vault even before the term *drag king* began circulating. "I had some initial hesitation about impersonating Elvis," Lowe notes,

> as I was leery of being thought of as a lesbian. There's nothing wrong with lesbians, but I'm hopelessly heterosexual, and my thoughts were "I'll never get laid doing this." But that first time I posed for Plauto, I couldn't resist keeping on the outfit and makeup. As I walked down East 4th Street as Elvis, the reaction I got from straight men was amazing. And I'm talking Puerto Rican drug dealers. Subsequently, several of my straight male friends asked me to have sex with them after seeing me in Elvis drag. My advice to anyone: if you wanna get laid, just look like Elvis. (Lowe 2008)

That Lowe could inadvertently succeed in attracting straight men through a demonstration of Presleyesque cool was a demonstration of the fact that the line between admiration and desire is blurry at best, particularly where icons are concerned. It should be noted, though, that Lowe's look as a performer was as a somewhat "femme" Elvis. When she appeared alongside Diane on the *Donahue* show in 1991, in a self-designed black and gold brocade jacket and gold high heels (she also sometimes wore blue suede high heels), the studio audience was keen to point out that she was the least convincingly masculine looking of the assembled cross-dressers. Yet facially she looked every inch like Elvis, a fact that points to Presley's own somewhat androgynous appearance. His glamorously costumed look, which even in the 1950s owed something to the camp example of Liberace, also mixed gender signals. Garber underlines his ambiguous status as an object of desire by noting that "the word 'impersonator,' in contemporary popular culture, can be moderated *either* by 'female' or by 'Elvis'" (1992: 372).

If Elvis's double-coded status as both masculine and feminine helps explain Lowe's appeal to straight men, it also played a role in Leigh Crow's appeal on the lesbian scene in San Francisco as "Elvis Herselvis."[3] She first ap-

3. Lowe believes that Crow's Elvis act was inspired by seeing her own version at the Vault club in New York. Be that as it may, Elvis Herselvis was a distinctive creation—not just an Elvis impersonation but a character in her own right, a lesbian Elvis impersonator who told stories of the King's life as part of her act.

peared in this role in 1989, in a lip-synch turn perhaps reminiscent of Peggy Shaw's James Dean at WOW nine years earlier. As Crow notes, "The fifties and sixties teen idols work for dykes because they were the sensitive rebels, the little boy lost." She adds that Presley's was "not really a butch image but a very dreamy one, [and he] had a definite feminine side" (qtd. Bashford 2005). The fact that he was not an aggressively macho male—combined with the pop cultural kitsch value attaching to Elvis impersonation itself—enabled the act to succeed even at a time when playing male was considered politically incorrect in the Bay Area lesbian scene. Crow remembers that "it was at a dyke rock 'n' roll club and they really went crazy for it. It was a chance for them to really get silly which in the dyke community [was] not really a common experience" (qtd. Bashford 2005). Moreover, experimenting with drag roles also proved sexually liberating in helping Crow expand her own sense of identity. A tall, masculine woman, she had nevertheless found that the traditional butch role did "not sit comfortably with me. I like a lot of attention and I found that as a butch I was expected to give the attention, rather than receive it." She discovered, however, that by projecting her sense of masculinity onto the stage—"I can get out the swaggering maleness which is in me"—she was able to see it as a performance rather than a defining identity. As a result, she also felt liberated to play with other gender options in similar ways. "Ironically," she says, "because of this I now feel very comfortable going out socially in femme drag. . . . I can even play at drag in a hyperfeminine style" (qtd. O'Sullivan 2005). Crow went on to become the key instigator in the development of San Francisco's drag king scene, hosting the city's first official Drag King Contest in May 1994, at the Eagle Bar, as well as its prototype contest at the DNA Lounge in September 1993.

Following the establishment of scenes in both New York and San Francisco, there came an explosion of self-initiated drag king troupes across North America during the mid-1990s, usually within a specifically lesbian subcultural context. In 1996 alone, new troupes were formed in Washington (the DC Kings), in Columbus, Ohio (the HIS Kings), in western and eastern Canada (the Vancouver Kings and Montreal's Mambo Drag Kings), and, of course, in New York City (Mo B. Dick's Club Casanova). In that year also, Diane gave a workshop at the "Genders That Be" conference in Minneapolis, which—according to critic Kim Surkan—inspired the subsequent emergence of two distinct troupes in Minneapolis and Saint Paul, the

Metro Kings and Dykes Do Drag (see Troka, LeBesco, and Noble 2002: 161–85). By 1998, the Columbus HIS Kings had coordinated the first International Drag King Extravaganza (IDKE), a jamboree event that—like the San Francisco Drag King Contest—continues to be held annually.

The queerly sexy appeal of drag king performance is difficult to articulate, but it clearly has much to do with the layering and blurring of gender registers already noted. On the one hand, pop-cultural constructions of masculine style are appropriated and reworked, sometimes as theatrical expressions of the performer's underlying sense of masculine identity. At the same time, the attraction for spectators in the queer club context lies precisely in their awareness that the performers are *not* biological males but "desiring to be desired" females (or trans-men). "[We are] liberating women to objectify kings as sex objects," comments Crow's San Francisco colleague Anderson Toone, a process that "is deeply healing for many and, I would venture to say, a feminist act" (2002b). Paradoxically, this position of spectacularized "sex object" can also be seen as according kings a "feminized" status given that masculinity is traditionally associated with looking rather than being looked at, with the desiring subject rather than the desired object. (Indeed, the sex object status of figures such as Elvis and the young John Travolta is arguably one of the factors that feminizes *them*.) Yet these are, as Tracy Blackmer anticipated, *empowered* sex objects, their appeal built precisely on avoiding stereotypes of female sexuality. Indeed, drag kings sometimes wryly reference their femaleness by alluding to the tools of the conventional femininity that they have foresworn. One flier for a Washington, DC, drag king night, for example, playfully foregrounds this switch with the iconic image of a goateed James Bond look-alike (Kendra Kuliga) brandishing a hair dryer rather than a Walther PPK pistol (see Troka, LeBesco, and Noble 2002: 103). "You could say [a drag king is a] male impersonator," Kuliga notes, "but that's so the tip of the iceberg. . . . I'm both a male and a female while I'm performing" (Bugg 2004).

In Sonia Slutsky's documentary road movie, *Drag Kings on Tour* (2004), some leading "second-generation" drag kings can be seen showcasing some fine examples of this kind of gender layering. Luster, for example (Sile Singleton), appears onstage as an African American dandy in vividly colored ties and knee-length "zoot suit" jackets, crooning lip-synched soul ballads that emphasize the alluring smoothness of this "ladies' man." Christopher Noel (Noelle Campbell Smith) is Luster's white-boy counterpart, lip-synching to David Bowie's "Boys Keep Swinging" (the artist and

lyrics already emphasizing gender morphology) while demonstrating a quick-change/strip act that moves from a tight, black leather suit, reminiscent of Elvis's 1968 comeback special, through a Boy Scout shirt and shorts, to a *Full Monty*–style posing pouch and black peaked hat. Intriguingly, Smith cuts a more straightforwardly masculine figure offstage (as a tomboyish butch) than on; her stage persona's greased-back hair and makeup emphasize her perfect cheekbones, making her a beautifully feminine male (as with Elvis or the young Bowie). In the film, one gay male spectator comments of her act, "I don't even know if I'm gay anymore because if you could look that way all the time I don't know if I care about anatomy." Conversely, as a heterosexual male viewer, I would have to confess that my own attraction to Smith in this film has at least as much to do with her effortlessly cool masculinity as with her femaleness.

In *Female Masculinity*, Judith Halberstam rightly concentrates attention on the fact that, since masculinity is often built on the illusion of "natural" understatement, effective female-to-male drag involves a certain damping down—rather than playing up—of physical expression. She thus coined the term *kinging* to describe "careful and hilariously restrained acts, which [appear] notably sincere, or, to use a Wildean term that tends to typify the very opposite of camp, 'earnest,'" with the emphasis on "a reluctant and withholding kind of performance" (1998: 239). For Halberstam, this new term is needed because the notion of camp, drawn from gay male culture, is inadequate; there is a "clear . . . difference between camp femininity and a very downplayed masculinity" (239). Yet this reassertion of the masculine-feminine opposition seems problematic given the extent to which drag kings tend to blur the binary. It is, moreover, undermined by her invocation of Oscar Wilde, whose dandified persona constituted a blend of gendered registers, and whose *The Importance of Being Earnest* stands not as "the very opposite of camp" but as the epitome of theatrical high camp. Onstage its hilarity relies precisely on restrained, deadpan performances from actors, who must treat the farcical circumstances they are embroiled in as if everything is perfectly under control, and without ever breaking their refined facades. In short, obvious artifice passes itself off as seemingly natural and in so doing implicitly questions the naturalness of everything else. *Earnest* demonstrates perfectly Jack Babuscio's key ingredients of camp sensibility—"irony, aestheticism, theatricality and humor" (Cleto 1999: 119)—but so, too, do most of the performances I have described.

High camp might be as useful a term as *kinging* to describe the drag

king's appeal. Certainly it differs from the burlesque camp of many drag queens in that, rather than flirting with or winking at the audience in a knowing manner (in effect, *giving* oneself to the audience), high camp gives nothing away. You either "get it" or you don't. Above all, as the Wildean example demonstrates, it relies on an awareness of incongruity, and it is arguably the knowingly sexy use of incongruity that unites the best drag king performances, from Shelly Mars's repellently attractive Martin through Leslie Lowe's high-heeled Elvis to Christopher Noel as a Boy Scout stripper. Another prime example would be Dred Gerestant, the Haitian American king whose performance modes run the gamut from flawlessly lip-synching to rapid-fire hip-hop to engaging passersby in casually "natural" encounters on the street. In each context, she specializes in the incongruous juxtaposition of masculine and feminine registers. Appearing first as a man, she might then expose some cleavage (or, onstage, strip down to a red bra) while retaining a plausibly masculine body language and leaving in place her goatee beard, which tends to make her bald head look inescapably male. "A lot of heterosexual men can't handle that," she notes.

> [T]hey say they're attracted to me from the neck down but not from the neck up. Or there was the gay man who wanted me to call him after I had a sex change. And vice versa with straight women. But I would ask them, why do I have to have a sex change? If you're attracted to me as I am now, why can't you take the whole package and get the best of both worlds? (2007)

Such provocations can be read as camp not only in their knowing irony (Dred is not actually offering herself to passersby) but in the gentle challenge they offer to people's notions of the normal or natural. Dred uses her undeniably sexy appearance (whether as a man or a woman) to throw the gaze back at her observers: desired object becoming questioning subject.

Diane, too, is a master of high camp. Take, for example, her performance at London's Transfabulous Festival in 2006. There, in a cabaret-style context that engendered expectations of broadly comic performances played knowingly to the audience, she opted to completely ignore her observers while silently executing a series of carefully choreographed movements with a five-foot-long pole. Accompanied by Spanish guitar music and wearing a Zorro-style mask and pencil-thin mustache, Diane appeared as a

kind of abstracted matador figure, swinging the pole calmly around her head, passing it between her legs, holding it at arm's length like a dance partner, and so forth, suggesting a range of possible movement traditions from martial arts to morris dancing. Significantly, in the context of a festival of transgender arts, the routine's physicality seemed almost gender neutral, performed by a body that could have been read as either male or female had an announcement of the performer's name not been made. Yet the masked opacity of the performance suggested "masculine" self-possession (recall the distribution of black shades to the guards in the Stanford prison experiment), and the pole a coolly ironized phallus playfully tossed about. In effect, this utterly deadpan routine literalized what is implicit in Diane's more unambiguously male characterizations: that she can appropriate and wield said phallus with the alacrity and authority of any man.

Drag king performance has been very important at the community level: it's an act of self-assertion and self-discovery, and it takes a certain amount of "cojones" to get up there on a stage and strut your stuff as a guy, even in front of a group of friends. I really enjoyed seeing the emergence of this culture through the 1990s, and of certain individuals within it. Some of the best performers, like Dred, Mo B. Dick, or Buster Hymen, could perhaps have had successful, profitable careers if there had been any modern equivalent of the vaudeville circuit that supported male impersonators at the beginning of the twentieth century. One performer who has made a successful career from a drag king character is Murray Hill, although this success is based in part on the fact that he does not perform as a "sex god" but as quite the opposite. Murray's performance persona is that of a chubby, jolly uncle, who seems flirtatious but also quite harmless. He can play the womanizer and tells off-color jokes, but his act is so knowingly anachronistic—recalling the Borscht Belt comedians of the 1950s—that he never seems lewd or predatory. Murray developed this character during the Club Casanova era of drag king performance in New York (although I first knew him before that, as a woman, when he worked as a web designer for Martha Wilson at Franklin Furnace), but by perfecting the role of an affable, wisecracking host, he was able to expand his potential "market" far beyond drag king clubs. Murray has become the regular host of new burlesque nights, lesbian cabaret events, and much else besides. As the

New York Times put it, he is "able to move seamlessly from old time-y clubs like the Plush Room in San Francisco (known for lounge acts like Patti Lupone's) to an East Village spot where nearly naked men dance on the bar" (Calhoun 2005). Moreover, Murray now keeps up his theatricalized persona all day every day: this is an act that has become permanent.

Still, Murray Hill is the exception that proves the rule. The fact that he has made a living in the nighttime world of clubs and bars is symptomatic of the fact that in the United States drag king subculture has generally been limited to such contexts because of a lack of funding for the arts. Because of this, a limited range of performance modes like those of the emcee or the lip-synching singer have become standardized, pretty much by default, as "what drag kings do." As part of an older generation of artists, however, I was never very active in the (youth-oriented) club scene as it developed in the 1990s. Instead, I was able to find ongoing interest in, and financial support for, my work in Europe—where a drag king scene also developed during the 1990s, almost simultaneously with the one in North America.

In Europe, artists have more often been permitted the resources to conduct detailed explorations of edgy subjects such as sex and gender variation. Cases in point would be the residencies I was invited to conduct in the Netherlands in 1993 and 1994. The first, at Arnhem's European Dance Development Centre (EDDC), resulted in a performance—*Scratch 'n' Sniff, Touch 'n' Feel*—that toured to venues in Holland, Germany, and England. The second, at the School for New Dance (SNDO) in Amsterdam, led to the making of a performance and a film, both titled *Open for Flavor,* which we presented at Theater het Liefje and a festival of erotic art in that city. I was invited by curators Aat Hougee (at EDDC) and Trudi Cohen (at SNDO) because I was known in Holland thanks to my time spent there in the 1980s and because they were aware of my dance background. Both schools commissioned me to explore questions of gender, desire, and the erotic with groups of dance and performance students, a task that felt very new and risky at that time and is still difficult to imagine being asked to repeat in academic institutions in the United States.[1] In both instances I began with ex-

1. The exception would be when well-resourced student societies initiate such projects, as in 2006 when I was hired by Hampshire College's Trans and Gay Societies to run a workshop called Gender Erotics.

plorations of the body's senses. How does the sense of touch or the sense of taste relate to or stimulate desire? Explorations of eroticism often begin with narrative or character, but, while the mind is always involved, providing context for our longings, it seems to me that desire itself begins and ends with the senses; it is triggered by sensory experience (sight, sound, touch, taste, smell), and it seeks a sensual (and often sexual) outcome.

At some point, of course, cross-dressing and the erotic inevitably coincide. There's a certain frisson generated, for example, by dressing in clothing that is thought to "belong" to the opposite sex, particularly when experiencing the shapes and textures of unfamiliar garments next to the skin. And how does one's perception of another person change when his or her gendered appearance changes? It was in *Scratch 'n' Sniff, Touch 'n' Feel* that I first experimented with transitioning from female to male in front of an audience so that they could see that transformation. In Amsterdam, however, I took the opportunity to develop these explorations further by creating male characters with the female students with whom I was working so they could gain access to sexual contexts that would normally be out of bounds for women. There were three women in the group besides myself but also one man, a very beautiful Indonesian androgyne, completely smooth-skinned, who had worked in the sex industry as a slave. It was really with his guardianship that we embarked on an exploration of Amsterdam's richly varied nightlife. (I should add that these were all mature students, ranging in age from early twenties to middle thirties, although that's not to say I didn't feel responsible for them.) The idea was to research what was out there because my feeling has always been that if you want to get beyond stereotypical notions of the erotic you have to confront what those are. We visited live sex shows, male-to-female tranny bars, S&M clubs, and the back rooms of places like Exit, which is a hard-core gay bar where (I found out later) they have been known to beat up intruding females. Of course we couldn't hang around long in a place like that because at some point or another your penis is going to be touched, and its authenticity will then come into question. But there was nonetheless a real sense of intrigue in entering an unknown environment where erotic contact is based on total anonymity. To the best of my knowledge, there's no real equivalent of that for women, no dark rooms where we can go and have sex with other

women. Cathay Che, one of the early drag kings, did try to implement something of that idea in the New York lesbian scene in the early 1990s, but the "back room" at her club night was more playful than anything else; there was a lot of tickling and kissing but no full-on sexual encounters.

These experiences provoked questions: in a world where men have always been granted greater license to pursue their sexual inclinations, how, when, and with whom do women—gay or straight—seek to have their own desires fulfilled? What are we going to do, as women, to redefine the culture? One of the younger workshop participants found a live sex show we visited particularly disturbing because the heterosexual penetration depicted reminded her of how unsatisfactory she had found her relationship with her one serious boyfriend to date. I think she came to realize, as a result of the workshop period, that the problem lay not with her but with the ways in which heterosexual desire is conventionally shaped in mainstream culture. The performance we eventually created (with the students' own input as the main resource) was one that sought playfully to challenge sexual expectations of all sorts. In one sequence, for example, one of the women appeared as an S&M-type leather man, leading the Indonesian guy in on a leash on all fours. She then produced an object that looked at first like a cosh with which to hit him but which then turned out to be a container of talcum powder. She gently showered his skin. When he was eventually "hit," it was with silk scarves that were draped and pulled over his body. He became a kind of willing plaything for the female performers. With hindsight, that scene stands out in my mind as epitomizing the fluid and consensual approach to eroticism and gender that we were trying to explore, an approach not necessarily bound by binary structures like masculine versus feminine and active versus passive. There was a miraculous kind of balance in the group itself and a real sense of trust. They did challenging, beautiful work together, and *Open for Flavor* provoked much discussion and interest among staff and students at SNDO.

During my residency in Amsterdam, I also presented the first public drag king workshop to be conducted in Europe, in the same Melkweg space where my go-go dancing performance had proved so controversial twelve years earlier. The British journalist Julie Wheelwright, who had written an inspiring book called *Amazons and Military Maids* (about

women who have passed as men in order to pursue military service) covered the workshop for the *Independent* newspaper and subsequently arranged for me to give another workshop in November 1994 at London's Institute of Contemporary Arts. We also presented a platform event in which Julie gave a talk on the history of women taking on male personae and I performed a gender transformation. That event was widely written up in the newspapers, and I was invited back to London in 1995 to run another workshop and make a television documentary about it for the BBC. That spring, the London Lesbian and Gay Film Festival organized the United Kingdom's first drag king contest.

The idea was starting to take off all over Europe. In 1995, I also taught my first German drag king workshops in Hannover and then Berlin, experiences that turned out somewhat differently. The workshop at Hannover's Tanz und Theater (TUT) Studio went so well that director Rita Holderegger invited me back to teach three more during the following year. Participants traveled from all over Germany, and indeed Europe (Luxembourg, Vienna, and Budapest), to attend. The Berlin workshop, held at the women's collective Pelze, proved less harmonious because, much against my will, the organizer, Brigitte Scheuch, had arranged for the workshop to be filmed for television: I arrived to find the ZDF network's cameras and lighting equipment in attendance. It was further evidence of the growing media interest in drag kings, but as the workshop leader I felt that my primary responsibility was to the participants, that they should not feel exposed or uncomfortable. When it became clear that the cameras were not going to be removed, I insisted that the participants' identities be protected by only filming the lower halves of their bodies. The results were of course a waste of time and footage for the film crew, but the presence of one extraordinary woman at that workshop—sex activist Laura Méritt—helped ease the tension in the situation for the participants. With her delightful, trilling laugh, Laura made light of our plight, and her enthusiasm for this opportunity to take on a male persona inspired everyone else in the room. At the end of the workshop, in our male guises, Laura led us on a tour of a male Berliner's nightlife, getting drunk in bars, visiting porn shops, and ogling the dancers at Berlin's biggest sex club, SexyLand, from which we were ejected for not knowing the correct etiquette. It turned out that we were supposed to get up and hire the dancers individually, not just sit staring at them. As we departed, a very tall and menacing transvestite screamed after us, "Was bist du?

Sind sie Frauen oder Männer? Was? Was? Was? Du Scheisse!" (along with some other German expletives that I didn't understand). Outside we all stood against the wall of the club laughing uncontrollably for a few minutes before deciding where to go next. That night really started something. Laura has remained active in the thriving Berlin drag king scene ever since, and in 2007 she wrote an article about the impact of that first workshop for the book *Drag Kings: Mit Bartkleber gegen das Patriarchat* (With Beard-glue against the Patriarchy), for which I wrote the foreword (see Thilmann, Witte, and Rewald 2007).

A spirit of adventure and the possibility to be more—to expand beyond the limitations of the "female" role—were what fueled the interest of the German workshop attendees. In 1996, I presented additional German workshops and gave talks in Hamburg and Düsseldorf and at the Munich Buchwoche (Book Week Festival), and my work was covered by journalist Claudia Steinberg for German *Vogue*. I was also invited to Switzerland for the first time. In Zurich a trio of artists, Sabina Baumann, Lilian Raber, and Christina della Giustina, had created a festival with the delicious title Erotisch aber Indiskret (Erotic but Indiscreet), which sought to poke fun at the "right" of men to keep their sexual activities protected, privileged, and secret. Indeed, the festival had come about in the first place *because* of an act of censorship. The organizers had previously mounted an exhibition "Oh Pain, Oh Life," that had been advertised using a line drawing by Ellen Cantor of a woman's G-spot being stimulated. The exhibition was closed down on the grounds that in Switzerland it is illegal to pee—or to depict peeing—in public. A legal challenge to this ruling was mounted, pointing out that this was an image of ejaculation not urination. They labored the point about this injustice to such an extent that Zurich's city council was embarrassed into funding a whole festival of erotic, feminist art. Among those represented at Erotisch aber Indiskret were the aforementioned Laura Méritt, Annie Sprinkle, and myself. My performance of *Drag Kings and Subjects* was staged in (of all places) the wine vaults of a convent—near the center of Zurich—and the piece prompted much discussion and uproar in the press. As a result, I was invited to perform again at the Frauenraum Reitschule in Bern that November as the main act in a national party titled The Night of the Drag Kings and Subjects. For that event, hundreds of men and women in their chosen drag outfits came from all over Switzerland to participate. The excitement at

the performance was palpable, and I heard later that the party had already begun out on the highway—at gas stations on the way to Bern—as people stopped to buy gas and noticed each other's outfits, realizing that they were all going to the same place.

Apparently this huge celebration of cross-dressed wildness at the Frauenraum marked something of a sea change in women's culture in Switzerland, not least in admitting biological men (albeit dressed as women) to a traditionally female-only space. Prior to this, the Swiss women's scene had become rather dull and politically correct. Foundational feminist ideas had been worked over too many times without fresh input, and there was a distinct lack of energy or effervescence in the community. Women's culture needed a big injection of joy—a kick in the ass—and I think the sheer sexiness of drag king performance offered that. It was a way in which ideas about alternative genders and sexualities could be physically embodied and "enlarged" upon. Similar excitement was apparent all over Europe. In 1997, I crossed the Atlantic repeatedly to perform and give workshops in theaters and at festivals in Vordingborg in Denmark, Helsinki in Finland, Berlin, Amsterdam, London, and Leeds in England. (This last appearance was a follow-up to my workshop at the Queer Up North festival in Manchester the previous year.)

For me, though, the high point of my drag king experiences in Europe came in 2002, when Bridge Markland and I codirected the month-long *go drag!* festival in Berlin. Bridge is an inspiring performer, a bald, curious-looking androgyne whom I have known since she participated in one of the very first drag king workshops in New York in 1990. The two of us worked together to create an international showcase of female-to-male drag performance that included theater and club events, as well as workshops, seminars, and film screenings (including Gabriel Baur's 2001 documentary film *Venus Boyz,* in which both Bridge and I are featured along with other leading drag kings from New York and London). Bridge secured the core funding from Berlin's Hauptstadtkulturfonds and arranged the venues, and together we curated the program. Bridge knew the best of Berlin's drag kings, and I was able to bring together some of the most talented of the performers I had encountered during workshops and performance residencies around Europe.

The number of women who flocked to Berlin that summer to attend the various *go drag!* events was extraordinary. The program featured a

good dose of the cabaret-style drag king performance also familiar in North America. The seven-strong Kingz of Berlin, for instance, are the best lip-synch troupe I have ever seen, except perhaps for the Chicago Kings, but they were given a run for their money by the Pussycoxx (also from Berlin), a mouthwateringly cute, three-piece boi band whose members dance hip-hop in perfect unison. Antonio Caputi, a smooth German drag king who styles himself as a "gigolo," proved the perfect cabaret compere. There were also many other forms of performance on view. For example, dance artists Sarah Spanton (from Leeds) and Doris Plankli (Bolzano) both presented extended studies in gender fluidity and ambiguity: Sarah performed as both an androgynous sailor and a sexy musketeer (complete with Louis XIV wig), while Doris, also working with a rapier sword, presented a poetic dance-dream in which she metamorphosed from mythical creature to cowgirl to buccaneer to angel. The actress Barbara Kraus from Vienna also did a tour of identities in *Wer will kann kommen,* transitioning from the sluttish Julie to the wannabe macho man Johnny (whom she had created at the first workshop I ran in Vienna, in 1998), while interacting skillfully and humorously with the audience. Another highlight for me was *this is not my body,* performed by the Scandinavian theater troupe Subfrau. I had first worked with this group during a three-week residency in 2001 as part of its members' final year of studies at the Helsinki Theatre Academy. Their theater training meant that Subfrau brought real precision to their exuberant performances as a group of all-singing, all-dancing Viking males who, rather than just raping and pillaging, demonstrate their underlying vulnerability and desire to love and please.

Two of the established stars of the festival were Bridge herself and the equally bald Dred Gerestant, whom I was able to bring in from New York. Dred packed the theater with her one-woman show *D.R.E.D: Daring Reality Every Day,* a tour de force of constantly mutating gender transformations in which she works her way through a whole rack of wigs and costumes to create the dreadlock look, the giant Afro look, the Superfly and Shaft looks, the street hooker look, and finally even an African goddess look. Dred hardly spoke throughout the piece, but the continual sense of male and female characters morphing into each other (a Rasta in a miniskirt; a gangster in a halterneck dress) was mesmerizing. Bridge's *Bridgeland zwei* was equally compelling. Like an updated version of a Weimar cabaret performance, she presented an

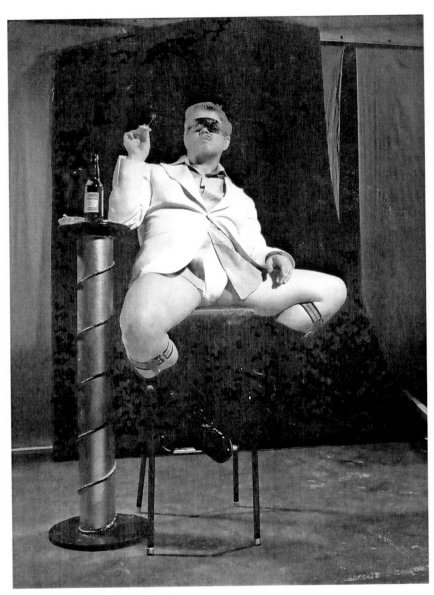

Diane Torr as Mr. EE, in *Bull,* by Ian Smith and Mischief La-Bas. Albany Theatre, London, 1997. Photographer: Nick Simpson. Used with permission.

abrasive cartoon of different gender stereotypes (a woman in evening dress and wig, a bald man in suit with penciled on mustache) and at one point climbed into the audience half naked (half female, half male) to lick at them with her long, insectlike tongue. The piece concluded with an eerie movement solo suggestive of some polymorphous creature that has gone beyond gender entirely.

My own contributions to the festival included a performance of *Drag Kings and Subjects* and an appearance—at one of the cabaret events—as Mr. EE. This character is my own, perhaps rather perverse, answer to the need for drag kings to have a short, sexy, musical routine in their repertoires. I originally developed him for a piece called *Bull* that the Scottish-based performance company Mischief La Bas created in response to the legend of Theseus and the Minotaur. Director Ian Smith commissioned eight performance artists to install themselves in various spaces at the Albany in Deptford, London (1997), and the following year at Tramway in Glasgow.[2] Spectators had to navigate their way around this "labyrinth" on foot. For my contribution, I chose to focus on the idea of the bull's testicles (which tend to be quite prominent!) and to think about testicles as aesthetic objects removed from the male body. I had been investigating issues around sperm counts dropping, apparently because of the environmental impact of industrial chemicals in crop soil and drinking water. In men's bodies, these infiltrations are read by hormone receptors as oestrogen and have resulted in an increase in oestrogen levels. I was intrigued by the fact that humans seem prepared to ignore such emasculation by stealth, even though a similar drop in the sperm count of bulls would mean a serious drop in their monetary value. I commented on all this in a kind of mock-polemical monologue, which was supported by a projection sequence including thirty slides of different male testicles (which I commissioned from gay photographer Gordon Rainsford), which were cross-faded with slides of cute male animals. At the Tramway performance, spectators were also given pairs of tiny pink water balloons to take home with them (I later heard that some people hung them in car windows like fluffy dice).

To introduce this performance, I created a mysterious character who

<hr>

2. The other guest artists included Ken Campbell, Anne Seagrave, André Stitt, The Divine David, Paul Johnson, Graeme Wilcox, and Jeremy Robins.

clearly had "balls," but balls you didn't necessarily want to see. Mr. EE is a kind of buffoon but thinks he's suave and sexy. He always wears a black eye-mask, to insist on his mysteriousness, and he dresses in a white tuxedo jacket, velvet bow tie, dress shirt, shiny black dress shoes, short black socks suspended from garters, and white Y-front underpants (appropriately stuffed). He's all dressed up but with no trousers, so he's weirdly exposed below the waist. His main performance task is to execute sexy dance moves for the audience's pleasure, but of course he repulses as much as he seduces. These are not the moves you would associate with a middle-aged man half undressed.

My original subtext for the *Bull* performance was that Mr. EE was in a gay club, cruising the guys coming in, but that was never made explicit to spectators because he never speaks. In fact, it was never made clear (and never has been since except where the context gives it away) that Mr. EE is played by a woman; he's simply an enigma, a question mark. I think when you are masked in a performance you give people all kinds of possibilities for projection, and I always accompany Mr EE's prowling with an intense techno track by Sven Vath, "Accident in Paradise," which builds in tension as it goes on, heightening a sense of anticipation. The character works really well in club and cabaret contexts because he can stalk about among spectators and tables and single people out for attention. I'm building here on my go-go dancing experience, picking out individuals and looking them in the eye as if to say, "You, yes you, you're the one." But Mr. EE's moves come not from go-go but from watching gay porno tapes. I wanted to study and appropriate the ways in which gay men turn each other on. There are moves that are implicitly sexy—like sitting down across a chair in a particular way, bending over luxuriously, or doing push-ups—and then there are also more openly lascivious or flirtatious moves. People laugh when confronted with this, of course (and I'm certainly chuckling inside as I perform), but there's also a degree of discomfort or uncertainty. Many times I've heard people asking later, or have even been asked myself, "What was that guy *doing*?" I suppose you could say that Mr. EE is my tongue-in-cheek response to drag king subculture. He's a kind of anti–drag king, not only because his female-to-male status isn't made explicit, but because the response he elicits from audiences for his hot, sexy, thrusting routine is more than a little ambivalent.

Five | Drag and Empowerment

It's not that Diane's doing drag was unique, because everybody was doing everything in New York back then, but I think what Diane did was study it. I mean, I had experimented with drag to get into men's toilets back in Nova Scotia, before I even came to New York, but it wasn't until I took her class that I realized I wasn't really standing or sitting or walking like a man. I was just dressing up. . . . When I took her workshop, the hardest part was really the psychological leap. You could prepare yourself with the beard, the suit, with ideas about your character—but it was the dwelling in that character, going out into the world as that character, that was the most difficult part. I think I probably knew this instinctively, because although I knew Diane was doing these workshops, it took me years to get up the nerve to take the class. But it was one of those life-changing events. . . . We think we understand men by looking at them, but it's not until you really go into their bodies and go through their motions that you start to see things from "the other side." It helps to put your body in another place, so you can make new grooves in the gray matter. Diane's work genuinely helps women to go into places where they haven't been before.

—MARTHA WILSON (2007)

The last chapter dealt primarily with the club and contest side of the drag king world, the side I think of as developing from Johnny Science's innovations. In this chapter, the focus is squarely on the Man for a Day workshop and its experiments in passing as male in public. Each time I've taught this workshop, and I've taught it hundreds of times, the people are different and so are their stories. I'm still apprehensive at the start of each workshop because I never quite know what I'll be confronted with. Sometimes people are looking for a sexual thrill through the frisson of cross-dressing, sometimes they are artists or performers and see the workshop as a way to make a public art performance, sometimes they are looking to explore what they see as an underacknowledged masculine side to their personalities, and sometimes they're looking to develop male alter egos for use in situations where they feel vulnerable or exposed. I've even had an effeminate man participate, one who wanted to learn how to temper his "girliness" for occasions

when a more conventional masculinity would help him pass unremarked. What unites many of these diverse objectives, though, is a sense of the possibility for personal empowerment, the idea that experiencing the world through "another set of eyes" or being perceived differently by others, will open up new perspectives and possibilities. There's also something pleasingly fanciful about the whole process, and I see what I do as facilitating fantasy.

Each person is responsible for the identity of the male she conceives of for herself, and I ask participants to bring with them the clothes they will need for their imagined male personae. In fact, I try to encourage people to bring two sets of clothes, so that they have options, because sometimes the first idea just doesn't work out. The fact is that, whoever you might envisage yourself becoming, you don't really know who you're going to be until you see yourself dressed and made up. You have to respond to the person you see in front of you in the mirror, and so you have to be willing to adapt your ideas. "I had thought I would want to be a 'new man,'" one journalist commented of this experience, "sensitive, expressive, searching and modest; but the moment I glared at my unsmiling, mustached mug with its five o'clock shadow, I knew I had to be—longed to be—mighty man: crude, virile, self-assured, smug, and successful in all the ways I wasn't" (Lawrence 1997: 19). Of course, not everyone adapts so readily, and because people sometimes have very particular fantasies I try not to be heavy-handed in my advice. I will, however, give people little tips about whether—for example—I think a pair of shoes will work with a particular jacket, and I will tell people if I think they're cutting corners. Wearing women's versions of masculine-styled clothing (be it sneakers, jeans, jackets, or suit pants) will *not* allow you to get fully into male character. There are important distinctions between what a pair of women's oxfords looks and feels like and what a men's pair looks and feels like; you perceive it yourself, and so do other people. It may not be conscious, but it is perceived. So to get both your conscious and your unconscious to cooperate with this process of transformation, you can't cheat on it. (There are detailed tips on the physical transformation process in my "Man for a Day: A Do-It-Yourself Guide" in this volume.)

When everybody is made up and has decided on his basic identity, we'll sit in a circle and discuss why people have come. A recurrent theme in these discussions is invariably the desire to experience from

the inside the physical behavior that men adopt, and the body language that portrays a sense of entitlement and privilege in the world. How do they use their bodies to portray a sense of owning space? How do they use their voices to express a sense of authority? How do they control situations through gestural statements? These discussions are always lively and frequently remind me of the feminist consciousness-raising meetings I attended in London and New York in the 1970s. Women today are often still acutely conscious of their socially prescribed "femininity" and of the constant disparity that exists between men and women. At some point I'll tend to interrupt the discussion, however, to point out how everyone is sitting. If you have a roomful of women sitting in a circle, they're very likely to be sitting up or forward on their chairs, engaged with the group, wanting to show that they're listening. All of that, too, is socially learned. A group of men in the same situation will probably be leaning back in their chairs, more defensively; there will be a lot of crossed arms and open legs. It's much more awkward because men haven't necessarily been socialized to be communicative in groups and they have issues such as who's going to be the top dog in the pack.

It's from there that I'll tend to start working with the group on simple body awareness and particularly on the idea of taking up space. Men tend to assume that they own whatever space they're occupying in a given moment; they won't sit perched on the edge of a chair when they can fill it up completely. Partly this is just a matter of comfort; if a man sits with his legs too close together, his balls will feel pinched. So we'll start off by experimenting with just relaxing by sitting with our legs wide open, or crossing them in the shape of a four (ankle to knee), and seeing how this sense of expansion feels. Then we'll try the same thing in terms of moving around the room. Usually I'll demonstrate how I would walk as Danny King. My hips are tight, I'm moving from the shoulders, and I'm moving forward and sideways at the same time, so I'm taking up more space. It's not just unidirectional movement; I'm occupying space in several directions at once. Even when stationary, men take up space like obstacles. Imagine going to a club event or seeing a band. You can't move past the male punters, who are standing there like walls, and as women we often end up squeezing our bodies through the available gaps. I try to encourage people simply to have the confidence to stand their ground and walk in straight lines without

feeling the need to move out of the way of people coming in the opposite direction. Imagine the world as a grid pattern, and stick to the lines! That's one of the first things that I noticed when I first went out as Danny, that people stepped aside. I was dumbfounded at being given so much space.

Participants usually grasp these initial pointers quickly, but when I then start having them introduce themselves to one another, in character, the cracks start to show because in terms of body language and body distance they're usually still behaving as women. Women in general get closer to each other than men do in social situations, so *as* men they have to learn to create a distance—and yet not to stand too far away, because that might appear hostile. They have to figure out how to maintain a correct distance between themselves and the other person. A key to this is learning how to shake hands "manfully." When women shake hands, they often stick their elbows out to the side—one of the ways in which we shorten the distance between ourselves and the person we're greeting. Men, however, usually shake hands with a straight arm, and the leverage is from the shoulder, not the elbow or wrist. Women often have to practice this for a long time before it begins to feel natural to them.

One way to work on these spatial issues, and also to develop people's male characters, is through scene studies. I'll usually put two or three people together, often very different types of characters, in a given context to see how they interact. One scenario I frequently use, for example, is a group of guys getting stuck in an elevator. This forces presumed strangers to interact, and it also forces some attention onto *how* these men would respond to such a situation. At what point would they start to speak to each other, for example? At what point would they start to face each other instead of facing the elevator door? How friendly or competitive would they become? Frequently, these new men will end up trying to break open the door, as if in some parody of action hero behavior. Afterward I have to point out that elevator doors aren't made to be broken open and that the really difficult thing for some men to cope with might be the waiting around to be helped. What would they *do* with that time? I'll also invite other participants to provide their own comments on what they've observed in the scene. It's very difficult to improvise in character with people watching you, particularly when you're trying to come to grips with male body lan-

guage, but performers and observers alike learn a great deal through this process.

Sometimes during a workshop, I'll present a more involved performance of masculine and feminine physicality to prompt discussion. "A man fries an egg," for example, is a satirical essay in staccato movement. Danny King goes to an imaginary counter and mimes getting out eggs, a frying pan, and oil, then cracking the eggs, cooking them, and making some toast to go with them. Danny does all this in a very linear, plodding manner, doing one thing after another, as if he's having to think carefully about each step. I'll then demonstrate "a woman" frying an egg, using motions that are much more fluid and animated. She's multitasking, getting the bread in the toaster while also managing the egg, and she gets the job done much quicker. Yet she appears less defined in her movements, almost vaporous; her fluidity makes her less *visible*. When women are in a flow of action, there's no real weightedness to what we're doing, whereas the staccato, masculine quality to Danny's attempts makes it seem as if everything he's doing is purposeful and significant. There are lessons to be learned here in terms of giving the *appearance* of being in control of a situation. Other people will give you that control, very often, if you assume it.

Depending on what people's characters might need, we'll also go over details such as smoking like a man or eating like a man. Of course, all men eat differently, but generally speaking men are not as self-conscious as women about the way in which they eat. It's a functional thing; they're hungry and they need to eat. The food goes from the plate straight into the mouth. They often stuff quite a lot in, and if a guy is eating a sandwich the ends of his fingers might even go in with it. If he's using a fork, he'll put the fork right into his mouth, not nibble daintily at the end of it. When he picks up a glass or cup, he'll use his whole hand, as if to say, "I own this cup and I own this saucer I'm picking it up from." And when he discards paper napkins at the end of his meal, he really is *done* with them; he'll scrunch them up and toss them onto the plate in a single action, rather than folding or placing them.

Of course, all of this is very, very generalized, and I try to explain to people that these details have come from my observations of particular types of men sitting in diners in New York. In the Four Seasons, men would be eating very differently (they wouldn't have paper napkins for

one thing). So I have to be clear about contextualizing where this information has come from and to encourage people to make their own observations, whatever is relevant to their characters. I don't want them all just to become clones of Danny King. I do, however, encourage people to be bold and pronounced in their masculine actions for the sake of clarity. As a result, I'm sometimes accused of promoting stereotypes—reductive binary oppositions of male and female behavior—and of course it's true that none of the distinctions I demonstrate in the workshop apply to *all* men or *all* women. The fact is, however, that most of them do hold for a sizable proportion of the population, and what we're doing in these early stages of the workshop is sketching out recognizable signifiers of "male" behavior. If a woman is going to have any hope of passing successfully as a man outside the workshop, she needs to get the broad brushstrokes right first. The point is not to reinforce stereotypes, though, but to undermine them by demonstrating that women, too, can exhibit this behavior and make it look natural. You need to work through the stereotypes in order to get past them to your character's distinctive mode of individual expression.

Sometimes participants protest that they want to create a feminine or effeminate man, and when I can see there is real curiosity about how to achieve this I'll try to help facilitate it. More often than not, though, this is just a cop-out. The woman doesn't want to try too hard in developing her character, and she hasn't registered that "feminine" behavior in men is not at all the same as it is in women. Even the queeniest gay men have been conditioned, while growing up, in much the same way as straight men, and that conditioning is usually still apparent in certain ways, however fluid and expressive they might have become physically. So for a woman to assume the character of a feminine man is by no means easier than assuming that of a "manly" man, and indeed for most it's much harder. Women often find that they are far more intuitively aware of how to present typically "straight" male behavior, because we've had to learn those signals in order to know how to protect ourselves.

Obviously, the more time participants have to work on their characters the more complex and nuanced they become. Although the workshop started out as a one-day event, that's not usually long enough to get into much depth, and so I'll frequently insist on a minimum of two days when I'm invited to teach it. Ideally, the study should

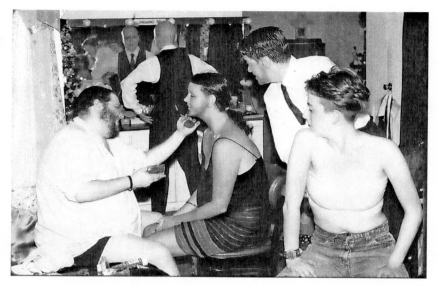

Sprinkle Salon, New York, 1990. Left to right: Johnny Science, Bridge Markland, Jwala, Diane Torr, Chris Teen. Photographer: Annie M. Sprinkle, Ph.D. Used with permission.

be sustained for much longer. (I have taught versions as long as three weeks in theater academies and art schools in Europe, and these have never seemed "too long.") When working within a limited time frame, though, it's necessary to work on mastering general principles.

> Go to the extreme so you can take it back. I would teach that, too, be-
> cause otherwise it's just going to be mushy. You have to play with the
> cartoons and the extremes before you can refine it. Fake it till you make
> it. It's like when you first get a massage from someone. Hurt me first be-
> cause then I can say not so hard; that's way better than it just being ten-
> tative and mushy and unclear. (Shelly Mars 2007)

Another key part of the workshop is the exercises I teach in extend-ing the voice since men are typically less hesitant than women about speaking out (somewhere in our social conditioning, the old maxim "little girls should be seen and not heard" still lurks). I use exercises de-rived from my aikido training to help participants practice using their voices with greater volume and at a lower pitch. A lot of women (and

men, too) tend to speak from their throats; the sound is forced out from the vocal chords, and it's relatively constricted. I try to teach people how they can use the whole of the torso as a sounding board by extending *ki* energy through the body and out through the mouth. That way the sound flows out over the vocal chords rather than getting strangled. The voice is coming from the gravitational center of the body, and because it's not strained you can increase the volume of your voice and also change its timbre by modulating your breathing. There's a Japanese rowing exercise that's particularly useful for developing this kind of vocal extension. Imagine there's a horizontal string running through your navel and out of the middle of your back that is attached to the walls in front of and behind you. Then slide your body back and forth along this string as if you're on a conveyor belt, using solidly placed feet and slightly bent legs as your levers. As you move, focus on taking large, concentrated breaths in and out in rhythm with this bodily movement. Breathe in through the nose as you move back and extend your breath out through your mouth as you move forward and make these sounds with volume: "Heeee ho, Heeee ho." Over time you get into a kind of trance with your breathing, and the voice opens up. If I have people doing this for about ten minutes, they suddenly find they can speak with really loud, powerful voices, and they're often astounded at their own abilities. Equally important for voice, though, is to think of yourself *psychologically* as male, to learn to express yourself vocally *as* your character. I once worked with members of an all-female opera company in New York who were learning to perform trouser roles. They came to me wanting guidance in gesture rather than voice since they were already trained vocalists. I had to point out to them that voice itself is "gestural." As one of them commented in questionnaire feedback:

> I was amazed to find how little absolute pitch of the voice conveys about gender, as opposed to word choice and manner of speaking. Later I was practicing certain musical pieces "as a man" and "as a woman"— as a psychological exercise only, without consciously manipulating the voice—and was even more amazed to hear how different the two voices sounded, even when singing the same piece. This revelation has been extremely useful to my work.

A useful rule of thumb for beginning "psychological" work is that, while men's voices and physicality are often more expansive than women's, their visible emotional range is typically more limited. Becoming a man, as I often say with tongue only partially in cheek, is an exercise in repression. The journalist Liz Gilbert grasped this point very quickly when I gave her a personal tuition session for a feature she was working on for the magazine *GQ*.

> Granted, there are men in this world who are engaging, attentive, and sparkly eyed, but Luke Gilbert cannot be one of them. Luke Gilbert's looks are so on the border of being feminine already that I can't afford to express any behavior that is "shorthand for girl," or my cover is blown. . . . Which means that gradually, throughout Monday afternoon, I find myself shutting down my personality one degree at a time. . . . All my most animated and familiar facial expressions have to go, and with them all my most animated and familiar emotions. . . . Slowly now, as I turn into Luke, I feel the whole room chill. Toward the end of the afternoon, Diane gives me her best and most disturbing piece of advice. "Don't look at the world from the surface of your eyeballs," she says. "All your feminine availability emanates from there. Set your gaze back in your head. Try to get the feeling that your gaze originates from two inches behind the surface of your eyeballs, from where your optic nerves begin in your brain. Keep it right there." Immediately, I get what she's saying. I pull my gaze back. I don't know how I appear from the outside, but the internal effect is appalling. I feel—for the first time in my life—a dense barrier rise before my vision . . . roping me off from the people in the room. I feel dead eyed. I feel like a reptile. I feel my whole face change, settling into a hard mask. (Gilbert 2004: 208)

Not all workshop participants end up as "reptiles," of course, but the psychological shift is important to consider. If you are a person for whom people stand aside as you walk down the street, for example, you will inevitably view the world differently than a person who is made to feel invisible, and has to struggle for attention.

Since the workshop emphasizes developing characters who can pass plausibly in everyday life, the "acid test" comes at the stage when we

move out of the studio and go outside. The whole issue of "passing" as male is of course a fraught one. On the one hand, as Linda Schlossberg points out in her introduction to a book on the topic, "[P]assing can be fundamentally conservative [because] it generally holds larger social hierarchies in place." That is, one passes by conforming to existing, recognized patterns of behavior, by *not* stepping out of line. And yet, on the other hand, "[P]assing can also, it seems, be experienced as a uniquely pleasurable experience, one that trades on the erotics of secrecy and revelation. . . . This contradiction, we would argue, suggests that there may be something fundamentally 'queer' about the phenomenon of passing itself" (Sanchez and Schlossberg 2001: 3). The potential radicalism in passing lies in the question of who controls the "revelation" of the secret and in what context. In 1989, the year that I first passed publicly as male, a media furore blew up over the death of Billy Tipton, the respected jazz trumpeter, who—when examined by the coroner—turned out to have female genitalia. He had lived his life passing as a man, and the press became obsessed with figuring out why. Did he do it because the music world was biased against female musicians? But if so, why keep his "true" identity secret even from his wife and son, who claimed to have been as surprised as anyone by the coroner's revelation? Then, of course, there was the question of whether people believed that the wife was an "innocent" party. Was she covering up a "lesbian" relationship? I remember being struck by the fact that all this speculation acted as a smoke screen for the key issue, which was that Tipton had lived so publicly as a man without raising any serious "suspicions" even among those closest to him. People don't like to acknowledge that so-called gender norms can be that easy to defy. But how would our understanding of the case have been different if the press and medical authorities had not been the arbiters of its "truth," if Tipton himself, or a surviving friend or relative, had been able to document his experiences from a "firsthand" perspective? The Scottish writer Jackie Kay attempted a fictional version of just such a document in her haunting novel *Trumpet* (1998). Its portrait of a deceased jazz trumpeter, Joss Moody, was inspired by the case of Billy Tipton.

The impulse of the drag king workshop has always been that participants should experience their temporary passing as male as a pleasure and a thrill, an exercise in "keeping a straight face" (although they may be dying to laugh at some of the ways in which they are treated) until they have the opportunity to recount their experiences to others in the

safety of the studio or a bar. After the workshop is over, of course, they also have the opportunity to tell and retell their stories to friends and relatives in their own way, to control the revelation of their own secret adventures. Perhaps, then, Schlossberg's boldest assertion has the potential to be realized: "Passing's ability to be both playful and serious asks us to reconsider our interpretive strategies and forces our most cherished fantasies of identity to self-deconstruct" (3–4).

It is not always possible, though, for every participant to pass successfully. The process by which people attribute a gender to those they come into contact with is instinctive but also complex and depends on a number of interrelated factors. Passing is much easier, for example, if you can find a "setting" where your particular guy can blend in and not stick out. Another factor is the company you keep. I try to encourage people to go out in ones or twos as much as possible because if they go out as a group they become a pack, and in a pack you tend to draw more attention than as an individual. (Also people don't stay in character as well in a group because they often drift into talking about themselves as women and lose the plot completely.) The best way for people to make the observations they need to make is if they go out singly, although pairs are useful, too, if people can stay in role for each other and so help sustain each other's characters. Even so, someone might be completely convincing as male in terms of voice and body language, might have a really good "disguise," and might choose the right setting, but still have difficulty passing if—for example—her basic physical attributes are hard to read as male (e.g., possessing a particularly petite body or slender face).

Interestingly, though, even in cases in which observers become suspicious, they usually don't realize that what they're seeing is a woman dressed as a man; they know something is "off" somehow, but they can't figure out what. Sometimes workshop participants will return from their adventures with tales of being referred to as "that thing" (or other, similar phrases) by freaked-out people who just don't know how to process what they're seeing. To my mind, if you can put people in that kind of interpretive doubt, even for a moment, then you've done something to question their assumptions about gender "reality." There again, misinterpretation can also have dangerous consequences. In Hannover in 1995, a group of workshop participants had assembled late at night and were walking through some streets close to the river when we heard loud, threatening calls from behind us. A gang of Turk-

ish men, immigrant workers, was coming toward us fast, yelling what we eventually made out as "Schwule Sau! Schwule Sau!" (Homosexual Pig!). Realizing we were in real danger of being beaten up, we hastily agreed on a rendezvous point and then ran as fast as we could in different directions in an attempt to defuse the group attack. Thankfully, my drag king "ducklings" all reassembled safely shortly afterward. This is just one story about the potential disadvantages of being perceived as a nonnormative male; it certainly made us ponder how it is for gay men walking about in Hannover. The process of experiencing the world as a man makes one realize firsthand the threats and prejudices that many men face on a daily basis. Dred Gerestant, for example, has observed that she finds it far harder to hail a taxi in New York when in drag than she does as a woman, apparently because of the imagined "threat" represented by African American men.

The flip side of this scenario is the amazing sense of welcome and acceptance that a workshop participant can suddenly experience from men when she is perceived as "one of the boys." As a result, she can also find that she has talents she didn't even know she had. On another occasion in Germany—this time in Braunschweig—I went out in drag with two other women, one of whom was married with two kids and five months pregnant with a third. She was small but easily transformed into a "fat," weaselly looking punk. The other woman had pink hair, so I gave her a thin, pink goatee beard, and together we went to an underground dive bar called the Shark, a setting where I figured they would blend in. The bar had a huge aquarium in it and a tabletop football table, and very quickly my two friends were challenged to a game by two other guys. They had never even played before, so I just told them, "Whatever happens, don't smile and don't laugh and don't say anything. Just hold it in." Much to their surprise they won a game, and so the guys challenged them again and evened the score. It went to "best of three," and by now my friends were developing such confidence in their roles, because they could "pass" as tabletop football players, that they won the last game! They were so elated that we had to leave immediately because we were all just bursting to laugh. Later that same evening all twelve workshop participants assembled for a rendezvous at another pub, where on the stroke of midnight we sang a deep-voiced "happy birthday" to our pregnant colleague.

For those women who find they can pass (often more easily than they dreamed they could), the experience of being responded to as men—after a lifetime of being treated as female—can be revelatory. Take, for example, the following comments from former workshop participants.

Tracy Blackmer: I feel like it changed the way that I hold myself and carry myself. I take up more space now: Diane taught us how to sit with our legs spread out on the subway, to be comfortable, or to stand in that subway car taking up the whole doorway section. I'm a tall person—five ten or five eleven—and I'm broad-shouldered, so I can puff myself up to look bigger, just like any skinny guy can. It was empowering to learn to take up my rightful amount of space. And whenever a woman would come by, I would make way for her, but if a man came by I probably wouldn't. I'd make him move around me. It's these little things in New York, the little turf battles that you have with people—and of course it's a little cheap thrill to play around with people like that. (Blackmer 2007)

Mirjam from Zurich: What surprised me the most and is still important for me [two years later],[1] is the experience of having soooo much space in the world as a man. Women all got out of our way, they looked away, never straight into our eyes. In the line we were much faster than women, the ticket was bought faster, to get beer was easier. Till now this is an incredible experience, and till now I try to remember this feeling when I want to get something, to convince someone, to complain about something. Then I sit very broadly in the chair, put both feet on the floor, feel my ass on the seat, breathe deep and take as much time as I want to explain something. And till now it really helps! . . . Even my mother is now using men's way of sitting, walking, talking, when she has uncomfortable meetings where she has to push something through.

Mara from Germany: [I learned] that it is much more "normal" to pass than not to pass, and therefore I can be more secure as a man. . . . I enjoy more and more the feeling of being ascribed to be a man, [and] the in-

1. In 2004, my laptop computer was stolen and with it a collection of e-mailed questionnaire feedback forms. I e-mailed all those past participants for whom I had contact details, asking if they would be willing to reconstruct their feedback and send it again. This resulted in some intriguing responses indicating the longer-term impact of the workshop.

ner question: "how would you do that as a man?" is something that is opening up a way of reacting, of more thoughtless self-confidence, that is empowering—that is freeing me from the limited bunch of patterns of behavior you have as you constantly consider yourself implicitly as female. And it made it easier for me to play with the performance of femininity: now I have the feeling that I can allow myself to play with femininity because it is one option of at least two. This is also really empowering.

Anonymous German, age twenty-nine: I never was totally happy about this being-a-woman. I think there is a lot more inside of me than the role society offers. As a woman, I often feel like I'm much too kind, much too polite. [But] going drag helps to get rid of the gender you were educated in. After the workshop I had a lot of energy; I was so brave in the next few days—remembering "the world is made for me"—that I finally asked the woman I was interested in for some weeks to take me home. Now I got a new love. Nice effect!

Julie, twenty-eight, expatriate American in Berlin: [It's] the final proof, as far as I'm concerned, that gender behavior has nothing to do with hormones, genes or other biological factors but is simply learned behavior like any other. [I now have] the freedom to "be a man" whenever I want, even without changing my apparent sex; the fun of "acting like a man" while wearing skirts and make-up.

Giving people more options is what this whole process is about. Nobody is suggesting that women cease to be "feminine" as and when it suits them. Indeed, very often I find that it's better *not* to confront a situation in the way that Danny might; you have to know at what point to just say nothing, to assume that certain privilege of being the female who's in the background. Part of our wisdom is to know when to speak and when not to speak. But it's all about strategizing, and traditionally women have conceded too much power through nonverbal behaviors like constantly smiling, apologizing, nodding, and agreeing, trying to make other people feel at ease. It's a total no-contest situation. The workshop helps to give women access to behavioral options that allow them to have more self assurance, to have more sense of their own autonomy and their power in the world.

I've heard all kinds of different stories about the ways in which women have used what they've learned during the workshop. One New

York–based artist, for example, had been trawling galleries all over the city trying to get people to look at her slides and think seriously about exhibiting her work. After taking the workshop, she went around to some other galleries with the same slides, but as a male artist character, and found that she was received very differently. She finally got herself a show. Another woman went in drag to buy a car because she had never been able to get the salesmen to treat her seriously. She knew all about carburetors and transmission fluids, but the salesmen would just try to catch her out, as if her knowledge was a challenge to them. When she went back as a man, she was treated completely differently; the salesmen simply assumed that this "guy" knew what he was looking at and didn't try to mess her about. All she had to do was make a few grunts and appreciative noises and she was able to cut herself a really good deal.

I've had similar experiences myself. On one occasion a friend of mine was in hospital with serious burns, and she couldn't see herself properly because of the dressings. She wanted to find out the extent of the damage, but the doctors were all just making reassuring noises and avoiding her questions. I dressed up as her "boyfriend" (she's a lesbian) and spoke to the doctor on her behalf. I was able to be really up front because, hey, if this woman's going to be disfigured I don't know if I'm going to want to stick around. That, at least, was the subtext of the way I addressed my questions. And, sure enough, the doctor gave me a lot of information that he hadn't given to his patient, which I duly passed on to her.

I would never idealize incidents like this; they simply underline the kind of unthinking chauvinism that women face every day. Passing as male in order to "play the game" with men is a short-term strategy for dealing with immediate practicalities. In my friend's case, the situation was urgent. Or take the case of single mothers and how useful it might be for them to adopt a male persona if they have to talk to somebody at a school, or a medical or social authority. Single mothers are at a disadvantage because they don't have ready access to male authority and the kind of built-in respect it is afforded. But if they could perform as men, they could show up as the father, or get one of their friends to, and that would completely change the equation. Of course, some people will be appalled that I'm saying this, but I'm talking about confronting realities. As feminists, we've disentangled a lot of knots around what is expected of us as women, but to put those liberating in-

sights into practice you need different strategies, and passing temporarily as male can be one of them.

On one occasion in the 1990s, an activist group called Women's Health Action and Mobilization (WHAM) asked my advice on how to deal with a lobbying visit to Washington. The organization was founded in 1989 and had close links to the AIDS Coalition to Unleash Power (ACT UP). Its members knew how to launch street protests and stage sit-ins, but they weren't sure how best to gain a serious hearing on Capitol Hill, and they were very concerned about a bill on the federal regulation of silicone implants that was being read in a committee hearing. WHAM had all kinds of research at their fingertips about operations that had gone wrong, so that implants had burst inside women's bodies or had become loose and drifted out of place. They wanted to make a statement at this hearing, but they knew that access was going to be limited for members of the public, so I suggested that they should dress and behave as men. They all wore suits, shirts, and ties, and I gave them a tutorial in how to walk and talk. I stressed that they shouldn't shout and yell but just display the kind of self-reserve and confidence that would suggest they *belonged* in that hearing. In short, they should go to Washington and act like they owned the place rather than yelling vainly at the doors of power. Some of them, I have to say, were very convincing, and, sure enough, they gained access to the hearing and were able to read out their statement.

When people protest that this kind of subterfuge is giving too much power to men, my response is, no, the problem is that men already have the power, and women still don't have much access to it. Even female business executives frequently turn out to have less power than one might assume. At another workshop in Hannover, I had a participant who was an executive with the automobile company BMW, and she had that kind of masculine businessperson arrogance about her even before dressing as a man; that was how she'd got to where she was. And yet she turned out to be desperate for attention. When a few of us went to a café in drag, she kept looking around to see if people were noticing her, but nobody responded because they just assumed we were men. So when she paid the cashier she said, "Did you know that I'm really a woman?" After that, the cashier was alerted to the fact that some of the rest of us weren't men either; word got around, and sud-

denly we were all under scrutiny. It had been so unnecessary for this woman to blow our cover like that, but talking to her later I realized that her need for attention stemmed from the fact that—as the only woman in board meetings at her company—she was constantly ignored when she spoke. Her ideas would be picked up by a male colleague, and he would be acknowledged for them, but she never got any credit, and she had become increasingly frustrated. How could she assert herself in that high-powered work environment? I suggested that sometimes the best way to assert oneself is to have the confidence *not* to—rather than seeming too desperate to impress—but I didn't envy her situation. According to some recent reports, female executives are leaving businesses faster than they're being recruited because of the prejudicial environment. A 2006 report by Catalyst, which studies women in the workplace, found that women who act in what are considered stereotypically feminine ways—such as "focusing on work relationships" and expressing "concern for other people's perspectives"—are considered less competent than their male counterparts, but women who behave in "masculine" ways—"act assertively, focus on work task, display ambition"—are seen as "too tough" and "unfeminine" (qtd. Belkin 2007). It's a lose-lose situation. As the psychologist Peter Glick observes, studies of this sort seem to give women no way to fight back, *as women,* because "the problem is with the perception, not with the woman" (qtd. Belkin 2007). Maybe one way to start to change such perceptions is to fight back *as men.* I have this fantasy scenario in which female executives go home one day as women and return the next day looking and acting exactly like their male colleagues. (They would be stared at, of course, but the answer to that is to just stare back.) I want to put feminism to bed, in a way, to say, look, this discrimination against women is just so outmoded, but maybe if we were *all* men you'd have to stop discriminating.

There are probably a million feminists across the country right now who are watching the show, and they're saying I cannot believe that with all the strides that we have made as women, to get ahead, that you women want to take us back fifty years and say that the only way that we can get ahead is to dress like a man. (Montel Williams on *Montel Williams,* 5 July 1995)

When I appeared on the *Montel Williams* talk show in 1995, along-side drag king colleagues including Shelly Mars and Tracy Blackmer, much of the discussion focused around another guest, Valerie, who was using the techniques Johnny and I had developed to pass as male in her work life. She was employed in a New York recording studio as Val, a bearded, long-haired, rocker dude in leather (which is how she appeared on the show). I completely understood the impulse behind this because working in an all-male environment as a woman can be very difficult. You are treated differently, even by the most well-intentioned colleagues, and Val clearly felt that it was better, in that context, simply to be seen as one of the boys. As she explained:

> I don't think it's the only way we can get ahead, but for me, I've got to be perfectly honest, I tried it out as a joke, as an experiment, and I got into it. There's a part of me that enjoys this because I don't have to deal with the other stuff that I have to deal with, just being a feminine woman. When I'm a woman I'm very feminine, but I grew up getting hit on, and there's a certain point where you get a little tired of it. I thought I'd try this for a while. I didn't think it was going to be a future, but I keep doing it, and part of it is because I'm enjoying it.

Tracy chimed in to explain that she had developed a similar rocker character, Claudio, so that she could go out alone and anonymously to see rock bands play without feeling that she was being eyed up all the time. Montel was unimpressed by any of this and insisted that Val should be trying to "break the glass ceiling" as a woman. To me, though, his feminist rhetoric rang hollow. I had the impression that he was repressing his real opinions about us somewhat, that if he could allow them free rein he might really turn quite nasty. Indeed, he more than once made reference to hitting us on the pretext that we were putting ourselves in danger by dressing as men: "If you front up to me as a guy on the street," he said, "I'm going to *beat* you like the man you want to be." I reminded him that women are constantly beaten by men anyway, so sticking to skirts wasn't a great argument for self-defense. But Montel's whole attitude was that we should get back to being our "feminine" selves as quickly as possible. He even wheeled out a female psychologist, who made the mistake of telling Shelly, "I would like to see you transform yourself back to a woman and be a strong woman."

Shelly responded by prancing across the stage in a hilarious parody of "a strong woman" before pointing out that it *takes* a strong woman to successfully pass as male. Despite the bias of the presenter, I think we made our point.

Ironically, because these passing strategies rely on *not* making the subterfuge visible publicly, TV talk shows of this sort have been among the most public contexts in which the implications have been discussed. There have, of course, been some really poor variations on this theme. I once saw an edition of *Maury Povich* in which a whole collection of New York drag kings were lined up as in a carnival sideshow so that the audience could guess who was "really" a man and who was "really" a woman. (Cue deafening screams of "MAN!" or "WOMAN!") I was more selective in my own appearances, and I made a point of appearing only on those shows that paid a proper appearance fee for artists. (A lot of them—even *Oprah!*—seemed to assume that I should just "do it for the publicity," but why subsidize multi-million-dollar corporations with free labor?) Perhaps as a result, I've been fortunate to have engaged in some reasonably serious discussions such as the ones on *Montel*, and the *Donahue* show in 1991. Phil Donahue seemed to have a good grasp of what we were up to with the "man for a day" concept, and he even drew a connection between the workshop and the civil-rights-era book *Black Like Me*, by John Howard Griffin (1961), which documented Griffin's attempts to pass as a black man in the Deep South so as to experience firsthand the kinds of discrimination suffered by African Americans simply on the basis of skin color. It was an imprecise analogy in many respects, but it showed that Donahue had a sense of the wider implications of what we were doing and was trying to enlighten his audience. He also made a point of noticing that it seemed to be the young men in the audience that were "not so comfortable with this. What do you care?!" It was an important question, but it wasn't just the young men that objected. On the way out of the studio, a group of women wouldn't let us onto the elevator. They stood there in their false nails and heavy makeup accusing us of letting down "womanhood" as if they embodied that notion.

The least productive of my talk show experiences was an appearance on *Jerry Springer* late in 1993. This was in the days before that show had descended into all-out gladiatorial combat—with the crowd baying "Jer-ry! Jer-ry!"—but it turned out to be completely stage-managed

nonetheless. Jerry talked to me, Tracy Blackmer, and a third drag king guest for a little while at the start of the show before springing on us a man who claimed to represent "the American Society of Men." He ranted on about how women were taking over and men had let this happen and exhorted, "Come on guys, let's get it together!" To me the whole thing was fishy, so I didn't want to respond. As a way of distracting myself, I decided to look at every single person in the audience and try to imagine what they were thinking. (They all looked like they were sucking hard-boiled candy, staring at us with big, saucer-shaped eyes!) By the time I had gone through the whole audience, Tracy had taken up the baton and was creating television by yelling back at the sexist. She could have saved her breath, though, because we had been stitched up. Jerry's little wrap-up homily was along the lines of "It's great to be a strong man in men's clothes, but it's even better to be a strong woman without having to change your look."[2] After the show, the "American Society of Men" representative came up to us in the green room, all friendly, and shook hands. As I'd suspected, he was just an actor doing a job, and in a sense, of course, he'd been doing precisely what we were: presenting a theatrical repetition of stereotypical male attitudes. That irony, though, had not been signaled to Springer's audience. Later I took my revenge by appropriating the idea of an "American Society of Men" for use in my performance piece *Drag Kings and Subjects.*

The truly distressing thing to realize, as a feminist, is that for all the legal and social advances on gender questions in the last three or four decades, all too many people still subscribe to the kinds of attitudes espoused by our actor friend on *Jerry Springer.* And while we might now be able, in many contexts, simply to laugh off this kind of chauvinism, it is also the case that in many parts of the world feminism has yet to make even preliminary inroads into public consciousness. During a performance residency in Istanbul, Turkey, in 1999, I discovered that the notion of "taking up space" takes on a whole new meaning there. If you walk down the street as a woman in the crowded downtown area of Taksim, you have to twist and slide and walk sideways a lot because if you don't you will more than likely bump into a man and then be

2. Unfortunately I don't have a videotape of this show, so I am paraphrasing from memory here.

subjected to verbal abuse (this holds true even for Western women). When I taught a workshop for a group of Turkish feminists, I was astonished to find how much more space I had on the street as a man. I could even feel the wind around my body and my scarf blowing about. Jane Czyzselska, my partner at the time (in work and life), is considerably younger than me and experienced an even more pronounced difference in responses.

> Gender coding seemed stronger in Istanbul than in other cities Diane and I visited with the workshop. I was dressing in quite a feminine way at the time, I had lots of curly, long hair and makeup, and I was being hit on a lot by guys who were really not respectful of personal space at all. They would just come up and touch you in a way that wouldn't happen in the U.K. unless someone was very, very drunk. Yet as soon as I had my drag outfit on, I was totally left alone. I could walk in an absolutely straight line down the street and people would move out of my way. In cafés, I'd been getting unwanted attention as a woman, but as a man no attention whatsoever. . . . In certain places, the guise of a man does afford a certain degree of freedom and agency. You can just go about your own business and engage with people on a nonsexual level. (Czyzselska 2008)

The other side of the "attention" issue in Istanbul is that *married* women simply seem to disappear from view. The Turkish woman I went out and about with in drag during the workshop took me to a restaurant she had been going to with her husband for many years. For the first time ever, she was able to place an order with the headwaiter, a man who, previously, had always deferred to her husband and barely even acknowledged her presence. She couldn't believe that he didn't recognize her.

It took a lot of courage for those Turkish women to participate in the workshop because in a cultural context where patriarchal authority is almost completely unquestioned I don't know what would have happened to them had their covers been blown. In 2006, when I taught a workshop during another residency in New Delhi, India, the organizers took the safety precaution of having a van follow the participants around between sites for backup. I was very struck by the choices these women made as to where they wanted to go in drag. They wanted sim-

ply to go into a bar, for example, which they never did as women, or smoke a cigarette on the street or visit the bazaar at night. One woman wanted to go to a discotheque so that she could drink beer while standing on the dance floor. These things might seem negligible to many Western women, but in New Delhi cross-dressing as men was an opportunity for these women to try out simple, everyday things they had never been permitted to do.

Wherever I teach the workshop, I always have to keep in mind that what holds true for a woman like myself, or a man like Danny King, with our particular cultural, racial, and class backgrounds, does not necessarily hold true for the other people present. The issues and risks always vary according to context and locality. My own basic "performance" remains much the same, because I have to project confidence in my role, but I'm not just repeating a tired old script. Each new version of the workshop tests my own cultural presumptions against the specific situation in which I find myself. In India, particularly, I found that many of the observations I would normally make about the way Western men tend to carry themselves did not apply, and this prompted me to pay particularly close attention to the observable differences.

Indian men appeared, to my eyes, quite soft and gentle, unafraid to hold hands or put their arms around each other in ways that would be considered distinctly feminine (or effeminate) in the West. Their willingness to interact, and in such a tactile manner, seemed a very positive contrast to what I was used to. I would watch Indian men walk side by side along the street and fall into synch with each other, flowing along, and this quality of movement was very beautiful to watch. It also made a strutting hardnose like Danny King seem a strange beast in New Delhi. Nevertheless, American tourists and businessmen are ubiquitous, and I gave Danny a plausible scenario for being there, scouting out fabrics that he could import for his Pittsburgh department store. Just as he does anywhere else, Danny represented an idea of male authority and entitlement that was vital for me to exhibit if I was to remain effectively responsible for the workshop participants in my charge. Moreover, as I quickly discovered, unquestioned male authority is far from being an alien concept to Indians; it simply manifests itself in different ways. Women in India are still not considered legitimate on their own; they have to be escorted by a man if they are not to

run the risk of being assaulted (verbally or physically) or even ab-
ducted. In some parts of the subcontinent, women face enforced mar-
riages and—should they resist or defy their fathers or husbands—the
very real threat of "honor killing" (a pseudonym for murder). Accord-
ing to a report by the United Nations Children's Fund (UNICEF), more
than five thousand brides are killed annually in India simply because
their marriage dowries are considered insufficient (see Mayell 2002). In
contexts like this, the notion of "passing as male"—perhaps even of
disappearing completely into a male identity—presents a potentially
lifesaving strategy.

Of course it would be easy, in a discussion like this, to fall into sim-
plistic oppositions between the West and East—between the developed
and developing worlds—so let me reiterate that every context is differ-
ent. Recently, for example, I have been invited to Spain on a number of
occasions. Spain is a developed, Western European country but one
where feminism has still to gain a serious foothold in a deeply macho
culture. Sexism and racism are both endemic in Spain. You only have
to look at the appalling figures for domestic violence to realize this, or
to note (in the public arena) the monkey chanting that spectators still
frequently direct at black soccer players during international matches.
When one remembers that this nation was still suffering under a fascist
dictatorship as late as 1975, when General Franco finally died, such
prejudicial attitudes seem rather less surprising. Thankfully, Spanish
culture has developed enormously since Franco, and there are some
wonderful artists and activists at work there such as friends and col-
leagues Beatriz Preciado, a feminist philosopher based in Barcelona and
Paris, and members of O.R.G.I.A., a feminist art collective in Valencia.
Yet it seems to be only now, in the 2000s, that the kind of serious bat-
tle for basic respect for women, fought elsewhere in Europe during the
1970s, is beginning to be waged. That was certainly the impression I
gathered during three visits to Spain between 2006 and 2008 to present
performances and teach workshops.

It is not for me, I think, to say too much about the specific relevance
of the workshop in these other cultural contexts. In the end that is for
others, within those countries, to judge. Instead, the next chapter fo-
cuses on my own uses of drag to explore my specific cultural heritage. I
will say, though, that my performance of Mr. EE seems particularly pop-

ular in Spain. Perhaps this masked man reads there as a parody of the kind of preening macho hero so integral to Spanish culture: a matador with his pants down?

POSTSCRIPT:

In 1997, the Manhattan Theatre Club premiered *Corpus Christi*, a new play by Terrence McNally, which retold the story of Christ's birth, ministry, and death by depicting him and his disciples as gay men. Even before the play opened, the theater had received protests and even death threats against members of staff, and on the day of the premier it was besieged by around fifteen hundred religious protesters, furious that this "blasphemous" play was receiving a public hearing. A counterprotest was organized in the name of free speech by Norman Lear's People for the American Way. Around four hundred people, including playwrights Tony Kushner and Wallace Shawn, stood across the street in silent rebuke. I turned up as Danny King, waving a big, homemade placard. Danny's a pretty conservative guy, and street protests are not the kind of thing he would normally get involved with, but I figured that by appearing as a well-dressed man I would command more attention and respect than I would as a funky artist called Diane. Danny is my Trojan horse subterfuge strategy; he evokes a sense of straight white male importance and entitlement. And he believes absolutely, without a doubt, that he is right. That was how I felt about those protesters—how dare they try to silence a play they hadn't even read?—especially in New York City after more than fifteen years of a medical crisis that had killed so many gay men living within walking distance of this theater.

I was angry, but I also saw this as a performance, and I wanted to see what I could get away with. It was amazing to me, for one thing, that I could get past the barriers that had been erected to keep the groups separate. I still don't know how I managed that. One minute I was in a crowd, and the next minute I found myself walking up and down with my placard in front of all these "Moral Majority" type protesters. They were seething with fury at me, but everybody is entitled to their opinion. They were expressing theirs, and Danny's placard expressed mine: "JESUS CHRIST—GET OVER IT."

Six | Drag and Memory

[Claude] Cahun's photographic self-portraits manifest a restless need for metamorphosis already evident in the pseudonyms she would adopt. Born Lucy Schwob in 1894 into a wealthy and renowned literary family in Nantes, she was active as a writer and political theorist in Paris during the 1920s and 1930s. . . . A Jewish, lesbian, surrealist revolutionary, she spent her life as a marginal figure, always fitting uneasily into the numerous circles she frequented—and her creative work was her form of rebellion against any idée fixe about Woman in general and herself in particular.
—SHELLEY RICE

I first saw Claude Cahun's self-portraits in 1997 at a Guggenheim exhibition titled "A Rose Is a Rose Is a Rose: Gender Performance in Photography." It was also the first time I had seen a truly comprehensive exhibition of visual artwork dealing with shifting sex and gender identities. Contemporaries of mine such as Nan Goldin and Cindy Sherman were represented, but it was Cahun's work that struck me most forcefully. I remember being particularly drawn to an image from 1928 in which she's wearing a black and white checked shirt and turning toward the camera. There's a mirror next to her, and reflected in it you can see a pronounced muscle in her neck that seems very masculine. In the mirror image, her gaze goes off at an angle in what seems quite a hostile, aloof manner; she looks for all the world like an arrogant young man. But the face looking directly at the camera seems somehow more feminine, the gaze more searching. The image seemed to me to epitomize the themes of gender performance and androgyny that I had been exploring since the early 1980s. Investigating Cahun, I became fascinated with her entire story. Her assumed name meant that, in her own era, she was often mistaken as a male artist, and referred to in reviews with the male pronoun. To my mind, her work was the equal of anything else produced by the surrealist movement, and yet she was marginalized by the chauvinism of André Breton's circle. In 1937, she

retreated with her lover Suzanne Malherbe to the island of Jersey, in the English Channel, where her family had a country house. Jersey is technically British but much closer to France and thus has a marginality, or "in-betweenness," with which she seems to have identified. The island came under Nazi occupation during the war, and she and Malherbe risked their lives by distributing anti-Nazi resistance leaflets to German soldiers stationed there.[1]

I began to feel a certain solidarity with Cahun, not only because of her boldness but because of her outsider status. I haven't faced the dangers she did, but I've lived my life on the edges, not quite "belonging." In America I'm perceived as a foreigner, but in Scotland I sound like an American. I'm perceived as a lesbian by a lot of straight people and as straight by a lot of lesbians. As a member of the Guerrilla Girls collective of feminist art activists, I thus decided to adopt "Claude Cahun" as my guerrilla identity.[2] Guerrilla Girls were only ever seen at lectures and demonstrations wearing gorilla masks, and we took the names of female artists of the past as our aliases. (The information about our identities is now publicly available since our archives were sold to the Getty Museum.) I wasn't one of the original members of the group, but I joined in 1995 at the invitation of Martha Wilson ("Gertrude Stein"). At first I was "Mary Wigman," the German expressionist dancer, but when I found out that the real Wigman had compromised with the Nazis in order to secure studio space, I switched to a resistance fighter. Charged with the responsibility of representing Claude Cahun, I really had to "get to know her" so that I could speak as and about her at Guer-

1. As a result, they were arrested and incarcerated for the rest of the war. Their house was occupied by German forces, which destroyed many of the artworks and photographic plates Cahun had created there.

2. The Guerrilla Girls are a collective of radical feminist artists who formed in 1985 after a visit to an exhibition titled *An International Survey of Painting and Sculpture* at New York's Museum of Modern Art. Of over 160 artists featured, only 13 were women. The ratio of artists of color was even smaller, and non-white women were completely unrepresented. Outraged by the partiality of the curators and their obvious lack of concern for their discriminatory practices, the Guerrilla Girls launched a poignant and lively attack on sexist practices in art choices made by museums, and by the art world in general. They created a unique combination of text and graphics that presented feminist viewpoints in a humorous manner on posters, billboards and stick-ons. In order to protect their individual identities, the GGs wore gorilla masks when appearing in public and each took on the name of a dead woman artist. In 2001 the Guerrilla Girls split into three separate and independently incorporated groups, to bring fake fur and feminism to new frontiers: Guerrilla Girls on Tour, Guerrilla Girls BroadBand and Guerrilla Girls, Inc.

rilla Girls gigs. I also had to fictionalize her sometimes, improvising in character when people asked questions that the historical record doesn't answer, but I felt that a polymorph like Cahun would have approved of this strategy of creative personification.

I mention all this now by way of introducing the fact that many of my public performances have been concerned with cultural memory. One of the key projects of feminism has been to retrieve and rewrite the "herstory" of culture and art, to reinstate female players and perspectives in the historical narrative. But I have always been concerned to challenge binary conceptions of the "her" and the "his," so as a Guerrilla Girl it seemed appropriate for me to focus on a gender-blending female artist with whom I feel certain affinities. In my performance work, I have often attempted to reconceive aspects of my own cultural history and heritage by using *male* character roles to claim a kind of ownership. Take, for example, the character of Jack Sprat, who misspent his youth as a London mod in the mid-1960s and is still rather pitifully obsessed with that period of musical history. Jack stemmed directly from my anger at reading historical accounts of mod culture, which were entirely focused on the male experience. I had been a mod girl, and these accounts simply did not reflect my experiences at all, partly because mods were mostly from working-class backgrounds, but have often been written about by middle-class intellectuals. I figured that the best way to provide my own perspective was not as a girl, complaining from the supposed sidelines, but by appropriating and satirizing the "central" image of the mod boy.

Social class is another identity zone in which I would classify myself as "in between." I grew up in Aberdeen, on the then new Mastrick council estate (a "housing project" in American terms). Most of the people I knew were from working-class backgrounds, often working in the fishing industry, but my father always insisted that we were middle class. He worked in a factory but as a mechanical engineer rather than a manual laborer, and, being English, these distinctions mattered to him. The people he worked with used to call him "Tony the Toff" because they thought he had ideas above his station. (Danny King, based partly on my father, has always reflected something of this "superior" attitude.) When he moved the family back to where he had grown up, in West Wickham, Kent, in 1963, I was sent to Beckenham Grammar School. Beckenham was one of those London suburbs (like Bromley

and Croydon) where mod culture was most strongly rooted, and I was quickly seduced. Among the other mod girls at the school was Rina Vergano, who was living in Amsterdam when I had my residency there at the School for New Dance in 1994. It was in collaboration with her that I developed Jack Sprat's fifteen-minute monologue performance. (Incorporated as part of the original version of *Drag Kings and Subjects* in 1995, I later pulled it out to stand alone as a solo, which I've often performed as part of group performance evenings. The script is reproduced in this volume.)

In mid-1960s London, the youth option was either to be a mod or a rocker. The sometimes violent confrontations between these two tribes were one of the major social concerns of the period in the U.K. Fights occurred where territories overlapped or rival factions happened upon each other—most often in seaside towns on the south coast of England such as Margate, Brighton, Bournemouth and Clacton. Rockers wore leather jackets, had long, greasy hair, and rode heavy motorcycles. They emphasized their "manliness" by acting loutishly, spitting and swearing, and they listened to 1950s rock and roll by white American artists like Elvis Presley and Gene Vincent. Although I hung out with some rockers for a while, because I liked riding their motorcycles, I found that scene very boring. What attracted me, at age fifteen, to defect to the mod scene was that they were much more concerned with style, with creating their own, distinctive look, which changed almost daily. (One version of it came to be defined as "the mod look," and was later commercialized.) I also preferred the mod choice of music: we generally listened to 1960s rhythm and blues, soul and ska by black American and Jamaican musicians, and of course to white British mod groups like The Who, The Small Faces and The Yardbirds.

The mod look was very exact and highly prescribed, almost like a uniform. Mod boys wore parkas, cut their hair short and bristly, and took militaristic pride in keeping their clothes neat, their shoes shining. They were like the displayers in the bird kingdom, and part of the display was having a motor scooter—a Lambretta or Vespa—which was custom painted and decorated with totems such as a weasel's tail hanging off the back. The mod girl's role was to select the coolest-looking guy with the best scooter. I still remember the rush of riding pillion, travelling in a big pack. The mod boy was usually far more in love with

Diane Torr as Jack Sprat, dancing to The Who's "Can't Explain." Amsterdam, 1994. Photographer: Claude Crommelin. Used with permission.

himself, though, than with his girlfriend. The relationship was like that between Narcissus and Echo: he'd show up with his stay-press pants perfectly creased and say to his girlfriend, "Don't I look sharp?", and the girlfriend would echo, "Yeah, sharp, sharp, sharp!" It's little wonder that the rockers thought of mods as "pansy boys," and yet there was nothing foppish or fey about them: the mods were a provincial, deeply tribal movement, and like any gang culture they could be violently aggressive. There were the notorious, bloody punch-ups with rockers (I witnessed one such on Brighton beach, in 1965), but there was also "domestic" violence. Mod girls were beaten up by the boys, especially when they were coming down off speed.

It was this combination of hypermasculine aggression and a more "feminine" concern for self-display that I wanted to explore with Jack Sprat. In contrast to the unambiguous signifiers of dominant masculinity that Danny King adopts, I decided to dress Jack in skintight leggings, which showed off his backside, almost like ballet tights. Admittedly this was more of a punk period look than mod, but I thought of Jack as someone who would have picked up other subcultural references along the way, on his journey to the 1990s. The London punk scene of the 1970s bore certain obvious resemblances to the mod scene a decade or so earlier—the obsession with style being just one—and both punks and mods loved the big, black, Doctor Marten's boots that Jack also wears. The incongruity of that look (heavy boots and tight leggings) also fed into Jack's movement vocabulary. Could I dance to the Who's "Can't Explain?" as a really crude, "masculine" man, kicking my boots out sharply, jumping around, shaking my ass, and bouncing my head? It was the kind of exhibition that would inevitably seem "too much" when isolated in a theater space; spectators would remain well aware that this was an "act" by a female performer. Yet this was also just the kind of exhibition I had often seen from mod guys. I was interested in the way in which certain kinds of men will happily make spectacles of themselves when having fun in a group, while remaining completely unconcerned with the way their behavior is perceived by others. Much the same goes for individual behaviors such as hacking or sniffing or rubbing the backs of hands across noses, which can seem completely gross to anyone watching, but which certain men are quite un-selfconscious about.

At the same time, I wanted people to look at Jack with more affec-

tion than disgust. His attempts to cling to, and share, his memories of this particular time period, when his own life was at its most energized, make him a slightly forlorn figure. Yet his enthusiasm for the music that drove the scene remains undiminished. An important aspect of this was to foreground the importance of black music for mods, another aspect of the story that is often omitted. Thanks to pirate radio, the blues were very hot with British teenagers in the early to mid-1960s, and a lot of mods also loved other black musical genres such as ska, blue beat, and rhythm-and-blues. There was a kind of fascination with black culture, partly because it seemed "off limits" somehow, and I used Jack Sprat to smuggle that perspective back into the story, too, by adapting some of my own experiences from the mid-1960s such as visiting a house party in Brixton with my friend Sonia, who lived there, and finding myself the only white person in the room.

I adopted a similar "cultural revisionist" strategy in conceiving *Ready Aye Ready* (1992), the first evening-length performance that I created using a male character as its basis. This piece attempted to explore another aspect of my cultural identity, that of an expatriate Scot. In my role as Hamish McAllister, a Robert Burns aficionado, I felt I could bring a certain "male authority" to bear on revising the cosy, antiquated picture of Burns that is usually perpetuated. Yet it was important to me that Hamish did not represent an official, scholarly perspective. I thought of him as a self-taught enthusiast, a shipping clerk from Dumfries, whose lower-middle-class status marked him, in a certain way, as an outsider.

The roots of *Ready Aye Ready* lay in the alternative Burns Night suppers that I'd been cohosting annually in New York since 1986.[3] These

3. Burns Night suppers have been part of Scottish culture for over 200 years. The ritual was started by close friends of the Scottish poet, Robert Burns, a few years after his death in 1796 as a tribute to his memory, and a celebration of his life and poetry. Burns was the author of many Scots poems including *Auld Lang Syne*, which is sung widely at New Year celebrations around the world. The suppers are normally held on Burns' birthday, January 25th—both around Scotland, and by members of the Scottish diaspora internationally. The suppers may be formal or informal but they should always be entertaining. All Burns Night (Burns Nicht) suppers have certain elements in common—including the recitation of Burns's poems, and the consumption of Scotch whisky and haggis (a Scottish sausage-type dish, which Burns immortalized in a poem, "Address to the Haggis"). The formal dinners given by organisations such as the Caledonian or St. Andrew's Societies follow a standard format and are often for men only. However, when women are present, they might end in a ceilidh, where couples dance to well-known Scottish country dances such as "The Gay Gordons" or "The Eightsome Reel."

events had started out as a spoof dreamed up by myself and two other expat performance-artist friends, Eileen Muir and Fiona Templeton. Since Burns Nights were originally stag events, we thought it would be fun to hold one for women only. We hosted a gathering of around fifty women on 25 January 1986 in the dance studio on East 9th Street that I shared with choreographers Jody Oberfelder and Linda Austin. Since Eileen played the saxophone, she substituted it for bagpipes, playing "Scotland the Brave" to herald the arrival of the haggis. Fiona recited some of Burns's poetry, and Eileen danced the Highland fling and the sword dance (both of them had won prizes for these talents when growing up in Scotland). As for my contribution, I was, as Eileen said, "a chancer." I had never been interested in my Scottish heritage when I was growing up—Burns Night seemed a total bore—but living so far away in New York I had begun to feel the need to look again at my roots. So I acted as master of ceremonies that night, reciting Burns's "Address to the Haggis" and sticking it with a dirk (a Scots dagger) as tradition demands. Later I also presented "The Immortal Memory"—a speech about an aspect of Burns's life—which concludes with a toast to him. Very few of the women in attendance had any idea what a Burns Night was supposed to be like, but we all had great fun, and the performance critic C. Carr (who wasn't officially invited) even reviewed it in the *Village Voice*.

After that, our alternative Burns Nights became an annual fixture (Fiona was only involved with the first one, I think, but Eileen continued to host them with me until she left New York). I would always host them as myself, Diane, but when I discovered that I had the capacity to take on a male persona to the point of "passing" it occurred to me that *as* a man I could have access to a certain gravitas with this material that simply wasn't available to me as a woman. Burns's poems tend to sound very different when read by women instead of men. If I could sing "Ye Jacobites by Name" with a stout, full-blooded, masculine persona, I might also be able to subvert the kind of cultural "ownership" that is perceived as going along with that demeanor. When I've heard "The Immortal Memory" at traditional Burns Night suppers, it has usually been given by men who seem completely full of themselves and the fact that they are representing the great Scottish poet. Hamish McAllister gave me a certain "authority" to speak about something that Scottish men have taken as their prerogative and to say things that they might never say.

Cast of *Ready Aye Ready (A Standing Cock has Nae Conscience)* at the Burns Memorial, Central Park, 1992. Left to right: Tom Keith, Adolpho Pati, Paul Langland, Scott Heron, Irving Gregory, Robin Casey, and Diane Torr (as Hamish McAllister). Photographer: Dona Ann McAdams. Used with permission.

I researched Robert Burns's life (1759–96) in detail for *Ready Aye Ready*, reading not just his poetry but obscure biographies from the nineteenth and early twentieth centuries and also some of the political tracts and epistles he had written. It became clear to me that this was not at all the twee national poet I'd learned about at Muirhead Primary and the Aberdeen High School for Girls. He was a real firebrand, a supporter of the Jacobite opposition to English rule in Scotland and of the antimonarchist Jacobins in France. As the son of a peasant farmer, he was also a man of the people, the "people of honest toil . . . scant o' cash." Burns died in poverty at the age of thirty-seven. Looking at a print engraving of his funeral entourage, which seemed to be a mile long, I wondered where all those people were when he was trying to borrow money on his deathbed. I was struck by the hypocrisy surrounding the "Burns story," which continues to be perpetuated. Everyone wants to claim a piece of him, but they don't want the whole picture, just a sanitized version. I wanted to "scribble" on that graven image. I conceived *Ready Aye Ready* as a kind of parodic lecture- demonstration accompanied by slides of Burns heritage sites and memorabilia, and I worked with artist Russell Christian, who drew wonderful, graffiti-style cartoons on some of the slides. Beside an image of the cottage in Alloway where Burns was born, Russell drew a punk walking up the street, and a satellite dish in the garden. We were making fun of the reverence with which such sites are treated.

I wanted the performance itself to begin on reasonably familiar territory, so I hired a bagpiper—the actor and Burns aficionado Tom Keith—who also advised on the script. He piped us in at the start and recited "Tae a Moose" (To a Mouse) early in the piece. This is the Burns poem you might have come across in school because it's considered cute ("Wee, sleekit, cow'rin, tim'rous beastie / O, what a panic's in thy breastie"). After that, though, Hamish led the audience down a less predictable path, with stories about how, for example, Burns once worked as a tax collector to support the upkeep of his farm but would blow his horn ("Auld Nick's horn," he called it) when approaching peasant homes on horseback so that they could hide any undeclared assets before he got there. From this account of his political sympathies, the performance moved on to a presentation of some of Burns's bawdy poems, which were suppressed for centuries and were hard to come by even in the early 1990s. These poems give a hue to the life of Burns that is not often seen. I wanted to expose the hypocrisy of the puritanical, Calvin-

ist Scots who have adopted Burns as their own since his death but are the very people he despised. The full title of my performance—*Ready Aye Ready, a standing cock has nae conscience*—is an old Scottish maxim that refers to a warrior's lance going into battle, but it also has obvious sexual connotations.

On a summer residency in 1990 at the Cummington Community for the Arts in Northern Massachusetts, I had discovered a single, secondhand copy of Burns's *The Merry Muses of Caledonia* in the Globe Bookstore in nearby Northampton. I had heard about this collection of unexpurgated poems from Fiona Templeton, but the sheer unlikelihood of my finding this long out-of-print book, which contains poems written mainly in Scots dialect, in a small New England town made it seem almost as if the book was waiting there for me. Originally published in 1799, after Burns's death, and last printed in the mid-1960s, *The Merry Muses* contains such wonderfully explicit songs as "Wantonness," "Ode to Spring," and "Nine Inch Will Please a Lady," each of which became part of *Ready Aye Ready*.

Come *rede* me, dame, come tell me, dame,	*advise*
My dame come tell me truly,	
What length o' *graith*, when *weel ca'd hame*,	*equipment; well called home*
Will *sair* a woman duly?	*serve*
The *carlin clew* her wanton tail,	*old woman scratched*
Her wanton tail sae ready:	
"I learned a *sang* in Annandale,	*song*
Nine inch will please a lady.	

"But for a *koontrie* cunt like mine,	*country*
In *sooth*, we're *nae sae* gentle;	*truth; not so*
We'll *tak twa thumb-bread* to the nine,	*take two thumb-widths*
An that's a *sonsy pintle:*	*hefty prick*
O Leeze me on my Chairlie lad,[4]	
I'll ne'er forget my Chairlie!	
Twa roarin handfus an a *daud,*	*two big handfuls; large piece*
He *nidge't* it in *fou rarely.*	*thrust; with great skill*

4. "Leeze me on" is an untranslatable expression denoting great pleasure in or affection for a person or thing. My thanks to Tom Keith for providing these glosses on Burns's Scots. (See Keith 2002.)

"But weary *fa' the laithron doup,* of the lazy rump
An may it ne'er be thrivin!
It's no' the length that *gars me lowp,* makes me jump
But it's the *dooble* drivin'. double
Come *nidge* me, *Tam,* come *nidge* me, Tam, poke, Tom, poke
Come nidge me ower the *nyvel*! navel
Come *lowse* and *lug* your batterin' ram, unleash; draw out
 And thrash him at my *gyvel*!" gable [i.e., entrance]

These poems appealed to me because they were funny, and sexy, and also—though centuries old—completely relevant given the arts climate in the United States in the early 1990s. Censorship was a concern on everybody's lips, particularly given the plight of the "NEA 4," the four performance artists (Holly Hughes, Karen Finley, John Fleck, and Tim Miller) whose 1990 grant awards from the National Endowment for the Arts were withdrawn because the content of their work was considered sexually "indecent." I thought it worth pointing out that similar things could be said of some of our most revered cultural icons.

Burns's bawdy ditties were sung in *Ready Aye Ready* by a frolicking, multiracial foursome of male-to-female drag performers, whom I nicknamed the Highland Illusion: Irving Gregory, Scott Heron, Paul Langland, and Adolpho Pati. I had arranged Scottish dance classes for them in Kearny, New Jersey (a community with a strong history of Scots immigration), with the aptly named Mary Stewart. She taught them the sword dance and the Highland fling, and they performed these with great gusto at the performance's climax. Again, I was poking fun at how seriously men in kilts seem to take themselves: why not just lampoon it completely and have them as drag queens? I didn't wear a kilt myself, though, but a smart black suit with a white shirt and tartan tie. Hamish was very well dressed, in an understated way, because I wanted him to seem like someone you might see on television hosting a Scottish heritage program. He knows all this weirdness is going on around him, but he's pretending everything is normal and aboveboard. After each song, he just continues with his talk in a normal, conversational tone because that's how a Scotsman would do it, dry and deadpan.

Ready Aye Ready was presented briefly at La Mama in February 1992 and revived for a sell-out run at P.S. 122 in March. (I also toured the piece that October.) To give the performance a further contemporary

spin, it began and ended with some lewdly sexual hip-hop dancing by three women dressed as "homeboys." Rap music, too, had recently been subjected to censorship with the introduction of "Parental Advisory" stickers on album covers and with 2 Live Crew's album *As Nasty As They Wanna Be* (1989) having prompted a prosecution for obscenity that by 1992 had gone all the way to the Supreme Court. The topicality of the sex and censorship issue helped attract attention to the performance, and so, too, did the reviews. According to *Paper* magazine, "Torr's twist on what could be a dry lesson in English lit makes her a unique and enduring figure in the downtown performance scene" (Palmer 1992). Another critic called the show "a breath of fresh air . . . as literate as [it was] irreverent" (Koroly 1992).

The write-up I treasure most, though, was by Charles Barber, who interviewed me about the show for the gay magazine *NYQ*. He was a charming young man, full of life and humor but with a highly developed sense of sarcasm, and we enjoyed each other's company so much that we met several times after that interview and would just hang out, talking and laughing together. I knew he was sick, but I really thought we were going to be friends for life, and then quite suddenly he was gone, struck down by an AIDS-related illness at the age of just thirty-two. I felt completely lost and weirdly betrayed. I think his death brought home to me, in an immediate way, the recent news of the death of my brother Donald back in London. Donald, too, had died of an AIDS-related illness on 6 January 1992.

That whole period, from the mid-1980s to the early 1990s, had been devastating for everyone in the downtown New York community, and the question of how best to *remember* those who had died became pressing for all of us. We had lost great, inspirational artists such as Charles Ludlam, Keith Haring, and Jack Smith, and each of us had individually lost many personal friends, including, in my case, the filmmaker Steve Brown, writer and art critic Cookie Mueller, and fellow artist and mother Bibi Smith. At times it seemed that every week we were going to a different funeral. This was a community of people who had experienced a tremendous period of creative energy and experimentation in the early 1980s. We had all been feeding off of each other, going to shows and clubs, hanging out together, and generally being stimulated by the downtown cultural scene. And then at a certain point it felt as if we had entered into a completely different zone. There was suddenly a sense of urgency—so many people were dying of AIDS-related dis-

eases—and we really had to start paying attention and doing whatever we could to try to persuade the cultural mainstream, and the deeply homophobic Reagan administration, that money was urgently needed for AIDS research. There had to be a way to cure, or at least contain, this murderous virus. I attended ACT UP meetings regularly and was also part of a small, mainly female group doing our own research, one of many such groups at that time. Most of us had no scientific background, but we were so desperate to keep our friends alive that we attended seminars, read papers, and learned whatever we could, passing the information on at ACT UP meetings.

But there was also the pressing question of how we treated our friends in death. I was repeatedly struck by the incongruity of attending memorials to friends in churches—listening to organ music and Bible verses—when those friends had had nothing to do with Christianity. It was as if their families were controlling the way they were remembered, and this really became an obstacle to mourning for those of us who maybe knew them much better as adults. In 1990, I conceived a performance called *Crossing the River Styx,* which Martha Wilson presented at Franklin Furnace, that attempted to address this problem of mourning. Among the performers were the soon to be famous actor Steve Buscemi, as Charon the boatman, and a live rock band led by composer Judith Dunway, who played original songs such as "It's Your Death," a loud, angry exhortation to take ownership of the way our after-death rituals are carried out.[5] We also had an installation that audience members participated in at the beginning of the evening; they were invited to write a note to someone who had died, saying whatever they needed to say to that person. The notes, we explained, would not be read by anyone living but were literally to be plastered into the wall during the performance (by my then husband Marcel Meijer). These were personal communications to be read only by phantoms. As far as I know, they're still there.[6]

5. The performers also included my daughter, Martina Meijer (age six), writer Linda Yablonsky, and visual artists Isobel Samaras and Russell Christian. There were slides by Nan Goldin, a film by Peggy Ahwesh and Jennifer Montgomery, and costumes by Loredana Rizzardi.

6. There's a footnote here to the censorship debate that was raging at that time, and which Franklin Furnace was right in the middle of. We had one audience member who tried to leave the show because he thought the amplified music was too loud in this small, underground theater, but he found he couldn't get out because the door person wasn't on duty during the performance and the buzzer to let yourself out wasn't readily visible to the pub-

That performance seems to have been quite therapeutic for a number of people, but in 1992 the deaths of Charles and Donald, so close together, hit me in a whole different way emotionally, and I needed a different, more private kind of exorcism. I decided to memorialize them by "becoming" them. I created a character called Charles Beresford, who was based on my immediate memories of the physicality and spirit of Charles Barber and also partly on Donald. The character was never intended for public performance. Like the plastered notes, he was a way for me to deal privately with my sense of loss and also to celebrate these men, to remember what joy they had brought in my life, so that I wasn't just stricken with grief all the time.

I only went out as Charles Beresford a few times, but I had a specific route, which was based on what I knew of Charles Barber's regular haunts. I wanted to be in those places for him now that he couldn't be. I would walk down Christopher Street to the coffee shop where he would have his morning espresso and croissant. I'd withdraw cash at the Chase Manhattan ATM on Sheridan Square and then visit the bookshops, card shops, or men's leather shops that he would go to in that part of the West Village. Then I would wander down to the derelict piers at the bottom of Christopher Street on the Hudson River. Men would go to these piers to have anonymous sex with each other, and they were forbidden places for women. That whole area is a park now, where people go walking and rollerblading, but at that time Manhattan was not being so rapaciously developed and there were many buildings and spaces that could be used as illicit playgrounds. I remember looking up, as Charles Beresford, at one of those ruined pier buildings and seeing men on different levels, walking, cruising, and having sex in total silence. All you could hear was the shuffling of feet and the water from the Hudson River hitting the pier's wooden structure over and over. That moment is imprinted in my mind. I remember feeling like it was the collapse of something.

lic. Having time to contemplate as he waited to be released, and getting angrier by the minute, he realized that the place was a firetrap. After leaving the building, he called the Fire Department, which turned up the next day, shut the place down, and put yellow tape across the door. Martha was never able to use that basement performance space again, but, as there was an exhibition of work by Karen Finley on show in the gallery space on the first floor at the same time, she was able to use the situation to her advantage. Since Karen was part of the NEA 4 controversy, Martha could spin the closure of the building as another case of backdoor censorship by the city. The theatrical producer Joseph Papp gave her use of the Public Theater for a Franklin Furnace benefit in which various downtown performers, myself included, participated.

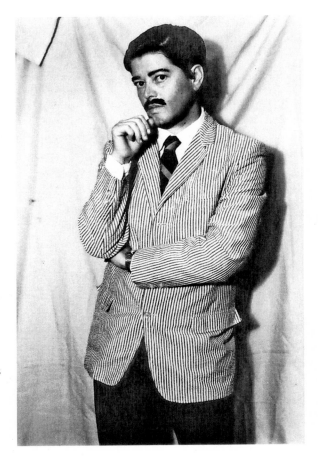

Diane Torr as Charles
Beresford, New York
City, 1992. Photogra-
pher: Vivienne
Maricevic. Used with
permission.

From there I'd walk along Eighth Avenue, to a club that Charles used
to go to called Rawhide. I'd have a drink in there and maybe talk to
somebody, using my version of those sarcastic, witty comments of his.
Generally, though, I was just observing, just making his presence still
felt in those spaces, as if to say this person isn't just going to disappear.
It was a tough act, to pass as a gay man, but it was my way of saying
you're not dead, your spirit lives on. I would give up a day of being my-
self, Diane Torr, in order to embody the memory of Charles Barber.

I eventually realized that other women might also benefit from the
experience of performing as brothers they had lost to AIDS, just as play-
ing Charles Beresford had been healing for me. There are so many sis-

ters whose brothers (whether blood brothers or soul brothers) have died of AIDS, and many of these men were bon vivants, life enthusiasts, and creative souls whose lives deserve to be remembered in a spirit of joy and affirmation. Performing as a loved one is a way to confront loss that is much more positive and creative, it seems to me, than just sitting and mourning, and it was with this in mind that I organized the first "Brother for a Day" event on World AIDS Day, 1 December 1997. It's an occasion I've organized annually ever since.

The venue for that first event was Club Mother in New York's Meat-Packing District, which was appropriate given its history of gay, lesbian, and trans nights. The show was stolen that night by my drag king colleague Shelly Mars, who performed as Peter Powell, a character based on a close friend of hers who had suffered from AIDS dementia. "Peter" launched into a hilarious analysis of "Shelly's" appearance that alternated between high praise for her style and utter derision for her low-down scumminess. Other performances included Martha Wilson's appearance as the late Stephen Reichard, the much-loved director of the Performing Arts Program at the Brooklyn Academy of Music (BAM). In the years since, there have been many memorable impersonations at "Brother for a Day." The visual artist David Wojnarowicz was played by Jean, a fellow member of his band, Three Teens Kill Four. Another year Dred Gerestant performed as Marvin Gaye. It's true that Marvin Gaye didn't die of AIDS, but Dred was celebrating the spirit of someone she thought of as a soul brother who had died too early, and it's not my business to be prescriptive. Indeed, the event blasted off one year with a performance by New York's most sexually confrontational drag king troupe, the Backdoor Boys, who gave it up (with dildos erect) for the dead and the living while lip-synching and humping to the Backstreet Boys' "I Want It That Way." Although the Backstreet Boys are still very much alive, this impersonation nevertheless summed up the spirit of Brother for a Day, a celebration of life, sex, and joy. Life is something to hang on to, and "Come one, come all, but please wear a condom!" has become a kind of motto.

At each of the Brother for a Day events, I have performed as my brother Donald in remembrance of his inspirational life. Because my most vivid memories of him are from the childhood we shared, my favorite performance of Donald is the one I do of him as a teenager, lip-synching to Dusty Springfield. Donald had very particular interpreta-

tions of Dusty Springfield's signature movements. She had a gesture, for example, which involved throwing her hands up in the air and then letting them float down, as if on a feather. Her moves were specific, so you could reproduce them quite accurately if you were as dedicated as Donald was to his idol. Because he didn't have the life experience that lay behind the gestures, his version was a weirdly exaggerated copy; it wasn't Dusty Springfield's gesture, it was Donald's adaptation of it. Yet he did manage to capture a certain dramatic, dignified quality in the way she moved. He wanted to own that kind of poise in the way he presented himself because he was determined to go far, as far away from Mastrick as possible. Indeed, he enjoyed a taste of fame in the early 1970s as a member of a popular BBC-TV song-and-dance troupe, the Young Generation.

In a kind of counterpoint to my campy extravagance as Donald doing Dusty, I created yet another kind of drag memorial to gay men in 1999 in which the emphasis was on ordinary, unremarkable lives. I was in a relationship at that time with Jane Czyzselska, and when I first knew Jane she was living in an area called Bramley in the northern English city of Leeds. Jane had a small, terraced house that had previously been owned by a gay male couple. It was fantastically incongruous, a one-up/one-down with a Jacuzzi in the bathroom! There was also a mirror all the way down one side of the bedroom, designer units in a kitchen the size of a shoe box, and a large, fake-marble fireplace that dominated the living room. It was designed like some fantasy of working-class gayness but in an area where you would hear about queer bashing in local schools and teenage gay suicides. Gay people in Bramley really had to stay well under the radar just to try and live a normal life. Coming into this environment from downtown New York, where gay people are such an integral part of the culture, was really disturbing to me, and my immediate response was to create something that might challenge people's thinking about the stereotyping of sex and gender identities. My initial proposal to Jane was that we should do an installation in this house, inviting people to look around and presenting ourselves as the gay men who owned it, as a way of initiating debate. Jane, however, was quite rightly resistant to having that kind of light shone on her home, so instead the idea morphed into a photographic project.

We dreamed up a life for the two men we imagined living in this house and named them Ricky and Keith. They were a kind of man-and-boy couple, reflecting the age gap in our own relationship: Jane and I

Jane Czyzselska and Diane Torr as Ricky and Keith. One of the images from the *Ideal Homo* installation. Leeds, 1999. Photographer: Gordon Rainsford. Image copyright: Diane Torr.

used to go out together in drag all the time, and we were often read as male lovers even by gay men.[7] We hired the London-based photographer Gordon Rainsford to take pictures of us in various locations engaged in ordinary, everyday activities. So there's one of us in bed together, reading the *Yorkshire Post* and *Racing Post,* and another of us

7. One such misreading is recounted in vivid detail by Jane: "We were staying with one of my friends, John Addy, who had a house out on Fire Island, in the Pines, the gay male enclave. We cross-dressed quite a lot while we were out there to blend in better. One time we visited a men-only bar called the Boathouse, right on the seafront. I was dressed as a young surfer dude, and Diane was wearing a mustache and a blue seersucker suit. She had her period, and when she had to go to the bathroom to change her tampon I went with her. I was kneeling next to Diane in the cubicle as she sat on the toilet, but when the barman came into the bathroom he must have thought I was giving her a blow job. 'Excuse me

outside with Jane's car, looking under the hood. In others, we're shaving in the bathroom together, cooking in the kitchen, and going for a walk on the Yorkshire moors, hands interlinked. We decided on nine or ten images that we particularly liked and used these to create a gallery installation called *Ideal Homo*, which included printed text about the history of Ricky and Keith's relationship. (We decided, for instance, that they had met at Leeds Central Post Office, where they also worked. They weren't part of the Leeds gay community and had different interests. My character was keen on jazz, for instance, rather than clubbing.) There was also a looped audio track on which two gay men with broad, Yorkshire accents are heard improvising a gently comic dialogue about their daily routine. The whole idea was that these characters should seem quite ordinary, that this was just a day in the life of two normal guys, guys who are still alive, still here, just getting on with things. The twist, of course, is that they're not as "normal" as they seem, partly because they're not really guys but also because just living a simple life together is still a very hard thing for gay couples to do in many parts of the world. Hence the title of the installation. *Ideal Homo* has been exhibited in Leeds, London, New York, Berlin, and Tokyo.

Queers are queer because we recognize that we have survived our own deaths. The Law of the Social has already repudiated us, spit us out, banished us, jailed us, and otherwise quarantined us from the cultural imagination it is so anxious to keep clean. . . . The possibilities opened up by the sexual revolution, we have been told, have been foreclosed by the onslaught of AIDS. This claim is both shockingly inaccurate and deceptively true. . . . As we go about making new sexual sexualities in the technologies and misprisions of "safe(r) sex" we also mourn the loss of the "liberation" (however phantasmatical) that stands behind this remaking.

—PEGGY PHELAN, *MOURNING SEX* (1997: 4–5)

gentlemen,' he said, 'I'm sorry, but you can't both be in the cubicle at the same time.' He was quite threatening about it. I just looked at him and said in a very English and probably very female voice, 'You're not serious?' He said 'Yeah, we can get closed down for that kind of thing.' (This was post-AIDS, of course, and the whole spirit of Fire Island was much more cautious than it had been previously.) Later, when I went to the bar to order a drink, the guy said to me, 'I'm so sorry, sir. You know I think your man-boy love thing is beautiful, but really we can't have two gentlemen in the stall at the same time, because the police are watching us and they don't like to have that kind of activity around here anymore.' And I said, 'It's all right, mate, no worries.' He had really believed that we were these two male lovers. We really enjoyed the fact that we could be read as gay men even by gay men, who you would think might know better" (Czyzselska 2008).

It is, perhaps, no coincidence that Diane's private act of mourning as Charles Beresford and her public act of remembering Robert Burns's bawdy poetry occurred in the same year, 1992 (the year in which Ron Vawter's solo performance *Roy Cohn/Jack Smith* also premiered, memorializing two strikingly different gay men, both recently claimed by AIDS). As Phelan implies, the need to recall and reenact a liberated sexuality was all the more intense at a time when conservative forces were using the catastrophe of the AIDS crisis as an excuse to "foreclose" the possibilities of sexual freedom opened up by the countercultural movements of the 1960s. Senator Jesse Helms's notorious campaign against controversial art—and the resultant singling out of openly queer performance artists for defunding by the NEA in 1990—was just one manifestation of that backlash. In this context, Diane's mining of some obscure eighteenth-century poems was both witty and pointed. Burns's uninhibited celebrations of the lusty passions of the Scottish peasant class suggest an exuberant sexuality free of repressive bourgeois mores. The words *fuck* and *cunt,* Hamish McAllister tells his audience with dictionary dryness, were in everyday usage in eighteenth-century Scotland "without the debased meaning they have come to acquire." Sexuality, as Burns's poems insist, is nature. "Ode to Spring," presented with gusto by the Highland Illusion in *Ready Aye Ready,* begins with the line "When maukin bucks, at early fucks / In dewy gress are seen," and concludes with the image of a young man energetically humping a girl in a flowery bower, his "arse beat[ing] time" with the various birdsong rhythms that he hears around him: thrush, blackbird, linnet, and lark.

Such pastoral imagery notwithstanding, *Ready Aye Ready* also shows an acute awareness of the fact that human sexuality is never purely "natural" and uninhibited. As Judith Butler argues in *Gender Trouble,* channeling Michel Foucault, "[T]here is no 'sex' in itself which is not produced by complex interactions of discourse and power" ([1990] 1999: 131). The role of Hamish McAllister, as "master" of ceremonies and self-appointed authority on Burns, neatly emphasizes the presence of structures and laws within which sexual license is granted (or tacitly permitted). *Ready Aye Ready*'s frolicking dancers are invited to camp it up at certain intervals, but are then quietly ushered offstage again with an indulgent smile so the lecture can continue. Hamish strides slowly and purposefully about the stage (even on videotape, you can hear his feet making very deliberate contact with the floor), very much in control of the proceedings. His Burns research, more-

over, often emphasizes the power imbalances that can hold sway in sexual relations. Burns's embrace of "Wantonness for ever mair," Hamish tells his audience, resulted in seventeen to thirty illegitimate offspring (estimates vary), with all the resultant consequences for the women involved. "Burns's bawdry is unashamedly masculine," he continues:

> Bawdry was popular in eighteenth century Scotland (we of course had no pornography then), and they got their sexual stimulus from watching the mating of animals. . . . The viewing of the mating of animals was barred to nobody, except the viewing of the stallion and the mare, which was barred to women, whether spinsters or married. The reason being that women, after watching this act, instantaneously fainted or had an orgasm and wanted to have sex with whatever man came along, regardless of his social station or sexual proclivities.

Diane's deadpan delivery of Hamish's "factual" observations on the intersections of legal and sexual custom represents another deft use of high camp. The disarming tone "neutralizes moral indignation, sponsors playfulness," as Susan Sontag's "Notes on Camp" puts it (Cleto 1999: 64), and the unspoken fact that this is a woman playing a man produces some delightfully layered ironies. So, too, does the contrast with the Highland Illusion's overtly effeminate camp, which is also cunningly employed to comment on Burns's verse. Their version of "Nine Inch Will Please a Lady," for example, is performed in a bizarre, gender-blurred costume of tartan leggings (rather than kilts) and starched white blouses with ruffled collars. These latter are of the sort worn by eighteenth-century men but cover heaving fake bosoms, and are set off by caked-on lipstick and rouge. The performers sing the poem while pirouetting around the stage and simulating blow jobs on each other before concluding with delicious pleas to the audience to "Come nidge me, Tam!" The effect is to playfully highlight the fact that this demand to be roughly penetrated was written by a man, albeit ostensibly in a woman's voice.

This queering of Burns continues shortly thereafter with a solo performance of "Wantonness," this time sung, quite seriously and movingly, to slow violin accompaniment (by Robin Casey). Adolpho Pati, now wearing a tight black evening dress and feather boa, strikes a series of seductive postures throughout the song and gently caresses himself, thereby rendering Burns's male-voiced celebration of his own wantonness as narcissistically

"feminine." When Hamish subsequently screens a slide juxtaposing an iconic portrait of the fresh-faced Burns with a virtually identical portrait of his great-granddaughter, dressed in mimicry of her forebear, the borderline between genders is further queried.

If the performance suggests an implicit critique of Burns's masculinist bias, though, it carefully avoids any Helms-like slide into judgment on his sexual adventurousness. Burns's own "standing cock" did, Hamish suggests, have a conscience. As evidence, he presents "The Fornicator," a poem whose narrator promises that, though "a pruiven fornicator," he will not shirk responsibility toward the woman he has been found guilty of impregnating: "But for her sake this vow I mak, / An solemnly I swear it, / That while I own a single croun / She's welcome for to share it." The peculiar similarity of this defiant promise to a marriage vow is wryly underlined in *Ready Aye Ready* by having the rather square-looking piper, Tom Keith, sing it sweetly to one of the Highland Illusion dancers, who dandles on his knee, an almost conventional image of "wooing."

The performance text of *Ready Aye Ready* is not included in this volume because it would make little sense on the page without the presence of musicians, dancer-singers, and Diane/Hamish's ongoing, improvised asides and banter with the audience. Although I have, myself, seen the piece only on grainy videotape, one catches there a sense of the performance's lovely, lively ephemerality, its deliberate rough edges, which any print version would betray. To cite Phelan again, "I want less to describe and preserve performances than to enact and mimic the losses that beat away within them" (1987: 12). In the case of *Ready Aye Ready,* the losses implicit in the work are closely connected to those underlying Diane's private performances as Charles Beresford later that year.

Diane's Jack Sprat monologue, *Happy Jack,* which holds up well on the page, is included here. Pointing back to Diane's own memories of the 1960s, this too alludes to the spirit of "sexual liberation" that the AIDS crisis seemed to "foreclose." Indeed, as she explains, "mod sexuality was prodigious; we were all rampantly active, and STDs like 'the clap' (gonorrhea) were more of a joke to us than a disincentive at that time." For the "born to be wild" mods that Jack represents, though (just as for the hippies more readily associated in the popular mind with the "free love" revolution), freedom is very much a male-oriented concept. Despite their ostensible heterosexuality, Jack and his mod boys seem to overlook their girls almost entirely, except as a potential source of shoplifted goods or as the butt

of crude jokes. Instead, Jack's monologue celebrates a preening narcissism and a bond with his "mates" that—thanks to Diane's ironic rendering—plainly borders on the homoerotic.

Jack Sprat, in both his invocation of iconic pop-culture figures (the Who) and his status as a working-class rebel, is closer than most of Diane's characters to being an identifiable drag king "type." Other drag kings have frequently resorted to playing working-class figures because, as the San Francisco drag king Silas Flipper contends, "Men in suits are just too boring to imitate . . . there's no theater there" (Volcano and Halberstam 1999: 137). Danny King might beg to differ, but then he is not a character regularly deployed by Diane in a cabaret context. The reality is that, for the sake of laughter or applause, it is easier to resort to parodying working-class masculinities—grease monkeys and cowboys and blue-collar studs—than it is to evoke the image of a dominant, middle-class masculinity that passes itself off as "natural" and unremarkable. Precisely because they are already marginal to the dominant "norm," working-class masculinities may appear to have more obviously "theatrical" dimensions. Appropriating them is understandable in the case of someone like Flipper, who is "recalling and spoofing" her own background (134), although it is surely more problematic if working-class stereotypes are paraded by middle-class performers as a source of humor on the pretext of critiquing male power.[1]

Happy Jack avoids this potential pitfall by presenting *both* a cartoon of English working-class crassness (hacking, burping, and all) *and* a pointed recollection of cultural history. Though very funny, the monologue is also oddly poignant in depicting a character lost in his own past, and unable to connect with the present, because he doesn't have much of a future. Jack's fond memories of pointless aggression (whether expressed in the form of gang violence or sublimated in the wild release of the Who concert) reflect the kind of "protest masculinity" that the sociologist R. W. Connell observes among disenfranchised young men, "a response to powerlessness . . . a pressured exaggeration (bashing gays, wild riding) of masculine conventions. [Through] interaction in this milieu, the growing boy puts together a tense, freaky facade, making a claim to power where there are no real resources for power" (1995: 111). Tense and freaky Jack certainly is in Diane's angular, wired performance of his physicality, but the very fact that he ap-

1. Vicki Crowley refers directly to the recurring problem in drag king performances of "relatively privileged, white women taking the piss out of men by drawing on reductive stereotypes and at times questionable appropriations of ethnicity" (Troka, LeBesco and Noble 2002: 289).

pears alone ("I usually travel with my mate Phil, on accordion, but he couldn't afford the fare") also makes him awkwardly vulnerable and exposed. Protest masculinity, as Connell notes, is usually a group phenomenon, but Jack is a middle-aged loner left behind by history, and, although the memories he shares are vivid ones, he now seems directionless. Ultimately, he cuts a figure as pitiable as he is laughable.

Contrasting, more affirmative remembrances of 1960s pop culture are offered in two more recent projects. The first is *The Undergrad* (2003), a thirty-nine-minute drag king remake of Mike Nichols's classic film *The Graduate* (1967), written and directed by Michele (now Mickey Ray) Mahoney, and guest-starring Diane Torr.[2] *The Undergrad* offers a telling spin on the original film's satirical treatment of the way in which American middle-class youths of the 1960s rejected their parents' sexually repressive, bourgeois lifestyles. *The Graduate* suggests that, like Jack Sprat's, this rebellion was ultimately futile and directionless. At its conclusion, Ben Braddock (Dustin Hoffman) turns up at the church to save Elaine Robinson (Katherine Ross) from beginning a joyless marriage but then jumps on a bus with her and sits—unsmiling and unspeaking—as they ride off to nowhere in particular not knowing what to do next. Existential ennui notwithstanding, Nichols's film is ultimately conservative in spirit. Braddock gets his girl by repudiating the sexual experience he gained with her mother, Mrs. Robinson (Anne Bancroft). The traditional, oedipal family structure is reinforced, and it is the transgressive mother who is most obviously "punished" by the narrative. Yet, if there is precious little "sexual liberation" in Nichols's film, Mahoney's variant—set in Chicago with an all-female cast drawn largely from the membership of the Chicago Kings drag troupe (founded in 2001)—proposes a witty revision.

Here, Ben Braddock's raunchy affair with Mrs. Robinson is seen to be liberating for both parties (even though it primarily involves bondage) and continues uninterrupted by other events. Although Ben's refreshingly liberal parents, convinced that he is gay, try to get him to date the Robinsons' son Alan (a stand-in for Elaine), their one date is ruined by the entertainment in the bar Ben chooses: not a stripper, as in the original, but lip-synching lotharios (Alan: "Drag kings freak me out!"). Alan, it transpires, is secretly engaged to another boy, Jon, whom his parents disapprove of not

2. Copies of *The Undergrad* were available on DVD, at the time of writing, from www.mick eyraymahoney.com/undergrad.html.

because he is male but because he is a Republican. At the film's conclusion, their gay wedding proceeds uninterrupted by Ben's window-banging intervention in the church ("Alan! Your mother's coming!"), and at the concluding wedding party everyone is happy. Alan dances with Jon, Ben dances with Mrs. Robinson, and Mr. Robinson (played by filmmaker Mahoney) dances with Ben's father, Bud Braddock (played by Diane). In a delightfully touching subplot, this last pair have gradually come to realize that—having been best friends for decades and best men at each other's weddings—they have always shared a passionate longing for each other.

The Undergrad's conclusion thus offers utopian comedy instead of bleak bewilderment. More than that, though, it proposes an alternative model of extended, queer community in place of the oedipal, heterosexual bonds reinstated by The Graduate. Here the characters end up as one, big, joyously perverse family with no one relationship model privileged over the others and everyone happy to let each other explore their desires in liberating directions. The scenario reflects, perhaps, the gang dynamic of the Chicago Kings themselves, which is showcased beautifully in the group musical routines that punctuate the film. On a more theoretical level, though, Mahoney might almost be alluding to Judith Butler's coterminous attempts to rethink the politics around appeals for the legalization of gay marriage. In her essay "Is Kinship Always Already Heterosexual?" Butler rejects psychoanalytically justified attempts to insist on continued legal precedence for heterosexual marriage but also queries the advisability of campaigning for gay people to be permitted parallel legal status. "[A] more radical social transformation is precisely at stake," she notes, "when we refuse, for instance, to allow kinship to become reducible to [the nuclear] 'family,' or when we refuse to allow the field of sexuality to become gauged against the marriage form" (2004: 129–30). The Undergrad climaxes with a gay marriage (as if to recognize that option as viable) but then dissolves it into a wider, communitarian celebration of diverse pleasures.

Another model of queer kinship is sketched out in Diane's performance Donald Does Dusty, which premiered at the Berlin Drag Festival in 2008.[3] This concise and deceptively simple, monologue-based piece builds on Diane's many "Brother for a Day" performances as her brother Donald "doing" Dusty Springfield. It climaxes with Diane, in blonde wig and black evening gown, lip-synching to Dusty's torch song "I Count to Ten." The

3. At the time of writing, this piece is still regarded by Torr as a "work in progress," though the Berlin script is reproduced in Part 3 of this book.

main part of the performance, however, is dedicated to recollections of her youth in Aberdeen in the 1960s and of how she and Donald drew lifestyle inspiration from watching the television variety show hosted by Springfield, *Ready Steady Go!* Their parents are significantly absent from this narrative, which implicitly rejects the traditional assumption that girls come into feminine womanhood by mimicking their mothers and boys into masculine manhood by following their fathers. Instead, Donald and Diane form a queer triad with their lesbian "mother," Dusty (with Diane playing all three roles through shifts in vocal and physical emphasis). Donald learns sophisticated feminine allure from watching Dusty's every move and then attempts to teach his wayward sister how to pose alluringly and walk in high heels. Yet Diane, whose dedication to field hockey—she tells us—made her a rough, tough schoolgirl with little sense of feminine style, presents herself as a Calamity Jane tomboy who learns her brother's lessons with a certain ironic detachment, as well as sisterly devotion. The piece offers a picture of childhood inculcation into gender roles that suggests not inherited psychological imperatives but self-conscious options for self-invention. The various hip-swaying, 1960s pop dances with which Diane punctuates the piece add further to this sense of learning body stylization as fashion choice rather than legislated norm. Obviously this is not the whole story of Diane's upbringing, as her narrative in this book makes clear, but in *Donald Does Dusty* she opts—as does *The Undergrad*—to outline utopian potentials.

Indeed, Diane's whole self-presentation in the piece suggests a studied gender neutrality onto which masculine or feminine stylings can be layered. Opening with the masked, pole-wielding dance routine she first showcased at the 2006 Transfabulous festival, she then replaces the drawn-on mustache of this implicitly masculine figure with the lipstick of an implicitly feminine one but remains dressed in simple black T-shirt, pants, and wristbands for the remainder of the performance, until, that is, she reappears in full Dusty drag at the conclusion. This sequence recalls, perhaps, her previous performances of exaggerated femininity in her go-go days while also intersecting with the recent trend in queer communities internationally for "female to femme" (F2F) or "femme dyke" drag, a phenomenon distanced from the "lipstick lesbian" trend of the 1990s by its self-conscious theatricality and emphasis on gender artifice. In part a response to drag king and FTM performance, "F2F" treats femininity as "neither phallic fantasy nor default," Ulrika Dahl explains. "It's beyond surface and it certainly does not passively wait to come alive through a (male) gaze. Fiercely

intentional, neither objects nor objective, we have stuff to get off our chests" (Volcano and Dahl 2008: 18). Similarly, *Donald Does Dusty*'s lip-synching routine emphasizes the strange forcefulness of Springfield's gestural vocabulary, with Diane peering tragically through open fingers, clutching palms to heart, and raising fists aloft before bringing them crashing down to the music. This Dusty is utterly femme and yet very far from "ladylike," as befits a historical figure who, as the performance reminds us, was an instigator of wild celebrity food fights and publicly acknowledged her desire for other women at a time when many would have considered it career suicide.

Yet this Dusty is also, crucially, played by a nearly sixty-year-old Diane Torr, whose own postmenopausal body has—as she invites her audience to notice without embarrassment—become "tubular" from torso to waist and slacker in facial definition (changes that add further to the impression of gender neutrality in her basic appearance). We see, then, a Dusty not recalled in pop-culture memory, not the youthful, angular, black-and-white Dusty of the 1960s but a suggestion of the Dusty who died at fifty-nine, brought down by breast cancer. Diane's rendition of "I Count to Ten" functions as a memento mori just as surely as does the video sequence that immediately precedes it. Here we see color footage from Donald Torr's 1992 funeral followed by black-and-white TV studio footage from the early 1970s in which he performs with the Young Generation dance troupe. The energy and vivacity of their pop routines still seem infectiously "live," and yet we know that at least one of the performers is long dead. Within the context of *Donald Does Dusty*, this performance from the archive—like the broader piece as a whole—looks back as it also points forward, a reminder of the mortality of everyone in the theater, of the need to live life while it is still with us, and of the need to celebrate—with song and dance—our memories of the departed.

Seven | Drag and Self

Paul is in his early twenties . . . cool and streetwise [but] shy around girls—a really sweet guy . . . I chose my favourite male characteristics and qualities from different men in my life and threw them all in to create my ideal partner. [But] I couldn't believe how good-looking Paul was and this did affect his personality. He wasn't arrogant, but he knew he was cute, and he certainly played on that fact. Paul developed a different smile, sort of a baby-faced grin. He completely took over Paula—a bit sort of Jekyll and Hyde, but not so scary. When I left Glasgow on the Sunday night, it took a long time for Paul to go and Paula to come back. I didn't really want Paul to go, and for the next few days I adopted some of Paul's characteristics. . . . Thanks to you I have found my perfect partner—me!

—PAULA, AGE TWENTY-FIVE (QUESTIONNAIRE FEEDBACK)

The experience described here by 2002 Man for a Day workshop participant Paula Hateley is not an unusual one. Many women experimenting with performing male personas find that the characters they create become "real" to them in a more profound way than they had expected—almost as if an alternative identity has been stumbled upon. In the following pages we look at this phenomenon, and some of the ways in which women experimenting with gender crossing have discovered new dimensions relating to their sense of self—opening up possible new directions for personal development or gender identity, and challenging habituated patterns of being. The chapter begins with further reflections on the experiences of Man for a Day workshop participants, moves on to consider some broader developments in transgender culture and performance, and ends with a consideration of Diane's signature performance, *Drag Kings and Subjects*. Through all of this, we (Diane and Stephen) have written collaboratively: by undermining the notion of a single authorial voice, a "self" that is addressing "you," we're hoping gently to question the commonplace notion of a singular self or identity. "The two of us wrote *Anti-Oedipus* together," Deleuze and Guattari remark at the beginning

of *A Thousand Plateaus:* "Since each of us was several, there was already quite a crowd" (1987: 3).

The Man for a Day workshop, discussed in detail in Chapter 5, is also the basis for Diane's "Do-It-Yourself" guide to male impersonation at the end of this book. There's an aspect of parody or satire about both these other discussions of taking on male personas, but it's important to recognize too just how intimate and fluid the gender transformation can seem for some participants, as their new alter egos come to life in the studio. "It surprised me how easily 'Roger' became real to me," notes one questionnaire respondent: "Once I had on the right clothes and make-up and a comforting bulge in my trousers, the Roger within came tumbling out." Similar experiences with role play are often recounted in theatrical improvisation classes of other varieties, but this ease with stepping into male shoes is nonetheless striking, given the insistence with which women and men are culturally separated from, and opposed to, each other from birth. It is as if, despite these everyday gender prescriptions, we all have some degree of transgender potential in our makeup. Another participant notes in questionnaire feedback that the workshop gave her "more consciousness, more understanding for cross-gender people. This area feels sort of familiar."

Perhaps potential masculine identities lie dormant within even the most seemingly feminine of women. Certainly, it is striking how often workshop participants emphasize the sense of *authenticity*—as opposed to theatrical artifice—experienced in their assumption of male characters. This emphasis makes any neat distinction between an underlying, female self and a superficially assumed masculine role seem inadequate. "This is ceasing to be weird," one journalist reports a fellow participant remarking during a workshop, "It really is ceasing to be weird. I really feel like a man!" (Knapp 1993: 5). In other responses, even the simile—"like a man"—is dropped. As one American participant, Carli explained in feedback:

> There came a point in the workshop where I was not a woman "acting" as a man—I was a man. It's bizarre, yet amazing. . . . I'm a 20-year-old straight girl who has been brought up by a single father and thus in a male dominated environment. I was interested in what the workshop would teach me [and] I found it inspirational. It really intrigued me with regard to the possibility that I can decide that "today I am going to

be a man", and go out and be a man—accepted as a man, not a woman dressed as a man.

If male and female identities can coexist within the same body, then the concept of singular identity, let alone singular gender, is thrown into question. Do we really "know" ourselves as well as we tend to assume? Can exploring alternative identities lead to a fuller understanding of the self as multiple and mutable?

This is not just a matter of future possibilities but also of understanding better our heritage and upbringing. Carli's stress on the male-dominated environment in which she grew up perhaps helps explain her own confident assumption of (male) masculinity, but it also draws attention to the importance of family more generally. The experience of looking in the mirror, once your makeup and clothes are on, and finding your brother or uncle or father staring back from your reflection is a common one for participants in the Man for a Day workshop. This can come as a shock for some people, but it's also very telling. To find that you so strongly resemble a male relative is to be reminded that your own identity is relative—or relational—rather than independent of others. It's determined by genes and upbringing and environment, as well as by your own choices. Some people shy away from this and don't want to face it, particularly if they have had bad experiences with their families. But other people realize that they want to embrace this awareness of relationality as part of a process of self-discovery or self-development. Tracy Blackmer, for example, began performing as Jim Morrison partly because her father was "a lot like Jim Morrison. I had a good role model because I had grown up with this Jim Morrison–type of guy for a dad, so I had all that to draw on. I think in some ways I was working out my relationship with my father, although also I thought Jim Morrison was extremely sexy, and I wanted always to claim that sexiness for myself" (Blackmer 2007).

Fathers are a less frequent reference point, however, than brothers. In making themselves up as fantasy masculine versions of themselves, workshop participants often find themselves creating sexier, more confident "sibling" versions of themselves. Jane Czyzselska found that the surfer dude identity she assumed in her first Man for a Day workshop reminded her, uncannily, of her own brother. She also found a kind of "brother within," noting, "I learnt that being a boy was an extension of

myself and it was exciting—like discovering a new friend who I already knew" (questionnaire feedback). Similarly, the comments from workshop participant Paula Hateley, cited at the beginning of this chapter, suggest that she experienced her alter ego, Paul, as her immediate male equivalent, a kind of twin brother. And yet, on the other hand, she sees him—in a moment of wonderfully narcissistic self-reflection—as her "ideal partner," the kind of boy she would love to be in love with. Paula's subsequent experimentation with the role of Paul, after the Glasgow workshop in 2002 where she created him, further complicated this strangely sexualized sense of dual identity. As she told us recently: "The other thing is that when I'm Paul he's attracted to women. Paul is straight—he's not a gay boy—and when I'm Paul I find women attractive. I would never walk down the street as Paul and look at a man and see him in a sexual way. I suppose the lesbian in me comes out when Paul's out" (Hateley and Hateley 2008).

The fact that Paula is so comfortable with the experience of her own, predominantly heterosexual orientation seeming to shift when she is "in character" may in part result from having grown up with a (nonfictitious) queer sibling, the transgendered writer-performer Joey Hateley. "Queer subjectivity can be both negotiated and learned through siblinghood," Denis Flannery notes, because "the queer and the sibling have a mutually haunting and mutually productive relationship." Both sibling love and same-sex desire "are about similarity, both thrive—and need to play—with the difference within similarity. . . . [O]ne [is] sanctioned yet shadowed with taboo, one tabooed yet incited by societal demand" (2007: 6, 18–19). Further "difference within similarity" can be discovered and explored through cross-gendered role-playing (still a somewhat "taboo" act in itself): the effect can be "a bit sort of Jekyll and Hyde," as Paula puts it. So it seems significant that Joey and Paula chose to attend the Glasgow Man for a Day workshop partly because the two-day event led up to that year's "Brother for a Day" performance for World AIDS Day. Having grown up as sisters, the idea of exploring their mutual relationship as "brothers" had a particular appeal given Joey's trans identity. This concern might seem rather removed from the original idea for Brother for a Day (the act of memorializing and celebrating brothers, blood or soul, lost to the AIDS virus), but it is very closely related to my own sense of having developed my

personal identity as Diane through a deep, conspiratorial bond with my brother Donald.

For Joey and Paula, the workshop experience created an unexpected twist in their previous experiences of Paula being seen as the "straight" sibling in relation to Joey as the queer one. Joey found himself "completely in awe of Paula's transformation. . . . With her male character, as with Diane's, you really see the switch. She passes more than I do in a way." Joey's male character at the workshop—like all his self-presentations—consciously maintained a degree of gender ambiguity and fluidity, with the result that he was read as "gay" in relation to the "straight" Paul. In a sense, then, Joey remained the more socially marginal figure of the two but by virtue of Paula, the "straight" sibling, having taken a seemingly longer leap across the borders of cross-gendered presentation. Paradoxes and category confusions of this sort abound in experimental contexts such as the Man for a Day workshop.

Joey had been experimenting with performances of masculinity for several years prior to taking the workshop, and there was little new for him to learn about his own self-presentation. Yet drag king performance has played a significant role in the development of FTM trans identities, and it was particularly important in this respect during the 1990s, when the trans movement was in the process of "coming out" to the wider queer community. For many, particularly in London and San Francisco, drag king performance became an intermediate stage between a butch or androgynous lesbian identity and that of a trans-man. Often these performances of maleness were initially played with in the context of queer club nights. Jason Barker, for example, in his former identity as Jewels Barker, was the main instigator of drag king club nights in London in the mid-1990s (following the first British king contest at the Lesbian and Gay Film Festival in 1995). Appearing sporadically under various names in various locations—Club Naive, Club Knave, Club Geezer—these nights gave Jason the opportunity to discover and perform a more expressive, extroverted side to his character than he had previously experienced.

> It's not that it felt natural to be putting on mustaches and things, but I think what felt really natural for me was the attention I got, the opportunity to show off. I'd never had an outlet for that because I'd always

struggled to find my humor as a woman. I looked rather "matronly" as a woman, but playing the kind of "geezer" characters that I did I suddenly found myself being called "handsome." It was as if my body and face, which had never helped me when I was supposed to be a woman, were working in my favor as a drag king. And I really enjoyed relating to people as if I was that man. (Barker 2009)

Jason stresses that he doesn't know exactly how this opportunity for extroversion related to his growing desire to transition: clearly, theatrical display does not translate directly into a wish to alter one's body. At a certain point, though, he began to feel the need to take his performances of masculinity more seriously. "There was this idea that we were just dykes," he recalls, "just playing around, and my aspiration was to be a trans-man." He thus stopped organizing club nights at around the time he began hormone treatments so that the performance could become the life choice.

This scenario of exaggerated role play eventually leading to serious changes is common to a number of former kings. Jason's main drag king coconspirators in London—Hans Schierl, Svar Tomcat, and Del LaGrace Volcano—also began transitioning at around the same time. For other people, though, a very different journey is necessary. Kit Rachlin, who has worked extensively as a therapist with trans people in New York, points out that "the average person doesn't have the skills and the desire to get up on stage to do anything." Even the theatrically inclined who find that drag king performance "allows them to express an aspect of themselves that's very real and very dear" have to find ways to tone down their stage personas if they want to develop that realization further in their everyday lives (Rachlin 2007). There is a particular role, then, for experiences such as the Man for a Day workshop, where the emphasis has always been on the development of plausibly realistic character roles for the purpose of passing "invisibly" as male. Rather than being expected to perform for an audience, participants are able to explore their desires and fantasies in public anonymity.

Many butch and male-identified women have found that the workshop gave them a framework in which to explore questions that may have been with them for years. Petra, for example, a forty-six-year-old Swiss lesbian, explained in her feedback questionnaire that she wanted to use the workshop to

refine and make visible a part of me that's been part of me as long as I can remember. . . . "Joe" lived as a sort of idea [in me, but] only facets of his existence came through here and there. It wasn't until your workshop that he was really born and became openly visible. I was very impressed by the approach (Who are you? Improvisation and voice exercises, etc.) leading to a complete filling out and living of the character. And I'm very satisfied with him. The workshop has given me enormous encouragement to let this side of me grow more and become part of my daily life.

Similarly, another Swiss woman, thirty-eight years old and "born butch," explains that she was motivated to take the workshop not because she wanted to learn new self-presentation skills ("for this I would have been more interested to have a 'being femme' class") but in order to

discover and develop my gentleman-butch character, because I feel it is part of me and my dreams. I always used to identify with these characters in books, films etc. . . . Partly, I am this man I performed, and I think I should get to know him better. Some [friends] are afraid I will become a man (they were always afraid of me being queer), but some are really interested in this.

The process of reflecting, actively and creatively, on this sense of identifying with male characters can lead different women to very different conclusions. Rose, who describes herself as a butch dyke, attended a workshop in Leeds with the initial intention of developing a purely theatrical male persona, a caricature of a "beer-swilling trucker." She surprised herself, however, by developing him

into a more real persona who I named Danny—a straight, quiet, working class man who was a bit suspicious of anything arty or weird. The opposite of me in some respects, but definitely an "old" part of me. I felt like this was the me that never left Liverpool (where I'm from), especially since I felt like a man when I was younger, before I came out. I found it very cathartic to be in this persona, to name it, and it gave me a lot to think about. . . . I felt really sexy as a man, confident in a way I'm not as a woman. It felt "natural" to me, and walking about the city I felt it was *mine*.

And yet, Rose emphasizes, this process of identifying and naming her male alter ego was *not* experienced as a step toward cross-gender transition. Quite the opposite: the character was one that had helped her come to terms with past experience, not one she wanted to adopt in the future. After the workshop, she notes,

> I felt more whole in a way and more appreciative of my "woman-ness." I'm happy in my body and happy being queer. I don't feel the need to drag up to feel complete, but knowing how to develop an alter ego has been of use in everyday situations and I can draw upon the knowledge that I *can* act with authority. . . . The experience made me realise what a girlie I am—how eager I am to please all the time!

For some butch women, like Rose, the workshop seems to have provided a confidence-building reassurance that they do indeed like themselves as women despite the hostility they may have experienced for failing to conform to stereotypes of femininity ("As a dyke I've had a lot of bad messages to do with looking like an ugly man," Rose notes). Conversely, though, for other participants the workshop process has led to a clearer sense that they may want to become men. Take the case of Fiona, a twenty-year-old Scottish participant.

> I have always identified with boys/males since I was a kid. When I was younger I used to dream and pray and wish to wake up a boy every night before I went to sleep. To this day I choose men's clothes and shoes, I keep my hair short, I'm generally attracted to straight women, and am sad that I cannot have a natural baby with the woman I love. All these issues led me to the workshop [in Glasgow, November 2003. The male character I created was] Liam. He was me. He was me but shyer than me as it was the first time I had "worn" him, obviously. I didn't want to put on an act, because it felt so natural for me to sit as a boy. Liam was shy, but mainly because inside I was spending the workshop going "wow, this is really comfortable." . . . Liam was the name my mother and father were going to give me if I had been born a biological male. Liam has always been here, he lives with me. However, what I have now realised is that Liam isn't Liam, he is Fionn [pronounced "Finn"]. This is the exact male version of my name and I have spent the months since the workshop coming to terms with my dual existence,

my split/yet whole personality. Fionn and Fiona exist equally. Some-times I have to remind myself to let them both breathe, [but] Fionn and Fiona have met, and now I have a HUGE road of discovery ahead to find peace with my appearance.

The additional twist for Fionn/Fiona was that one of the other par-ticipants, Deirdre, who identified as straight, fell in love with "Liam" during the workshop. They became a couple, and went traveling to Mexico together, but without this experience it's unlikely that Deirdre would have explored her dyke tendencies. There again, does falling for a potential trans-man necessarily make you a lesbian? These are the kinds of ambiguity and indeterminacy that are thrown up as the con-ventional binaries begin to blur, and it seems of the utmost importance that they're allowed to *stay* blurry. Fionn/Fiona's decision to take time for careful consideration, rather than pushing immediately toward transition, showed great maturity, a willingness to live, at least tem-porarily, with a sense of having an unresolved gender identity. That's not an easy position to maintain, because as s/he further observed, the FTM meetings s/he attended in the wake of the workshop were "very geared towards the transition. I can see how I might too easily be swept up onto that bandwagon, and I'm not sure yet if it's right for me." Pres-sure in the direction of clinical treatment is sometimes also exerted by members of the mainstream medical establishment, who will seek to resolve or "correct" gender ambiguity rather than allowing it to remain ambiguous. "Some days maybe I want to be a man," Fionn/Fiona would tell me in e-mails, "but at the same time I don't know if that's re-ally what I want to do." He eventually resolved to go ahead with hor-monal and surgical transition but after due consideration of the kind that's necessary for such a major decision.

The various medical treatments available to facilitate sex/gender transition are, for many, the right choice. But I do know trans-men who have come to regret a too hasty decision to undergo treatment, as well as women who considered the idea but eventually decided against it. "I thought about it," admits Dred Gerestant of the idea of taking testosterone,

but I knew deep in my heart that I didn't want to change. I've always been like a tomboy, but at one point I was expressing Dred so much

that I felt I was losing my woman self, and I had to change that. Because I realized I was ashamed of being a woman and that I was hiding behind Dred because I didn't like being a woman in this society. What it meant to me at that time didn't feel good. But that changed. (2007)

Similarly, Jane Czyzselska now comments that, although she felt she was expressing a strongly masculine side to her personality when she first took the workshop,

> this kind of stuff goes beyond gender, and I think now that I was externalizing my own lack of self-acceptance. . . . I'd felt trapped by people's expectations of me when I was growing up, and so drag was a way to put two fingers up to the world, to say "I'm not what you think I am, and I'm not what you want me to be." I really enjoyed expressing that anger for a while, just being arsy with people as a guy, and even being accepted for it, rather than being seen as a "difficult woman." (2008)

Dred, Jane, and Fionn all went through lengthy processes of self-discovery to reach their varying conclusions. Thankfully, an emphasis on *process* rather than premature "arrival" is now standard in queer and trans scenes internationally (in the United States, the United Kingdom, the Netherlands, and Germany, among others). A whole spectrum of genderqueer orientations has emerged over the last decade or so, and choosing not to undergo hormonal or surgical treatment doesn't have to be seen as a failure of nerve, as it was by some when "transgender liberation" first became a live issue in the mid-1990s. At that time, I was sometimes criticized for "dabbling" in trans issues by taking masculine identities on and off without committing to a full-time gender transition. "For all their radical vision," wrote Tina Papoulias in an article on my workshop,

> a lot of women who engage in some form of gender play will nevertheless balk at the spectacle of the chemically or surgically transformed body, perhaps because even with the most provocative of disguises, we retain the implicit knowledge that there is a "real" woman underneath. This knowledge soothes us by confirming gender exactly at the point where we have been engaging in its subversion. (1995: 42)

This line of reasoning, however, implies that unaltered biological females are ultimately incapable of "gender subversion," that one would almost *have* to shoot T to really confront people's assumptions about biology. I've always maintained that you can also challenge people's perceptions performatively, without needing to go the clinical route, and that position is now commonplace among a younger generation of genderqueer people who sometimes view reassignment treatments as appearing to give continued credence to biologically based notions of gender identity. Jason Barker notes that attitudes are now very different from what they were in the late 1990s, when he began transitioning. At that time, calling oneself "he" was contingent on undergoing clinical treatment.

> It was like trans people were the top of the heap and got to be called "he," whereas the rest of us thought, "Oh, I really wish somebody would call me 'he.'" The difference is really marked now. I have a lot of friends who are butch dykes, or who are trans but not transitioning [medically], who call themselves "he." Who cares? It's just a pronoun. If you want it, have it. (2008)

Joey Hateley notes, importantly, that attitudes are still far more traditional outside the genderqueer community. "I've recently asked some of my closest friends and family to call me 'he,'" he says, "but it seems like you almost need to take testosterone for some people to go, 'Oh, you're a he!'" (Hateley and Hateley 2008). For that very reason, he adds, "it might be more important *not* to" undergo hormone treatment. While he acknowledges that he probably will do so eventually, this will not be in order to "validate . . . my masculinity" but so that his appearance is more in keeping with his age. The physical changes brought on by testosterone would finally allow him, in his thirties, to be read as more mature than the "sixteen-year-old boy" that he finds many people still perceive. As he remarks pointedly in his 2004 performance *A: Gender*, "Just exactly what is it going to take for the world to finally see me as an adult?"[1]

1. If Joey chooses medical intervention, he adds, it will be "to invert masculinity from within, in a socio-political sense, to continue my gender identity journey, and to keep my body more in keeping with my s/he, herm-like perception of self."

On the other side of the equation from those who advance the possibility of nonclinical trans identities is the emergence of another constituency now opting for surgical nontrans identities. Working as a visiting lecturer at Glasgow School of Art, I recently met the New York artist Kerry Downey, who (after a long process of reflection) underwent "top surgery," a double mastectomy to remove both breasts. (Her story was documented by the *Village Voice* under the title "Bye Bye Boobies" [Romano 2007].) This is clearly an extreme measure and one usually resorted to only by cancer victims and FTMs. Yet Kerry, endowed by her genetics with big breasts, felt that they dictated too much about the way she was perceived in the world: men and women alike would stare at her chest before they even looked at her face. This put her at odds with her own body, and since binding was too uncomfortable to be a regular or permanent option she concluded that surgery was the way to go. "I feel gender neutral, and deeply androgynous," Kerry comments, "although I choose in most circumstances to pass as female." Her flat chest now gives her the option to "become invisible" when she wants, to pass easily as masculine when she dresses down. Obviously surgery is not an option to be resorted to lightly, nor is it one that many people can afford (since it is considered cosmetic surgery, not surgery "necessary" to maintain one's health, which can be subsidized by insurance companies or state programs). Kerry, though, seems very satisfied with her decision.

It's important that this discussion of the growing range of genderqueer life options should not be seen as invalidating the more "traditional" transsexual narratives of those who still experience an acute sense of gender dysphoria—of being born into the "wrong body"—and for whom full surgical reassignment is the only satisfactory option. (That was certainly the case for Johnny Science, for example.) What is needed, as Jay Prosser argues in *Second Skins: The Body Narratives of Transsexuality*, is "a politics of home" whereby all individuals are permitted the right to find a place on the complex map of gender identities where they feel they belong while remaining aware, of course, that "home is, on some level, always a place we make up, that belonging is ultimately mythic" (1998: 204–5). For some, home may lie at the other end of a transsexual journey that takes one from biological female to surgically assigned male (or vice versa). For others, it may lie in the experience of transition itself and in the process of maintaining a gender position somewhere in between the traditional poles of (masculine) male and

(feminine) female. There are several men I know in Cologne, for instance, who went through sex changes and became men but have quite deliberately kept a lot of their "female" behavioral patterns rather than simply learning to pass as men. They don't necessarily want to participate in male culture, so they've collectively avoided adopting the kind of dominant white male traits that you see in Danny King, for example. A lot of their body language, particularly their smiles, points back to their female conditioning even though you can see in outward appearance that these people are men. So they're really blurring the boundaries of male and female, masculine and feminine. At the same time, of course, there are many everyday contexts in which it can be desirable for trans people to appear less ambiguous and more "normal" in their performance of conventional gender expectations (to be "in stealth"). This allows the refuge of a certain invisibility so as to avoid unwanted attention and maintain personal safety. Paradoxically, this act of "passing" in everyday life is, for many, more of a performance (in the sense of being an assumed artifice) than the act of standing out from the crowd.

The need to acknowledge and celebrate the performed status of identity itself is now central to the field of transgender arts and performance, which has come a very long way since the late 1980s. Viewed today, for example, Annie Sprinkle's film *Linda/Les & Annie* (1989) now looks like a curiosity from another era. As an attempt to document and make publicly visible Les Nichols's experiences as a transsexual man— through both his firsthand testimony and Annie's third-person commentary—it was genuinely ahead of its time when it first appeared. But the film's focus on the inadequacies of the various (exorbitantly expensive) penis-construction surgeries then available to FTMs makes Les seem a rather forlorn figure in some ways, which he was not! In the film, his new penis is small, stubby, and oddly placed; it cannot function for urination, cannot become erect without the insertion of a plastic tube, and has no more erogenous sensitivity than any other part of the body's skin. Les and Annie finally have to abandon their attempts at hetero sex and resort to stimulation of his still-intact clitoris. The fact that two decades later medical science has still to develop much in the way of better options for "bottom surgery" may be in part a result of underlying prejudices against female-to-male transition, a protection of the authority of the "authentic" phallus. But very few FTMs now

even seek such surgery (though top surgery remains common). The debate has long since moved on from any private sense of lack regarding what lies between one's legs toward a public expression of gender diversity.

London's Transfabulous Festival is a great example of this celebratory attitude. Coproducers Jason Barker and Serge Nicholson initially dreamed it up as an opportunity for transsexuals who were musicians or performers, but not necessarily "out" as trans in their professional lives, to have a common platform, "Trans people doing trans things for trans people to watch," as Jason wryly puts it. That idea quickly gave way, however, to the creation of a much broader umbrella. At the first fund-raising night for the new festival, in 2004—titled "A Night of Tall Women and Short Men" (the first club event Jason had organized since his drag king days)—the audience turned out to be much more diverse than anticipated. So, too, did the performers onstage. Jason himself coordinated an "F2M Full Monty" routine in which the disrobing participants included nontransitioning trans-men alongside others who had undergone surgery. Whatever they had or didn't have, physically, went on display to the delighted crowd. Ever since then, the definition of *trans* adopted by the festival has been deliberately nonspecific. In Barker's words, "To say what trans *is* also means saying what it isn't, and then you end up excluding people who really should be there" (2009). It was with this in mind that Jason invited me to perform at the first festival (in 2006) on the Transfabulous Extravaganza cabaret night. My character Mr. EE opened the proceedings and "set the tone"—Jason suggests—because most of the audience did not know whether this gyrating figure in tuxedo, Y-fronts, and mask was a man, a woman, or a trans-man. And did it even matter?

Jason adds, tellingly, that the Transfabulous event he is most proud of having staged to date is the "Border F*ckers Cabaret" of June 2008. Directed by Jet Moon, the evening featured a group of activists-turned-performers from the Queer Beograd (Belgrade) festival, in Serbia, whose definitions of border-crossing were profoundly influenced not only by gender issues but also by the recent history of war and genocide in the former Yugoslavia. One Bosnian performer, Dylan Sarzinski, did a stand-up comedy routine about his work as a forensic pathologist who was required to excavate war graves in Srebrenica. He emphasized the paradox of being obliged, as a trans person with a fluid gender, to cate-

gorically identify disinterred remains according to gender, nationality, and faith. Biological sex can usually be determined by studying the pelvis, he explained, but these other attributes are much harder to identify, and yet the horror of the war was based on these intangible divisions of nationalism and faith. "The whole night," Jason summarizes, "was about crossing geographical and political and gender borders, but in a really concrete way. That was the pinnacle of what I want to do with Transfabulous" (Barker 2009).

"Trans is much more than just a kind of blinkered perception of what a transsexual is," Joey Hateley concurs. "Trans is a kind of political tool for consciousness that transitions between multiple spaces and addresses multiple issues" (Hateley and Hateley 2008). That idea is apparent not only in staged performances, like those at Transfabulous, but in the work of border-crossing artists such as Tobaron Waxman, whose interdisciplinary practice ranges from FTM porn videos to gallery installations alluding to the Israel-Palestine conflict.[2] I first met Tobaron prior to his transition, when he attended my workshop in 1993 at the Buddies in Bad Times theater in Toronto. At the time he was working as an actor and saw the workshop primarily as an exercise in character development. Over the next several years, however, as he began to masculinize his appearance (a transition he had been thinking about since childhood), he found some of the physical pointers learned during the workshop very useful in helping him to be recognized as male in everyday life. He began to drop these "acted" behaviors at the point when his immediate appearance could be read unambiguously as that of a man. Now, looking male but not necessarily conforming to cultural norms, he is often read as gay, although he can readopt more stereotypically "masculine" presentational strategies when a situation seems to require it. The question of how he is read does not stop, however, with masculine or feminine, gay or straight. Although Tobaron is Jewish and white, he has been mistaken as Arab, Muslim or Sikh, even by members of those communities. Such misreadings partly result from his open, friendly attitude toward others and partly from his physical appearance (since his transition he has grown in a full, natural beard, which—never having been shaved off—is soft and silky rather than thickly bristled). His project *Fear of a Bearded Planet* (ongoing since

2. See online documentation at www.tobaron.com.

2007) includes documentation of an intervention he has staged in various tourist sites in Western cities by posing for souvenir portrait sketchers without volunteering anything about his background to the artists. He tends to be drawn as a religious Muslim, and in one rather disturbing sketch made in post-9/11 New York City, the street artist rendered him in a turban, playing electric guitar, with money pouring out of his pockets. This grinning caricature is posed in front of what looks very much like the twin towers of the World Trade Center.

Tobaron's artistic practice is richly informed by both his everyday encounters and his Jewish faith. "Much of the practice of Judaism," he maintains, "has to do with studying and honoring the text, or with acknowledging the body in space and time" (Waxman 2001: 681). The latter element relates, obviously, to his FTM status, but the former is also very important to him. He spent several years living in yeshiva, studying the sacred Jewish texts. Since the yeshiva is a male-only environment, he could have encountered real difficulties had his medical history been known to those around him. As he observes, though, the question of how best to navigate potentially hostile environments is familiar not only to transpeople but also to Jews and indeed any diasporic people. His everyday negotiations, within the yeshiva, over how to engage with others sincerely and yet also safely have also informed his encounters with others beyond it. When addressed as a Muslim by Muslims, for example, the question is how and when to let his interlocutors know that he is Jewish while still maintaining a constructive dialogue with them. Since such encounters may take place in public, there is also the question of who else witnesses them. On one occasion he was approached by a Muslim man at Brighton Beach subway stop in Brooklyn, an encounter that led to a forty-five-minute conversation on the B-train ride all the way back to Manhattan. "We talked about how his family and Jewish families had been friends and colleagues before the British [rule in Palestine]," he recalls. "We held hands and cried—an expression of affection and emotion that is taboo for western men in public" (Waxman 2008). The political implications of this incident—a young Jew and an elderly Muslim being witnessed sharing intimacy in public—are obvious. There are many forms of privilege that come with being perceived as male, Tobaron notes, and the question is knowing how to use that currency. He regards the transsexual body not

only as a site of physical modification but as "a potentially beautiful political moment" (Waxman 2008) indicating a plurality of different worlds.

> Judaism makes distinctions between day and night, for example, but we do so at dusk, thereby also acknowledging the spaces in between—i.e. variance in nature. It is necessary to our cosmology to make distinctions, however this need not be done in a way that establishes conflict and opposites. It can be done in a way that honors distinctions. Why not mark a semi-permeable membrane that acknowledges difference rather than build a wall? The result might be an entire absence of the notion of "sides." (Waxman 2004)

A contrasting approach to some similar issues is offered by Oreet Ashery, a London-based Israeli artist I got to know during our shared residency in New Delhi in 2006. Oreet, who comes from a secular Jewish family, created her male alter ego, Marcus Fisher, in the late 1990s as a means of mourning the loss of a close friend who had turned to Orthodox Judaism and thus foresworn contact with friends from his old life. Marcus presents himself in full beard, with long ringlets of hair coming from under his black hat, and he has allowed Oreet to infiltrate various Orthodox Jewish contexts. In her video piece *Dancing with Men* (2003), for example, she documents herself participating in an outdoor, male-only celebration in northern Israel held to commemorate the death of a kabbalist rabbi. Yet her intentions are considerably less reverent than Tobaron's (the name Marcus was chosen because it translates, in Hebrew, as "Mr. Cunt"). Oreet's objective is to challenge the patriarchal, gender-divided character of traditional Judaism by pointing out that, whilst all it takes to join in these male-only rituals is a "change of clothes," the risk of being found out—with its potentially serious consequences—highlights the reality of a deeply entrenched religious culture that continues to marginalize women as secondary citizens. At the same time, though, Marcus represents a way for her to challenge Western attitudes toward Judaism. In London she has taken him into incongruous locations such as the sex industry hub of Soho: "People would stare all the time . . . I couldn't get served. Sometimes people would be openly aggressive" (qtd. Smith 2003: 35). At drag king

club nights, too, Marcus has tended to stand out as a kind of "transgender clown" in contrast to the sexy, white, Western forms of masculinity typically paraded by other participants.

In *Say Cheese,* an interactive installation performance that Oreet presented in various locations internationally between 2001 and 2003, Marcus Fisher welcomed visitors into a hotel bedroom for private, one-on-one encounters lasting up to ten minutes each (see Ashery 2009: 12–14). Participants were invited to sit or lie next to him on the bed and have their picture taken with him (hence the title). They could then ask him to do anything they liked provided this didn't involve physical harm to anyone. Oreet shares various anecdotes about these intimate encounters. On one occasion, for example, a man apparently unaware that Marcus was actually female asked to see his circumcised penis. To the man's consternation, Marcus produced a dildo from a drawer and offered to use it. This turning of the tables typifies the way *Say Cheese* operated. It traded on, but also questioned, the Western fascination with the exotic "other." "Having your photograph taken with Marcus is like having your photo taken alongside a tourist attraction or an animal at the zoo," Oreet notes (qtd. Smith 2003). The non-Western, non-Christian other is conventionally portrayed as the "feminized," "passive" partner in intercultural exchanges with the West, but Oreet turned this dynamic around. People came into Marcus's bedroom, but he always remained in control of the situation, and as the dildo anecdote illustrates, he would sometimes take the sexual initiative, much to the surprise of those expecting him to behave as the object of their fantasies.

The examples of Tobaron and Oreet illustrate how trans and cross-dressed performers have used "passing" performances of various kinds to explore intersections with social and cultural power dynamics well beyond the masculine-feminine binary. Gender never exists as an independent identity category but always works in conjunction with ethnicity, class, nationality, and so forth, and the most progressive work in the field clearly demonstrates that. Unfortunately, it's also the case that female-to-male cross-dressing has, latterly, been appropriated for more conservative purposes—much as a century ago vaudeville male impersonators eventually became celebrated as guarantors of the gender divide rather than as undermining it. Norah Vincent's best-selling book *Self Made Man,* published in 2006, is the most prominent example of

such appropriation. The book documents the year in which Vincent (a journalist known for her right-wing views) passed as a man named Ned in a variety of cultural contexts.[3] As she readily admits, this experiment was inspired by her friendship with an unnamed East Village drag king. And yet most of Vincent's "undercover reporting" might equally well have been carried out by a male reporter. She makes little sustained effort to reflect critically on her own experiences as a woman passing in male-oriented environments, and her attention is trained primarily on contexts that are themselves marginal to American culture: a monastery, a workingmen's lap-dancing bar, an *Iron John*–style men's movement retreat. In effect, she functions as the eye of the mainstream peering in on the other. Moreover, she seems intent on reinforcing precisely the gender binaries that drag kings and trans performers have sought to challenge. "I believe that [men and women] *are* that different in agenda, in expression, in outlook, in nature," Vincent contends, "that we live in parallel worlds, that there is at bottom no such thing as that mystical creature we call a human being, but only male human beings and female human beings, as separate as sects" (2006: 281–82). She avoids the rather obvious point that, by focusing on male-oriented environments she was bound to perceive binary divisions between the sexes rather than any progress toward a less divisive future. Instead she insists that, even as a masculine lesbian, she is necessarily more feminine than men, and when dressed "as a man, people were seeing my femininity bursting out all over the place" (277). Exactly how she passed for so long, if that was indeed the case, is not explained.

The fact is that, whatever cultural advances are being made, there is at least as much cultural forgetting occurring on a daily basis. This is partly why it seemed important to put this book together, to document recent history from a particular perspective. It is also why my performance *Drag Kings and Subjects* remains relevant today. First performed in 1995, it has been modified in various ways over the years, but it remains essentially the same piece. Its focus is on gender transition and transformation, on the idea of being "king" over your identity, sexuality, and desires rather than being "subject" to social conventions. Yet it

3. The queer theorist José Esteban Muñoz has cuttingly described Vincent as "the far right's lapdog dagger . . . who regularly denounces advances in academia in her 'Higher Education' column" for the *Village Voice* (2005: 112).

addresses these questions not by attempting to be "cutting edge" in any confrontational way but by seeking to be as accessible as possible to as wide a range of people as possible, to bring greater public understanding to these issues. One way it does that is by starting off with a character that you wouldn't normally expect to hear about in radical gender discussions: a middle-aged housewife.

In creating this piece, I wanted this woman—who I think of as Sylvia, though she is never named—to be as "straight" and "normal" as possible so as to emphasize the idea that *anybody* can search out his or her own fulfilment and challenge expectations. Sylvia is the kind of woman that I was supposed to become, growing up in the 1950s and 1960s in Britain. There was no suggestion whatever, in those days, that women should explore what their own desires might be. Male pleasure was of central importance, and if your own wishes happened to coincide with that then all was well and good. But for women of my mother's and my grandmother's generations, once their husbands had lost interest in them sexually, the assumption was simply that they would stay celibate until they died, living lives of "quiet desperation." This situation has changed since the 1960s, of course, but not completely. Sylvia is a figure who, like Danny, is both anachronistic and completely familiar. She's the helpful, middle-aged woman who facilitates for other people and follows convention except that, rather than simply resigning herself to celibacy, she discovers vibrators. And then one thing leads to another. When her friends become curious about these little "friends," too, she ends up becoming a rep and holds gatherings where ostensibly heterosexual women get giggly and try vibrators out on each other.

In the second stage of this three-part performance, Sylvia's newfound interest in fetish (her appropriation of the phallus?) moves to a different level as she begins to cross-dress and perform as male. She finds that she really likes being a man, but her husband and children reject this out of hand, and so she leaves her family to pursue her fetish, a completely forbidden thing for a middle-aged, heterosexual mother to do. It may well be, of course, that she's not all that "straight" after all; there are many women out there who may always have known that they weren't much into heterosexual sex but were brought up to "do the right thing." The narrative of the man with a wife and family who goes off to explore his sex or gender inclinations is not an unfamiliar

one, but people still don't think about women in that way. That's why I wanted Sylvia to suggest other possibilities. The twist is that she becomes so good at being a man that she gains acceptance and, as "Danny," becomes a member of the American Society of Men, a reactionary, chauvinistic organization. S/he even becomes a spokesman for them. We see Danny lecturing the audience on the arts of "how to gain and retain respect as a man." The audience has been taken on a journey from an extreme of feminine reserve to an extreme of masculine assertion, and yet the contrast is obviously paradoxical when we have seen this man *as* a woman.

From there the piece moves to a third stage in which Danny—having met other members of the society who secretly like to dress as women—begins to experiment with male-to-female transvestism. He even visits Lee's Mardi Gras fetish store, a secret emporium in the Meat-Packing District of New York that I really did "infiltrate" once as a man. I was utterly amazed by the place. Every fetish you could imagine was catered to, and the male clients were from all walks of life. Like my fictional American Society of Men members, most of them hid their cross-dressing fetish well—beneath the outward appearance of social respectability—but that didn't necessarily make them hypocrites or "closet cases." Doesn't everybody have a hidden life, even if it's just in fantasy? How many men out there secretly wear women's panties under their suits or would like to? Male-to-female transvestism is still very much a taboo subject, one to be tittered about, perhaps, but not to be taken seriously as a legitimate form of self-expression. If a man has an important job but is caught dressing as a woman, he could really lose his status (more so, nowadays, than if he were to come out as gay), so it takes some guts to live out this particular desire. Since male cross-dressers are frequently heterosexual family men, without the support of a gay subculture, they have often had to find their own way in the dark, as the voice-over reminiscences used in the show make clear.

Drag Kings and Subjects wants to honor the struggles of cross-dressers of all varieties, so I conclude the performance with a celebratory, drag-queen-style dance routine to Sylvester's "You Make Me Feel." This drag femininity isn't a reversion to the stereotypical (female) femininity that Sylvia started with, though. Instead, to create this final "Dolores" identity, I carefully studied the dance moves of a lot of tranvestites and drag queens, to try to re-create that body language. I noticed that, even

Diane Torr making up as Danny King in *Drag Kings and Subjects*, P.S. 122, New York, 1995. Photographer: Dona Ann McAdams. Used with permission.

dressed as women, men tend to keep their arms and shoulders tight, and there can be a bulky, staccato quality to their movements that seems incongruous with their ultrafeminine accoutrements. I play with all those gestures in the performance. My appearance also adds to the "drag queen" illusion, I hope. My upper arms and shoulders are fairly muscular from years of aikido, and I emphasize that "nonfeminine" physique by highlighting their whiteness in relation to Dolores's long, black evening gloves and her glittering black gown. Similarly, in middle age my face now has a lived-in quality that helps me pass more plausibly as male, so when I begin to apply extravagantly feminine makeup to that face, *after* having presented myself as a man, there is sense in which the audience "sees" a man making up in drag. I'm looking to blur these binary constructions of masculine and feminine as much as possible in the process of piling them on top of each other (Diane becomes Sylvia becomes Danny becomes Dolores). That gender-blurring intention is also apparent in the presence of three backup performers whose tongues and bums are seen poking out through holes in a curtain at key intervals, wiggling and shaking excitedly. The audience interacts with these performers—caressing their bottoms with flashlight beams, for instance—but you never know for sure if they are male or female, even when they appear in girlie drag as a chorus line for the final dance number.

Drag Kings and Subjects speaks volumes about Diane's concerns with gender identity and sexual expression (and now this is Stephen, the critic, writing), and it is also a kind of summary essay in the physical studies she has undertaken. During the central, Danny King section, for example, she demonstrates an entire catalog of the kind of firm, assertive gestures and postures that she has observed in "dominant" white men, by way of demystifying and denaturalizing them. (Many of these are itemized in Diane's "Man for a Day" guide in this volume.) But *Drag Kings and Subjects* also seeks, very importantly, to denaturalize the notion of femininity. "What does it mean to be a woman?" Sylvia asks her audience at the outset. "What kind of a woman am I?" There are at least four different stages in Sylvia's self-presentation. First, she is a woman looking to be desired sexually by men, practicing how to walk, sit, and present herself so as to catch the male gaze. She delivers this demonstration with all the icy cool of an etiquette instructor from *The Stepford Wives,* blowing mechanical kisses to the audience with an

eerie, staring-eyed fervor. Then, admitting to her status as "an older woman," Sylvia becomes more recognizably "realistic," smiling helpfully and smoothing her skirt over crossed knees as if in sexual resignation. Third, she becomes a coyly sexy, self-possessed version of this older woman, caressing herself sensuously from cheek to thigh with the tip of a dildo. Then, finally, she becomes an upbeat salesperson, merrily presenting an array of different vibrators to the audience in a lecture-demonstration that tellingly parallels Danny's subsequent demonstration to men on how best to present themselves.

If the shifts between these different poses seem oddly unsettling, it is because they undermine any sense that this Sylvia is a knowable psychological creature. She is, rather, a set of selves in constant mutation and variation. "Gender ought not to be construed as a stable identity or locus of agency from which various acts follow," Judith Butler writes. "[R]ather, gender is an identity tenuously constituted in time," a series of acts "which, in their occasional *dis*continuity, reveal the temporal and contingent groundlessness of this 'ground'" (Butler [1990] 1999: 191–92). Moreover, the discomforting opacity of this multifaceted woman also begs the question of when—if ever—she is also Diane Torr. The conventions of performance art might lead spectators to assume that this is all some form of autobiographical confessional, particularly since Diane is known as an artist who has specialized in passing as male. Yet Sylvia is surely too masklike a character to "be" Diane, and ultimately the question of where the "real" Diane Torr lies in this performance is beside the point, as well as being completely central. She is both nowhere and everywhere. Through the constantly shifting, transitioning use of differently gendered characters, Diane conjures a sense that she overlaps and is invested in all of them. Indeed, the defining trope of *Drag Kings and Subjects* is transition itself, permanence in change, a fact brought home most strikingly by the two long periods in which she transforms, onstage, from female to male, and then from male to male-to-female. These transformations are steady, deliberate, and utterly matter-of-fact; there is nothing stagy or forced about them. And while Diane provides spectators with a multimedia plenitude of contextualizing information during these changes (using film, slides, music, and taped voice-overs), so that there is never any danger of boredom, the most compelling thing onstage is always the transformation itself: the changing of clothes, the steady application or removal of

makeup, the constructing of a mustache, the binding of actual breasts, and the construction of false ones. These changes, made completely without comment on Diane's part, beg all kinds of questions of the audience about the ways in which we construct and naturalize our own gendered appearances.

Perhaps the most important thing to note about *Drag Kings and Subjects*, though, is how much fun it is. Unsettling though the performance's implications often seem, Diane's wit and showmanship are utterly disarming. This is a performer in full command of her material, enjoying her opportunity to move between different poses and dances (Danny King's staccato, fist-punching disco routine brings the house down on every occasion). And the show's playfulness is emphasized, finally, as a thematic concern; its last twist is not the making feminine of a man who was a woman, but the rendering as childlike the many layers of disguise and deception involved in his/her journey. As Dolores remarks of enacting fantasy fetish scenarios with cross-dressed businessmen, "It reminded me of what I would do with my girlfriends when I was seven years old. It was so much fun." In children's uninhibited games of make-believe and reinvention, perhaps, there lies a challenge for adults. Can we, too, rediscover our propensity for fantasy and transformation?

PISSING CONTEST #3 (NO CONTEST)

In January 1999, I was invited by Gül Gürses—the Turkish founder of Vienna's Theater des Augenblicks—to come to Istanbul to work on *Trans-Chans*, a performance project involving local gays, lesbians, feminists, transvestites, and transsexuals. In Turkish culture, concepts of feminist and queer liberation had yet to gain a solid foothold, and at that time these minorities remained secretive, disenfranchised, without any real public voice. The idea for *Trans-Chans* was to bring these disparate groups together and begin to build dialogue and solidarity between them through the process of making a performance. I was invited onboard as someone who might function as a conduit between the trans people and the feminist/lesbian community. By conducting a Man for a Day workshop during my residency, I was able to open up questions of gender transformation to women with very little previous

exposure to the subject. A number of them became involved with *Trans-Chans* as a result.

The performance itself was very much "under the radar." We presented it for one night only at a club called Magma, in the Taksim area of Istanbul. Some of the club's regular audience members came, along with members of the feminist, gay, and trans communities, but the program was a little different than usual! There were several sections in the performance, such as a daring, confessional monologue by the transsexual activist Demet Demir, who has bravely taken many young male-to-females into her home and taught them how to be women. The Istanbul police are particularly brutal toward transsexuals, and Demet talked of one nasty cop—known as "the Hose"—who would literally whip transsexuals with hard rubber piping.

My own contribution to the performance involved teaching a trainee drag king how to pee in a men's urinal, for audiences of women who were ushered in groups into the club's male toilets. In Istanbul, this broke a major taboo. None of these women had ever been in a men's toilet before, and as an audience they seemed somewhat perturbed at witnessing a urination demonstration. Most of them must have thought my colleague and I were men since the concept of "drag kings" didn't yet exist in Istanbul. Moreover, from a comfortable distance the penis I had looked real. (This was a device that sculptor and trans-activist Svar Tomcat had made in London, a pink, rubber, clog-shaped thing that hooks into the vagina and directs the pee out of a hole in the end.)

During each repetition of our performance, I would bark instructions to my partner in bold, American-accented English: Walk straight up to the urinal. Don't stand too close to anyone else. Don't let your jacket touch the edges of the urinal. Look straight ahead as you pee. Don't turn your head to the left or right unless you want people to think you're queer. If anyone speaks to you, don't look at them but do reply. Act like this is a perfectly normal conversation . . .

The idea was to demystify this male-only space and male-only ritual for a female audience by demonstrating the kind of anxieties many men have around displaying their penises in public. It occurred to me also, in the context of *Trans-Chans*, that the information I was outlining could be the sort of thing that FTM transsexuals—more than drag kings—might find useful. I don't know if there were any potential

trans-men present, though. As far as I know, any FTMs who existed in Istanbul at that time did so in total secrecy, and in fear of retribution.

Looking back, I like to think that I was addressing an imagined future audience, an audience that might one day exist in Istanbul if these sex and gender minorities could organize and develop themselves further. One thing I've learned, after decades of involvement with activism and performance, is that we have the potential, at all times, to call change into existence.

We're not just pissing in the wind.

Part Three | TORR TEXTS

Happy Jack

BY DIANE TORR

Jack is a middle-aged rocker in skin-tight black leggings, heavy Doctor Marten's boots, and a red, white and blue-striped Ben Sherman shirt. His hair is incongruously teased and spiked up into the air. He struts onstage:

Good evening everybody, I'm Jack Sprat. I'm a successful singer-songwriter, and I usually travel with my mate Phil, on accordion, but he couldn't afford the fare, so I'm 'ere on me tod. His accordion is on the tape. Easier that way, you know? One man band? (*laughs*) I'd like to start with a song I wrote twenty-five years ago called "Money."

He sniffs, clears his throat, sings rapidly:

If you want to make some money, first you lend some then you
 spend some
Sell your body be a doggie—be a killer not a jogger!
Have no lovers, use the others, eat your fill but keep down nuffink
Pay your dues to whom you choose
How much do you, how much do you, do you want to be rich?

Housing, clothing, motorcycle—Guard-dog, jackpot, escort, airport
Doctor, dentist, anaesthetic—Getting fatter, doesn't matter
Eating, feeding, sucking, fucking, dropping bucks around
How much do you, how much do you, do you want to be rich?

If you want to make some money, first you lend some then you
 spend some
Sell your body be a doggie—be a killer not a jogger!
Have no lovers, use the others, eat your fill but keep down nuffink
Pay your dues to whom you choose
How much do you, how much do you, do you want to be rich?

He finishes, bows.

Thank you very much everyone. People talk to me about the Beat-
les. Let me tell you, when I was a mod we 'ated the Beatles, 'cos
they was a bunch of wallies wasn't they? When you was a mod it
was a fucking commitment. We mods believed in discipline. The
whole mod thing was like the army. You 'ad to work, didn't matter
what kind of shit job you 'ad, but you needed the dosh, you know,
the folding gear? To buy the uniform: The clobber, the threads.
You 'ad to keep up wif the fashions. I 'ad a job working for Toppers
shoe shop on Carnaby Street. Come pay-day, I got a chance to
swagger. I got a fifty percent discount, so I'd buy two, three pairs
of Italian shoes, my mates'd come by, they'd get a discount too . . .
 Of course the other way to get stuff was shoplifting. That was a
really big deal. I 'ad this bird and she was ace at nicking stuff. She
'ad this duffle coat with enormous sleeves, and she'd go into the
record shops and just suck up these albums into 'er sleeves, like
she was some sort of creature at the bottom of the ocean just suck-
ing things up. She was so good at it, everybody wanted to go out
wif 'er, but I went out wif 'er, so I 'ad this really great record collec-
tion. She used to shop at the "Bus Stop" in Croydon, that's where
all the mod girls'd 'ang about. She'd go in there and take a few
'angers into the dressing room, take off whatever she was wearing,
put that on the 'anger instead, cut off the labels, put on the new
dress, put the 'ole kit and caboodle back on the rack and exit the
shop! Nobody ever said nuffink!
 So anyway, if you was a mod, you needed the dosh, for clothes,
records and scooters. I 'ad all the gear. I 'ad a parka that said "Beck-
enham Mods" stencilled on the back. I 'ad a Lambretta, an LI6,
black-and-white checker tape all the way round, fluorescent or-
ange and green colours, antenna with a weasel's tail flying off the

back! My mate Phil, 'e had a Vespa. Bank holiday came, all of us, a load of mods, we'd all go down to Brighton—fight with the Rockers. And Rockers they was really dirty fighters, you know? D'you remember? They'd take the chains off their motorbikes and slash you across the face. And then we'd get the boot in and kick someone's 'ead in. The pebbles would all be covered wif blood, and the Brighton police would come down and arrest everyone. That was a great laugh, we 'ad such a good time, it was really fucking funny! You shoulda been there! (*snorting with laughter*)

Records, right? If you was a mod, the blues was really important, weren't it? I was really into Sonny Boy Williamson. Any of you like Sonny Boy Williamson? Jesse Fuller? Remember San Francisco Bay Blues? Goes like this: (*sings*) "Got the blues for my baby down by San Francisco bay / Took an ocean liner and she's gone so far away . . . " Ring any bells? No? (*Gets out harmonica, blows general blues riffs, including "You Gotta Move" and freight train sounds. Bows, and expects applause.*) Thank you very much, everyone . . . My mate Phil, 'e liked Blue beat. Blue beat came before ska, and after ska you got reggae. You all know reggae, right? Blue beat was like this: (*sings*) "Uh oh seven, an ocean we live in, wif the rude boys at the wheel." Remember that one? My mate Phil, 'e had all these friends, these spades 'e knew in Brixton. They used to 'ave these parties wif a speaker in every room, size of a fuckin' armchair! And the walls'd be moving, the ceiling was moving, the floor'd be trembling with the bass, and with all these people dancin', you know? It was fuckin' amazing. We was all high on blues. French blues, that is. (*Laughs. Looks nonplussed when audience doesn't get the joke.*) Uppers? Speed. Amphetamines! (*pause*) Oh ne' mind. So we'd go to these fuckin' amazing parties. We was the only white blokes there, and nobody wanted to talk to us, but we was all right, as long as we left the black birds alone. And you know, when you was on speed you wouldn't want to fuck anyway would you? Could barely get an 'ard-on, let alone shoot your wad! (*Snorting laugh.*)

We was a bunch of pill'eads, you know, all us blokes together. We'd go down all the mod clubs in the West End of London, we'd go down the Scene or the Marquee on Wardour Street, then there was the Alphabet, or the Flamingo on Old Compton Street. Go down there and go in the toilets, and the floor'd be littered wif lit-

tle brown envelopes. That's where you'd go to drop your speed, see? The dealers used to sell those French blues in little brown envelopes, and, oh, they called 'em French blues 'cos they came from France. Cos amphetamines was illegal in Britain, weren't they? So we'd drop a load of speed, keep you going all night long. Everyone was blocked, you know? Out of their 'eads. You see anyone who's blocked, right, their pupils was the size of dinner plates. It was like they was lookin' at you, and through you and past you, all at the same time. Everyone'd say "What you lookin' at?!" You know? And you're like, "They ain't lookin' at nuffink are they? They're just blocked!"

Remember the Scene Club? You'd go down there, and feel like there was gonna be a raid any minute, right? And there was this warning on the back of the Marquee that said "SPEED KILLS!" Oh yeah? Well I'm still 'ere ain't I?! (*Laughs; opens can of beer.*) You know, 1964, down the Marquee, I saw loads of bands. I saw Howlin' Wolf down the Marquee in 1964. He used to come to England 'cos he couldn't get any gigs in America. And he liked English beer. I saw some really good bands, but the best was definitely The Who. We felt special, me and me mates, because we knew The Who. We knew 'em when they were still the High Numbers and they used to play down the Gold'awk in Shepherd's Bush. They were fuckin' brilliant. The Who were the first ones wif cabinets. (*Gestures to indicate amplifier cabinets.*) Entwhistle. He designed those cabinets. The best sound around. Everybody copied The Who, didn't they? We 'ad special Who membership cards. We used to get down the gig early, you know, and Kit Lambert, 'e was the manager of The Who, 'e'd give us a bunch of posters and some condensed milk and a paintbrush and we'd go down the 'dilly, to Leicester Square, down the tube, Tottenham Court Road, and stick up the posters. Condensed milk really made them stick, I can tell you. Those fuckin posters are still there, I betcha! If you was to pull off the layers—all the posters for Genesis, U2 and all those other shit bands that came along later—you'd eventually come to our posters for The Who. Anyway, when we'd done that, we'd go back and 'ang about outside, and the mods would come from all over, North London, South London, East London, West London, they'd all come down the Marquee, and they'd say to us, "Who's

playin'?", and we'd say, "The Who, mate." And they'd say "The who?" And we'd say "YES YOU CUNT, THE WHO!" Used to fuckin' love that! (*Laughs, snorts.*)

Inside it was us lot, the audience, we'd all be decked out in the latest gear, remember? Ben Sherman button-down shirts wif epaulets. Packet of Embassy in the top pocket. Two-tone tonic strides. Italian shoes. The lot! I 'ad a full-length maroon leather coat, went all the way to the ankles. Now maroon, that ain't a colour you see much these days is it? But maroon was *the* mod colour. I painted my room maroon! My mum 'ated it.

So a geezer in a mohair suit come walkin' up to the microphone, 'ands in 'is jacket pockets, to make a really special announcement. Suddenly The Who would come stormin' onto the stage, and the noise would come up like thunder: WHOOOOOOOOOOOO! Weren't no screamin' from no soppy birds, it was us blokes makin' that noise. The heat would get really close as the crowd pressed in, and I'd take one last look at my Who membership card—I used to call it my nose card, 'cos it 'ad a picture of Pete Townshend on it, and Pete Townshend's got this huge conk, used to call him a nose on a stick, you know? And as I stood, looking at my membership card, and then at the Marshall speakers all draped in Union Jacks . . . Christ, I felt really proud to be British! Then the air would come up, and the sound of "Can't Explain" would come shakin' through the speakers: "GOT A FEELIN' INSIDE I CAN'T EXPLAIN, CERTAIN KIND CAN'T EXPLAIN!" People at the front would 'ave to move back, 'cos the way Daltrey swung that microphone, you'd think 'e was gonna knock some cunt's teeth out. Then 'e went an knocked 'is own fuckin' teeth out, didn't 'e, at that Charlton gig in 1967! (*Mimes this happening: DOOF, ARGH!*) Wally!

I tell you, that's one thing The Who'd do, they fuckin' made you step back a bit. The place'd get really stuffy and stink of sweat, condensation would be drippin' off the walls. But you really didn't care there weren't no room for dancin', when you saw the madness in Moonie's eyes, swingin' those drumsticks like a lunatic, and Daltrey, 'is golden locks stuck to 'is 'ead wif sweat, bashin' the shit out of a new tambourine on 'is mike stand, harmonica blazin' rhythm and blues, down the microphone, out into the speakers,

out into the system—you didn't care! Entwhistle? Steady as a rock! And then that mad geezer Townshend, his right arm swingin' like a fuckin' windmill—Rickenbacker, goin' through the cabinets like a knife through butter. And afterwards, you know, you felt . . . spent. Your clothes were fuckin' wet through. And you'd go outside for a bundle. A punch-up. And the birds was always screamin', tryin' to break up the fight, but when you're comin' off speed, your nerves are really shot. You don't like humanity. You just want to fuckin' kick someone's 'ead in! Right? (*Laughs.*)

Remember the bouncer at the Marquee? 'e was another wally—'e'd always mess about wif the birds when they came outside. 'e'd say, "'ere, are you backin' Britain?" And they'd say (*dumb voice*) "Yeah." And 'e'd pull down 'is pants and pull out 'is plonker and say "Well back onto this then!" (*Laughs, snorts.*) And then 'e'd say, "Do you like chicken?" And they'd say "Yeah" and 'e'd say "Well suck on this then, it's fowl!" (*More snorting.*) It was a right laugh . . .

He becomes aware that the audience is not laughing. Awkwardly composes himself.

I'd like to finish this evening wif a song that I used to play down the Three Tuns in Beckenham, where that wanker David Bowie used to play, before they turned it into an Arts Lab, whatever the fuck that is. It's a song I'd like to dedicate to my mum.

Blows notes on harmonica; sings:

He was a mutant, she was an amputee
They met at a picnic held by the company
She'd lost one leg but he was born with three . . . legs
Three legs
They wanted children to raise a family
They fucked all the time but not very easily
She'd lost one leg but he was born with three . . . legs
Three legs
His leg would get stuck, inside of her cavity

But she finally got pregnant, wondered what it could be
She'd lost one leg but he was born with three . . . legs
Three legs
The nurse brought the infant holding it awkwardly
They pulled back the blankets looking expectantly
They pulled back the blankets looking so anxiously
And all that they could see were three . . . legs
Three legs
Three legs
Three-eeeeeeeeeee legs!

(*Applause.*)

Thankyou very much, goodnight!

NOTE: This monologue was written with mod vernacular assistance from Rina Vergano. The songs ("Money" and "He was a Mutant, She was an Amputee") were cowritten with Jeffrey Isaac and other members of the DC10s.

Drag Kings and Subjects

BY DIANE TORR

Performers: One middle-aged WOMAN.
Three DANCERS of indeterminate gender.

This performance begins with an installation that consists of three benches on which are positioned three prostrate bodies. Each of the bodies is covered with a black cloth which has a hole where the mouth is. Each mouth is open and covered with an inverted glass filled with water balanced on the gums and held in place by the lips. (The performers must close their throats to prevent the water being swallowed.) A wiggling tongue protrudes into each glass, like an underwater creature, and that is the only part of the body that appears to be alive. There is a single light shining on each of the tongues, giving the illusion of a video projection, rather than live action. The background is a dark blue wash, and atmospheric music plays. The audience enters from behind the stage and walks across it. They are invited by the stage manager to examine each of the tongues, and they wander around the reclining bodies before taking their seats in the theatre. When everyone is seated, lights go out and the benches are removed. A curtain is pulled across the front of the stage, close to the first row of the audience, hiding the benches from view. There are holes in the curtain at the level of the mouth and the buttocks. Carnival music is heard. The seats on the front row of the audience have battery-driven flashlights on them, and members of the audience are asked by a member of the theatre staff to "turn your flash-lights on now, please." There follows a dance by the tongues behind the curtain that is lit by the light of the flashlights shining on them as they protrude through the holes in the curtain. When the dance is over, members of the audience holding the flashlights are

asked to "turn your flash-lights off now, please." The tongues leave the stage in black-out and the curtain is pulled back. Low light is projected on a WOMAN who is standing at the back of the stage. This light shines from behind so the audience sees the WOMAN's outline rather than her face. Recorded music of a woman singing a high, plaintive, but pleasant operatic aria. This continues in the background as the WOMAN begins speaking, slowly and deliberately:

WOMAN: What does it mean to be a woman?
What kind of a woman am I?
I am normal. I am average. I am invisible.
In this guise, I am acceptable.
Acceptability means normal behaviour.

Music stops. WOMAN walks upstage.

Now as this woman, my power lies in my desirability.

She walks across the room with her eye on the audience; stops stage left.

When I walk across the room, I am aware of being watched. I am aware of your gaze following me.

She stops and turns, walking in a diagonal towards a table and chair downstage, then returns to centre stage and stops, facing the audience.

My way of walking is meant to appeal to your desire.

She stops and looks at a man in the front or second row of the audience.

My way of smiling is meant to make you feel comfortable.

She holds a "smile" pose for a moment, looking out at the audience.

My way of looking is meant to make you feel at ease.

She assumes an "interested-in-you" look for a moment.

My way of holding my head is meant to make you feel that you are important.

She cocks her head to the side as if she is genuinely impressed by someone in the audience.

My way of engaging is meant to make you feel that you are special to me.

She folds her fingers under her chin and looks out at the audience as if fascinated. Music begins again. She holds out her hands and looks at a man in the audience.

I want you to want me.

She looks at another person in the audience.

I want you to like me.

She looks at another person in the audience.

I want you to hold me.

She looks back at the man in the front row.

I want you to fulfil my dreams . . . To take me to the top.

She begins to blow kisses to him, lightly and tenderly at first, and then more passionately. She turns to someone else in the audience.

I want you to fulfil my fantasy. You know what it is.

She blows more kisses—randomly to various people in the audience.

Take me, I'm yours.

She is blowing kisses more frantically now and extends an arm to the original man.

I want to be part of you.

Music stops. Lights come up.

At least that's what I used to think . . . but at this point in my life, I am resigned to my role as facilitator, reconciliator, accommodator, the invisible lubricant that keeps things flowing along, day after day after day.

She is moving toward a table on stage right as she says the last line. Then she sits down at a chair next to the table and crosses her legs.

I emphasize my good points, and camouflage what might be considered unappealing. (*She gestures to the bags under her eyes.*) After all, it's important to look young. That's how we women get by, right?

She laughs. Lights change. Kicking off her shoes, she creeps forward from her chair on her tiptoes, and talks conspiratorially to the audience.

But I still have a little mischief in me. I leave the cookie on the plate that I know has been dropped on the floor, and wait to see which of my guests eats it.

She creeps back to the seat. Lights change.

You know I used to think that men wanted to hear what I really thought, but actually they don't want the truth, they just want you to agree with them. No arguments. Three phrases that I use to keep them there: "that's nice" and "how interesting" and "you're *right!*" And you know it really works. It really works.

Lights change.

I don't remember the last time my husband and I had conjugal relations. He's a businessman. He's always working. He makes a deal and then he's hired as a consultant on the basis of the deal, which leads to other deals. We don't talk much. We had more fun when

the kids were young. We would go to parties, to concerts, art open-
ings. He was more involved. But now I hardly see him. He talks
more to his cell than he does to me. (*She laughs, and then remarks
as if quoting a newspaper headline:*) "Woman replaced by cellular
telephone." He plays squash during the week and golf at week-
ends. We're married but we live separate lives. Sound familiar . . . ?

She waits for a response from the audience and then continues.

When *was* the last time we had sex?

*She thinks to herself for a while, pondering in silence, and then remembers.
Grimaces.*

Who has time for a sex life anyhow? House, garden, job, kids, pets.
Then I found out that many of my married friends don't have con-
jugal relations either. They call themselves heterosexual, but they
actually don't have sex with anyone. I never intended to be celi-
bate, but that's what I am. Unless you could call sex with yourself
. . . what is that? Can you still be celibate if you use one of
these?

*She takes out a small vibrator from her pocket and draws it gently up the front
of her body.*

And what if you think of holy things? I sometimes read the Bible
while I'm doing it. I think the bible is super sexy. All that beget-
ting and begetting and begetting. And that sssssssssnake. Yeow!
Then I told a couple of my girlfriends about my . . . I call it my
"friend." I told them that I'd got this "friend," and they thought
that was so daring. They wanted to try it, but I told them to go to
the Pleasure Chest on 7th Avenue in the Village, and get their own.
But they didn't have the courage to go themselves, so that's when
I became a rep.

*Sound of Eartha Kitt's "Je cherche un homme" plays. Light changes. Woman
pulls out a case and opens it on the table, displaying the interior of red velvet
and black lace, and containing several black drawstring bags.*

We'd have these try-out parties with our "friends", and we'd try the "friends" out on each other! That was a hoot!

She takes a large, black, ribbed vibrator out of a lacy black cover.

Let me show you some of them. They all come in their little sheaths. Here's one that could be considered a fetish for house-wives. I call this one "vacuum gigantum."

Displays a smooth-curved, royal blue, rubber dildo with a slight twist. It is abstract rather than penis-shaped. She returns the vibrator to the case and brings out two double-ended vibrators, the first in the shape of a boxer with extended fists.

Now these are two-in-oners. Some of my girlfriends think this one looks like Bill Clinton, but it's actually the head of a boxer and these are his fists. Cute, eh? But this line has been discontinued and this is the contemporary equivalent—perhaps inspired by Joan Miró—the design is clear yet still available for interpretation . . .

Displays a smooth-curved, royal blue, rubber dildo with a slight twist. It is abstract rather than penis-shaped. She returns the vibrators to the box and brings out three more.

Now these all have similarities. You press a button and things happen. (*She presses some of the buttons and the vibrators "come alive".*) But thematically they are very different—this one is a mermaid—ever had a fantasy about doing it with a mermaid? Well here's your opportunity. She even keeps a beat. And here we have a maiden and her "dog"? It actually looks like an anteater, but the important thing is it has a long tongue, and you see these balls? Each one individually rotates—imagine how it would feel inside . . . You want to feel it?

She extends the vibrator to a member of the audience.

Hands only, OK? And I want it back. Now this one has a jungle theme going on—an elephant with a long trunk. And look at

this—a lion's tail to tickle your bum-hole too! So you can get quite a safari adventure there.

She returns the vibrators to the box. Lights change.

You know, my husband doesn't know about my "friends." He thinks I'm selling Tupperware, which if you think about it, is a plastic device designed to make women's home lives easier. Well, I suppose that's what I'm doing.

Lights out. WOMAN walks across to table at other side of stage. Music comes up and the black and white film Open for Flavor *is projected onto a hand-held sheet, which is moved subtly by two performers wearing black clothes and stocking face masks. The film is a flickering series of images of human bodies in chiaroscuro lighting, gender often indeterminate. The film is sensuous but also playful, at times humorous. We see bodies being massaged, showered with talcum powder, gently stroked with asparagus stalks and other implements. Bowls of fresh fruit such as pieces of pineapple, cherries, strawberries, cut-up melon, are passed around the audience during the showing of the film. Sensual music is heard.*

As the film plays, a soft light comes up on the WOMAN, who removes her women's clothes, and then carefully wipes off her make-up at a table. She binds her breasts with a bandage and dons a man's white shirt, white y-fronted underwear, and suit pants with a belt. When the film ends, performers and sheet leave the stage, sound fades out and light comes up further on the WOMAN. She is heard speaking on a pre-recorded voice-over, as she begins to apply sideburns and a moustache at the table, to adopt the appearance of a man.

WOMAN'S VOICE: The first time I dressed as a man, Eartha Kitt was playing at the Café Carlyle. Someone I'd known since childhood had died of AIDS, and Eartha Kitt was his hero. He idolized her. She was an example to him of the kind of rags to riches fame that he had wanted. He loved to dress in drag, and I felt I owed it to him to honor her in his style. I went with my friend Winnie who looked gorgeous in a fake leopard number. When we arrived at the Carlyle I dutifully took our coats to the cloakroom, and when I came back, some slimeball was chatting her up at the bar. His swivel chair was turned all the way round, and he was leaning into her. As I walked back into the room and glared at him, the response was immediate.

He sat up straight, and turned his chair back to face the bar. I joined Winnie and watched him in the bar mirror. He glanced up and saw me staring at him. He never bothered us again.

Winnie and I had the best time. Being a man gave me such a feeling of power, of authority. I wanted to try it again. People would step aside when I walked down the street. It felt different. I could at last get my share of the seat on a subway, even learned to pee in a urinal. There's a piece of camping equipment like a suction cup with a tube—easy to conceal. That's what I'd use.

Voice-over ends, but WOMAN now begins speaking as if continuing her thoughts uninterrupted. She is now applying five o'clock shadow, and slicking back her hair.

WOMAN: I had these three separate identities: wife, mother, and man. But the husband and kids could not embrace a mother's fantasy, so I had to leave. That was tough. I had some friends who also liked to go out dressed as men, and we had many adventures together. The freedom we felt, walking along Coney Island beach at four in the morning on a hot summer's night, knowing we would never have the courage to do that as women. As men we could be more carefree. I felt safe as a man. I wanted to find out about other women who have lived as men, or had explored masculine identities as women. So I did some research. . . .

An image is projected on to the screen behind her.

Here we have the Billy Tipton Trio. Billy Tipton is the man in the middle. Billy Tipton was a saxophonist who died in Seattle, Washington, in 1989. It wasn't discovered until after Tipton's death that he had female genitalia.

Another image appears on the screen.

Isabelle Eberhardt was a Swiss-Russian adventuress and accomplished equestrian. She lived at the turn of the twentieth century and worked as a writer and journalist, travelling across North Africa on horseback in the guise of a Muslim man. She was so successful in this role that she actually gained access to the Muslim

brotherhood. Not an organization known for its acceptance of
women.

Another image is shown.

The Civil War in America was highly emotionally charged, and
men and women on both sides passionately wanted to aid the war
effort. If you were a woman, though, your contribution was to
send food parcels or blankets to the men at the front. So if you
wanted to engage in any action, you had to get out the charcoal
and disguise yourself as a male soldier. There were many women
who did, such as Loreta Janeta Velasquez, who became a scout for
the Confederate army. Many of these women were never discov-
ered, and some died on the battleground, but those whose identi-
ties were revealed were immediately discharged on the grounds
that they were sexually incompatible.

Another image appears.

Dr. James Miranda Barry graduated from the Medical Academy in
Edinburgh in 1812. As women were not allowed to study medicine,
it was only in the guise of a man that one could do so. Dr. Barry
went on to live and work in the West Indies, where he made many
new discoveries and advances in the area of tropical medicine.

Another image appears.

Frida Kahlo was an artist who endlessly explored ideas of identity
in her paintings and in her life. In this painting, she has cut off all
her hair and is wearing men's clothes.

Another image appears.

Here's a photo of her dressed as a schoolboy.

Another image appears.

Brandon Teena, christened Tina Brandon, was murdered in Falls

City, Nebraska, on December 31st, 1993. Brandon Teena identified as male and had several girlfriends. Some of the men in the town were jealous of Brandon's popularity and hunted him down. They raped, assaulted and eventually killed him. After his death, a group of the women who loved Brandon got together and mourned his loss, remembering in particular what a good lover and kisser he was. Brandon Teena's story is now immortalized in the movie *Boys Don't Cry*.

End of images. The WOMAN removes a suit jacket from a clothes rail, and puts it on as she continues speaking.

As for myself, I wanted to infiltrate male society—to see how far I could get. I had heard about a misogynist organization called the American Society of Men, and I wanted to see if I could gain access. I managed to enter one of their meetings without raising suspicion. I was so stunned that I was able to pass, that I went to another meeting, and then another. I was so successful in my disguise, and became so well known, that by the fifth meeting they had invited me to be an organizer.

WOMAN has now transformed to MAN. Lights go out as table and rail are removed, and s/he walks to the back of the stage. Then all lights up, including house lights. MAN walks forward from the same spot WOMAN appeared at the beginning of the show.

MAN: Good evening gentlemen, and welcome to the American Society of Men. (*Pause.*) The American Society of Men was established in Pittsburgh, Pennsylvania, in 1989, as an organisation that would protect and preserve the rights and privileges of men. Now these aren't any ordinary rights—these are God-ordained privileges—handed down to us from Adam. I am here on behalf of the American Society of Men to set up our first chapter in [*insert name of city in which performance is taking place. If it is in a non-U.S. city, in Spain for example, add:* henceforth to be known as the Spanish Society of Men.] Now as many of you will have realized, otherwise you wouldn't be here tonight, many of our rights and privileges are being eroded. And why is this happening? It's because of women.

Women getting above their station in life. Instead of staying home and nurturing their children, nurturing their husbands, they're becoming executives, doctors, lawyers, bankers. Every time you see a man like one of us who is out of work, you can be damn sure some woman has taken his job. And each time you see a woman working in one of these jobs, you have to wonder if it's rightfully hers. And do you know why this is happening? It's because of inappropriate male behaviour. So I am here tonight on behalf of the American Society of Men to train you in how to gain and retain respect as a man.

Rule number 1: Territory. (*Pause*.) When you walk into a room for the first time, have a sense of ownership. Have a sense that you could own everything and everybody in that room. When you walk, take up space. Think of a boundary of about a metre around yourself. I like to tell my clients to think of themselves as a castle with a moat around them. When you walk, have a sense that with each step you take, you own that piece of floor for the moment that your foot rests there. Most importantly: don't budge.

Rule number 2: Stop Smiling. Now it's very nice when women smile—it makes them very appealing, it makes them appear friendly and unthreatening. It's sweet. But when a guy smiles, it leaves him open. It gives someone access, it makes him vulnerable to exploitation. And you don't want to concede any ground whatsoever. You want to maintain impregnability, at all costs.

Rule number 3: Stop Apologizing. Because as a man in a man's world, *you are right*. And even if you're not, who goes around saying "I'm sorry" all the time? Hey—they're lucky to have you around. I want you all, after the count of three, to say: "I'm Not Sorry!" (*He counts. The audience responds. He takes them through it once or twice more if dissatisfied with their sincerity.*) OK. Don't you forget it.

Rule number 4: Gesture. Be very specific and economic in your body language—direct, clear, precise. We all have our role models, people to look up to in life. Mine are Pat Buchanan and George Bush—Senior—not that poser of a son. I like to remember George Bush's State of the Union address during Desert Storm, when our gallant troops went in to rescue Kuwait. He had to get across to the millions of American people watching him, so his gestures were clear, defined, specific. He meant what he said and he said what he

meant. He only touched his body once, and that was to get his reading glasses from the inside pocket of his jacket. And when he moved his eyes, they never moved independently from his head. When he looked to the left, his eyes moved with his head. (*MAN demonstrates this as he explains.*) When he looked to the right, his eyes moved with his head. (*Demonstrates.*) When he looked up, his eyes moved with his head. (*Demonstrates.*) And when he looked down, his eyes moved with his head. (*Demonstrates.*) *Never* move your eyes independently from your head, because this could be conceived of as shiftiness of character, and will not confer you with the respect that you, as men, deserve.

Now. Some of you may find yourselves in an I.S.S.—an Informal Social Situation—and you may be obliged to dance. My advice to you is—*don't.* Because when you dance, you make your body open, people can get a foothold into you. You need to maintain opacity at all costs. However, if there is no way to avoid it—it's the boss's daughter, whatever—then keep your movements minimal, guarded and repetitive. I will demonstrate.

Lights change. Lights for "club scene" come up. A stomping dance rhythm is heard: Elvis Costello's "Pump It Up." MAN dances, rotating his fists and moving his legs, turning on the spot, pouting enthusiastically. He punches the air repeatedly. Dance lasts forty-five seconds, sound cuts off. MAN leaves stage right and as he is going, waves to the audience as if leaving a political meeting:

See ya later y'all.

Lights black out, and curtain is pulled across the front of the stage. Interlude music plays. When performers are in place, technician calls, "turn your flashlights on now, please." Performers then do the bum dance. Only their bums are visible through holes in the curtain, and they move in synch to the music. This consists of a Bach Cantata, "Gott Sei Dank," played for 1 minute, and then Slim Harpo's "Got Love if you Want it," played for 1.5 minutes. Bums are illuminated by the light of the flashlights held by the members of the audience in the front row. After dance is over, technician says, "turn your flashlights off now, please." Dancers vanish. Curtain is pulled back to reveal MAN at table, downstage right, transforming in front of a mirror. He

gradually takes off his male attire and puts on male-to-female fetish wear: black bra, corset, suspender belt, fishnet stockings. (Note: bra is added over the performer's already-bound chest, then stuffed with "falsies.") There is a slide show of male-to-female cross-dressers, with accompanying archive audio that plays during the transformation:[1]

MALE VOICE (*deep, Southern*): About seven years ago I saw an article about a person who had a club and helped people come out, and I cut out this article and put it under the blotter on my desk. And every night I would read it like a Bible story and—you know—start to make the call, and then hang up when somebody answered. Finally after about eight months, with the help of a large double Scotch, I screwed up enough courage to respond to the "hello" on the other end of the line. Then it was about another five months went by before I really could get up the mustard to go to a meeting. When the guys came in—all kinds of guys, policemen, bankers, contractors, you name it—they were talking about football, and baseball, banking matters, and then it would drift gradually to cosmetic things. You know, where can you get wigs and so forth. And these were the same people you would meet in the street, and never in a million years would you guess they wore women's clothes. That was the coming-out process. Men's clothing is functional. Women's clothes offset and reveal the body. A dress puts the legs on display. Hey, the shrinks may call it gender dysphoria, but for some of us, it's gender euphoria.

Burst of music: "A woman wouldn't be a woman," by Eartha Kitt.

ANOTHER MALE VOICE: As Janet, I can be more carefree, have a greater ability somehow to enjoy life. I didn't tell my wife for a long time. We're about the same size. She started getting suspicious, I guess, when she noticed the smudge of lipstick on the inside of a sequined mini-dress. It wasn't a dress she wore often. The lipstick was a plum shade, and she always wore bright red. There were questions. She'd thought I had another woman. I denied it. It

1. The recorded passages that follow are edited versions of interview transcripts in Mariette Pathy Allen's *Transformations: Crossdressers and Those Who Love Them* (1990) and are used with permission.

caused tension, like a cruel tweak in our marital routine. She held off on the lovemaking. Just turned her back to me and that was it. She was hurting, I was hurting. So one day, I showed her the place under the floorboards where I hid my shoes, wig, make-up, dresses, jewellery. What I have always admired about women . . . they can just break down and cry in front of anybody, and it's OK. Men really can't do that without being labelled "weak". When I am dressed as Janet, I can express my emotions freely. I started getting female clothes by going through backyards and alleyways, taking them off of clotheslines, not knowing if they would fit or not. I had one friend, Eddie. He knows me as Janet, and he has accepted me as Janet, but he knows that he don't want to mess with me, because I'll just come out of my girl-bag and put on my man-bag and just whip all over him. My brother Hank died this summer. His childhood domination over me, and my screams of anger and frustration are hidden within me . . . However, if his teasing and bullying is in any way responsible for my becoming part-time Janet, I am forever grateful to him. It has given me the most exquisitely wonderful pleasure that I think can be known, except for the intimate pleasure between my wife and me.

Another burst of Eartha Kitt's "A woman wouldn't be a woman."

ANOTHER MALE VOICE: I didn't mean to tell my daughter Lisa about my crossdressing, but she was picking up clues, and unless I wanted to lie to her and make up stories about the high heels under my bed and my shaved arms and legs, I had to explain. Shortly after I told her we went out for dinner with a transvestite friend and his daughter. Both of us fathers were in drag, and the girls were very relaxed. When Lisa and I got back to the house, I explained that I had wanted her to meet Joanne and Anna, so she wouldn't feel like she had the only father in the world who liked to wear a dress. I may not be a typical father, but she shows me that she loves me, because I am *her* father.

Another blast of Eartha Kitt, then silence. Light comes up further on MAN, who is now applying drag queen-style make-up and dangling, glittering earrings and necklace:

MAN: Some of those men I met, through the American Society of Men, became friends of mine. I wanted to reinvent myself, and they introduced me to Lee's Mardi Gras. Now this isn't a place you would just come across. It's in the Meatpacking District of Manhattan, on 14th Street and 9th Avenue. There's a hidden doorbell, and you enter via an elevator that opens out onto the street. You ride to the third floor, and on the way up, the elevator operator has plenty of time to check you out. I was very nervous going there, but when the elevator door opened on the third floor, my fears disappeared. I found myself in an Aladdin's Cave of secret male sexual fetish. Every fantasy to fit every desire—in rubber, leather, lace, fake fur, and all kinds of bras and padding and shoes with five inch high heels, and corsets and stockings and make-up—guaranteed to cover that 5 o' clock shadow. As I wandered around the fitting rooms of forbidden fantasies, I watched portly executives squeezing themselves into schoolgirl uniforms, and a bald man putting on a custom-made diaper. All these men had one thing in common: they grabbed their fetish, and lived their fantasy. Now, not later. These men didn't have to give up their families to have their fantasy. I knew I could learn from them. I got to know all these men, and they did become my friends. They helped me to choose make-up and jewelery. These earrings, and the wig—these are things I would never have worn as a woman, but we all loved to dress up and perform for each other. It reminded me of what I would do with my girlfriends when I was seven years old. It was so much fun.

MAN is now putting on an elaborate, black, glittering dress with white feather trim, and a pink wig.

This is a dance I would do for them as Dolores.

DOLORES walks across to centre stage and poses. At the same time, the three dancers appear dressed in purple-sequined dresses, blue wigs and high heels. They line up as a chorus behind her. Bright stage lights up as loud disco music is heard: Sylvester singing "You Make me Feel (Mighty Real)." The dance begins, with DOLORES lipsynching to the song, and the chorus doing a line

dance. Dance continues for approximately three minutes until sound comes out.

Curtain call.

Music continues and members of the audience are invited to dance with the performers onstage. Each performer goes repeatedly into the audience to bring people out, until up to twenty audience members are onstage. All dance until end of song. General applause.

END

BULL: A Monologue for Mister EE

BY DIANE TORR

Part of the collaborative performance *Bull*, co-ordinated by Ian Smith and Mischief La Bas at the Albany Theatre, London (1997) and the Tramway, Glasgow (1998). Like Theseus in the Minotaur's labyrinth, the audience moves from room to room of the theatre building, en-countering different characters and spectacles along the way.

Audience enters one by one and in clusters and stands around in the space. DIANE as Mister EE is seated at a bar on a stool. He is drinking a beer, smok-ing a cigarette, and cruising the audience—scrutinizing them through his eye-mask. When everyone is visible, Mister EE finishes his beer, puts down the glass, stubs out the cigarette, and walks on to a raised platform.

Mister EE (who wears no trousers), dances lasciviously for the audience to the sound of Sven Vath's "Accident in Paradise." During the dance, slide images of men's testicles are projected, cross-fading to images of cute animals (baby chimpanzees, baby deer, baby elephants, etc.). Mister EE eventually exits as the music and slides continue. When the music ends, he then reappears without his eye-mask, wearing a suit and baseball cap that says "BULL." He stands at a lit podium and addresses the audience as if they are at a conference:

MISTER EE: Gentlemen, we need to take the bull by the horns. You men are only half the men your grandfathers were. What I'm talk-ing about is no cock and bull story. Hundreds of the bedrock chemicals of the post-war age—such as PCBs used in the manufac-ture of electronics, polycarbonate plastics used in the making of

soda bottles, chlorine compounds that bleach paper—all these chemicals resemble the human sex hormone estrogen. In addition there is an enormous industry for using synthetic estrogen as growth promoters in livestock. In fact there's hardly an animal you've eaten that hasn't been treated in this way. This ain't no bull that I'm telling you!

Now men, as well as women, produce estrogen and so have receptors for the hormone. But the estrogen receptor in your body can no more tell that it's being occupied by an imposter than a door lock can tell that a thief's counterfeit skeleton key has been inserted. These estrogen mimics are quintessentially bulls in a china shop of the reproductive system, and sexual development in both males and females has gone seriously off course. "Half your grandfather" is no exaggeration. Since 1938, sperm counts of men in the U.S. and other countries of the world have plunged by an average of fifty percent. And this sperm is by no means the dog's bollocks! To make a clear comparison: a bull with a five percent abnormality rate in its sperm would be shunned for breeding and turned into hamburger meat, but a man with those numbers could boast of being a splendid rarity.

I'd like to keep the ball in the air on this one. Think of infinity as the bull's-eye of a target, and that's the future of the human race. Now think of that bull's-eye as a female ovum, and the human sperm swimming toward it—and you can see the kind of bullshit we have on our plate. Widely used pesticides are responsible for the decline and fall of Western manhood. It's as if we've been black-balled, or snookered from infinity. Gentlemen, the battle of the sexes is over. We've been emasculated, and we're the ones who've made the balls-up. But do you know something? Why do women rub their eyes in the morning? Because they don't have balls to scratch. *(He laughs.)* It makes you think again about castrati, doesn't it?

Sound of Farinell's "Castrati" is played in the background, while slides come up. He indicates the first slide:

This is the last castrato of the last empress of China. If the testicles as they function are now a load of old bollocks, I can foresee a renewed interest in castrati. No voice like it, I've heard.

Slides continue showing a variety of testicles.

But to keep the ball rolling, you might like to consider the testicles as aesthetic objects. Even the private parts have their appropriate beauty. The Greeks knew about this.

Slide of Greek statue's testicles.

If you examine the balls of any Greek statue, the left testicle is always the larger, as it is in nature. Now look at this—the idea of testicles as the "family jewels" demonstrated in a figurative sense.

Slide of testicle with piercings.

There are some good-looking nuts here.

Slides run until there is a slide of a breast.

And we mustn't forget breasts in women. This is breast cancer awareness month, and these toxins are making a balls-up of tits too.

Slides run until end. MISTER EE now dons top hat and gloves and becomes a showman.

ROLL UP, ROLL UP, IT'S THE JOLLY TESTICLES DANCE!

Showman now invites the audience to dance. Music is played. Big, pink balloons are thrown to the audience. Audience dances and bats balloons around. When music ends, audience leaves for the next leg of their labyrinthine tour. They collect their own, water-filled tiny pink testicle balloons on the way out from trays held by attendants.

Donald Does Dusty

BY DIANE TORR
(Work in Progress Version, Berlin 2008)

*Dark stage. Lights come up on DIANE as she dances with a pole for the du-
ration of song sung in Spanish by Eartha Kitt. She is dressed in black pants
and T-shirt, black wig and eye-mask, with drawn-on pencil moustache. She
manipulates the pole in many configurations, as if it were a sword, a baton,
a trapeze, a dildo. At the end of the song, she puts down the pole and sits at
a small table to take off the wig, mask and male make-up, and to apply lip-
stick. As she does this, a video extract plays of Doris Day, in the film*
Calamity Jane, *singing "Whip-Crack-Away."*

*DIANE stands, and in silence slowly turns the pages of a Dusty Springfield
promotional booklet which she holds in front of her chest, the images facing
out toward the audience. Large black-and-white stills of Dusty are projected
behind her. Eventually she puts the booklet down and speaks into a micro-
phone.*

DIANE AS DIANE: For those of you who are under fifty and did not
grow up in the United Kingdom, there is no way that you can
have any conception of the significance of three little words—
Ready Steady Go!—which meant: the weekend starts here!

*A 1960s pop song plays, and DIANE performs a dance along with it—"the
Twist." As the music continues, she returns to the mike:*

DIANE AS DIANE: *Ready Steady Go!,* or *RSG* as it was fondly known,
was no ordinary TV pop variety show. Hosted by Dusty Spring-

field, the content of the show was about hairstyles, make-up, new bands and the latest dance craze. It put the youth of Great Britain in touch with itself, and gave us a sense of freedom that we had never experienced before. (*She switches to the Aberdonian accent of her youth.*) It was in watching *Ready Steady Go!* that my brother first discovered Dusty Springfield, and when he discovered that she was (*half-whispered*) a lesbian, that just added to her appeal. We grew up in a housing estate in Aberdeen, in the north-east of Scotland, and the word "lesbian" was not a word you would ever hear. You might see it written down—like if you looked it up in a dictionary, in case you might want to know the meaning—but you'd never hear it. My brother Donald wanted to know *everything* about Dusty.

Pause. Diane sits down, placing a red, 1960s-style coat over her shoulders as she does so. She affects a sultry, English voice. Slides of Dusty are projected behind her.

DIANE AS DUSTY: I was bold enough, and brave enough, in the extremely repressed 1960s, to admit to a journalist that I could just as easily be swayed by a girl as by a boy—the consequences of which were huge, as I'm sure you can imagine. I was brave enough too, when The Springfields—my brothers and I—toured to South Africa in 1964, to insist that we would only perform to mixed-race audiences. Under segregation laws, we were arrested, thrown in jail, and then thrown out of the country. Back in the United Kingdom, I used *Ready Steady Go!* as a vehicle to make black American music visible. I promoted acts like Martha and the Vandellas, Stevie Wonder and Smokey Robinson, who performed in Britain for the first time in 1965. It was through *Ready Steady Go!* that I met Madeleine Bell, who was one singer I was particularly fond of, and with whom I shared, perhaps, more than a love of just music.

(*She removes the red coat.*)

DIANE AS DIANE: Donald was enamored. He examined everything she did—every flick of the wrist, every turn of the head, the exact

way she walked—and then he would practice *being* Dusty. When
my parents were out, my brother would sashay across their bed-
room floor, wearing my mother's evening dress, fur stole, high
heels and diamante earrings. I sat next to the mirror watching
Donald, watching himself, watching the mirror. My role was to be
his audience, judge and jury, and to award him points for his per-
formance. After the seventh or eighth time of watching him per-
forming to "Wishing and Hoping," I began to cheat and say, "You
really did better on the second time." Then he would get suspi-
cious and want particulars.

DIANE AS DONALD (*aggressively*): What was it about the flick of the
wrist that was different, exactly? Did it have more of a flourish?
Was it more *Dusty?* Tell me Diane! You weren't paying attention,
were you?

DIANE AS DIANE: I wouldn't have a response, and then he'd know
I'd been making it up. He would be completely furious and tear off
my mother's fur stole, pull off the earrings, kick off the heels, and
start jumping about in my mother's best dress! I'd be terrified that
we would get caught, so I'd say, "Donald, you *are Dusty!* You are
the queen of soul!" (*Pause.*) Donald knew all about style. He knew
how to walk in high heels, how to sit down in high heels, how to
cross your legs in high heels . . . He just seemed to know every-
thing. Me, I played centre forward in the field hockey team of Ab-
erdeen High School for Girls. My style was ground-stick-ground-
stick-ground-stick-ball! My brother had to try really hard with me.
Really hard indeed.

(*She puts on a pair of elegant, high-heeled shoes.*)

DIANE AS DONALD: OK Diane, let's see what you can do. This is
how you walk. Are you watching, Diane? This is how you step so
that you extend your leg, and show the curve of your calf, OK?
And you point your toe. And when you sit down, you sit down on
the edge of the seat, and cross your legs. You point the toe of your
shoe, and you lift it up and down to connote your desire. (*Pause as*

he demonstrates.) OK, let me see you do that again, Diane. That was useless! It's a subtle suggestion, not a clunky move! Oh my God, Diane, will you ever learn?

DIANE AS DIANE: I did actually learn some things from my brother Donald. I learned how to be a sophisticated lady. I want you all to participate in this experience. So everybody, all together now (*she demonstrates as she speaks*): suck in your cheeks. Enunciate your cheekbones. Look down your nose, elongate your neck, and—*flick your head!* I want you to look at somebody in the room, and do that for them. Suck in your cheeks, enunciate your cheekbones, look down your nose, elongate your neck, and flick your head. If you don't have any hair that's OK, you can just pretend you're wearing a wig. Now, let's try this one more time. (*She repeats the sequence once more, and watches the audience with pleasure.*) Good! You're all sophisticated ladies!

(*Pause. Diane re-dresses in Dusty's red coat.*)

DIANE AS DUSTY: They were the all-time food-fight parties . . . I would invite all of these wonderful people. There would be Martha and The Vandellas cowering behind the couch, because there was food flying everywhere, but then once they'd got used to it they would come out swinging with these huge long French loaves like tennis racquets. And God! The poached eggs! Tennis racquets and poached eggs were really good! I remember lobbing a sardine right across the room at one of the Shangri Las, and she had a very deep—how do you say it?—décolletage! And it went straight down! How many people were in that room at any one time? Seventy-five? I always believed that if you give people enough food and enough drink and mix them all up, it'll work! And if they don't like it . . . ? They can just go home. (*shrugs*) What do I care?

(*Music plays as she removes the red coat, pushes her chair back, and stands centre stage, in a half-squat. She begins rapidly punching the air with her fingers, making Scout salutes.*)

DIANE AS DONALD: Dyb dyb dyb, dob dob dob,
Dyb dyb dyb, dob dob dob;[1]
Akela, we will do our best—Wolf!

(*Video projection begins: camera pans in close-up around the badges sewn onto a blanket, showing the names of various European cities.*)

DIANE AS DIANE: Before he became obsessed with Dusty, Donald was in the boy scouts. (*echoing*) "Dyb dyb dyb, dob dob dob—Wolf!" I eventually inherited his scout blanket, and looking at it—knowing what I know about him—I wonder about how exactly he acquired all these badges from the boys that he met at International Scout Jamborees. What did he get up to on that blanket? He had so many of these badges! He was quite popular with the Scandinavians, in particular . . . (*Video ends.*) Donald could be very persuasive. At the age of fifteen, he persuaded my mother and father to let him attend a Drama School in London, and he left home. I was bereft! Donald had been my confidant—I could tell him anything and he always responded. But my father was an alcoholic (wasn't everybody's?) and my mother was constantly sick. So my brother was the one person I could confide in, and then he was gone. I would write to him when he was working in repertory theatres in places like Bournemouth and Swansea, Ipswich and Hull—places you might have heard of but would never want to visit—and I would just pour out my heart to him. All the insecurities and angst of a teenage girl. I missed him so much that I eventually persuaded my mother to let me go and visit him in London. But when I stepped off the train at Kings Cross, Donald scanned me up and down, and his eyes came to rest upon my feet. He just pointed at my shoes and said:

DIANE AS DONALD: You're *not* wearing those. You need some heels.

1. "Dyb" and "dob" were British Cub Scout abbreviations for "Do Your Best" and "Do Our Best." The first was a command called out by the pack leader, Akela (named for the head of the wolf pack in Rudyard Kipling's *The Jungle Book*). The second was the pack's chanted reply.

DIANE AS DIANE: In Donald's French lesson, at the beginning of the school day, my brand new, high-heeled shoes were removed from my feet and passed around under the desks. They were duly looked over by the kids, sniffed and touched and examined by each member of the class. I, meanwhile, was writing out French verbs. But there was something about those shoes. (*She is holding the brown, suede, high-heeled shoes up to her face, caressing her cheek with them, then scratching at them with a fingernail for resonance.*) They have quite an interesting sound, and a particular smell to them too. A special feel. I'm going to pass them around so you can all enjoy them. Stroke them, and see for yourselves.

(*She hands the shoes to two attendees, dressed in black with eyemasks, who take them around the audience for inspection. The song "My Cheri Amor" plays as this happens. Diane holds up still photographs of Donald posing in various theatrical costumes and portfolio shots. Similar images are projected onto the screen. As the song fades out, the shoes are returned to the stage.*)

DIANE AS DIANE: I bet you thought that was Stevie Wonder singing? No—it was my brother! Donald had heard that song on the B-side of a Stevie Wonder single, and he thought that if he could release it himself, he would have a pop hit! He somehow persuaded some record producers at Decca Records to invest in him. So imagine Donald's dismay when Stevie Wonder produced "My Cheri Amor" as an A-side! Donald was furious. He thought Stevie Wonder had stolen his idea. (*Pause.*) He tried again with "Green, Green Yesterday." (*The single sleeve for Donald Torr's recording of this song is seen on the screen.*) He didn't get anywhere with that, either. But he did have some success when he joined "The Young Generation," which was a BBC television song-and-dance troupe, who were very popular for a while. (*She displays their LP record sleeve.*) I'm going to show you a video of their work shortly, and I've made a special edit so you can watch Donald do the same sequence in reverse, just in case you missed him the first time. (*Pause.*) Everyone had to pretend to be straight in the early '70s, and Donald loved "passing" as a young straight boy. Here he is on the cover of the *Sun* newspaper. (*She displays a yellowing tabloid.*) "Hey ding a ding! We're first into Spring!" is the headline, and un-

derneath it says, "There's definitely a touch of spring in the air for Karen Knight, aged 16, and her boyfriend, Donald Torr, 22, both members of the Young Generation dance troupe." This was printed on Monday March 20th, 1972 . . . four days before my gay brother's twenty-fifth birthday.

("*Green Onions,*" *by Booker T and the MGs, plays loudly.*)

DIANE AS DIANE: This is the music we were dancing to in 1972. (*She goes into another shimmying, period dance, then eventually into a jogging run, before returning to the mike.*) As women get older, they become more tubular in shape. Have you noticed that? They lose their waist-lines—if they ever had one. I never really had a waist-line, which made it much easier for me to pass as a man. But I've also noticed, as a middle-aged woman, that as the ovaries no longer produce estrogen, this whole middle part of your body just sort of collapses. The network just goes *phlatt!* And these jowls? I never had jowls! Where did they come from? And *double-chins?* What's that about? To remind us that death is imminent? You're heading towards death! Well you know what, I'm not dead yet. Unlike my brother Donald, and Dusty Springfield. (*A slight pause; change of tone.*) But I do remember them. How do you remember the dead? Perhaps we could celebrate the spirits of those who were very close to us, but have passed on. I'd like us all to share in this celebration, so if you have someone you have loved and lost, I'd like you to write their name and a brief message on the pieces of paper that my attendants will hand out to you. These are very special pieces of paper, and they'll be collected up when I come back in about five minutes.

She exits the stage, as paper and pens are handed out by the attendees in black. During the writing interlude, a video is projected. Accompanied by an operatic aria, a hearse is seen leaving a small funeral parlor in London's Portobello Road, followed by a procession of cars. The coffin is then seen being removed from the hearse at the crematorium. Then the footage changes to black-and-white archive footage of The Young Generation, dancing energetically to "Keep on Running," by the Spencer Davis Group. The women wear spangled mini-dresses and knee boots; the men are in black but with white,

furry moonboots and overcoats. As the song ends, the video screen fades to black. DIANE reappears on stage at the microphone. She wears a blonde, Dusty Springfield wig, and a long, black velvet dress with black gloves and sparkling jewellery.

DIANE AS DUSTY lipsynchs singing to Dusty's "I Count to Ten." She brings particular focus to the hand and arm gestures—a palm held out as if to say "stop"; hands cover the face in sadness; arms spread out wide as if in an embrace; fingers curl down the length of the body. As the song finishes, the audience's messages to loved ones are brought to the front by attendees in a metal dish and placed on a pedestal.

DIANE AS DIANE: What happens when someone dies is that we, the living, contain their memory within us. There is no textbook explaining how to deal with death, so we might as well make it up. We are now going to send these messages into the ethereal plane. For all our departed loved ones. (*Diane lights the papers in the dish. They are flash-papers, which instantly ignite in a flare of energy.*) They will live on in us, and we will celebrate them. And dance like there is no tomorrow.

The audience is invited by attendees to join Diane on stage and dance, as Dusty's "I only want to be with you" is played. They dance until the end of the song. Diane thanks the audience. Applause. Audience leaves to the sound of Dusty singing "Little by Little."

END

Man for a Day

A DO-IT-YOURSELF GUIDE

1. PREPARATION

The creation of a male identity depends very much on your commitment to the investigation. If you put your male identity together in a makeshift way, then the chances are your character will also be makeshift. The more that you know about your male character, the more secure you will be in your invention. You need to have a strong sense of your male persona: you need to know his name, where he is from, whether he is married, single, gay or straight, whether he has children, what he does for a living, what he does to play, whether he owns a car, where he goes for his vacation, whether he has brothers or sisters, older or younger than himself. What is his relationship to his parents?

Consider his daily habits: What kinds of food does he like to eat? What is his preferred mode of transport? What does his apartment look like? Which newspaper does he read (if any)? What kind of music does he listen to? What clothes stores does he shop at, or does he buy his clothes from catalogs, or online? Then there are more particular aspects of his character, like the kind of fantasies he has, and where he'd like to be in five years time. Whatever you decide, you need to be able to back it up from your own experience: if you decide to be a computer programmer but you know nothing about computers, you won't get very far in conversation, or be able to sustain your role for long.

But let's begin at the beginning, and prepare your appearance.

2. UNDER YOUR CLOTHES

Breast Binding

This is something that was fashionable among flappers in the 1920s, as flat-chested women were thought to be attractive. Back then they used a smothering bra that squashed the tits flat. These are no longer available, but you could make one yourself, as the ever-practical German drag kings, The Kingz of Berlin, have done. However, what I use is a four- to five-inch width of Ace (or strong elastic) bandage, wrapped around starting just under the breasts. It's important to cover the nipples on the first wrap around if you can, and to distribute the bandage evenly. It's helpful to have an assistant for this, and that's especially important if you have big breasts, as they tend to pop out if not secured firmly (you might need two bandages to prevent this). It's also important not to let the bandage get ruffled or twisted, as it might just turn to ribbons as you move about, completely defeating the object of the exercise.

If binding your breasts seems uncomfortable, remember that in most cases "becoming a man" involves repressing yourself emotionally. This physical manifestation reminds you of the tightened-up effect you're seeking.

The Penis

There are many ways to make a fake penis. If you want it hard, for theatrical effect, you can use a dildo or even a banana, but it's far more realistic to create a soft penis. This is easily achieved and will also be more comfortable to wear. You can use a folded sock for this, or a condom filled with cotton wool or gel. I think that the most convincing fake penis is one made with a tubular bandage (the gauze kind used for fingers or thumbs) stuffed with cotton wool, and tied or sewn at both ends. Whichever option you go for, remember not to make the penis too large! This is a penis *at rest*—so it should have a kind of spongy feel, and be about three or four inches in length, just enough to create a visible signifier in your pants when you sit down. You also need to wear men's underwear for that authentic feel. Underpants with a flap or Y-shape at the front will give you something to tuck your penis into, but make sure you secure it with something: you don't want it to fall out when you visit the Men's Room. And remem-

ber, the penis dresses to the left or the right—definitely not down the middle.

We are of course missing out the testicles and how they rub against the inner thigh. I have been told by many men that they have a stronger presence for them than the penis itself, as the balls hang down and have their own weight whereas the penis is tucked in. However, the most convincing testicles I've experimented with are small water balloons, and they are both difficult to suspend, and rather impractical for going out and about. A fake penis is more functional, both as a visual sign to others, and as a physical reminder to yourself that you are "packing."

3. MAKE-UP

Moustache / Beard

Facial hair is the big signifier in creating a male identity. You can get the type of crepe hair I use for this from a theatrical costumer's or novelty store. It comes in different colors and in braids, and is usually made of wool. (You can also buy ready-made moustaches, but these generally need to be adapted, and although easier to deal with, they can come askew and are not as convincing close-up.) There are different techniques for using the crepe hair: the easiest method, I think, is to cut the hair into little pieces, about one-tenth of an inch long, and lay them out on a flat, clean surface, in the shape of the facial hair you want. Then, using a brush and spirit gum (a glue that demands accuracy as it is difficult to remove if you spill any on your clothes), paint the shape of the moustache, sideburns, or whiskers that you want onto your face. After that, you can carefully stick on the pieces of hair. This takes practice, so don't get frustrated if it doesn't look realistic first time around.

If you look closely at men's facial hair, you will see that the moustache is often a different coloring from the head hair. For example, the moustache and beard often show signs of age faster than head hair (i.e. gray hair), or there may be traces of ginger among the brown or black. You can buy crepe hair in different shades, so you might want to mix shades a little to create a more convincing look. Be bold! If you have dyed hair, though, remember also that your facial hair will need to be the same shade as your *natural* hair color: men rarely dye their whiskers!

Five O'Clock Shadow

It is important to add the five o'clock shadow *after* you create your facial hair, because traces of spirit gum are often left on the skin. You need to clean that up before you do the shadow, or else it will get patchy. You can use a matte dark brown eye shadow (make sure there's no shiny stuff in there!) and a blush brush to apply the shadow effect. Lift up the chin and stroke up the neck along either side of the trachea, leaving the central portion of the neck free, to give the impression of an Adam's apple. Don't overdo the shadow: blot it with a tissue so it has a subtle hue. You can also use a stippling brush and stippling cream—a sponge and dark cream that creates dots (like the beginning of bristles) on the face. This is professional theatrical make-up that you can buy from a theatre make-up store, and does help create an authentic look. It is your observational skills, though, that will determine how realistic you can make this.

If you examine men's necks (for example, on the subway, or in supermarket lines, where you have time to look), you'll see that the shadow is stronger along the edge of the lower jaw bone, unless the man has a double chin. Notice the line where the five o'clock shadow begins and ends on the cheek, above the lip, and where it joins up with the sideburns.

Eyes and Eyebrows

Eyebrows can be thickened with a black mascara and then defined with a mascara comb. Don't overdo it, or you'll end up looking like Dracula. You may also want to emphasize any bags under your eyes with a dark shadow. Most men don't have the worries women do about accumulating signs of age and haggardness, so emphasizing these may help enhance your male appearance, giving you that rugged, "lived-in body" look.

Hair

If you have long hair, you may want to comb it back and hold it with a rubber band at the nape of the neck: let the hair hang limply down the back, not up (as in a pony-tail). Alternatively, if your character is the kind who would let his hair hang loose, make sure there's no trace of back-combing (unless you're a heavy metal dude or Rod Stewart looka-

like). And be careful: tearaway hair may feel too "feminine" for you to convince yourself or those you're interacting with of your maleness. Remember, if in doubt, "Hold In, Hold Back, Hold On." For women with short hair, one option is to slick it back with a firm-holding gel: you may feel like your hair is plastered to your head, but again, this will help you get to feel more "withheld," which is usually appropriate in effecting maleness. If the gel doesn't work for you, you can also disguise your hair with a hat, but make sure the hat you choose is in keeping with your character. Alternatively, if you use a parting, remember that men normally part their hair lower on the head than women, and traditionally men would part on the right. (If a man parted his hair on the left, he was considered potentially effeminate, but that was in the dress-correct 1950s, and these things matter less now, if at all.)

4. CLOTHING

When thinking about the male identity you wish to construct, you need to be very attentive to the type of clothes that the person you want to be would wear. If you don't think it through, you will end up feeling awkward and uncertain in your male persona. You may desire to be a dapper dandy, but with mismatched jacket, shirt and tie, you could become a dawdling dilettante. As Mark Twain remarked, "Clothes make the man (naked people have little or no influence on society)," and that's still the case. Your outward appearance will convey much of what you think of yourself as a man—and the details matter. If you go for the power and privilege of a corporate executive, for example, you can strut around a room and take up as much space as you like. But if the clothes don't fit, the image won't work. Women's necks are usually thinner than men's, so it can be hard to find a well-fitting man's shirt. In that case, you could wear the shirt open at the neck, without a tie, but obviously that changes your identity. Similarly, if you have a big, feminine backside, you'll find that a suit jacket with a single vent will only accentuate it, whereas a double-vented jacket will help flatten out your back view.

Make sure you have cuff-links for the shirt if it requires them: rubber bands and paper clips won't do you justice. If you're really attached to jewellery, you might investigate tie clips, or a western tie (if that's within the possible wardrobe of your male identity) and shoes with a

buckle instead of laces. Speaking of shoes, don't try to get away with women's sneakers or brogues: they aren't unisex. Men's shoes are always wider and more roomy than the women's versions: they're constructed for men's feet and they are generally broader than women's, and cover more space on the ground. If you try on men's shoes, your feet (and consequently you) will feel a contact with the floor that you've never experienced before. They are generally stronger and sturdier than women's shoes: you'll feel as if you're standing on the ground, ready to stand your ground.

Other male touches include a male watch (and watchstrap), suspenders/braces, or a sturdy leather belt. Remember that men buckle their belts from right to left, and their shirts and jackets cross left side over the right, with buttons on the right side. Carrying a wallet in the back pocket of your jeans or in the inside pocket of a coat is also a typical male habit. Men generally carry their money on their person: the jangling of loose change in a pants pocket also helps to conjure up a certain kind of confident, masculine presence.

5. BODY LANGUAGE

In creating a male persona, you need to think about the particular identity of your character—whether he is high status or low status, for example, and what his social background is. In order to acquire authentic-looking gestures, you need to spend a lot of time doing research— observing men in bars, on the street, in the subway, in offices, at ball games, and so on. Then, try out these male gestures—ways of standing, looking, talking, smoking, eating, gesticulating—in front of your mirror at home, and practice them over and over until they become automatic. Appropriate body behavior will vary according to type, but there are certain basic physical patterns which will help identify you as "male" rather than "female" to casual onlookers. In my workshops, I demonstrate some of the gestures and behaviors that men have utilized to negotiate and retain power and control in different situations. These will be of varying appropriateness for different individuals, depending on your chosen character type, but it is as well to learn some broad brushstrokes of archetypally "masculine" physicality before trying to aim for subtleties. Thus, while some of the following comments may

seem "sexist," bear in mind that I am emphasizing *dominant male traits*, not universal laws. This is behavior that has been repeated over time, and so acquires the appearance of being "natural" to men, but they do not own this behavior, it is simply what many of them have adopted and made habitual.

First of all, now that you have a strong sense of who you are as a man, *adapt no more.* It is important to stop smiling, right now. Men don't smile as much as women. They smile when there is a reason to smile. As women, we learn to smile frequently in order to make ourselves unthreatening, so that people can feel comfortable in our company. When you smile, it's an act of friendliness that could be conceived as conceding ground. So give up the grin, and stop apologizing. Practice opaqueness so that you are impervious to even the most penetrating stare.

Learn to be direct: male gestures are specific and directed, so in communicating, gestures are used to emphasize rather than embellish. Gestures might include pointing with the forefinger, as in the phrase "*I told you* I wouldn't be around to pick up *the kids!*" Here you might point twice, at the beginning and the end of the sentence. Another gesture of definitiveness and authority is to slice the air with two hands, palms facing downward, just about mid-chest level (as in the phrase "I've *had it* with this job!"). One gesture of poignancy and determination is to punch the palm of one hand with the fist of the other. This is a gesture you use only once during a conversation because if you use it more often it loses power, and therefore authority. Men very rarely touch their bodies, unless it's to adjust their balls, to stroke their facial hair, or to hit the sides of the thighs as an expression of finality. They tend to remove their wallets from the inside of a jacket or coat pocket by lifting the garment away from the chest with one hand, and delving into the pocket with the other.

Take up space: When you enter a room as a man, act as if it's your space, as if you are completely comfortable with the surroundings. Even if you are petrified, act as if everything is familiar and within your grasp ("oh, there's a dead cat on the floor. I've seen that before. Somebody should get rid of it."). You own the room, and you own everything in it. Everything you look at is yours. You see that aquarium ? It's yours. The table and chairs? All yours, if only for that instant when

your eyes rest on the object. Never show signs of uncertainty or discomfort, because you could be construed as not being in charge, and it is most important that you maintain your authority at all times.

Think of an additional three feet perimeter around your body as included in your territory. Each time that your foot steps on the floor, it owns that piece of floor for the period that it rests there. Of course, in a crowded situation like a subway car, you have to give up on the additional perimeter space, but you can block people who try to nudge into your personal space. Literally use your body as a block: don't allow anybody to encroach on you or push you out of the way, in even the slightest amount. Stand your ground and take up all the space your body needs, even though the crowd might be pushing in on you to move over. Don't let anyone feel they can take up your space, not even an inch. Sitting on the subway means that you sit with your legs wide apart and your feet planted firmly on the floor. If your legs protrude into another passenger's seat-space, that's not your problem. You take the space you need. If you are not reading a newspaper (and this is a good way to define your space), jut your elbows out, either by folding your arms squarely, or by using your folded hands to cover your penis. Folded hands rest on thighs, hanging in front of your flies. This is simple protection, because a kick in the balls (even an imaginary one) can be really painful.

When you walk, jut your feet out to the side. The action comes from the shoulders. Hips are frozen and are led by the swing action in the shoulders from side to side. As you walk, you take up a lot of space as you are letting your weight fall first to one side and then the other as you are moving forward. Men walk, and use their bodies, as blocks, so don't twist at the waist to turn and look behind you if someone calls: turn your whole body round so that it's facing in the other direction. As you walk, and do most actions, your hands are in a semi-clenched position. Sometimes they hang in your pockets. Then the arms hang down too, and are bent at the elbows. Never bend at the wrist and let the hand hang from there. If you have any doubt, just maintain the semi-clenched fist. It's the most common way that men use their hands when they are walking, sitting or even lying down.

When you sit down: if you are wearing suit pants, adjust them by pulling up the creases at the knees, before you sit down. Then sink

down deep, with the whole of your ass on the chair. You will be leaning forward as you do this, and then as you straighten up, sit with your back resting on the back of the chair. Never sit on the edge of the seat. That's what women do. When you get out of the chair, take your time. Don't spring up. Lean forward as you move out of the chair, straighten up and take a step. Walk toward the table and pick up a glass. Keep your movements staccato, rather than fluid. When you hold an object, grasp it with the full strength of the hand. This might seem absurd if you are picking up a plastic cup, for example. But the idea is to show strength and ownership, not delicacy. Even if it doesn't take much effort to pick up an empty plastic cup, you don't want to appear "delicate." Better to over-emphasize your strength.

When you talk, you can speak really slowly, as people imagine you have something important to say. As a man, you have access to privilege. Each word, each jewel that you utter has thousands of years of philosophy behind it. When you pause to reflect, people imagine that you are contemplating these thousands of years of philosophy and that you have something important to say. You don't actually have to say anything at all. They're lucky to have you there. Try just looking at them with an air of bemused tolerance, and wait for them to say something that might interest you. And when you do speak, don't worry that you have a woman's voice. If you slow down your speech and speak in a deliberate tone, nobody will guess that you are female. Accompany your talk with appropriate, significant gestures, and you will be seen to be male. The visual presides over the aural.

When you look at people, look "through" them. To do this, imagine that your gaze is initiated from deep inside your head. As women, our gaze often appears to be on the surface of the eyes: we are eager to communicate and that intention is registered in our wide-open eyes. However, if you look with a sense that the eyes begin at the place where the optic nerve connects to the nerve framework within the head, you are giving a lot of distance to that gaze. It seems as if there is a lot of thought and scrutiny behind the eyes. This may not be the case, but at least you have the appearance, and along with that you gain the authority of the male gaze and a sense of self-reserve, of self-possession.

When you eat, it is purely functional. There is no flair, no shaping or playing with food. The food goes straight on to your fork and into your

mouth. Smoking a cigarette has the same purposeful quality. In fact, if all your actions have a sense of purpose, even the most trivial, you will be taken seriously as a man. Remember you are important and everything you do is significant.

Some further gestures to try out, for maximum "alpha male" impact:

1. Standing with your feet together, lift up your heels, and let them drop down with a click. *Object:* to show your authority in being present; that you are occupying space that is yours, i.e. demonstrating territorial ownership; to punctuate your importance as a man.

2. Jangle loose change in your pocket. *Object:* to show that you have money; to be heard when someone else is speaking; to show that you are a man—a man of money, of commerce, of importance—a man in a man's world.

3. Pretend to be listening to someone and then shrug your shoulders in a gesture of disinterest. *Object:* to show that you are the most important person in the room with the most important opinions; to demonstrate your authority as a judge of everything; to let the other person know that they are subject to your approval at all times.

4. Fold the arms and recede the head and chest while somebody is grappling to express themselves. *Object:* to let the person know they are an idiot; to exaggerate your position as judge and observer; to prepare everyone around you for your grand rebuff (which can be completely inconsequential).

5. Unbutton your jacket and put either one hand or both hands on the hips, thumbs touching the hip bone and fingers splayed at the front. If you just use one hand, don't let the other hang loose: use it to point with your finger, to add extra emphasis to your statement. *Object:* to show great strength of purpose; to show that you are proud and know what you are talking about; to show that the other person "better watch out" because you mean what you say and you say what you mean.

6. If you are sitting, clasp both hands together, interfolding fingers, and let the forefinger touch the chin, elbows on the table. Look straight ahead at the person in front of you. *Object:* to show your authority as supreme judge of any situation; to assume an air of absolute seriousness; to let the person you are talking to know how privileged they are to have you as a listener.

6. PASSING IN PUBLIC

The key thing to remember, when out and about in your male guise, is that you should *show no sign* that anything is unusual. When you eat in a four-star hotel dining room, for instance, it may arouse suspicion if your hair is dyed, because this is less common in men than women ("what is that guy with the weird hair doing in here?"). As everyone in the restaurant focuses in on you, it's important to maintain a nonchalant air. Ignore the stares as you wander around the buffet table, and remember to display the facial expressions that suggest a lack of self-awareness. These will help to sustain the impression that you fit in. OK, you have dyed hair, but hey, you're one of the guys! People will supply their own excuses: e.g. the geritol reacted badly to your hair color; or you were prompted to a dare by your girlfriend.

Be aware, if you go out to eat or drink, that the movement of your mouth will mean some of your facial hair will inevitably fall off (though you take every effort to secure it in the safety of your bathroom). Little pieces of hair may suddenly appear in your soup or mashed potatoes. Not exactly appetizing, but again, maintain a sense of nonchalance. Generally, it will not affect your facial appearance to lose a little hair here and there. If a large chunk of hair appears on your plate, though, you will have to fix the offending gap in beard, sideburn or moustache as soon as possible. But never acknowledge that there is anything wrong: keep an air of "I'm in control" about you as you exit to the bathroom to apply more facial hair.

Remember: Gender is an act. Whereas femininity is always drag, no matter who is wearing it (which is why it's easy to caricature), maleness is the presumed universal. It is thus more invisible in its artificiality. This is to our advantage when trying to pass in male guise. Sociological studies have shown that maleness is assumed, unless proven otherwise. And even if you feel you don't pass, the fact that you've entered into this transgressive act and are performing as a male is significant in itself. Maybe when people realize that gender is a cultural construct, it could eventually lead to a world where gender norms are abandoned, or in which genders proliferate beyond the pair commonly recognized. Just think, you are contributing to a dynamic revolution in the way we see ourselves, and how we are seen. You are creating a change in perception.

Chronology: Diane Torr

1976 Graduates from Dartington College, England; moves to New York to study dance at the Cunningham Studios.

1978 First solo performances presented at Franklin Furnace, New York, and in London and Nova Scotia; becomes a member of DISBAND with Martha Wilson, Ingrid Sischy, Donna Henes, and later, Ilona Granet.

1980 Performs with Ruth Peyser in Colab's *Times Square Show;* becomes a regular performer at Mudd Club, Club 57 and Pyramid Club, New York.

1981 *WOW-a-Go-Go* performance at second WOW Festival, New York.

1982 *Arousing Reconstructions* at St. Mark's Church Danspace (collaboration with Bradley Wester); *Show* (go-go performance) at Women's Festival, Melkweg, Amsterdam; new solo pieces *Go-Go World* and *Amoebic Evolution* tour to venues in Belgium, Holland, Germany.

1983 Performances of *Go-Go World* and *Amoebic Evolution* at Limbo Lounge and P.S. 1, New York.

1984 *Girl in Trouble* premieres at Movement Research Centre, New York.

1985 *Maldoror's Grey Lark* premieres at P.S. 122, New York; choreography of *Ulysses* for Creative Time's Art on the Beach Series.

1986 *Girls Will Be Boys Will Be Queens* premieres at BACA Downtown, Brooklyn.

1988 Tours twelve cities in nine U.S. states with performances of *Go-Go World, Girl in Trouble* and *Amoebic Evolution; Catastrophe and Beguilement* premieres at St. Mark's Church Dansspace, New York.

1989 Meets Johnny Science at Annie Sprinkle's Salon. First public "passing as male" at the opening of the Whitney Biennial; tours Canada with performances of *Go-Go World, Girl in Trouble* and *Amoebic Evolution.*

1990 First Drag King workshops with Johnny Science at the Annie Sprinkle Salon; *Crossing the River Styx* premieres at Franklin Furnace, New York; achieves rank of *shodan* (first degree blackbelt) in Aikido.

1991 First public performance as Danny King, at P.S. 122's annual benefit

271

event; appears with other drag kings and cross-dressers on the *Phil Donahue* TV show.

1992 *Ready Aye Ready, a standing cock has nae conscience* premieres in New York at La Mama, and transfers to P.S. 122; assumes persona of Charles Beresford in private acts of AIDS memorialization; Johnny Science hosts the first Drag King Ball at the Crow Bar, New York.

1993 *Scratch 'n' Sniff, Touch 'n' Feel* premieres at European Dance Development Centre, Arnhem; First Drag King Workshop outside New York, at Boston's Institute for Contemporary Art; a subsequent New York workshop features in the *Washington Post* and prompts appearance on the *Jerry Springer* TV show.

1994 First Drag King Workshop in Toronto at Buddies in Bad Times Theatre; *Open for Flavor* (film and performance) premieres at Theatre het Liefde, Amsterdam, under auspices of the School for New Dance; First European Drag King Workshop at the Melkweg, Amsterdam; First London Drag King presentation at the Institute for Contemporary Art.

1995 *Drag Kings and Subjects* (which at that stage includes the monologue later to stand alone as *Happy Jack*) premieres at P.S. 122, New York, and tours to Chicago, London, Hannover, Utrecht; BBC documentary on the Drag King workshop features on the *Q.E.D.* programme, "Sex Acts"; First German Drag King Workshops in Berlin and Hannover; guest appearance on the *Montel Williams* TV show; achieves rank of *nidan* (second degree blackbelt) in Aikido.

1996 Presents Drag King Workshop and revised version of *Drag Kings and Subjects* in Minneapolis at the *genders that be* festival, Intermedia; later presents same pairing in Zurich at the *erotisch aber indiskret* festival.

1997 First appearance of Mister EE in the premiere of *BULL!* (co-ordinated by Ian Smith and Mischief La Bas) at the Albany Theatre, London; guest appearance on the *Gayle King* TV show.

1998 First annual *Brother for a Day* event at Club Mother, New York; achieves rank of sandan (third degree blackbelt) in Aikido.

1999 *Ideal Homo* installation premieres in Leeds, England; participant in *Trans Chans* performance at Club Magma, Istanbul; also presents first Turkish Drag King Workshop.

2000 "Man for a Day" workshops (formerly the Drag King Workshop) in Germany, Italy and Portugal.

2001 *XX och YY* premieres in Helsinki. (Collaboration with students of the Helsinki Theatre Academy, who go on to form the drag king troupe SubFrau.)

2002 Features in Gabriel Baur's documentary film *Venus Boyz*, which premieres at Berlin Film Festival; co-directs the month-long *godrag!* festival in Berlin with Bridge Markland.

2003 Appears with the Chicago Kings in Michele Mahoney's film *The Undergrad*; performs as Saint Sebastian in the premiere of Ian Smith and Mischief La Bas's *Painful Creatures* (Big in Falkirk Festival, Scotland).

2004 Master of Ceremonies at *Manfest*, New George's Theatre, New York.

2005 Video work *Cigarettes, Reading, Masturbation and Boys* premieres at the London Lesbian and Gay Film Festival; performs as Mister EE and presents first Spanish "Man for a Day" workshop at Arteleku conference, San Sebastian.

2006 Six-week residency at the Khoj Art Workshop, New Delhi. Includes first Asian "Man for a Day" workshop at the National School of Drama; video work *Mountain Men and British Birds* premieres at the first Transfabulous Festival, London. Guest performer at the *Transfabulous Extravaganza* cabaret event; workshop performance of *Donald Does Dusty* at Glasgay! Festival, Centre for Contemporary Art, Glasgow.

2007 Performs as Angus McTavish in *Homage to Nam June Paik*, James Cohan Gallery, New York.

2008 Workshop Performance of *Donald Does Dusty* at Dragfest!, Berlin; "Man for a Day" workshops at International Drag King Festival, Rome and Casa Morigi, Milan; begins filming in Berlin for Katarina Peters' feature documentary, *Man for a Day*; DISBAND reforms to perform at the launch of the major retrospective exhibition *WACK! Art and the Feminist Revolution*, P.S. 1, New York.

2009 Performs as Mister EE at first ever Genoa Pride Festival; premieres full-script version of *Donald Does Dusty* (still in development) at Tron Theatre, Glasgow; DISBAND performs at Incheon International Women Artists' Biennial, South Korea.

Bibliography

Abbe, Jessica. 1981. "*WOW-a-Go-Go* Is Best Performance Piece." *The Villager* 49, no. 41 (8 October): 11.

Adams, Rachel, and David Savran, eds. 2002. *The Masculinity Studies Reader.* Oxford: Blackwell.

Allan, Vicky. 2003. "It's Reigning Men." *Sunday Herald,* 6 April, 3.

Ashery, Oreet. 2009. *Dancing with Men.* London: Live Art Development Agency.

Bailey, Andy. 1997. "Hair Apparent." *The Face,* October.

Banes, Sally. 1982. "Reviews." *Dance,* June, 20.

Banes, Sally. 1998. *Subversive Expectations: Performance Art and Paratheater in New York, 1976–85.* Ann Arbor: University of Michigan Press.

Baracks, Barbara. 1981. "Déjà Wow." *Village Voice,* 14–20 October, 103, 112.

Barber, Charles. 1992. "The Empowered Sex Object." *NYQ,* 29 March, 44.

Barker, Jason. 2009. Skype interview with Diane Torr and Stephen Bottoms, 14 January.

Bashford, Kerry. 2005. "Elvis Herselvis, Part 2." www.gendercentre.org.au/17article4.htm.

Beauvoir, Simone de. [1949] 1988. *The Second Sex.* Trans. H. M. Parshley. London: Picador.

Behn, Aphra. 1987. *The Rover.* London: Methuen.

Belkin, Lisa. 2007. "Life's Work: The Feminine Critique." *New York Times,* 1 November. www.nytimes.com/2007/11/01/fashion/01work.html.

Bell, Shannon. 1993. "Finding the Male Within and Taking Him Cruising: 'Drag King for a Day' at the Sprinkle Salon." In *The Last Sex: Feminism and Outlaw Bodies,* ed. Arthur and Marilouise Kroker (New York: St. Martin's), 91–97.

Benmussa, Simone. 1979. *Benmussa Directs: Portrait of Dora—The Singular Life of Albert Nobbs.* London: Calder.

Blackmer, Tracy. 2007. Telephone interview with Stephen Bottoms, 8 December.

Blitzen. 1981. "Everywoman's Planet." *Sojourner: The Women's Forum* 7, no. 4 (31 December): 19.

Bornstein, Kate. 1995. *Gender Outlaw: On Men, Women, and the Rest of Us*. New York: Vintage.

Bottoms, Stephen J. 1998. *The Theatre of Sam Shepard: States of Crisis*. Cambridge: Cambridge University Press.

Bottoms, Stephen J. 2004. *Playing Underground: A Critical History of the 1960s Off-Off-Broadway Movement*. Ann Arbor: University of Michigan Press.

Bratton, J. S. 1992. "Irrational Dress." In *The New Woman and Her Sisters: Feminism and Theatre, 1850–1914*, ed. Viv Gardner and Susan Rutherford. New York and London: Harvester Wheatsheaf.

Brubach, Holly. 1999. *Girlfriend: Men, Women, and Drag*. New York: Random House.

Bullough, Vern, and Bonnie Bullough. 1993. *Cross Dressing, Sex, and Gender*. Philadelphia: University of Pennsylvania Press.

Bugg, Sean. 2004. "Gender Blender: Blurring the Lines with Kendra Kuliga and the D.C. Kings." *MetroWeekly*, 22 April. Accessed at www.metroweekly.com/feature/?ak=983.

Burgheart, Catherine, and Sam Blazer. 1981. "Sex Theatre." *TDR: The Drama Review* 25, no. 1 (March): 69–78.

Burke, Phyllis. 1996. *Gender Shock: Exploding the Myths of Male and Female*. New York: Anchor.

Burnside, Anna. 1995. "Walk Like a Man." *Scotland on Sunday*, 14 May.

Butler, Judith. 1993. *Bodies That Matter: On the Discursive Limits of "Sex."* London and New York: Routledge.

Butler, Judith. [1990] 1999. *Gender Trouble: Feminism and the Subversion of Identity*. London and New York: Routledge.

Butler, Judith. 2004. *Undoing Gender*. Oxon and New York: Routledge.

Calhoun, Ada. 2005. "Meet Downtown's New 'It' Boy." *New York Times*, 9 January. Accessed online at http://query.nytimes.com/gst/fullpage.html?res=9D0DEEDD139F93AA35752C0A9639C8B63.

Carr, C. 1989. "All Smut, No Slut." *Village Voice*, 8 May, 97.

Carr, C. 1998. "Men? Oh, Pause: Peggy Shaw Goes through the Change and Comes Out Swinging." *Village Voice*, 9 June, 66.

Carter, Angela. 1979. *The Sadeian Woman: An Exercise in Cultural History*. London: Virago.

Case, Sue-Ellen. 1989. "Toward a Butch-Femme Aesthetic." In *Making a Spectacle: Feminist Essays on Contemporary Women's Theatre*, ed. Lynda Hart. Ann Arbor: University of Michigan Press.

Chambers, Jane. 1981. "A Decade of Dogma Gives Way to Delight at the Women's One World Festival." *Advocate*, 22 January, Ticket section, 19–21.

Chauchard-Stuart, Sophia. 1996. "Suits You, Madam." *Independent*, 8 May, sec. 2, 6.

Clark, David Aaron. 1992. "Drag Addiction." *Screw*, 15 June, 13.

Clay, Carolyn. 1977. "The Agony and the Irony." *Boston Phoenix*, 22 November, sec. 3, 1, 13.

Cleto, Fabio, ed. 1999. *Camp: Queer Aesthetics and the Performing Subject.* Ann Arbor: University of Michigan Press.

Connell, R. W. 1995. *Masculinities.* Berkeley and Los Angeles: University of California Press.

Czyzselska, Jane. 2008. Skype interview with Stephen Bottoms, 22 April.

Davy, Kate. 1994. "Fe/Male Impersonation: The Discourse of Camp." In *The Politics and Poetics of Camp,* ed. Moe Meyer. London and New York: Routledge.

Deleuze, Gilles, and Felix Guattari. 1987. *A Thousand Plateaus: Capitalism and Schizophrenia.* Trans. Brian Massumi. Minneapolis and London: University of Minnesota Press.

Devor, Holly. 1989. *Gender Blending: Confronting the Limits of Duality.* Bloomington and Indianapolis: Indiana University Press.

Dolan, Jill. 1989. "Desire Cloaked in a Trenchcoat." *TDR: The Drama Review* 33, no. 1 (spring): 59–67.

Dolan, Jill. 1991. *The Feminist Spectator as Critic.* Ann Arbor: University of Michigan Press.

Dolan, Jill. 2001. *Geographies of Learning: Theory, Practice, Activism and Performance.* Middletown, CT: Wesleyan University Press.

Dworkin, Andrea. 1981. *Pornography: Men Possessing Women.* New York: Perigree.

Feinberg, Leslie. 1992. *Transgender Liberation: A Movement Whose Time Has Come.* World View Forum.

Feinberg, Leslie. 1993. *Stone Butch Blues.* Ann Arbor: Firebrand.

Ferris, Lesley K. 1990. *Acting Women: Images of Women in Theatre.* Basingstoke: Macmillan.

Ferris, Lesley K., ed. 1993. *Crossing the Stage: Controversies on Cross-Dressing.* London and New York: Routledge.

Flannery, Denis. 2007. *On Sibling Love, Queer Attachment, and American Writing.* London: Ashgate.

Foucault, Michel, ed. 1980. *Herculine Barbin: Being the Recently Discovered Memoirs of a Nineteenth-Century French Hermaphrodite.* Trans. Richard McDougall. New York: Pantheon.

Friedan, Betty. [1963] 1973. *The Feminine Mystique.* New York: Dell.

Garbarino, Steve. 1992. "Cross-Dressing Women Win Drag Race." *New York Newsday,* 21 May, 67.

Garber, Marjorie. 1993. *Vested Interests: Cross-Dressing and Cultural Anxiety.* New York: HarperCollins.

Gerestant, Mildred. 2007. Interview with Stephen Bottoms, New York City, 4 October.

Gilbert, Elizabeth. 2004. "My Life as a Man." In *The Kaleidoscope of Gender: Prisms, Patterns, and Possibilities,* ed. Joan Z. Spade and Catherine G. Valentine. Belmont, CA: Thomson Wadsworth. Originally published in *GQ.*

Giles, Fiona, ed. 1997. *Dick for a Day.* New York: Random House.

Gray, John. 1992. *Men Are from Mars, Women Are from Venus.* New York: HarperCollins.

Griffin, John Howard. 1961. *Black Like Me*. Boston: Houghton Mifflin.

Grosz, Elizabeth. 1994. *Volatile Bodies: Toward a Corporeal Feminism*. Blooming-ton and Indianapolis: Indiana University Press.

Haney, Craig, Curtis Banks, and Philip Zimbardo. 2004. "A Study of Prisoners and Guards in a Simulated Prison." In *Theatre in Prison: Theory and Practice*, ed. Michael Balfour. Bristol, U.K., and Portland, OR: Intellect.

Halberstam, Judith. 1998. *Female Masculinity*. Durham and London: Duke University Press.

Halberstam, Judith. 2005. *In a Queer Time and Place: Transgender Bodies, Subcultural Lives*. New York: New York University Press.

Hargreaves, Tracy. 2004. *Androgyny in Modern Literature*. Basingstoke: Palgrave Macmillan.

Hasten, Lauren W. 1999. "Gender Pretenders: A Drag King Ethnography." PhD diss., Department of Anthropology, Columbia University.

Hateley, Joey, and Paula Hateley. 2008. Interview with Stephen Bottoms, Manchester, 30 January.

Heilbrun, Carolyn. 1973. *Toward a Recognition of Androgyny*. New York: Knopf.

Henkel, Gretchen. 1980. "All About Eve Merriam's *Club*." *Drama-Logue*, 9 October, 1, 13.

Hite, Shere. 1976. *The Hite Report: A Nationwide Study of Female Sexuality*. New York: Macmillan.

Hughes, Holly. 1989. "Polymorphous Perversity and the Lesbian Scientist: An Interview by Rebecca Schneider." *TDR: The Drama Review* 33, no. 1 (spring): 171–83.

Hughes, Holly. 1991. *The Lady Dick. TDR: The Drama Review* 35, no. 3 (autumn): 198–215.

Jowitt, Deborah. 1995. "Making Men." *Village Voice*, 28 February, 79.

Karr, M. A. 1980. "Eve Merriam Welcomes You to *The Club*." *Advocate*, 18 September, 27–28.

Keith, Thomas, ed. 2002. *Robert Burns: Selected Poems and Songs*. New York: Caledonia Road Publishing.

Knapp, Caroline. 1993. "I Was a Drag King." *Boston Phoenix*, 30 April, sec. 2, 4–5.

Koroly, John Michael. 1992. "Torr-de-Force for Perf. Artist." *Cultural Arts Bulletin*, March.

Koroly, John Michael. 1995. "Drag . . . They're Not All Queens." *Greenwich Village Press*, September.

Langland, Paul. 1996. "Between the Cracks: Interview with Diane Torr." *Contact Quarterly*, summer–fall, 16–25.

Lawrence, Leslie. 1997. "Drag King for a Day." *Oberlin Alumni Magazine*, spring, 18–20.

Linn, Amy. 1995. "Drag Kings." *SF Weekly*, 27 September–3 October, 10–18.

Lorde, Audre. 1984. *Sister Outsider: Essays and Speeches*. Freedom, CA: Crossing.

Lowe, Leslie. 2008. Skype interview with Stephen Bottoms, 21 February.

Maltz, Robin. 1998. "Real Butch: The Performance/Performativity of Male Im-

personation, Drag Kings, Passing as Male, and Stone Butch Realness." *Journal of Gender Studies* 7, no. 3, 273–86.

Mars, Shelly. 2001. "Exploring Your Inner Male." In *Sex Tips and Tales from Women Who Dare,* ed. Jo-Anne Baker. Alameda, CA: Hunter House.

Mars, Shelly. 2007. Interview with Stephen Bottoms, New York City, 1 October.

Mayell, Hillary. 2002. "Thousands of Women Killed for Family 'Honor.'" *National Geographic News,* 12 February. http://news.nationalgeographic.com/news/2002/02/0212_020212_honorkilling.html.

Merriam, Eve. 1977. *The Club: A Musical Diversion.* New York: Samuel French.

Merrill, Lisa. 1999. *When Romeo Was a Woman: Charlotte Cushman and Her Circle of Female Spectators.* Ann Arbor: University of Michigan Press.

Minkowitz, Donna. 1994. "Love Hurts: Brandon Teena Was a Woman Who Lived and Loved as a Man—She Was Killed for Carrying It Off." *Village Voice,* 19 April.

Munk, Erika. 1980. "Cross Left—Outrage Department." *Village Voice,* 1 October, 114.

Muñoz, José Esteban. 2005. "Utopia's Seating Chart: Ray Johnson, Jill Johnston, and Queer Intermedia as System." In *After Criticism: New Responses to Art and Performance,* ed. Gavin Butt. Oxford: Blackwell.

Munt, Sally, ed. 1998. *Butch/Femme: Inside Lesbian Gender.* London: Cassell.

Murray, Sarah E. 1994. "Dragon Ladies, Draggin' Men: Some Reflections on Gender, Drag, and Homosexual Communities." *Public Culture,* no. 6, 343–63.

Nestle, Joan. 1987. *A Restricted Country.* Ithaca: Firebrand.

Newton, Esther. 1972. *Mother Camp: Female Impersonators in America.* Chicago: University of Chicago Press.

Newton, Esther. 1996. "'Dick(less) Tracy' and the Homecoming Queen: Lesbian Power and Representation in Gay-Male Cherry Grove." In *Inventing Lesbian Subcultures in America,* ed. Ellen Lewin. Boston: Beacon.

O'Sullivan, Kimberly. 2005. "Elvis Herselvis, Part 1." *Wicked Women.* www.gendercentre.org.au/16article11.htm.

Palmer, Caroline. 1992. "Ready Aye Ready: Diane Torr Delivers Bawdy Burns." *Paper,* March.

Papoulias, Tina. 1995. "Self Made Men." *Diva,* February, 40–42.

Pathy Allen, Mariette. 1990. *Transformations: Crossdressers and Those Who Love Them.* New York: Dutton.

Pathy Allen, Mariette. 2003. *The Gender Frontier.* Heidelberg: Kehrer Verlag.

Peraldi, Francois, ed. 1981. *Polysexuality.* New York: Semiotext(e).

Phelan, Peggy. 1997. *Mourning Sex: Performing Public Memories.* London and New York: Routledge.

Press, Joy. 1994. "Walk Like a Man." *Guardian,* 4 May.

Prosser, Jay. 1998. *Second Skins: The Body Narratives of Transsexuality.* New York: Columbia University Press.

Pullen, Kirsten. 2005. *Actresses and Whores: On Stage and in Society.* Cambridge: Cambridge University Press.

Quart, Alissa. 2008. "When Girls Will Be Boys." *New York Times,* 16 March. www.nytimes.com/2008/03/16/magazine/16students-t./html.

Quinlan, Cathy. 2007. Interview with Stephen Bottoms, New York City, 3 October.

Rachlin, Kit. 2007. Interview with Stephen Bottoms, New York City, 4 October.

Rachlin, Kit. 2008. E-mail correspondence with Stephen Bottoms, 18 January.

Raymond, Gerard. 1992. "Lesbians Who Kill: Peggy Shaw and Lois Weaver and the Men That Made Them Do It." *TheaterWeek,* 29 June–5 July, 22–26.

Rice, Shelley, ed. 1999. *Inverted Odysseys: Claude Cahun, Maya Deren, Cindy Sherman.* Cambridge: MIT Press.

Rodger, Gillian. 2002. "He Isn't a Marrying Man: Gender and Sexuality in the Repertoire of Male Impersonators, 1870–1930." In *Queer Episodes in Music and Modern Identity,* ed. Sophie Fuller and Lloyd Whitesell. Urbana and Chicago: University of Illinois Press.

Rodger, Gillian. 2006. *Venus Boyz* (review). *Women and Music: A Journal of Gender and Culture* 10:107–11.

Romano, Tricia. 2007. "Bye Bye Boobies." *Village Voice,* 12 June. www.villagevoice.com/2007-06-12/nyc-life/bye-bye-boobies/.

Sanchez, Maria Carla, and Linda Schlossberg. 2001. *Passing: Identity and Interpretation in Sexuality, Race, and Religion.* New York: New York University Press.

Savran, David. 1998. *Taking It Like a Man: White Masculinity, Masochism, and Contemporary American Culture.* Princeton: Princeton University Press.

Science, Johnny. 1998. Monologue to camera, first episode of *That Show . . . with Johnny Science,* Manhattan Neighborhood Network TV (broadcast date unknown).

Sedgwick, Eve Kosofsky. 1990. *Epistemology of the Closet.* Berkeley and Los Angeles: University of California Press.

Senelick, Laurence. 2000. *The Changing Room: Sex, Drag, and Theatre.* London and New York: Routledge.

Shalson, Lara. 2005. "Creating Community, Constructing Criticism: The Women's One World Festival, 1980–1981." *Theatre Topics* 15, no. 2 (September): 221–39.

Shubin, Neil. 2008. *Your Inner Fish: A Journey into the 3.5-Billion-Year History of the Human Body.* New York: Pantheon.

Simpson, Mark. 1994. *Male Impersonators: Men Performing Masculinity.* New York: Routledge.

Smith, Emma. 2003. "Unorthodox Art Gets a Live Airing." *Western Daily Press,* 13 February, 35.

Solomon, Alisa. 1985. "The WOW Cafe." *The Drama Review* 29, no. 1 (spring): 92–101.

Solomon, Alisa. 1991. "Drag Race." *Village Voice,* 5 November, 46.

Span, Paula. 1993. "Guise and Dolls." *Washington Post,* 12 October, C1–2.

Sprinkle, Annie. 1989. "Inside a Female Gender-Bender." *Adam* 33, 29–30. Interview with Johnny Science.

Sprinkle, Annie. 2008. Skype interview with Diane Torr and Stephen Bottoms, 13 January.

Stone, Sandy. 1991. "The Empire Strikes Back: A Posttranssexual Manifesto." In *Body Guards: The Cultural Politics of Gender Ambiguity,* ed. Julia Epstein and Kristina Straub. London and New York: Routledge.

Straub, Kristina. 1992. *Sexual Suspects: Eighteenth Century Players and Sexual Ideology.* Princeton: Princeton University Press.

Stryker, Susan, and Stephen Whittle, eds. 2006. *The Transgender Studies Reader.* New York and London: Routledge.

Sundahl, Debi. 1987. "Stripper." In *Sex Work: Writings by Women in the Sex Industry,* ed. Frederique Delacoste and Priscilla Alexander. Pittsburgh: Cleis.

Taylor, Clare L. 2003. *Women, Writing, and Fetishism, 1890–1950: Female Cross-Gendering.* Oxford: Oxford University Press.

Taylor, Marvin J., ed. 2005. *The Downtown Book: The New York Art Scene, 1974–1984.* Princeton: Princeton University Press.

Teen, Chris. 1990[?]. "Adventures of a Drag-King Queen." Article for an unidentified fanzine.

Thilmann, Pia, Tania Witte, and Ben Rewald, eds. 2007. *Drag Kings: Mit Bartkleber gegen das Patriarchat.* Berlin: Querverlag. In German.

Thompson, C. J. S. 1974. *The Mysteries of Sex: Women Who Posed as Men and Men Who Impersonated Women.* New York: Causeway.

Todd, Mabel Elsworth. [1937] 1968. *The Thinking Body: A Study of the Balancing Forces of Dynamic Man.* Princeton, NJ: Princeton Book Company.

Toone, Anderson. 2002a. "Drag King Timeline" (online chronology). www.andersontoone.com.

Toone, Anderson. 2002b. "Keynote Address" at the fourth annual International Drag King Extravaganza (IDKE), Columbus, OH. (Text unpublished; quoted by permission of the author.)

Toone, Anderson. 2007. E-mail correspondence with Stephen Bottoms, 29 September.

Torr, Diane. 1997. "How to Be a Great Guy." In *Dick for a Day,* ed. Fiona Giles. New York: Random House.

Torr, Diane. 1999. "Release, Aikido, Drag King, Aikido, Release." *Movement Research Performance Journal* 19 (fall–winter): 5.

Torr, Diane. 2001a. "Any Woman Can Take on the Role of a Man." In *Sex Tips and Tales from Women Who Dare,* ed. Jo-Anne Baker. Alameda, CA: Hunter House.

Torr, Diane. 2001b. "Lake Cuntry Drag King Fling." In *Aroused: A Collection of Erotic Writings,* ed. Karen Finley. New York: Thunder's Mouth.

Torr, Diane. 2004. "Diane Torr: Interview mit der Drag-King-Pionierin." *Die Krone & Ich* 4 (November): 34–50. In English and German.

Troka, Donna, Kathleen LeBesco, and Jean Noble, eds. 2002. *The Drag King Anthology.* New York and London: Harrington Park.

Trumbach, Randolph. 1996. "London's Sapphists: From Three Sexes to Four Genders in the Making of Modern Culture." In *Third Sex, Third Gender: Be-*

yond Sexual Dimorphism in Culture and History, ed. Gilbert Herdt. New York: Zone.

Vera, Veronica. 1992. "Drag King for a Day." *Adam* 36, no. 11 (November): 10–13.

Vincent, Norah. 2006. *Self Made Man: My Year Disguised As a Man.* London: Grove Atlantic.

Virshup, Amy. 1983. "Political Sexiness at P.S. 1." *East Village Eye,* July.

Volcano, Del LaGrace, and Ulrika Dahl. 2008. *Femmes of Power: Exploding Queer Femininities.* London: Serpent's Tail.

Volcano, Del LaGrace, and Judith "Jack" Halberstam. 1999. *The Drag King Book.* London: Serpent's Tail.

Vorlicky, Robert. 1995. *Act Like a Man: Challenging Masculinities in American Drama.* Ann Arbor: University of Michigan Press.

Wahrman, Dror. 2004. *The Making of the Modern Self: Identity and Culture in Eighteenth Century England.* New York and London: Yale University Press.

Waxman, Tobaron. 2001. "Opshernish." *GLQ* 7, no. 4: 681–87.

Waxman, Tobaron. 2004. Untitled interview with Katrien Jacobs. www.tobaron.com/texts+CV/GenderFluXXors_HongKong.pdf.

Waxman, Tobaron. 2008. Skype interview with Stephen Bottoms, 14 April.

Wester, Bradley. 2007. Skype interview with Diane Torr and Stephen Bottoms, 12 November.

Wheelwright, Julie. 1990. *Amazons and Military Maids: Women Who Dressed as Men in Pursuit of Life, Liberty, and Happiness.* London: Pandora.

Wheelwright, Julie. 1994. "Out of My Way, I'm a Man for a Day." *Independent,* 11 November, 28.

White, Diane. 1993. "Why Can't a Woman Be More Like a Man?" *Boston Globe,* 29 June, 57–58.

Williams, Frances. 1995. "Girls Who Wear Moustaches." *Independent on Sunday,* 17 September, Real Life section, 4–5.

Wilson, Martha. 2007. Interview with Stephen Bottoms, New York City, 2 October.

Wood, Catherine. 2007. *Yvonne Rainer: The Mind is a Muscle.* London: Afterall.

Zimbardo, Philip. 2007. *The Lucifer Effect: How Good People Turn Evil.* London: Rider.

Acknowledgments

We have a lot of people to acknowledge for their part in bringing this book into existence. A particular thank-you is due to LeAnn Fields, at the University of Michigan Press, for her faith in this project, and to the Critical Performances series editors Robert Vorlicky and Una Chaudhuri for their unwavering enthusiasm.

Special thanks from both of us go to those who agreed to be interviewed as part of our research: Mariette Pathy Allen, Jason Barker, Tracy Blackmer, Jane Czyzselska, Mildred Gerestant, Joey and Paula Hateley, Leslie Lowe, Shelly Mars, Cathy Quinlan, Lucy Schneider, Annie Sprinkle, Tobaron Waxman, Bradley Wester, and Martha Wilson. Kit Rachlin, who also consented to be interviewed, is due particular thanks for allowing us access to the private archives of Johnny Science, who wanted to give us an interview but proved too unwell to do so. He died in December 2007, and this book is dedicated to his memory.

We would like to thank the photographers who consented to the use of their work in this publication, including Mariette Pathy Allen, Yvon Bauman, Caterina Borelli, Cori Wells Braun, Kathy Brew, Claude Crommelin, Sarah Jenkins, Dona Ann McAdams, Annie Sprinkle, Nick Simpson, Vivienne Maricevic, and the family of Paco Morales. Diane would also like to thank friends and colleagues who stimulated dialogue and helped determine historical facts related to her work in the creation of this book, including Peggy Ahwesh, Abigail Child, Laura Flanders, Su Friedrich, Alex Halkin, John Kelly, Paul Langland, Andrew McKinnon, Mickey-Ray Mahoney, Lizzie Olesker, Chris Koenig, Linda Ollie, Katarina Peters, Ruth Peyser, Melissa Ragona, Sara Seagull, Helen Silverlock, Rina Vergano, Stephanie Werthman and Rosie West.

Stephen could not have completed his contribution to this book without the support of the Arts and Humanities Research Council (United Kingdom) in buying him time away from teaching. He would also like to thank his many colleagues at the University of Leeds for their advice, support, and comments, particularly Denis Flannery, Tracy Hargreaves, Helen Iball, Jay Prosser, and Jane Rickard. Elsewhere, thanks also go to Penny Arcade, Gillian Rodger, Lara Shalson, Anderson Toone, and Oreet Ashery for encouraging correspondence and/or conversations.

Finally, in addition to those acknowledged above, Diane would like to thank the following people and organizations who have given support and/or aided in the development of her work: Liz Albin, Vicky Allan, Maryanne Amacher, Arvon Foundation DIY (Totleigh Barton), Sabina Baumann, David Berman, Valerie Briginshaw, Ramsay Burt, Ron Clark, Colin Cochran, Ellie Covan, Cummington Community for the Arts, Christina della Giustina, Rohini Devashar, Angie Dight, Gail Disney, Peter Dixon, João Fiadeiro, Marjorie Garber, Lia Gangitano, Alice Goldsmith, Gül Gürses, Rita Holderegger, Aat Hougee, Mike Hyatt, Anuradha Kapur, Lois Keidan, Caroline Knapp, Barbara Kraus, John Michael Koroly, Steve Kurtz, David Leddy, Jaine Lumsden (Scottish Arts Council), The Macdowell Colony, Bridge Markland, Moritz, Pauline Oliveros, Lucie Potter, Joy Press, Lilian Räber, Yvonne Rainer, Annie Reddick, Andrea Roedig, Andrew Ross, Mark Russell, Keith Sanborn, Carolee Schneeman, Ian Smith, Pooja Sood, Paula Span, Claudia Steinberg, Sub-Frau, Richard Teitelbaum, Pia Thilmann, Steven Thomson (Glasgay!), Catherine G. Valentine, Amy Virshup, Julie Wheelwright. Diane would also like to thank all the hundreds of participants who took part in Drag King/Man for a Day workshops in New York, Boston, Chicago, Minneapolis, Los Angeles, Boulder, London, Manchester, Leeds, Glasgow, Aberystwyth, Amsterdam, Arnhem, Berlin, Hannover, Hamburg, Düsseldorf, Munich, Bremen, Braunschweig, Zurich, Bern, Vienna, Lisbon, Madrid, San Sebastian, Bolzano, Rome, Vordingborg, Helsinki, Bordeaux, Milan, La Rochelle, Istanbul, and New Delhi. Big thanks also to the various academic institutions and performance venues, too numerous to mention, that have accommodated her research and performances. Thank-you to Joel Schlemowitz for accommodating Diane's papers and materials in New York. Last, she would like to thank Marcel and Martina Meijer for their support, suggestions, love, and forbearance over the years.

Index